DREAM HOMES

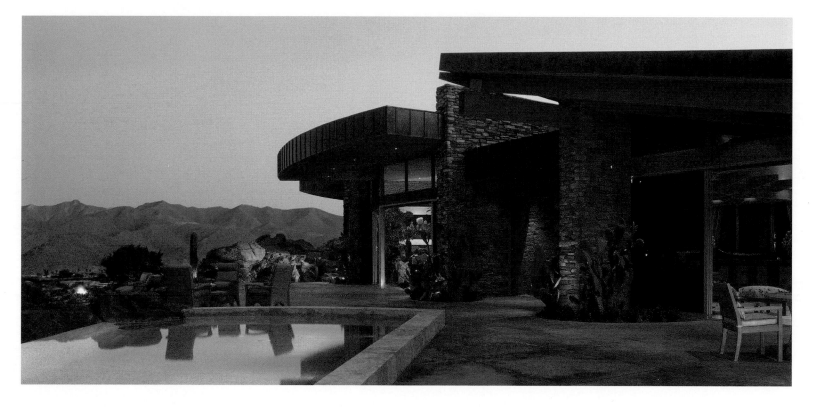

PACIFIC NORTHWEST

AN EXCLUSIVE SHOWCASE OF THE FINEST ARCHITECTS, DESIGNERS & BUILDERS IN OREGON & WASHINGTON

Published by

PANACHE
PANACHE PARTNERS, LLC

13747 Montfort Drive, Suite 100
Dallas, TX 75240
972.661.9884
Fax: 972.661.2743
www.panache.com

Publishers: Brian G. Carabet and John A. Shand
Executive Publisher: Steve Darocy
Associate Publisher: Kathie Cook
Editor: Lauren Castelli
Designer: Emily A. Kattan

Printed in Malaysia

Distributed by IPG
800.748.5439

PUBLISHER'S DATA

Dream Homes Pacific Northwest

Library of Congress Control Number: 2007930566

ISBN 13: 978-1-933415-01-7
ISBN 10: 1-933415-01-0

First Printing 2007

10 9 8 7 6 5 4 3 2 1

Previous Page Left: Krannitz Gehl Architects, *page 129*
Photograph by Big Horn Golf Club

This Page: Stuart Silk Architects, *page 175*
Photograph by Stuart Silk

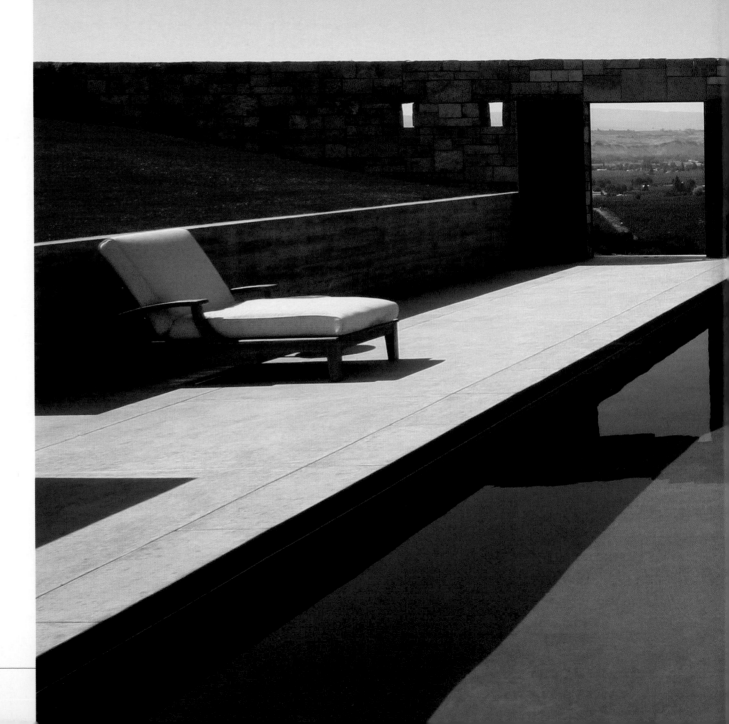

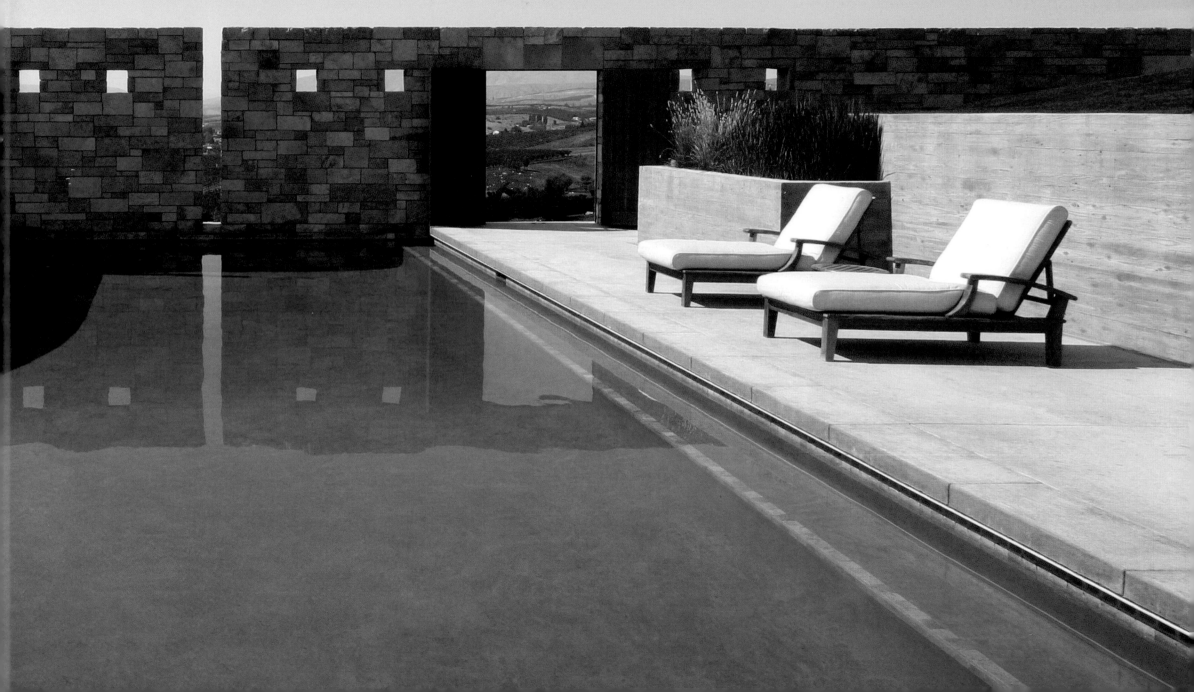

DREAM HOMES
PACIFIC NORTHWEST

AN EXCLUSIVE SHOWCASE OF THE FINEST ARCHITECTS, DESIGNERS & BUILDERS IN OREGON & WASHINGTON

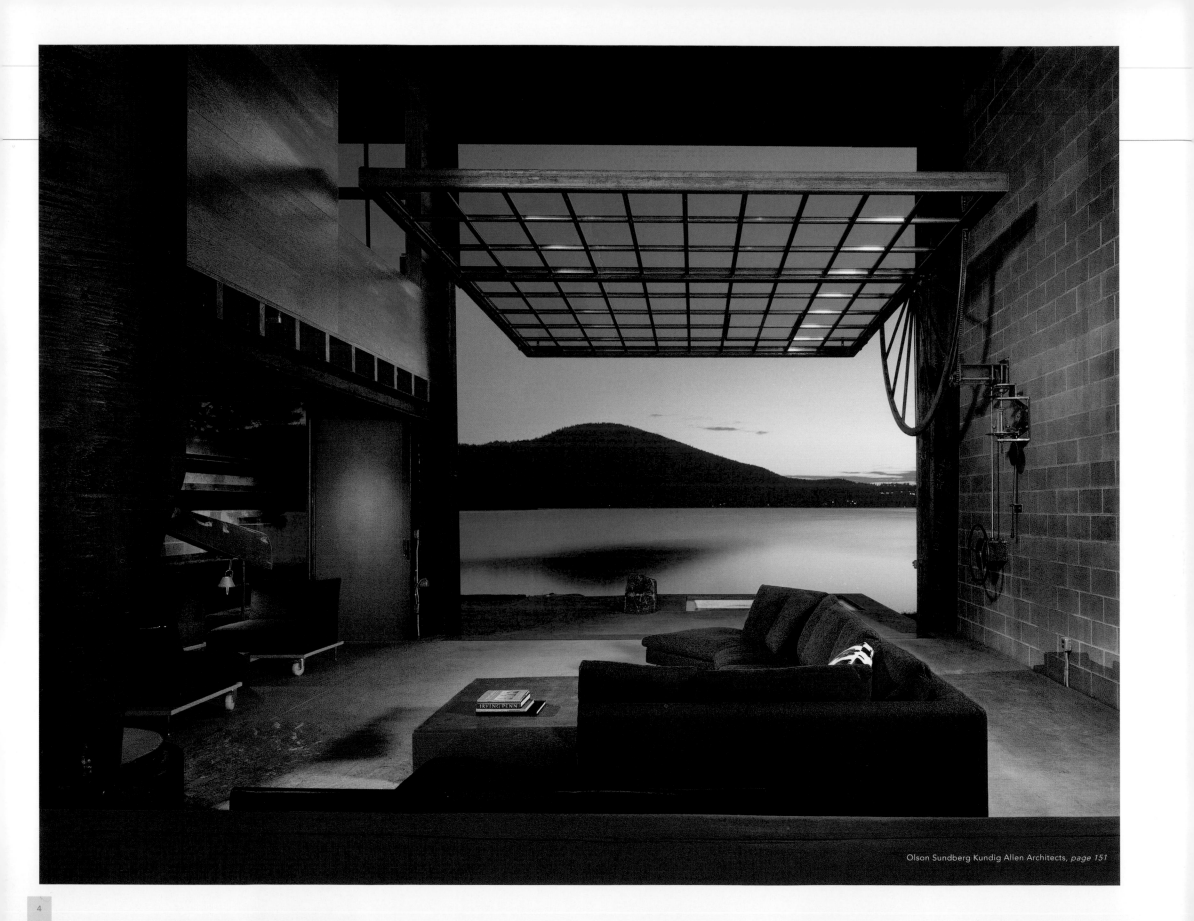

Olson Sundberg Kundig Allen Architects, *page 151*

Creativity abounds in the scenic region of the Pacific Northwest, a fact made patently evident by the abundance of talented artisans and craftsmen who call it home. The profusion of architectural opportunities, not to mention the breathtakingly beautiful and diverse landscape, serve as muse to creative minds at the top of their profession.

Dream Homes Pacific Northwest presents the work and philosophies of some of the most highly respected architects, designers and builders in the country. The design professionals featured on the pages that follow were selected for their talent, artistry and command of craft. Their work displays thoughtful, sophisticated and technologically innovative designs that epitomize residents' lifestyles and reflect the deep environmental sensitivity inherent in the region. Each home has evolved from its creator's strict attention to detail and keen aesthetic sensibility coupled with hard work and a genuine passion for fine architecture.

From coastal cottages to mountain cabins, renovations and historical restorations to urban infill and adaptive reuse, the projects vary broadly in scope. So too in style, representing the unique tastes of the people behind them—creators and owners alike. Though their ideas and approaches vary, all are bound by the quest to create unique and inspiring works of architecture. The professionals' command of a range of styles, genuine passion for Green design and sincere concern for the well-being of their clients engender homes as beautiful as the landscape they grace.

We invite you to get a glimpse into these magnificent homes and enjoy the work of these skilled artisans. Their exquisite designs vividly reveal that beauty and responsibility are one and the same.

Enjoy!

Brian Carabet and John Shand

Publishers

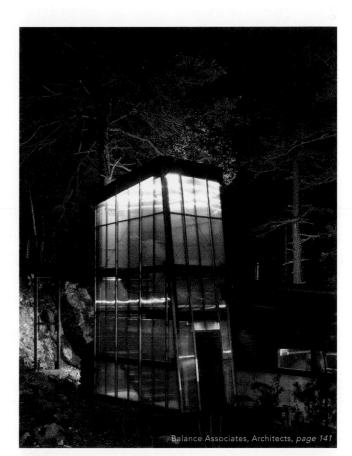

Balance Associates, Architects, *page 141*

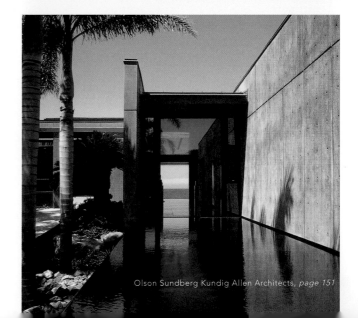

Olson Sundberg Kundig Allen Architects, *page 151*

Demetriou Architects, *page 99*

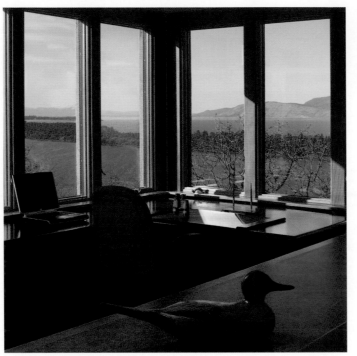

Robertson Merryman Barnes Architects, *page 55*

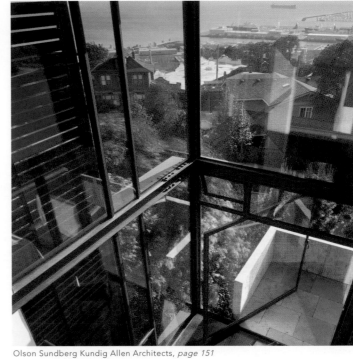

Olson Sundberg Kundig Allen Architects, *page 151*

OREGON

WASHINGTON

Richard Brown11
Richard Brown Architects AIA

Stan Chesshir17
Chesshir Architecture

Ray Derby & Rick Lesniak21
Blazer Development, Inc.

Mike Dowd25
Dowd Architecture Inc.

Mark Engberg31
COLAB Architecture + Urban Design, LLC

Dave Giulietti & Tim Schouten35
Giulietti/Schouten, AIA Architects PC

Jason Haggart & Jeff Haggart41
Haggart Luxury Homes

Jeffrey L. Miller47
Jeffrey L. Miller Architect, P.C.

Green Gables51
Design and Restoration, Inc.

Nancy Merryman & Linda Barnes55
Robertson Merryman Barnes Architects

Don Vallaster & Mike Corl59
Vallaster Corl Architects, P.C.

Mark Anderson, Mark Olason,
Dennis Marsh & Mark Elster65
AOME Architects AIA

Don Bender & Stephen Bender73
Bender Chaffey Corporation

Tom Berger & Jason Henry81
The Berger Partnership, PS

Eric Cobb .87
E. Cobb Architects Inc.

David Coleman91
David Coleman / Architecture

James Cutler & Bruce Anderson95
Cutler Anderson Architects

CONTENTS

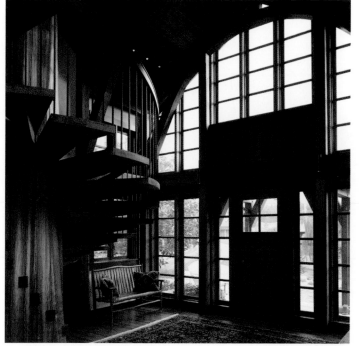

Chesshir Architecture, *page 17*

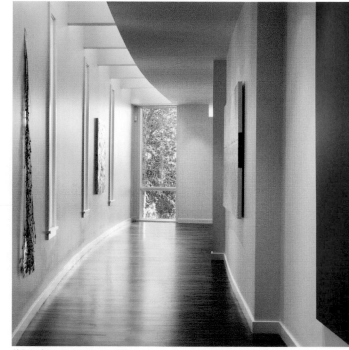

SkB Architects, Inc., *page 155*

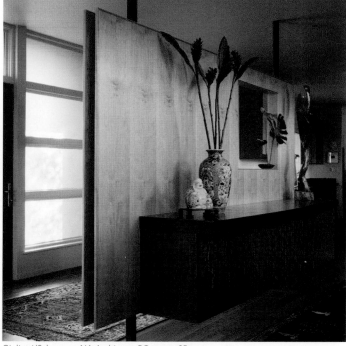

Giulietti/Schouten, AIA Architects PC, *page 35*

Vassos M. Demetriou99
Demetriou Architects

Tyler Engle. 103
Tyler Engle Architects PS

Tad Fairbank. 109
Fairbank Construction Company

Nils Finne . 115
FINNE Architects

Curtis Gelotte & Scott Hommas 121
Curtis Gelotte Architects

Bob Gradwohl. 125
Gradwohl Construction, Inc.

Bryan Krannitz & Barry Gehl 129
Krannitz Gehl Architects

Thomas Lawrence. 137
Lawrence Architecture

Tom Lenchek . 141
Balance Associates, Architects

David Miller, Robert Hull,
Norman Strong & Craig Curtis. 145
Miller | Hull Partnership

Jim Olson, Rick Sundberg,
Tom Kundig & Scott Allen 151
Olson Sundberg Kundig Allen Architects

Shannon Rankin, Kyle C. Gaffney,
Brian Collins-Friedrichs & Doug McKenzie 155
SkB Architects, Inc.

Owen Roberts. 161
Owen Roberts Group

George Schuchart, Jim Dow,
John Hoedemaker & Joseph Youngblood 169
Schuchart/Dow, Inc.

Stuart Silk . 175
Stuart Silk Architects

Dave Thielsen 181
Thielsen Architects, Inc. PS

Garen Willkens 185
Willkens Construction

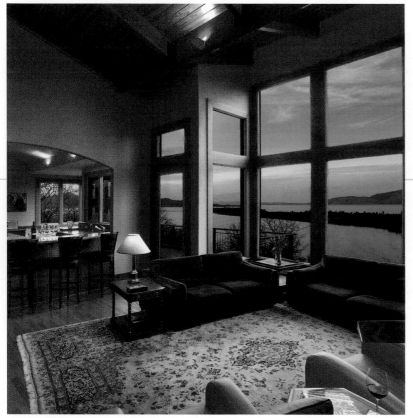

Robertson Merryman Barnes Architects, *page 55*

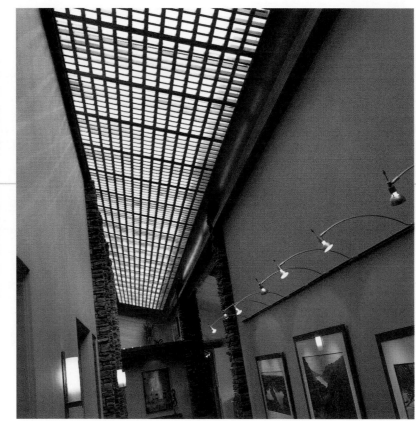

Blazer Development, Inc., *page 21*

Richard Brown Architects AIA, *page 11*

CHAPTER ONE

OREGON

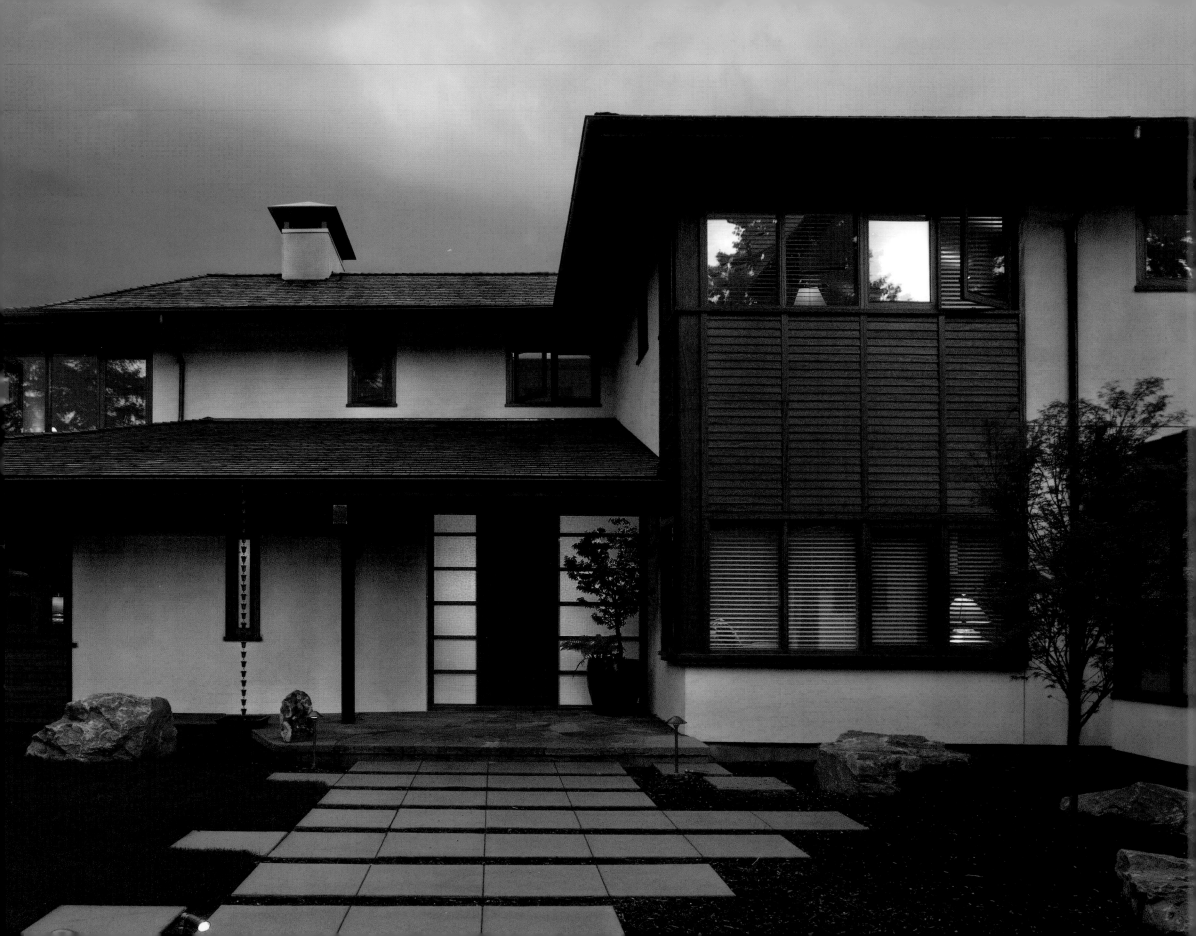

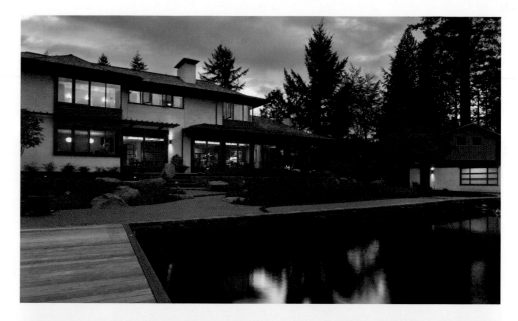

RICHARD BROWN

Richard Brown Architects AIA

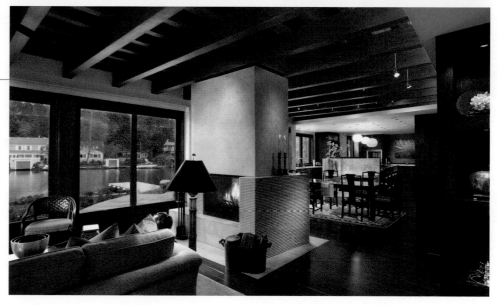

Above Top: Interior spaces open to the water and to views of the lake through broad bands of glass.
Photograph by Michael Mathers

Above Bottom: The raised ceiling of layered natural fir beams, mahogany windows and doors and Jatoba paneling give warmth to the living and dining spaces. Interior finishes and casework design by John Forsgren.
Photograph by Michael Mathers

Facing Page: Generous overhangs and flawlessly detailed custom windows and doors provide a welcoming entry for arriving guests.
Photograph by Michael Mathers

Richard Brown, AIA, had a unique beginning to his career when he was commissioned to design and help build a Tibetan Buddhist Monastery in Northern California. After earning a master's degree in architecture from the University of Pennsylvania, Richard immersed himself in this complex five-year design and construction project. The experience he gained during this time formed the core of Richard's design philosophy.

He learned the importance of natural daylight in creating beautiful spaces, the use of simple, traditional materials and the value of careful attention to detail and craft. Later, working for the nationally renowned ZGF Partnership, Richard forged these core values with a modern sensibility to create the regionally

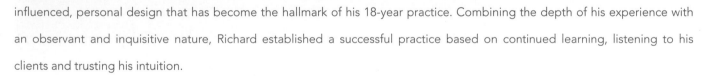

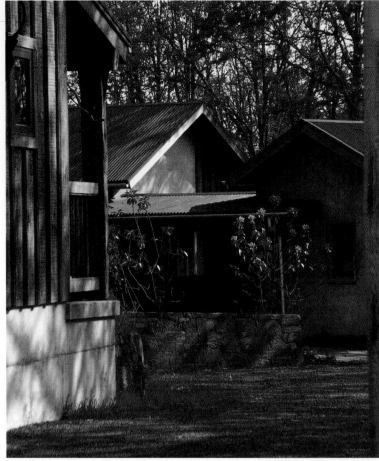

influenced, personal design that has become the hallmark of his 18-year practice. Combining the depth of his experience with an observant and inquisitive nature, Richard established a successful practice based on continued learning, listening to his clients and trusting his intuition.

While the firm is adept at a variety of project types, including religious, educational and commercial structures, Richard's passion has always been custom residential design. His designs are modern, but may be informed by a vernacular or historic tradition. The materials he prefers are elemental: wood, cement, steel and stone. He enjoys working closely with the craftspeople on site to achieve the best results.

For Richard, designing a house is not an abstract exercise. It begins with an understanding of his clients' needs, desires and personalities and then proceeds to a careful synthesis of the program, site, climate and budget. He believes a good house is an expression of a client's personal and often unspoken nature. The close communication between architect and client plays a key role in the design process. The best results come from a client's deep and enthusiastic involvement.

Common among the firm's projects is a painstaking responsiveness to the site. Each home is designed to take advantage of its setting, respect existing landforms and vegetation and incorporate the distant and proximate landscape views. Color palettes and material selections are often determined by the natural environment, so that home and site beautifully meld. Considering natural light an essential design element, Richard capitalizes on its functional and poetic possibilities.

Above Left: The living area opens to views of the meadow and the Columbia Gorge. The roof trusses and all doors and cabinets were made on site from reclaimed barn timbers. White plaster walls sit on radiantly heated concrete floors.
Photograph by Bruce Forster Photography, Inc.

Above Right: Dry stacked-stone walls and flagstone walks designed by landscape architect Marlene Salon tie the house to the native landscape. Recycled barn timbers, thick stuccoed walls and rusted metal roofing all help ease the house into its natural setting.
Photograph by Bruce Forster Photography, Inc.

Facing Page: This house, set in a meadow overlooking the Columbia River Gorge and Mount Hood, provides a gathering place for grandparents, far-flung family members and grandchildren.
Photograph by Bruce Forster Photography, Inc.

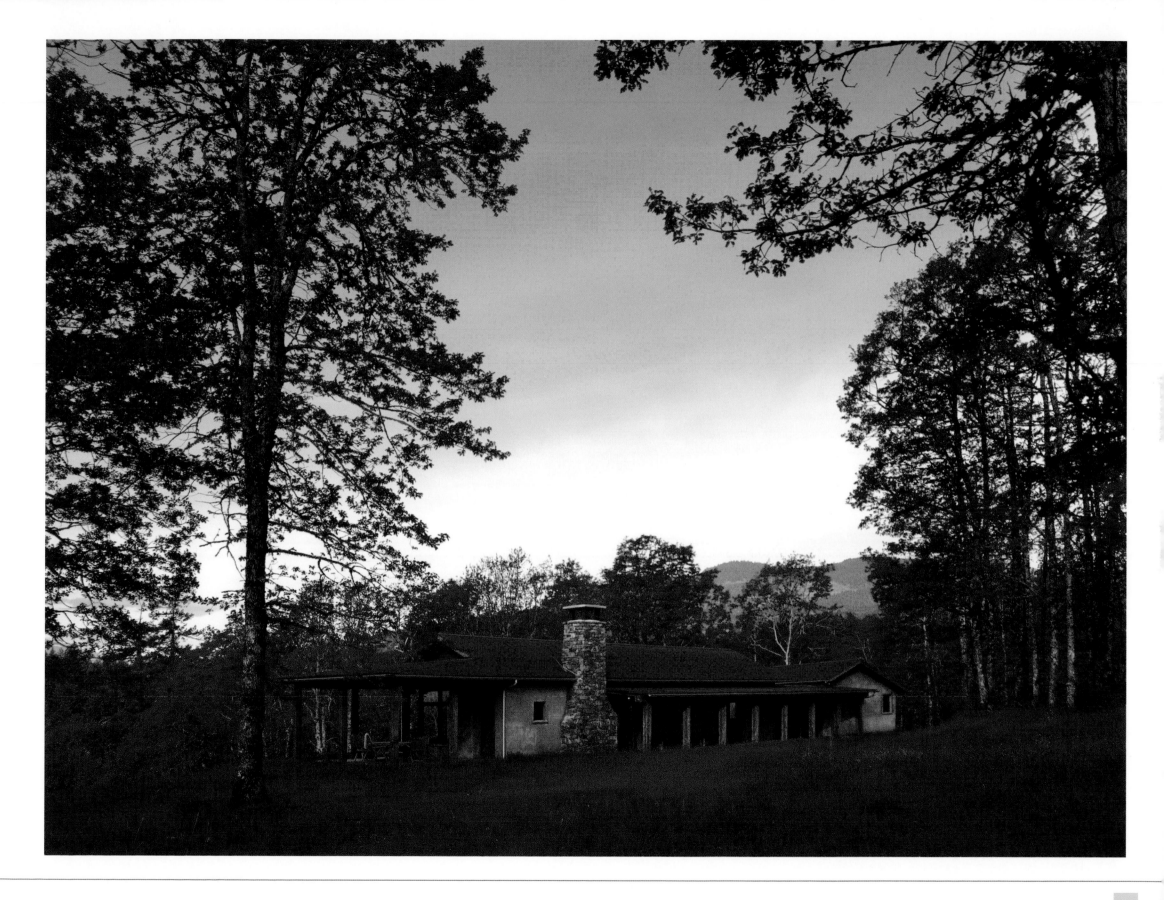

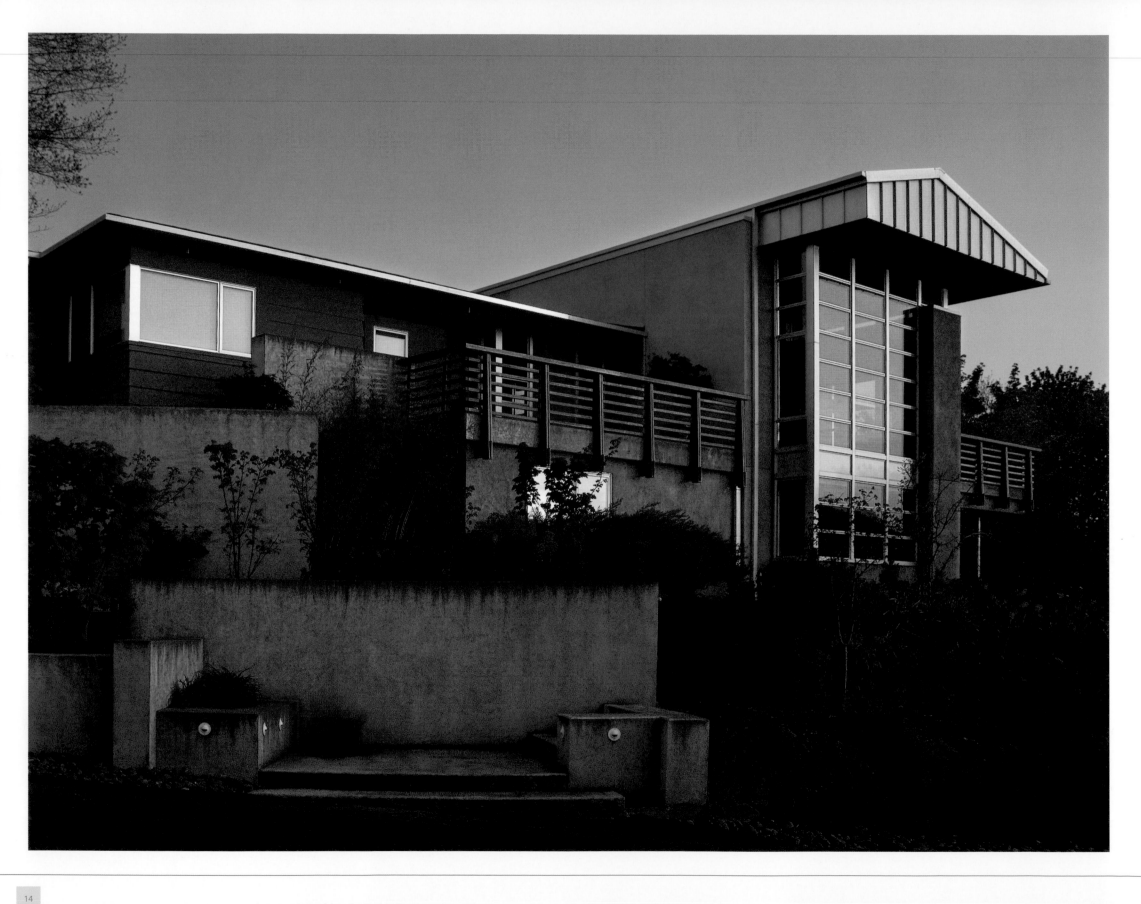

Acutely aware that the construction process and buildings themselves contribute to global warming, his team seeks out materials that are sustainable and require less energy to produce, install and maintain. Richard Brown's design projects have utilized wood reclaimed from local barns or lumber salvaged from riverbed logs. The firm encourages the adaptive reuse and renovation of existing structures. Richard promotes green roofs, passive solar heating and natural ventilation to reduce energy use. By carefully reviewing the program and planning efficient, multi-functional interiors, Richard provides his clients with houses of the highest quality and least possible environmental impact.

While committed to responsive and sustainable design, Richard and his team are ultimately dedicated to creating beautiful and supportive environments for their clients. The firm's record of excellence has earned it numerous local and regional AIA Awards, and its houses have been featured in Portland-area home tours. This recognition, while gratifying, cannot match the pleasure Richard derives from seeing his clients' lives enriched by the homes he has designed for them.

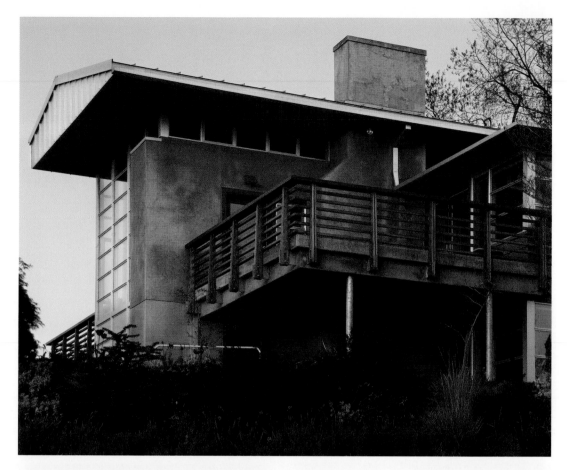

Top Right: Both the living and dining rooms open to generous decks with carefully detailed railings of Ipe wood. The broad top rail provides a comfortable place to lean and take in the views of the distant Coast Range Mountains.
Photograph by Bruce Forster Photography, Inc.

Bottom Left: The entry, with its low ceiling and horizontal ash-paneled wall, opens to the higher, light-filled living and kitchen area.
Photograph by Bruce Forster Photography, Inc.

Bottom Right: A new skylight floods the master bath vanity with natural light. Radiant concrete floors, reeded glass, Carrara marble and cabinets of horizontal ash lend natural elegance.
Photograph by Bruce Forster Photography, Inc.

Facing Page: New living and kitchen areas were added to the core of this mid-century hilltop house. Tall windows fill the space with natural light and provide views to the north and east. The new landscaped entry sequence was designed by John Forsgren.
Photograph by Bruce Forster Photography, Inc.

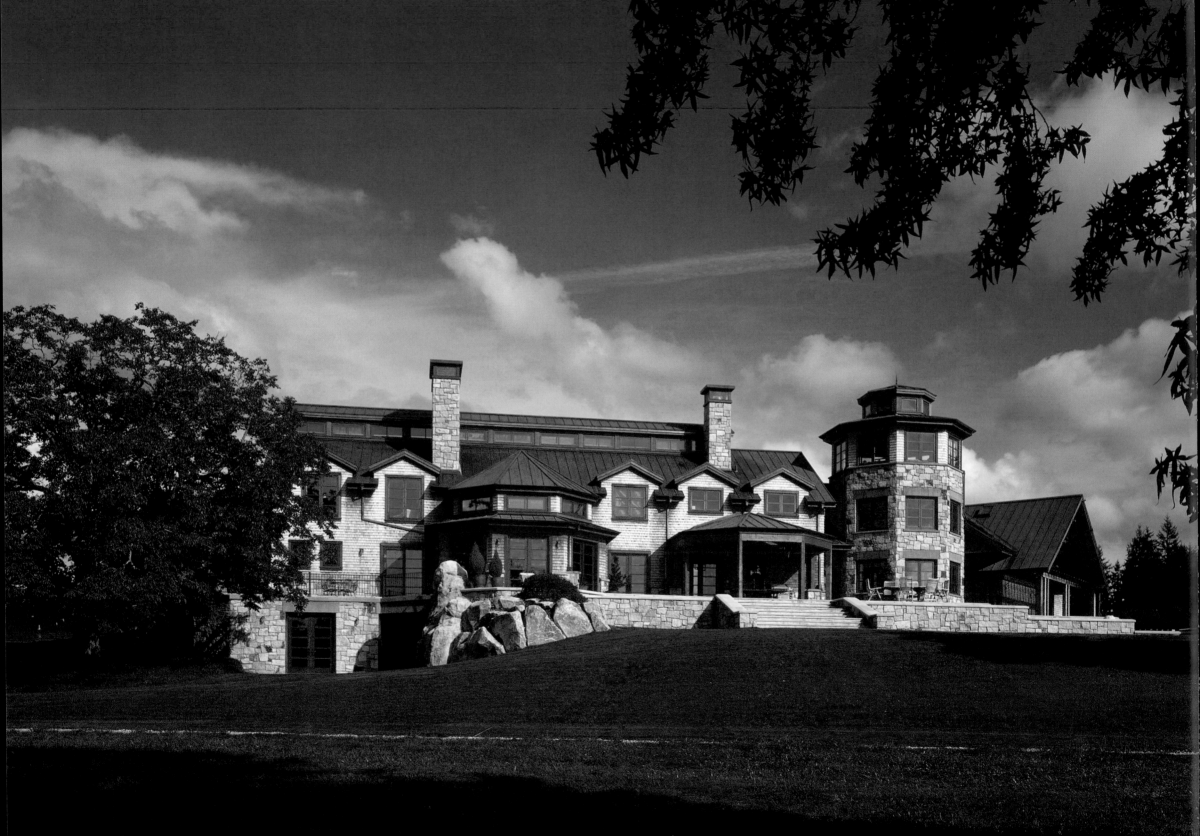

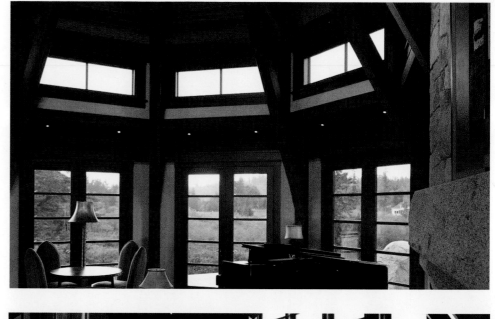

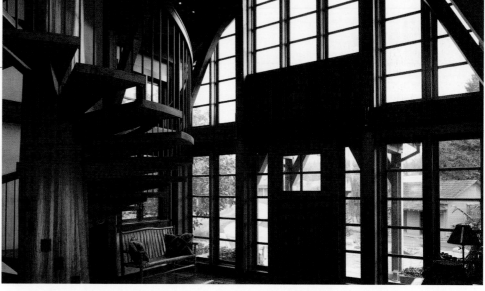

STAN CHESSHIR

Chesshir Architecture

Summer construction jobs and work with a design/build firm while attending college imbued Stan Chesshir, AIA, with a thorough knowledge of construction and a deep appreciation for craft, characteristics that inform the work of Chesshir Architecture. Running his own design/build firm immediately after college honed his skills and taught him the importance of collaboration between all parties involved in a project. He maintains that the client, architect and builder play distinct and vital roles in the design process and should have equal involvement and respect. Stan thus thoughtfully designs each project with the owners and builders' input, creating buildable, functional and unassailably beautiful homes that will stand the test of time.

Stan's profound respect for his clients precludes his strict adherence to a specific architectural style. Rather than bringing a preconceived image to a project, he carefully listens to his clients' vision for their

Above Top: The highest quality of craftsmanship and materials—including recycled old-growth fir timbers, copper-clad fir doors and windows and a copper roof—were used throughout, resulting in a home of enduring quality.
Photograph by Michael Seidl

Above Bottom: The foyer of the home is very light and airy and features a heavy timber stair radiating from a tree logged near the site.
Photograph by Michael Seidl

Facing Page: Located on a horse farm east of Seattle, this home was designed in the Cascade lodge timber-frame tradition. The design team was comprised of Jake Bigham and Marcus Koch, with John Hall as builder. Timber framing was performed by Timbercraft.
Photograph by Michael Seidl

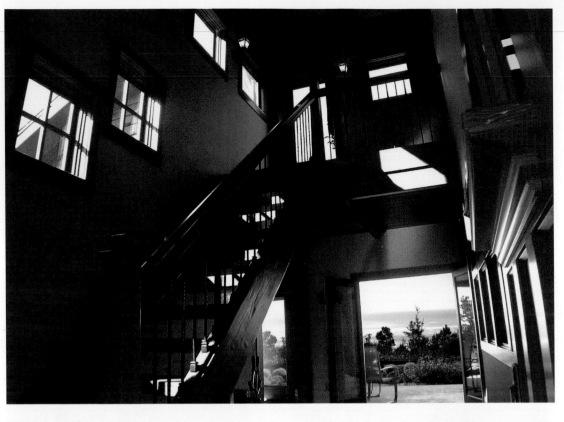

home and then refines and shapes their ideas into a design that enhances that vision. Stan's decision to keep the firm small ensures that clients are actively engaged throughout every stage and, as such, develop a genuine trust in the design team. Stan and his team become agents of their desires, solving any problems that might arise and making all decisions alongside them. Clients thus gain a full understanding of how and why the design was conceived and can proudly profess authorship of their homes.

While no two Chesshir Architecture homes look alike, all express Stan's philosophy that architecture must directly derive from its context. His team works diligently to discover the most striking features of each site and accentuates these in his designs. Blessed to work in a region that offers such a diverse landscape, the firm designs homes in the mountains, in cities and on the shores of the Pacific, and each setting presents its own climate and topography as well as a distinct aesthetic that the architecture serves to complement. Stan and his capable staff work as a team to achieve harmony with the environment both materially—natural materials in rural settings, refined materials in urban—and also experientially, creating visual and physical interconnectivity of home and site, regardless of the project's scale.

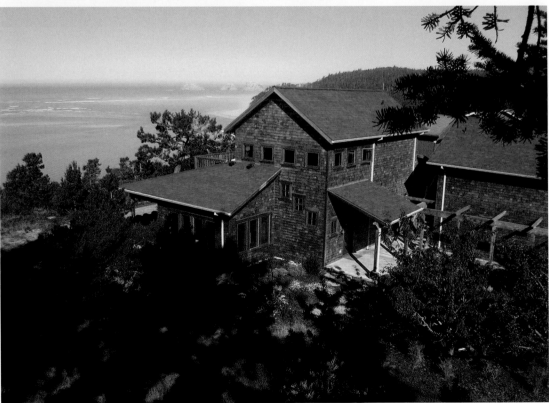

Top Left: Upon entry, one's view is immediately directed out to the ocean. The interior is finished with a recycled plank fir floor, fir beams, windows and doors and local stone. Interior relites transfer light into the core. Design team included Mary Beth Childs; Dale Ouverson served as builder.
Photograph by Bob Graves

Bottom Left: Situated on a bluff with a commanding view of the Pacific Ocean, this site-responsive home seeks to remain in the vernacular of a Northwest Beach Cottage.
Photograph by Stan Chesshir

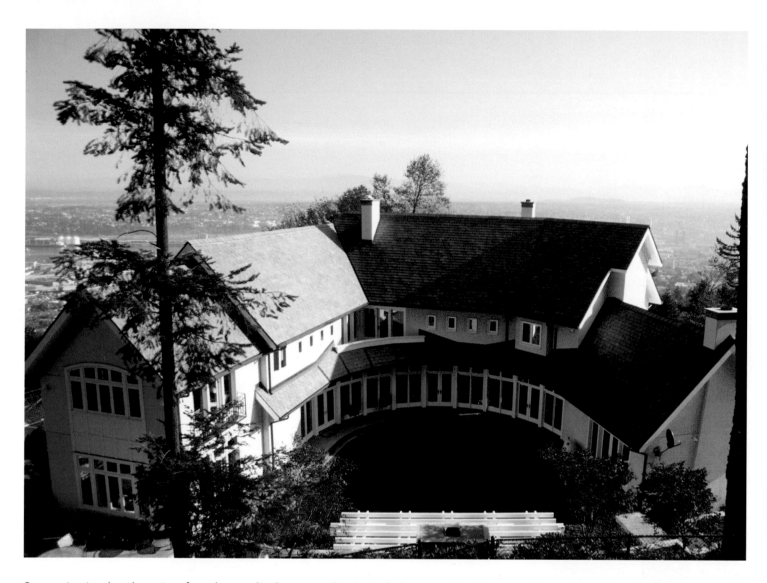

Stan maintains that the unity of outdoor and indoor space begins with the approach. Upon arrival, a person should feel an overwhelming sense of location identity. The home's exterior should look and feel appropriate to its environment, and the interior must possess transparency. That is, as a person enters, his vision should be directed through the house and out a window to a prominent view, so that he becomes acutely aware that while he is indoors, he is also on the beach, in the mountains or amidst skyscrapers in a sprawling metropolis. Connecting homes to their contexts ensures their aesthetic timelessness.

Chesshir Architecture further promotes its homes' longevity through its sustainable measures. Stan's experience designing earth-sheltered dwellings and homes run by passive and active solar energy harks back to his firm's beginning in the late 1970s, and he has remained empathetic to it throughout his career, working with efficient systems and ecologically sound materials as often as possible. Intelligent design, sound construction and delighted clients foretell a future of continued achievement—and to Stan, who derives great joy from his work, a lifetime of contentment.

Above Left: The home wraps around its site, capitalizing on 270-degree views of Portland and the landscape beyond. All of the spaces in the home have a relationship with views both outward and into the courtyard. The architectural design team included Mark Kogut; the builder was Green Gables.
Photograph by Jake Bigham

Above Right: The veranda on the view side wraps around the house and features rotundas at the primary corners. The stucco, slate roof, inlaid floors and classical woodwork give the home an urban sophistication and timelessness.
Photograph by Jake Bigham

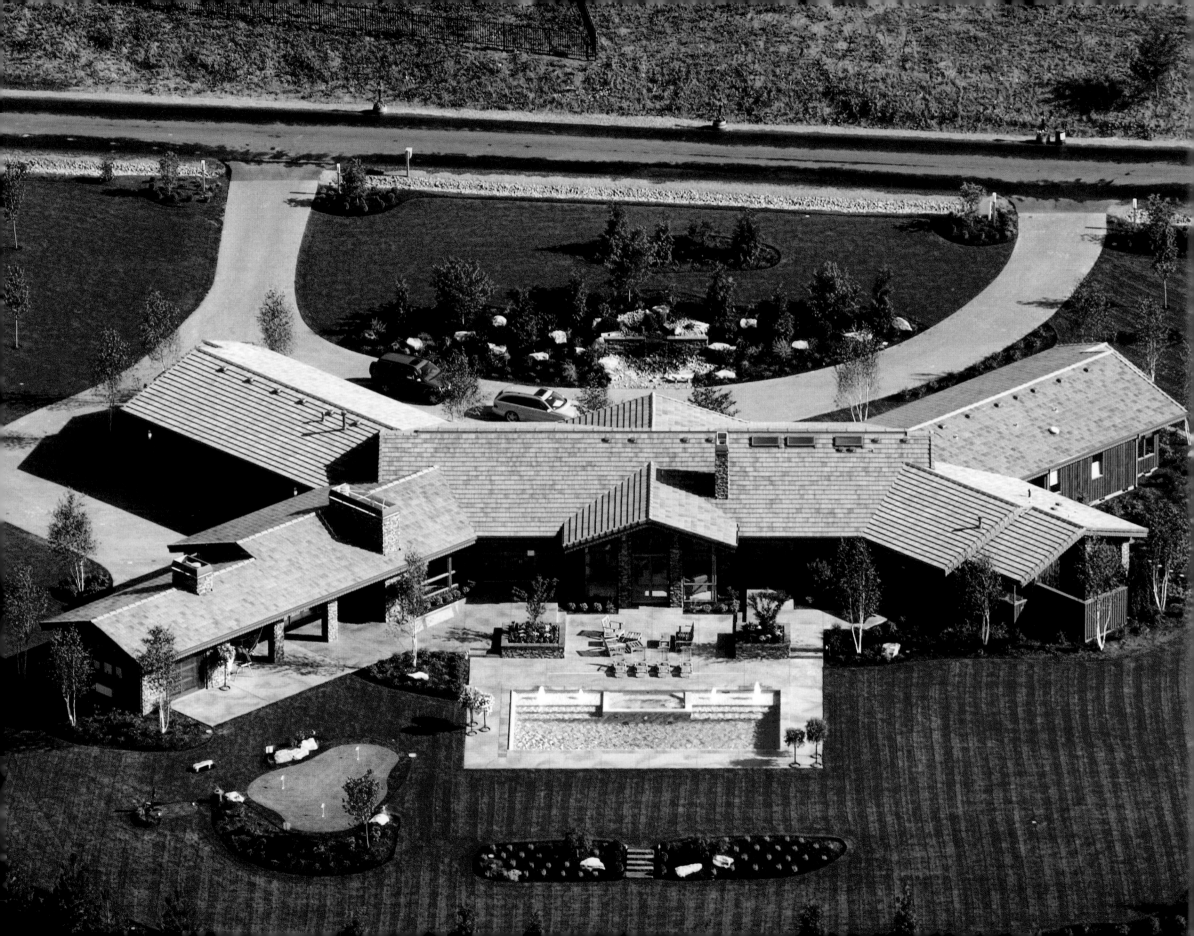

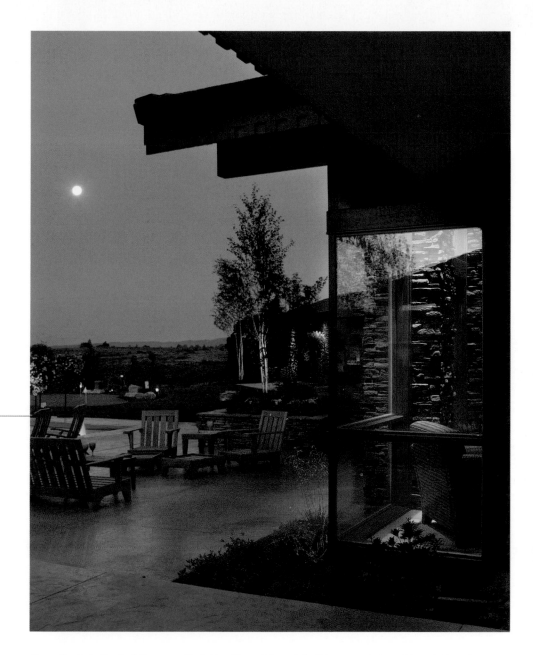

RAY DERBY
RICK LESNIAK

Blazer Development, Inc.

Aptly named for the trailblazers—the original settlers of the Pacific Northwest who migrated in covered wagons and developed the previously unclaimed land—Blazer Development has for 20 years provided beautiful custom and speculative homes to clients desiring not only a beautiful shelter but a truly enjoyable homebuilding experience.

Originally named Blazer Homes, the firm became Blazer Development when Ray Derby partnered with Rick Lesniak in 1999. The two have since kept the business intentionally small, working alongside three other team members. In so doing, the partners are able to fully immerse themselves in each project and develop intimate relationships with all of their patrons—relationships that begin with the initial consultation and continue to grow and evolve long after the keys have changed hands.

Above: Illuminated by the full moon and by light spilling out through the living room windows, this poolside patio becomes a peaceful extension of the cozy space within.
Photograph by © Alan Mascord Design Associates, Inc.

Facing Page: An aerial view of this home shows its multiple wings, which divide household activities, providing separate spaces for family entertainment, formal living and private family living.
Photograph by © Alan Mascord Design Associates, Inc.

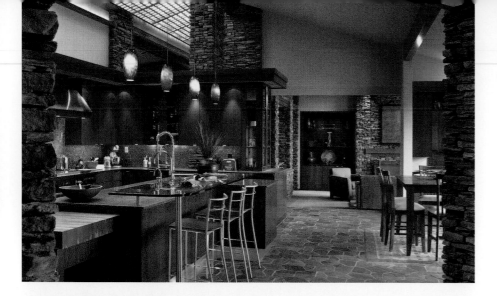

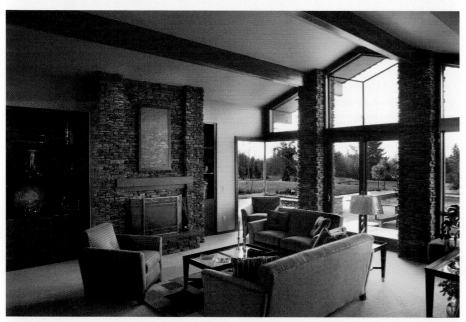

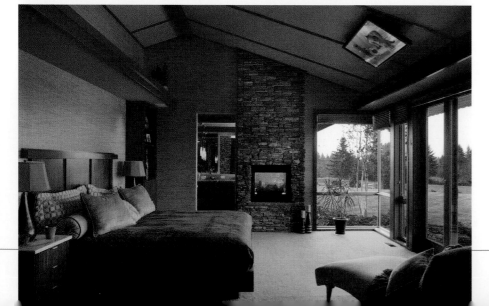

The firm's intimate size also affords the partners the opportunity to ensure that the vision for each project is fully and accurately articulated. Working closely with a select group of talented architects as well as those chosen by clients, the Blazer team is able to construct in a wide array of architectural vocabularies, producing homes that range in style from Traditional to Modern, European to Craftsman and Prairie, and Rustic Lodge to Ranch, depending on the clients' desires and the requirements and mood of the site. With the firm's broad network of skilled artisans and craftsmen, clients' homes can express any style or element they desire.

Along with its commitment to providing clients with spectacular homes that exceed their expectations, Blazer Development is dedicated to building Green. Environmentally responsible techniques that the team consistently employs include sustainable materials, radiant floor heating, energy-efficient HVAC equipment and nontoxic paints. As the technology behind these techniques has improved and become more economical, the Blazer team suggests them to a broader segment of its clientele, helping them make the best choices—both planetary and budgetary. Ray is actively involved in the building community and has served as president of both the Oregon Building Industry Association and the Home Builders Association of Metropolitan Portland, along with a variety of other offices within the latter. He has also served on the National Home Builders Association Board of Directors, and Blazer remains a member of both the local and national branches.

The firm has won a variety of awards, including the 2003 HBA/Earth Advantage Builder Award, many HBA Metropolitan Portland awards and numerous Street of Dreams awards. The Blazer team was also honored to have the unique opportunity to build the "Miracle House," raising $200,000 for the Doernbecher Children's Hospital.

The key to Blazer's success is the genuine love and passion both Ray and Rick have for their profession. The partners love working with their clients—90 percent of whom are referrals from architects, tradespeople or prior patrons pleased with their building experiences. For Blazer, constructing beautiful luxury homes is more than a vocation; it is an avocation.

Top Left: The 75-foot, wood grill-covered skylight infuses the open living space with ample natural light by day and provides backlit accents by night.
Photograph by © Alan Mascord Design Associates, Inc.

Middle Left: This vaulted formal living room's wall of windows fosters a strong connection to the outdoors.
Photograph by © Alan Mascord Design Associates, Inc.

Bottom Left: Sophisticated luxury and pastoral views make this master suite a quiet sanctuary.
Photograph by © Alan Mascord Design Associates, Inc.

Facing Page: The patio view of the house underscores its low roof, floor-to-ceiling windows and abundant natural materials both inside and out.
Photograph by © Alan Mascord Design Associates, Inc.

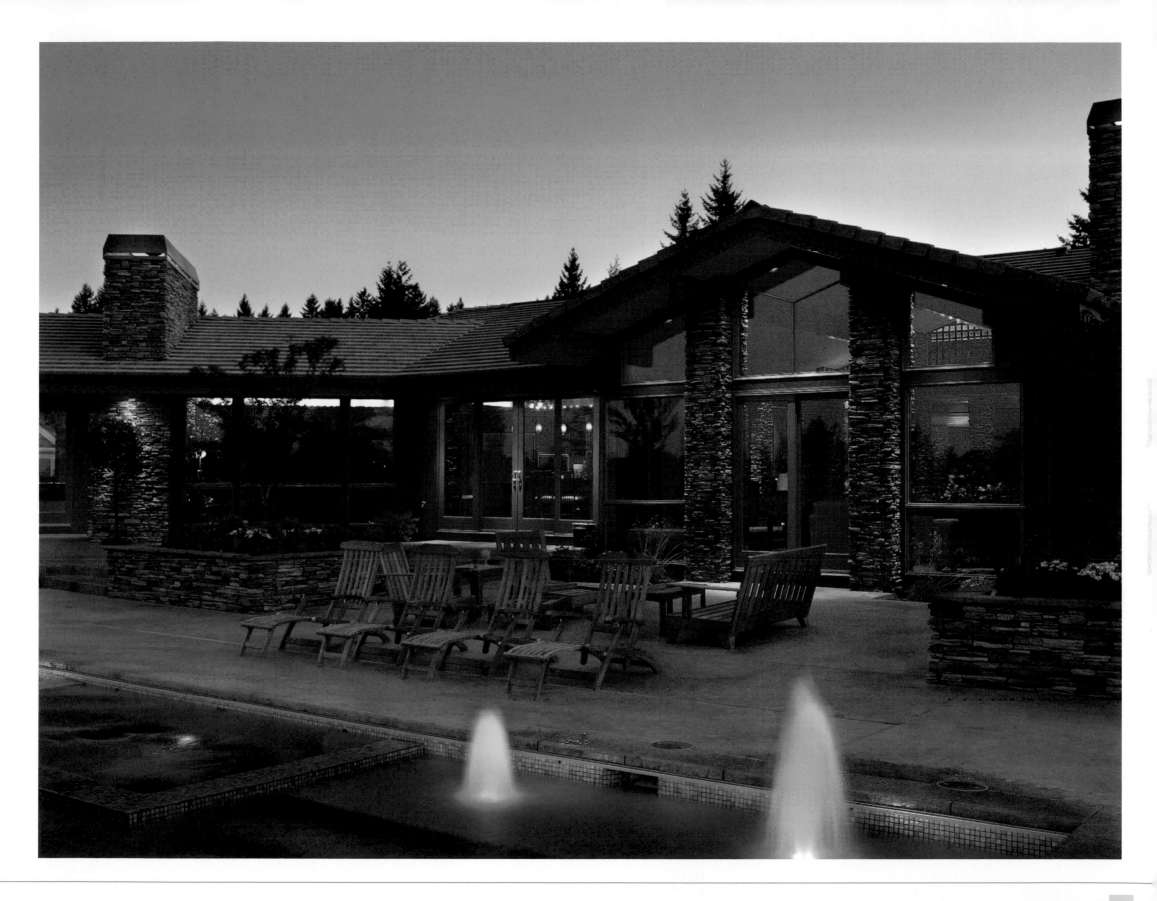

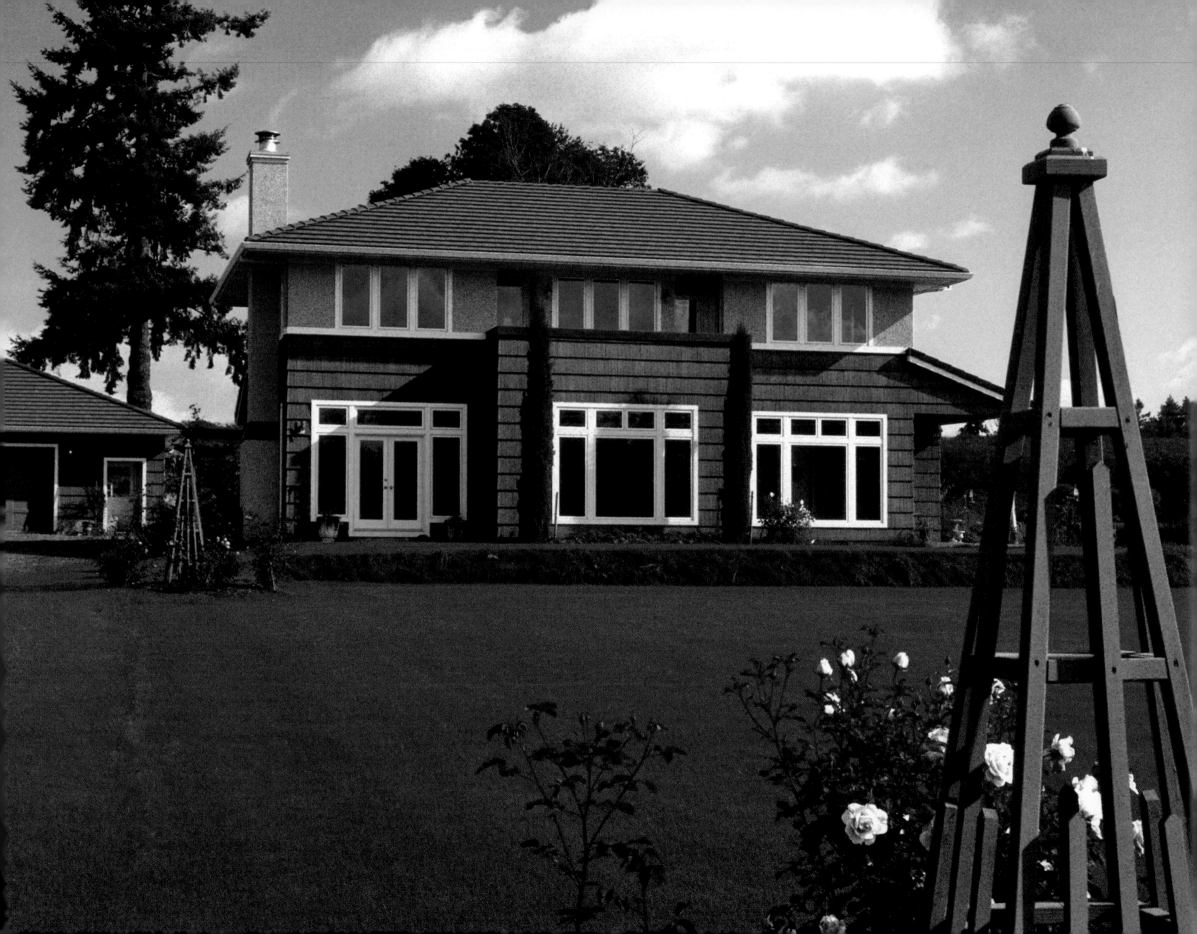

Above: The house's garage features a south-facing potting room overlooking a terraced garden, which also serves as an entry court for the house.
Photograph by Mike Dowd

Facing Page: Located above the Columbia River in Washington State, this house's daylight-filled living spaces overlook outdoor areas being developed into wonderful gardens.
Photograph by Mike Dowd

MIKE DOWD

Dowd Architecture Inc.

Imagine yourself in your ideal home. What would it look like, feel like? Where would the kitchen be? What view would you like to capture with your bedroom windows? Where would you do your Sunday morning crossword, watch "Monday Night Football," hold your weekly family Scrabble showdown? These are the issues at the heart of Mike Dowd's architecture. A firm believer that a home should be "real," Mike eschews abstract architecture, producing instead structures that are first and foremost livable from designs that are simple, logical, unpretentious and responsive to their programs and contexts.

The founding principal of Dowd Architecture Inc., Mike has kept his firm intentionally small since its founding in 1993, working with two or three draftspeople as needed. His preference for an intimate workplace is reflected in the scope of the projects he undertakes: Having spent his early career

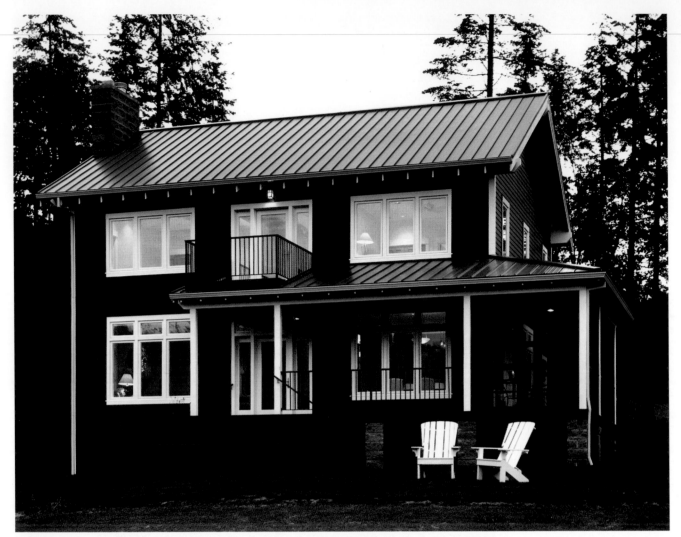

designing large-scale commercial projects, Mike discovered his predilection for the more personal work of residential architecture and has focused his firm's efforts thereon. He insists that he can do as much with a smaller project as he can with a larger one and derives a great deal of satisfaction from the knowledge that the owner and user of each home are one and the same.

Unlike many architects with his education and credentials—he earned both his Bachelor of Arts and Master of Architecture degrees from the University of Washington, is licensed in Washington and Oregon and is a member of both AIA and NCARB—Mike does not adhere to a particular style. Indeed, he does not even favor one design aesthetic over another. While many of the homes he has created exhibit a more traditional touch, they do so at the clients' behest, for it is the clients who inspire the home's motif. Rather than imposing a style, Mike interprets their preferences and melds them with the contextual requirements to create homes that look and feel innate to both the clients and the sites.

As a result, Mike is well-versed in a broad spectrum of architectural vocabularies, and he can produce the look his clients desire regardless of the home's size or function. He has designed everything from a beach house retreat to an urban art studio, and a large portion of his projects are home renovations, many of which have been quite complex. For one, he gutted a turn-of-the-century home down to its studs and rebuilt it with an

Above Left: Through thoughtful detailing and material selections, this simple house in the Columbia Gorge achieves a commanding presence belying its modest scale and budget.
Photograph by Laurie Black

Above Right: The house's straightforward, rectangular floorplan is organized around a central stair hall. Materials are simple, durable and elegant.
Photograph by Laurie Black

Facing Page: Traditional design and materials are used in this unpretentious Oregon Coast cottage. The inviting front porch provides sheltered outdoor space, usable year round.
Photograph by David Papazian

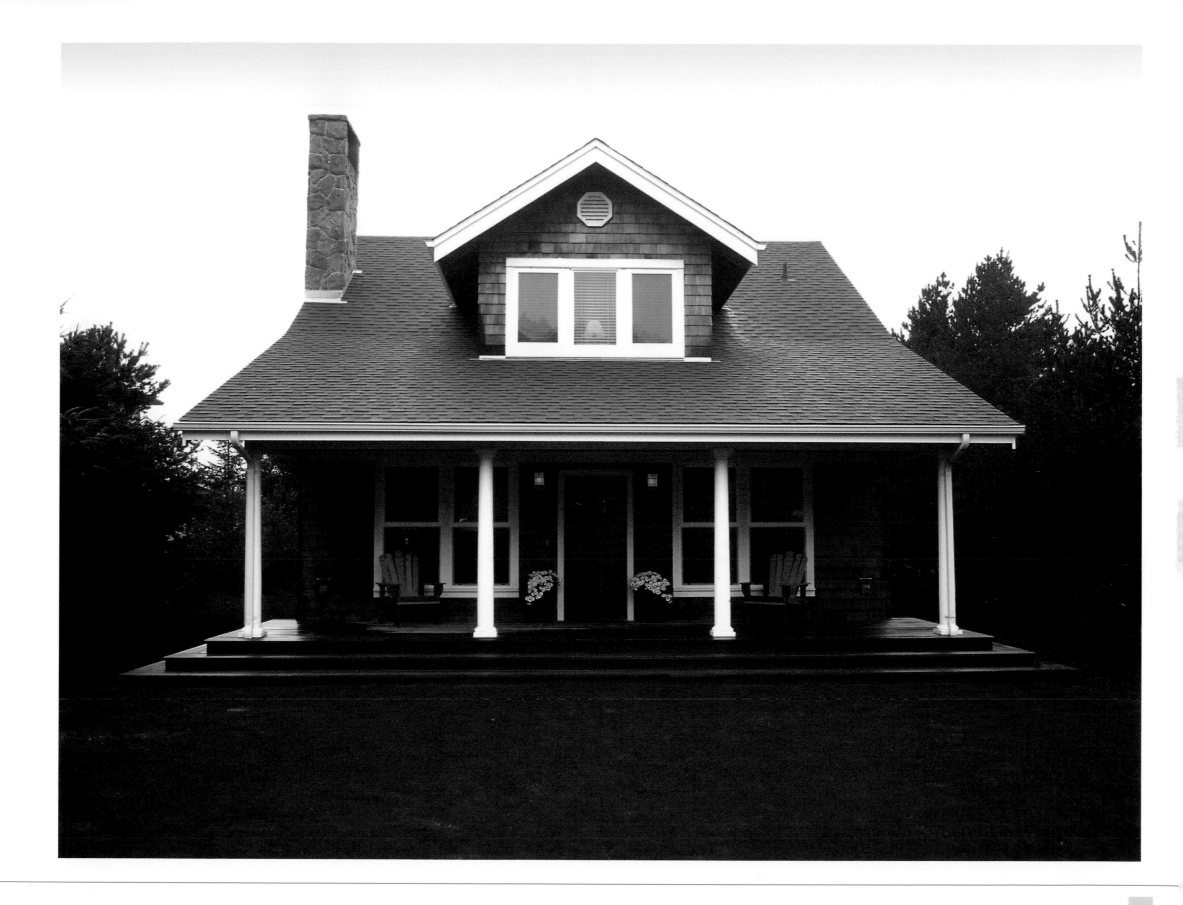

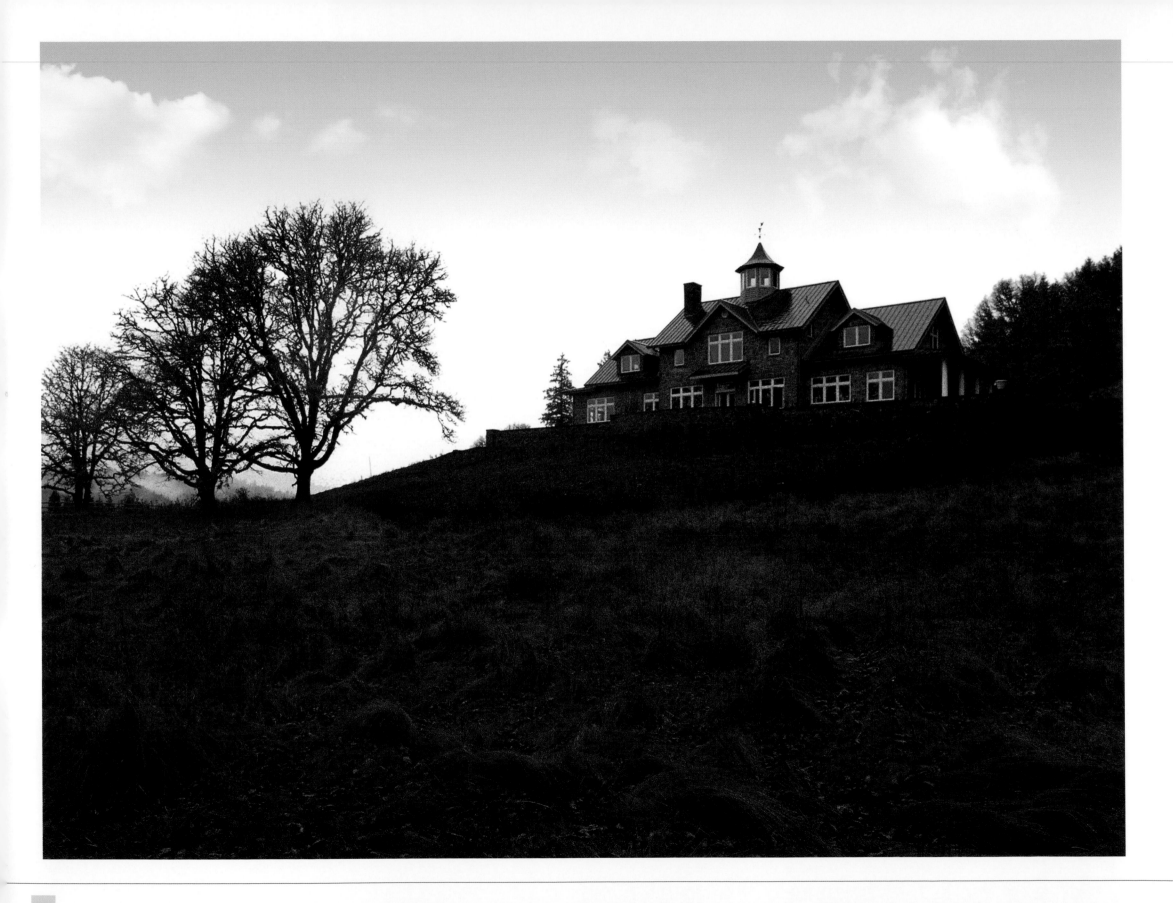

entirely new floorplan, which involved the re-creation from an aerial photograph of a third story that had been lost in a fire in the 1960s. The many residential alterations he undertakes have exposed Mike to numerous architectural styles, providing inspiration for his own designs.

It is more than evident that Mike Dowd loves his work. The sites his beautiful region affords him—he designs homes exclusively in Oregon and Washington—and the great people he has the opportunity to meet and work with provide him immense satisfaction. His enjoyment is largely due to the intense relationships he develops with clients, whom he describes as brave. He explains his choice of adjectives by stating that each project involves a leap of faith on the clients' part, as few have undertaken construction before, and many also find it incredibly difficult to visualize or read plans for their homes. Mike diligently strives to allay any concerns his clients might have, rendering multiple perspective sketches to help them see their homes before they exist—he has even drawn life-sized homes in the sand on site. He goes to great lengths to make his clients feel comfortable at every stage and prides himself on his dedication to guiding them toward realistic decisions. Mike also cultivates strong professional relationships with building officials and contractors, and many of his clients are referrals from contractors impressed with his previous home designs.

Mike's remarkable projects have earned him features in several national publications and frequent appearances in *Oregon Home*, twice on the cover. His architecture has also won him several awards, but Mike does not actively pursue them, feeling that awards programs are essentially fashion contests. As long as he gets that phone call from his clients, telling him that they so love their home they do not want to leave— the call he so frequently receives—critical opinions matter not.

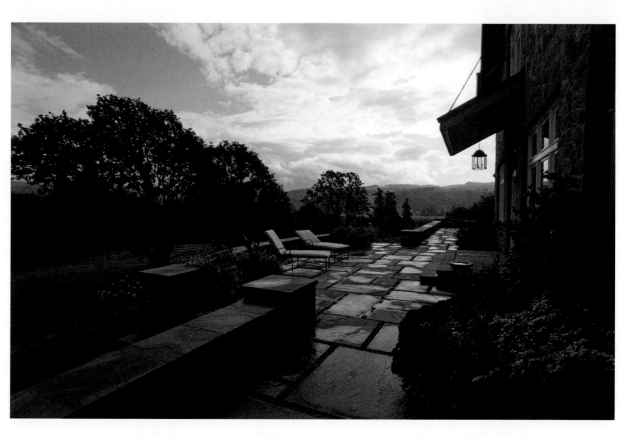

Top Right: A broad, southeast-facing stone terrace expands living space and offers a commanding view over the meadows, fields and mountains beyond.
Photograph by Mike Dowd

Bottom Right: Tucked against the edge of the forested hillside, the house is approached via a private dirt road meandering through woods and meadows.
Photograph by Mike Dowd

Facing Page: Located in a hauntingly beautiful setting, this stone-clad country house overlooks a working farm of several hundred acres in the Willamette Valley.
Photograph by Mike Dowd

MARK ENGBERG

COLAB Architecture + Urban Design, LLC

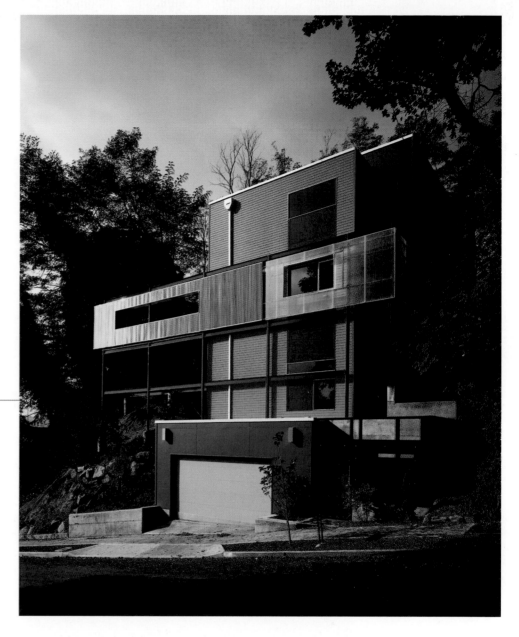

Above: From the street, passersby get a view of the Brandon House's remarkable architecture.
Photograph by Barry Hill

Facing Page: Traditional industrial and residential materials commingle in the Brandon House.
Photograph by Barry Hill

Collaboration and experimentation so define the philosophy behind COLAB Architecture + Urban Design, led by Mark Engberg, AIA, that the concepts are literally embedded in its name, a combination of "collaboration" and "laboratory." Founded in 1994, the award-winning design studio creates compelling and innovative residential, commercial and urban design projects for an impressive clientele base the world over. Alongside his team of seven other architects and designers, Mark strives to continually challenge existing practices and infuse new ideas into the structures the firm creates.

With a graduate degree in architecture and urban design from Columbia University, Mark nurtures a deep sensitivity to the restoration and preservation of Portland's historic residential flavor. Working within very small, narrow and often unusually shaped sites, Mark marries private and public space,

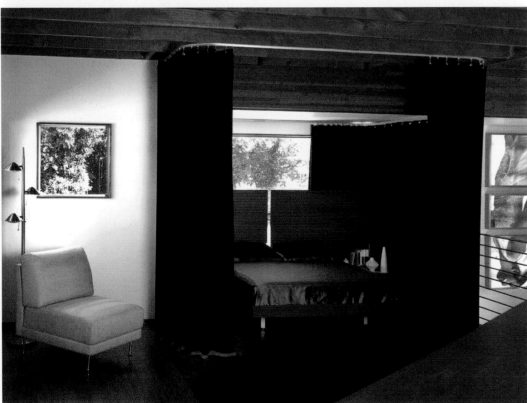

creating row houses and mixed-use spaces that foster family and community cohesion, alike, while adding character to the urban landscape. Emphasizing pedestrian rather than automobile traffic, Mark promotes residents' connectivity to the neighborhood by bringing the houses right up to the sidewalks.

The Brandon House, a home he designed on two once-rectangular lots that were bisected by the expansion of a major freeway, presented a particular challenge. The two lots had become one and were transformed into the shape of a triangle. With a nod to the industrial buildings to the south and residential architecture to the north, COLAB created a home that blends elements of both and works to mend the fabric of a once thriving neighborhood.

At the heart of COLAB's work is Mark's exploration of various genres. He arrives at innovative solutions and carefully selects and re-envisions materials to produce beautiful, functional and fascinating architectural designs. For one project, he created an enclosed, gently curving bridge from existing to new construction to best utilize available lot space and preserve a treasured old tree; to convert a warehouse into a residential loft space, he combined steel and wood elements to represent the commingling of the industrial and natural worlds that defines city life; in yet another stunning project, Mark designed a hip, modern restaurant entirely out of fiberglass, making him one of the first architects to work in that medium; and when confronted with the challenge to create a room divider entirely out of glass and steel, Mark and his COLAB associates constructed a glass curtain, lending fluidity to otherwise rigid materials.

The tenacity with which the COLAB team strives to envision and produce fresh architectural designs while maintaining and rebuilding the historical and cultural framework of the regions in which they work has earned them accolades and awards, including the Boston Society of Architects' Rotch Travelling Scholarship and awards from the Portland Chapter of the AIA. In addition, the Brandon House was featured on HGTV's "Dream House" series. COLAB's dedication to collaboration and experimentation ensures that it will continue to produce innovative and significant work—from Portland to Dubai—for years to come.

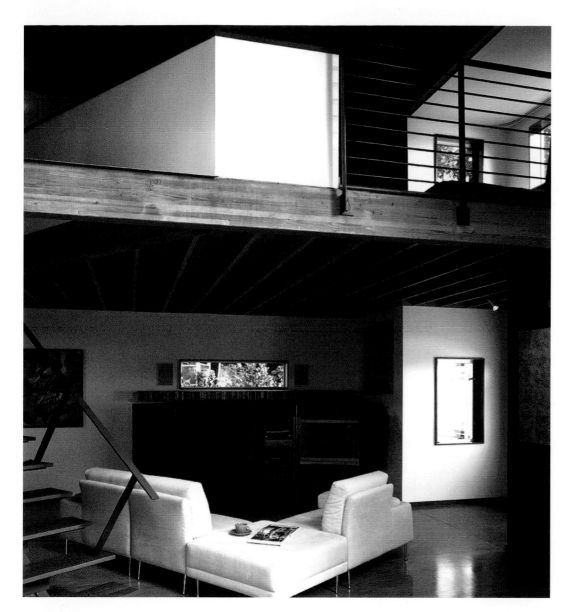

Above: The open interior layout exposes multiple levels, providing views of both a cozy living area, replete with a steel fireplace, and the sleeping deck above.
Photograph by Barry Hill

Right: Backlit wall art and large, horizontal windows add aesthetic interest to this two-story living space.
Photograph by Barry Hill

Facing Page Top: Plywood floors and cherry paneling comprise the living room, which opens out onto the second living room—an industrial deck.
Photograph by Barry Hill

Facing Page Bottom: The third-level sleeping quarters open to the living room below. Curtains around the bed provide privacy in an otherwise open space.
Photograph by Barry Hill

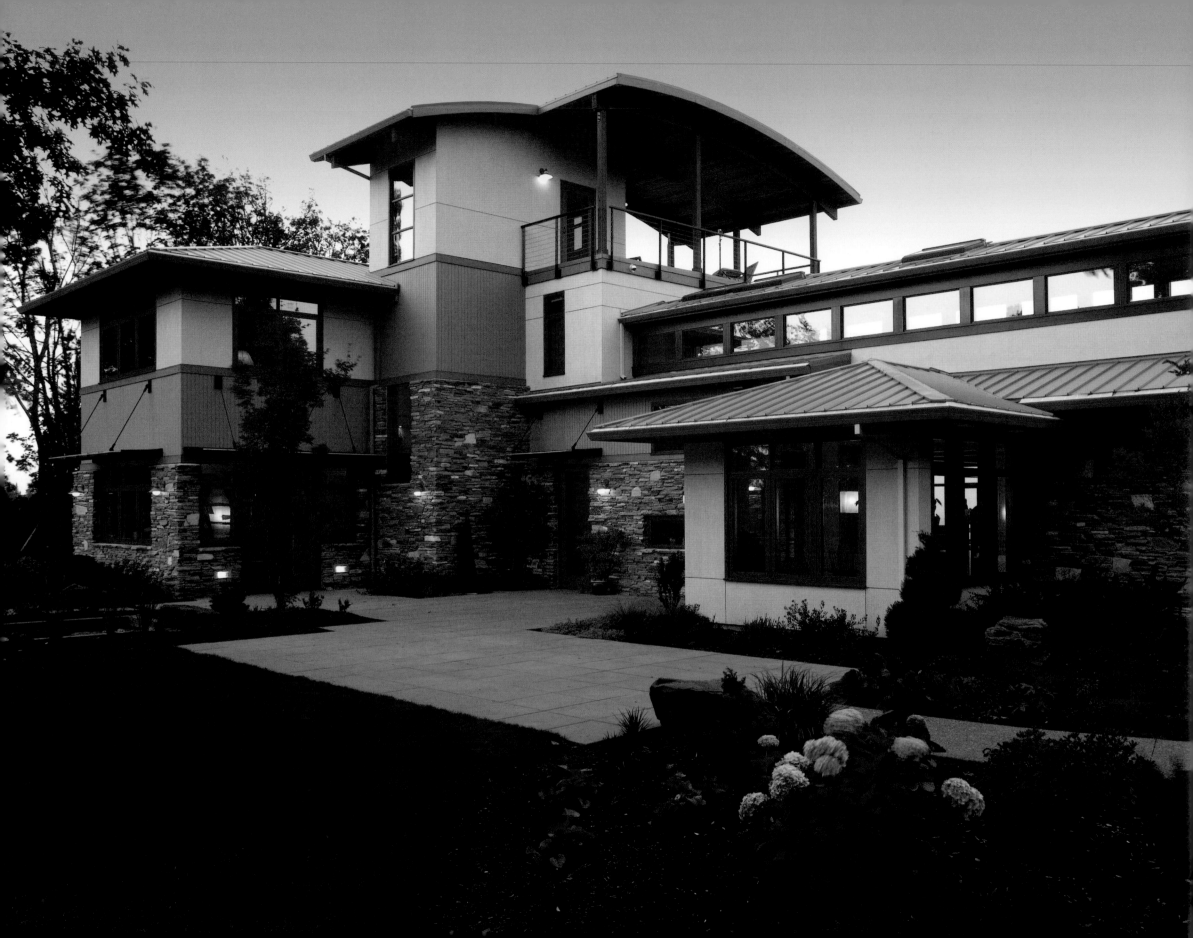

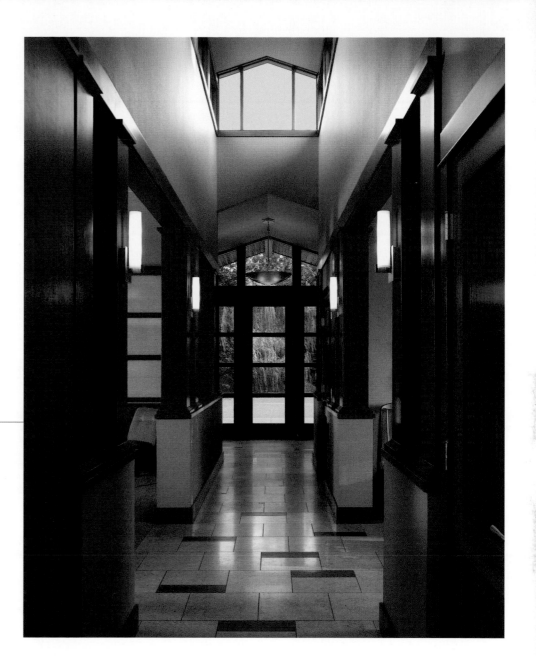

DAVE GIULIETTI
TIM SCHOUTEN

Giulietti/Schouten, AIA Architects PC

A stroll through the TWA terminal of New York City's Idyllwild Airport—now JFK International—had a lasting impact on David Giulietti, AIA. A child at the time, Dave still vividly remembers the sculptural, modern architecture and its profound effect on his sensibilities. He carried this awareness—that a structure can leave an indelible impression on a person—throughout his young life, ultimately harnessing it when he founded his architecture firm in 1987. Timothy Schouten, AIA, joined the firm in 1993, and upon his becoming a partner in 2000, Giulietti/Schouten, AIA Architects got its official start. Now housing a solid team of six, Giulietti/Schouten is committed to creating structures that powerfully affect and shape the lives of those within them.

Both Dave and Tim share a love for art and creation and an appreciation for modern principles, and these qualities permeate their designs. The firm's intimacy allows the partners to work in close

Above: Natural daylight floods the main entrance of the Leftwich residence through the clerestory spine, which runs the length of the house.
Photograph by David Papazian Photography, Inc.

Facing Page: This residence's office and dining room open out to the garden. The stair tower rises to the covered rooftop deck, providing exquisite views of four of the Cascade Mountains and the Columbia River.
Photograph by David Papazian Photography, Inc.

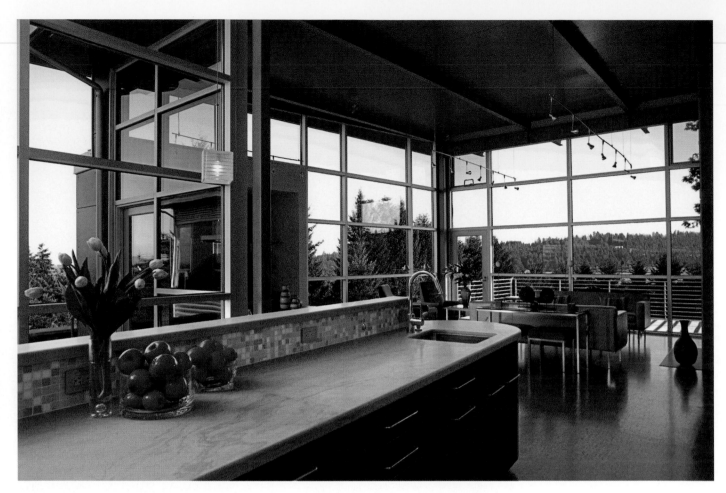

collaboration with the entire team on all projects and affords them the personal involvement with each client upon which they insist. They strive to fully grasp clients' goals and guide them to design decisions that will bring their visions to fruition. While residential projects comprise the majority of its work, the firm also undertakes a select number of small-scale commercial projects for clients desiring a residential feel for their businesses. Indeed, the team's ability to seamlessly weave commercial structures into the neighborhood fabric has become a Giulietti/Schouten hallmark.

So, too, has the diversity of the firm's projects. Dave and Tim's wealth of knowledge and remarkable talent allow them to easily articulate any design a client desires. Homes range in style from Traditional to Modern, Shingle style to Craftsman, depending on the project's requirements. While each is different, all exhibit the principals' propensity for modern philosophy: Clean lines, simple forms and contrasting planes pervade. Also apparent in all Giulietti/Schouten homes is the extreme importance placed on natural light. With the region's frequent periods of gray skies and steady rainfall, sunlight is a precious commodity. Both Dave and Tim strive to capture and amplify light within their home designs, remaining closely attuned to the fenestration in each room to ensure abundant illumination.

The firm remains diligent in helping clients through every phase of a project, devoting as much time to the interior architecture as to the exterior. To fully integrate the home's overall aesthetic, the firm designs and helps select built-in furniture, case work, cabinetry, light fixtures and other interior elements. While frequently commissioned to create additions to existing homes, quite often their remodeling projects demand wholly interior architecture work.

Above Left: The Walnut house's cork floors and composite paneled ceilings highlight its steel-framed open kitchen, dining and living room with surrounding valley views through metal and glass curtain walls.
Photograph by David Papazian Photography, Inc.

Above Right: The built-in screen wall provides a lacy separation of the entry from the living room/loft while providing display shelves for the owners' artwork in the Skyline Ridge residence.
Photograph by Pizzi + Thompson

Facing Page: The open plan of the rural Walnut house is expressed with exposed poured-in-place concrete, glass curtain walls and cantilevered roofs and decks.
Photograph by David Papazian Photography, Inc.

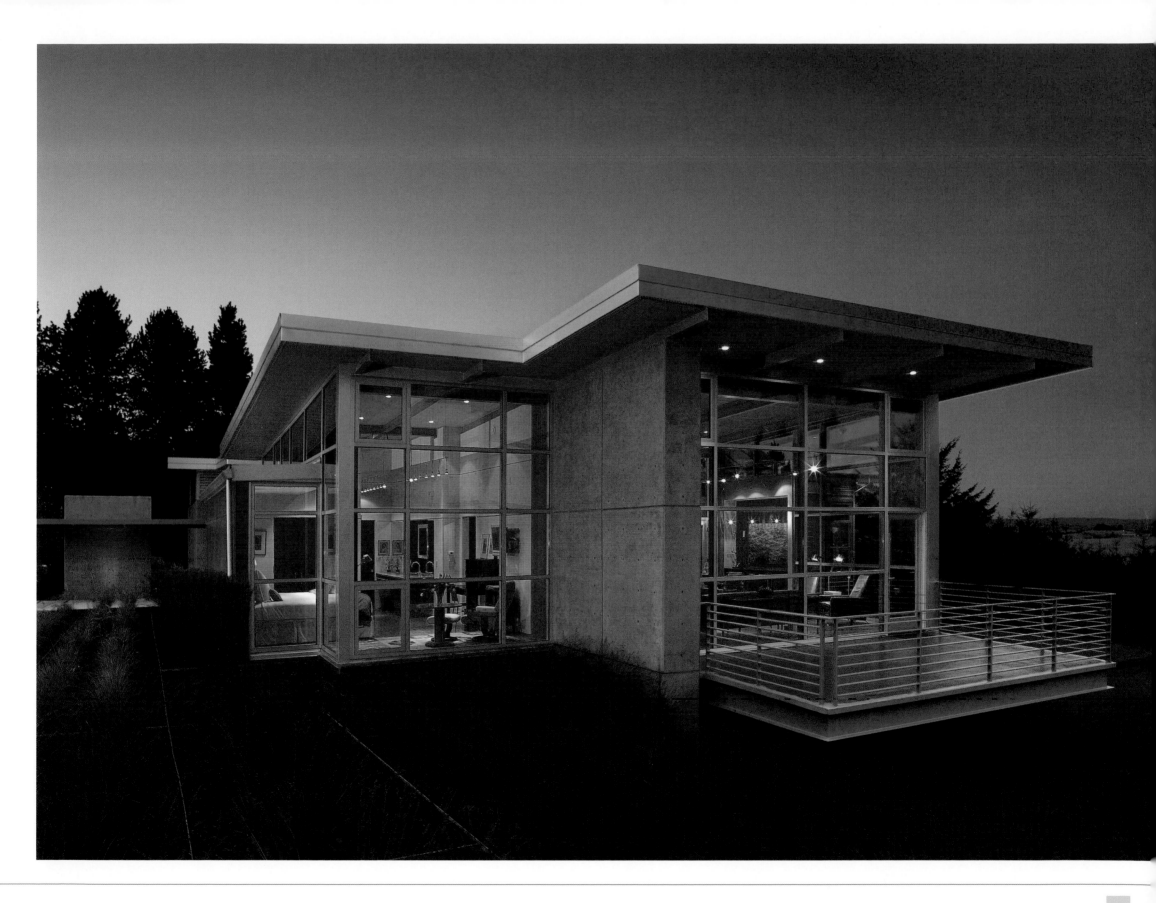

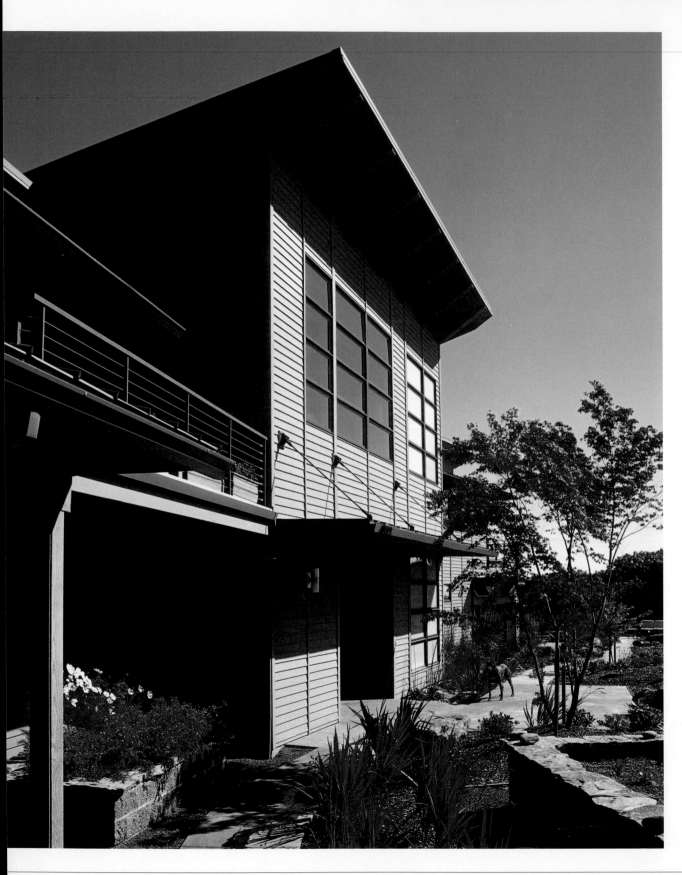

Whether increasing a home's size or merely re-envisioning its internal layout, the team effectively improves its artistic value and livability, incorporating a high level of thoughtful design and detail into every space.

Committed to preserving the beauty and sanctity of the natural environment that affords the Pacific Northwest's residents such a high quality of life, Giulietti/Schouten designs homes to the utmost Green standards. Both Dave and Tim firmly believe in applying LEED®, Energy Smart, Green Building Council and other innovative Green strategies early in the planning process. Each site is carefully analyzed for best solar orientation as well as for natural daylighting and cross ventilation to conserve energy. They incorporate toxic-free materials and efficient conservation strategies such as recycling rainwater for irrigation and graywater for toilets. Additionally, they request that contractors obtain local certification to prove that they meet required standards for energy, insulation and appliance installation.

Giulietti/Schouten's spectacular architectural designs have won a number of local AIA chapter awards, and the firm has also received several awards for interior design. Its projects, which span the globe from Oregon, Washington and Montana to Japan, grace the pages of *Sunset*, *Custom Home*, *Residential Architect*, *Oregon Home* and *Bend Living*, among a variety of other regional publications. Most gratifying to Dave and Tim is the ability to apply their talents for artistic creation to a wealth of different challenging and satisfying projects that ultimately fulfill their clients' dreams. When in the end the client is rewarded with a home as unique as he, the team is also rewarded with the ultimate compliment—a lifelong friend of the family.

Left: A simple shed roof and suspended entry canopy on the south wall define the Skyline Ridge residence, which maximizes natural daylight and the five-mountain view.
Photograph by Pizzi + Thompson

Facing Page Left: The remodeled dining room in this home features new poured-in-place walls to complement the home's existing wood and concrete accents.
Photograph by Laurie Black Photography

Facing Page Right: Natural wood built-ins and exposed concrete walls abound in the residence's entry and adjacent powder room.
Photograph by Laurie Black Photography

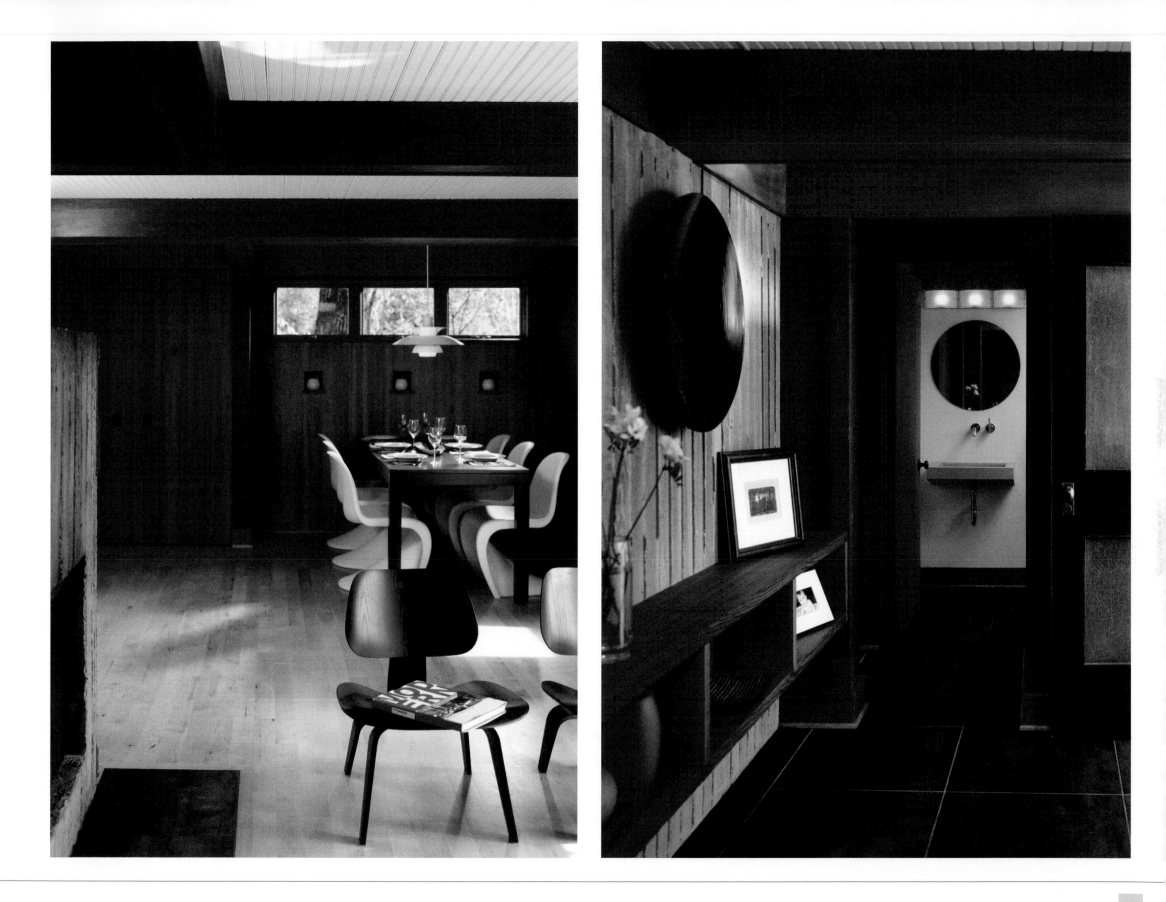

JASON HAGGART
JEFF HAGGART

Haggart Luxury Homes

Building on their dreams, brothers Jeff and Jason Haggart have established a business dedicated to creating the finest in luxury homes. Jeff and Jason work closely with their five-person team, overseeing every phase of the building process—from helping their clients pick the perfect piece of land to delivering the gift basket upon move-in.

Founded in 1997, Haggart Luxury Homes offers clients the expertise that the team's combined 46 years of experience provides. Robert Haggart, Jeff and Jason's father, was a building construction teacher, and thus the two brothers were introduced to the building industry at a very young age. The team's wealth of knowledge affords Haggart Luxury Homes the ability to confidently create multimillion-dollar homes that are technologically innovative, aesthetically timeless and the epitome of what Jeff and Jason strive to create—livable luxury.

Left: The front elevation of "Lakewood Manor," a 2004 Northwest Natural Street of Dreams home, illustrates its careful integration with the beautiful surroundings.
Photograph by Fabienne Photography & Design

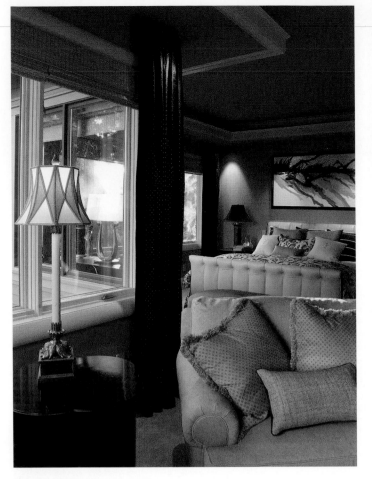

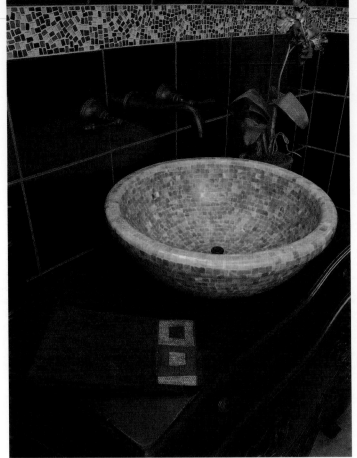

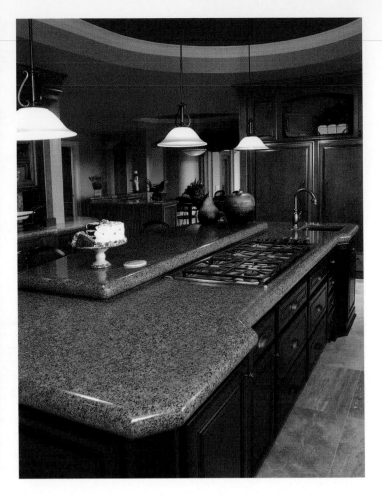

What sets Haggart Luxury Homes apart is the immense care and energy the team dedicates to each and every project. While the brothers have different strengths, both are able to complement one another all the way through the construction project. Jason, a former investment consultant, is able to shrewdly advise Haggart clients on funding choices and helps to assist the team's account manager to ensure that the project remains within the allotted budget. Jeff works on site to oversee and assist with construction, providing Haggart clients guaranteed attention to every detail that goes into their home.

Both Jason and Jeff demand nothing less than the best in quality and craftsmanship, not only from themselves and the Haggart team, but from their subcontractors and suppliers as well. Due to this insistence on excellence, Haggart Luxury Homes prides itself on working with only the best in the trade. With these strong professional relationships, Haggart clients benefit by receiving a truly unique home, built to their personality and style.

Along with its passionate pursuit of excellence is the team's commitment to Green design principles. Oregon natives, the Haggarts embody the environmental consciousness characteristic of the Pacific Northwest and seek to preserve and sustain their spectacular surroundings. Strict adherence to zoning and environmental standards and incorporation of efficient elements—such as low-voltage energy and radiant floor heating—allow the team to create homes that blend with their natural surroundings while helping to beautify the community.

Above Left: This exquisite master bedroom, replete with a sitting area, graces "Diamond in the Quarry," the firm's 2005 Northwest Natural Street of Dreams home.
Photograph by Fabienne Photography & Design

Above Middle: Stunning tile work and elegant fixtures create a sophisticated guest bathroom.
Photograph by Fabienne Photography & Design

Above Right: An inlaid Venetian plaster ceiling, granite countertops and marble flooring add drama to an expansive kitchen.
Photograph by Fabienne Photography & Design

Facing Page: A custom pool with lighted laminar jets sets the mood for the outdoor living space at "Diamond in the Quarry."
Photograph by Fabienne Photography & Design

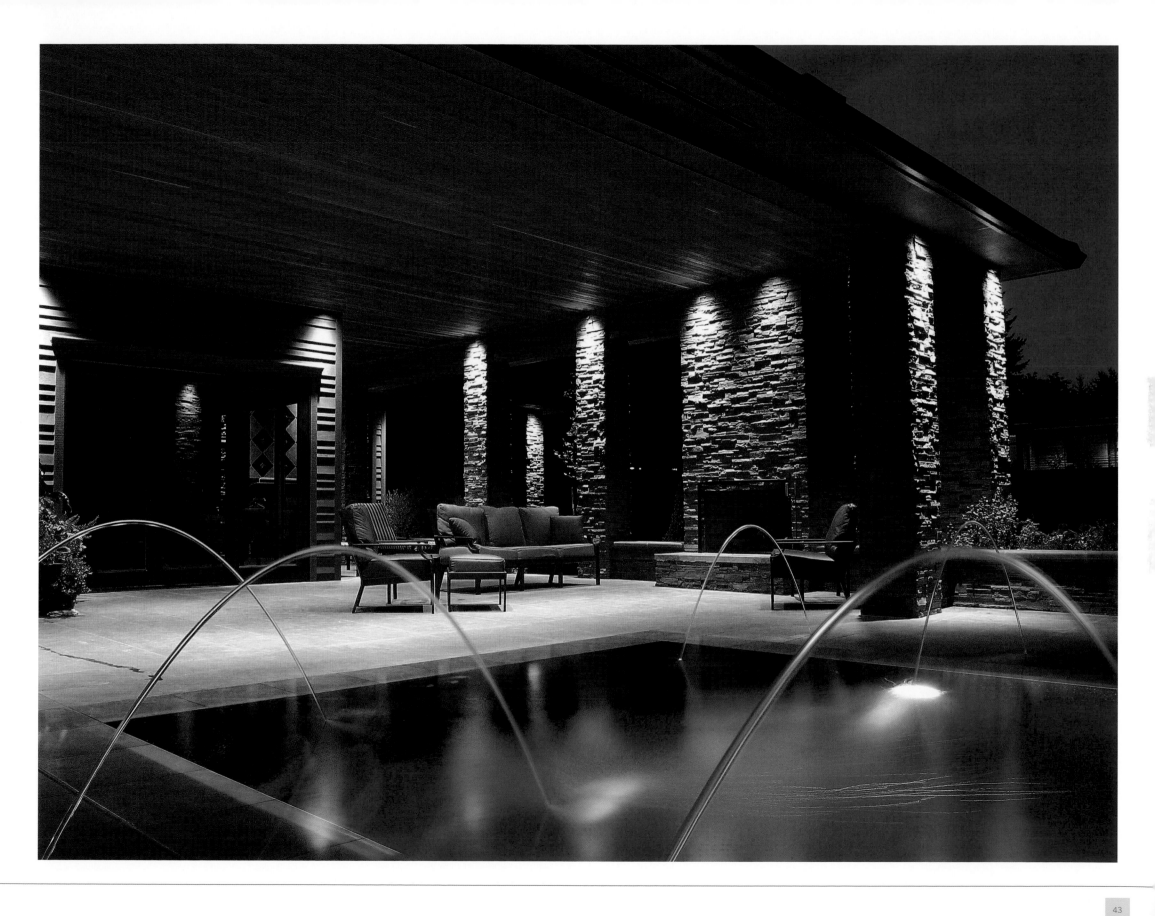

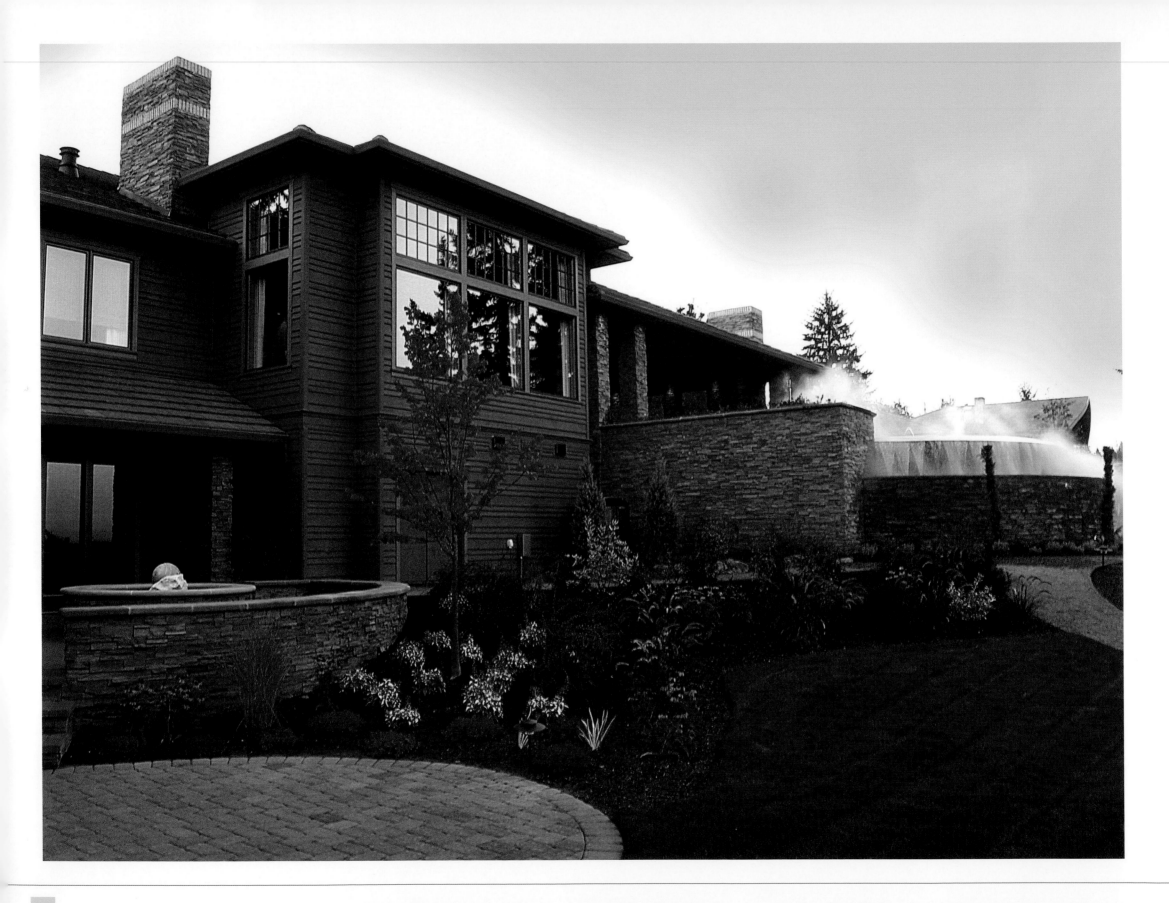

Haggart Luxury Homes was nominated an "Honor Roll Builder" by the Home Builders Association of Metropolitan Portland in 2003, and the firm further distinguished itself by obtaining the designation of "Certified Master Builder." Jeff and Jason both serve on a variety of Home Builders Association committees and have showcased their exquisite homes and talent for three consecutive years in Portland's NW Natural Street of Dreams. Their most recent home showcased was the largest and highest in value ever to grace the tour and was honored with the "People's Best in Show" award, one of two top awards given by the Home Builders Association. While well known for its work in metropolitan Portland, Haggart also has a strong presence in southwest Washington.

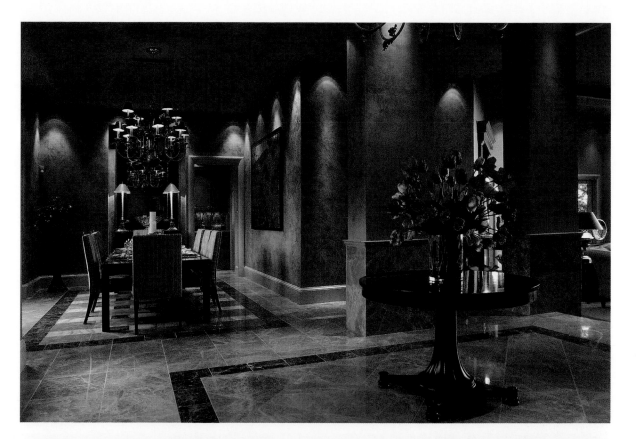

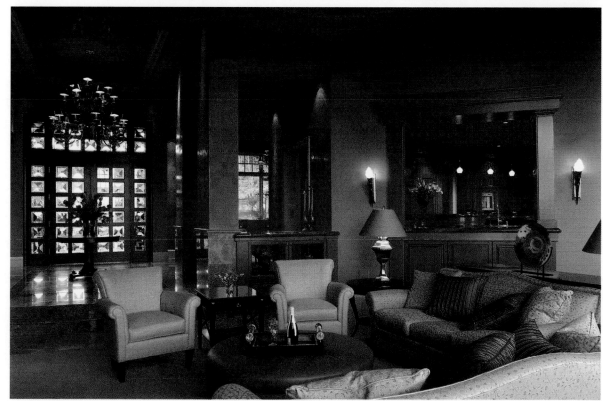

Top Right: Marble floors and Venetian plaster define the amazing entryway and dining room of "Diamond in the Quarry."
Photograph by Fabienne Photography & Design

Bottom Right: Custom hand-blown glass composes the home's grand entry doors, and marble steps lead residents and guests to the formal living room.
Photograph by Fabienne Photography & Design

Facing Page: The exterior of "Diamond in the Quarry" displays superior craftsmanship and abundant natural materials.
Photograph by Fabienne Photography & Design

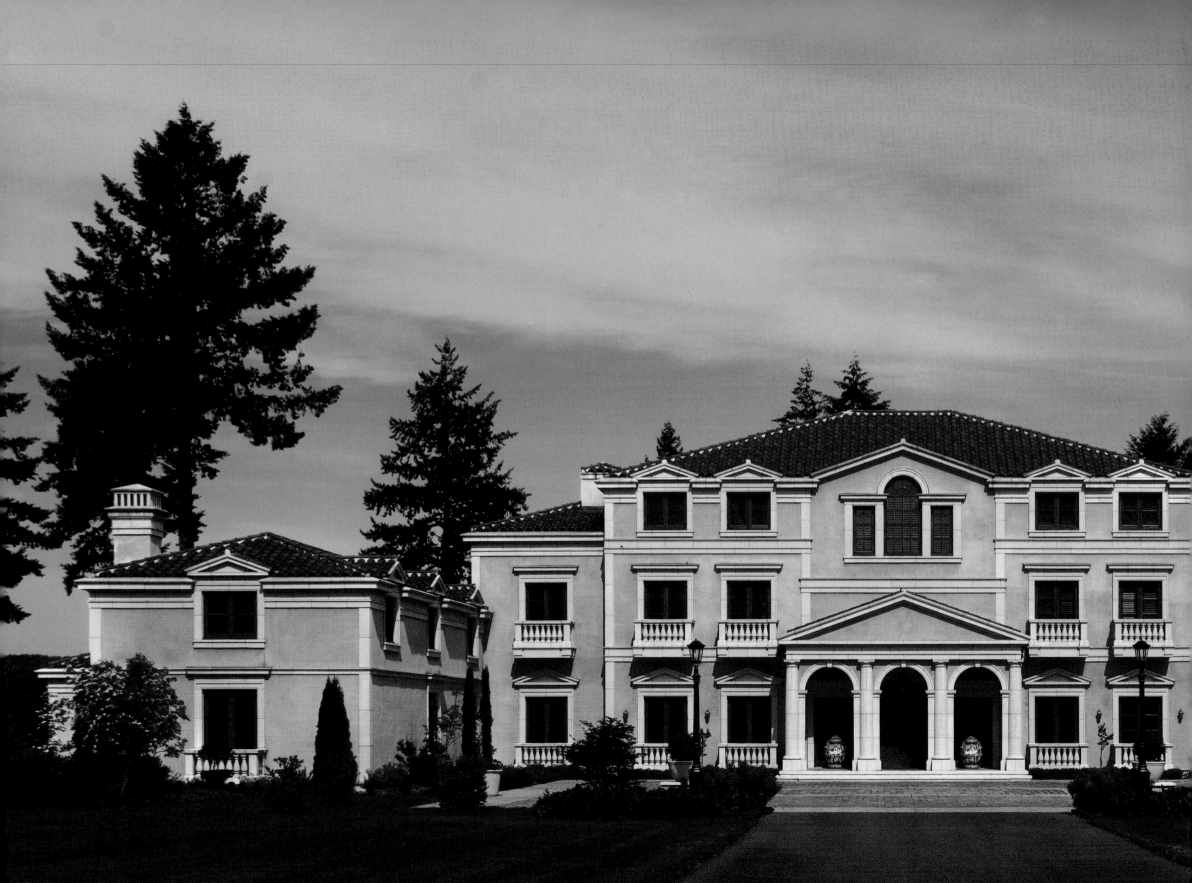

JEFFREY L. MILLER

Jeffrey L. Miller Architect, P.C.

For Jeffrey Miller, AIA, a career in architecture naturally evolved from a lifelong fascination with shelter creation. For as long as he can remember, his free time was consumed by creating enclosures that mimicked a house. Inside, furniture was overturned; outside, scraps of wood or cloth and tree branches were employed. A few architecture and planning courses in college solidified his decision, and he earned a Master of Architecture degree from the University of Washington. Obtaining his license in Oregon, he founded Jeffrey L. Miller Architect and for 27 years has created residences for discriminating clients throughout his home state as well as in California and Hawaii.

Left: The grand entry to the Mediterranean-style "Villa Del-Mar" welcomes guests to this Willamette River, Oregon estate.
Photograph by Robert Reynolds, Reynolds Wulf Design

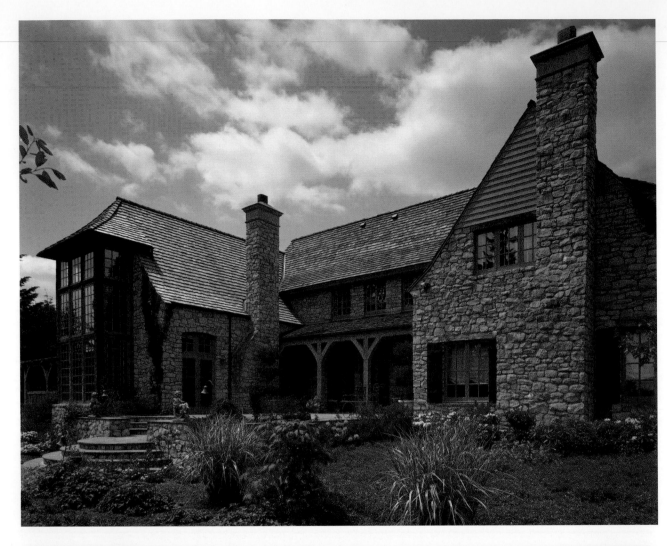

While trained in the Modern school of architecture, Jeffrey's work reflects a classic influence inspired in part by travel abroad and studies in Rome, Italy. Jeffrey discovered early in his career that the flat roofs and heavy use of glass and stucco common to modern architecture did not always work well in Oregon's climate. Furthermore his clients desired more traditional forms that gave them a stronger sense of enclosure and protection from the outdoors. While Jeffrey was reluctant to contradict his education and training, he felt vindicated by the work of A.M. Stern who was successfully doing major residential work in traditional styles on the East Coast.

Close collaboration with clients has been critical to Jeffrey's philosophy. Rather than imposing his own style on a project, Jeffrey believes that his role as an architect is to graphically translate his clients' ideas into architecture. The client therefore has the primary role in determining his own architectural program and style. Jeffrey then invents a structure that fulfills the client's requirements. Jeffrey states that the projects that excite him the most are those for clients who desire a style or elements that he has not worked with before and require some research or investigation. Jeffrey enjoys the challenge of determining how to accommodate each unique request to create the best possible home while still fulfilling his clients' hopes and wishes.

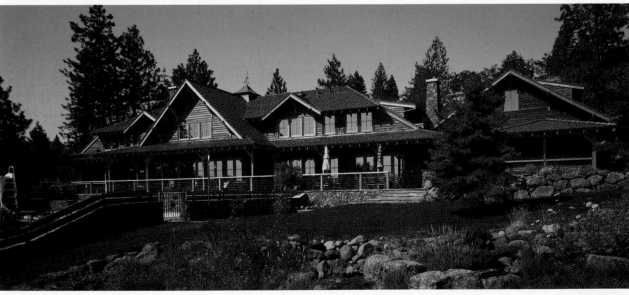

Top Left: Located in Stafford, Oregon, this home appears indigenous to its site, due to its natural palette of stone and wood.
Photograph by Sally Painter Photography

Bottom Left: Set amidst the trees in the picturesque Columbia River Gorge, this lodge provides its residents with abundant views and ample access to the outdoors.
Photograph by Sally Painter Photography

Facing Page: Nestled in the tall grass of the Willamette Valley, this residence expresses true cottage-style design.
Photograph by Sally Painter Photography

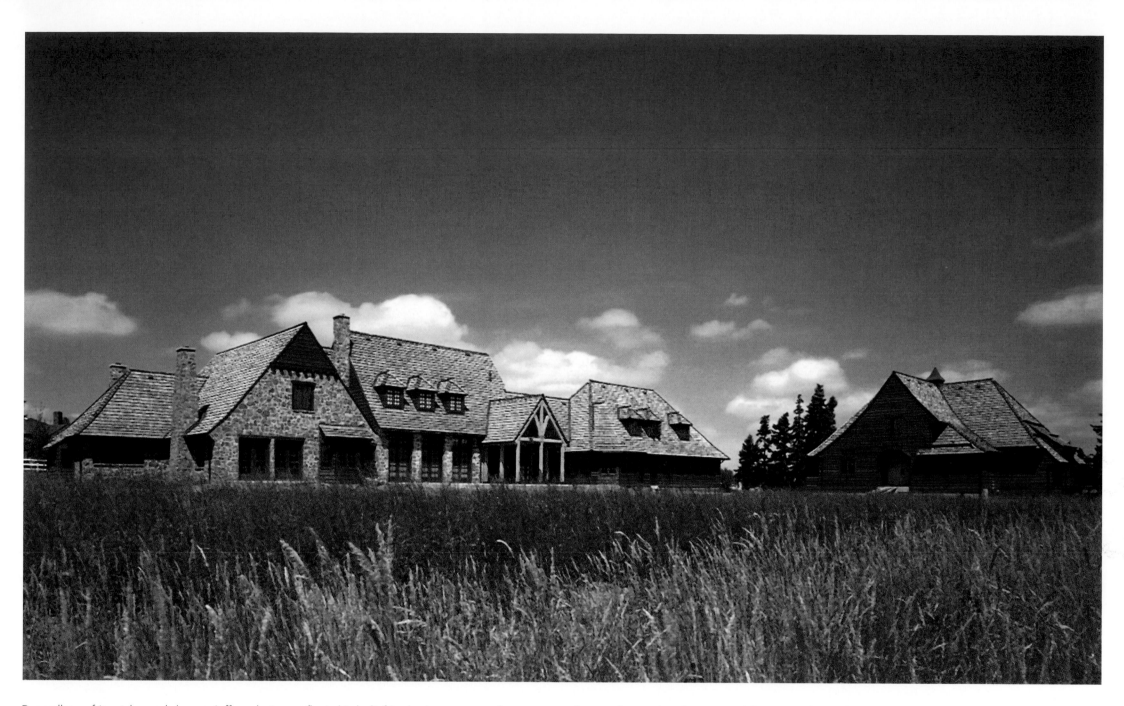

Regardless of its style, each home Jeffrey designs reflects his belief in the importance of a strong connection to the site and the environment within which the structure will sit. He strives to provide each space with as many exterior exposures as possible—windows in every room that capture all possible views and doors that provide physical access to the outdoors whenever practical. These different exposures not only provide a variety of views but also allow the character of the room to change as the light moves from one exposure to the next. Jeffrey's choices of materials—most frequently wood and stone—exhibit an outdoor influence and lend his homes a natural feel. That, along with an obsession to fit the house thoughtfully into its site, gives the building a sense of belonging to or emerging from its site rather than being imposed on it.

While his designs have been featured in such publications as *Traditional Home, Oregon Home* and *Country French Decorating*, among others, Jeffrey most values positive reviews from his clients.

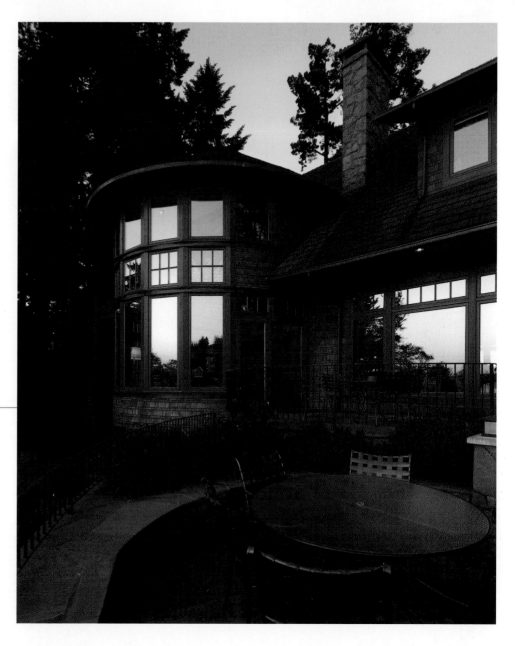

GREEN GABLES

Design and Restoration, Inc.

A t Green Gables Design and Restoration, the most important element of a beautiful home is not the detailing. Nor is it the materials used or plans drawn. For founders Lindley Morton and Corrine Oishi, the most important ingredient in the creation of a beautiful home is people. Each Green Gables project is inspired by and constructed for people. Thus, Lindley and Corrine owe the firm's success to their gifted project managers, designers, carpenters and laborers—and, of course, the exceptional clients and architects—who have surrounded them.

Educated as an architect, Lindley's passion for construction impelled him to establish a design/build firm more than 30 years ago. Offering both services combined his talent for design with his love of craft,

Above: Designed to have a lodge-like feeling without being too rustic, interiors and exteriors feature Green Gables' signature craftsmanship and wood detailing.
Photograph by Timothy J. Park

Facing Page: This residence celebrates lakeside living with spaces that spill out across terraces and the lawn, down to the edge of Lake Oswego.
Photograph by Timothy J. Park

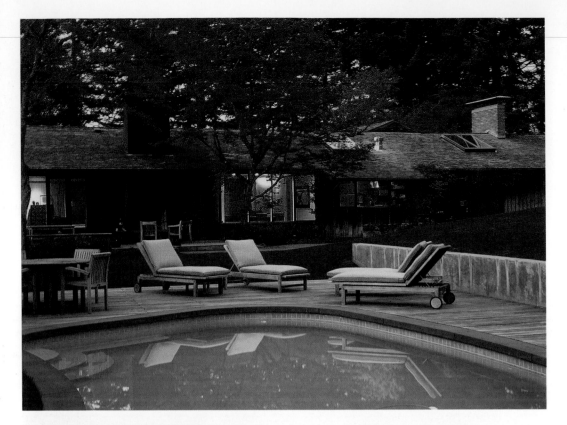

affording him the opportunity to consult with clients in the office and work alongside craftsmen on the job site. His intimate knowledge of every phase of design and construction allowed him to assemble a team of professionals as devoted to the process as he.

Committed to preserving the integrity of the design/build vision, the firm's designers frequently serve as project managers, overseeing the construction of the projects they draw. Moreover, Lindley insists that the same team, including craftsmen, work on a project from initial design through construction completion. The firm fosters open communication between everyone involved, from the clients to the tradespeople, for the duration. Maintaining that some of the best suggestions come from those on the job site, Green Gables encourages every individual to voice his or her ideas throughout the course of a project. This active engagement cultivates a widespread sense of ownership, translating into homes of superior quality.

It is this ethic that draws clients to Green Gables time and again. The firm's willingness to express any style, and to do so with excellence, garners a host of clients with strong design sensibilities and the desire to participate in the design/build process. Forever expanding its skill set, Green Gables collaborates with other architects and continually explores various innovative and sustainable materials and systems. The firm's dedication to that which makes good sense for construction and the environment drives its efforts to offer clients cutting-edge sustainable practices. These measures, along with the human quality the team infuses in its work, guarantee that Green Gables' meticulously crafted homes will endure for generations to come.

Top Left: Green Gables has undertaken several additions and remodels that respect the original design of this Northwest Modern classic, initially designed by John Storrs.
Photograph by Dave Davidson

Bottom Left: New accessory structures are designed to harmonize with and not distract from the original historic residence and gardens of this Dunthorpe home.
Photograph by Dave Davidson

Facing Page: An extensive remodel to a formerly characterless house on a Riviera-like site opens out to spectacular views of Lake Oswego below and the hills beyond.
Photograph by Dave Davidson

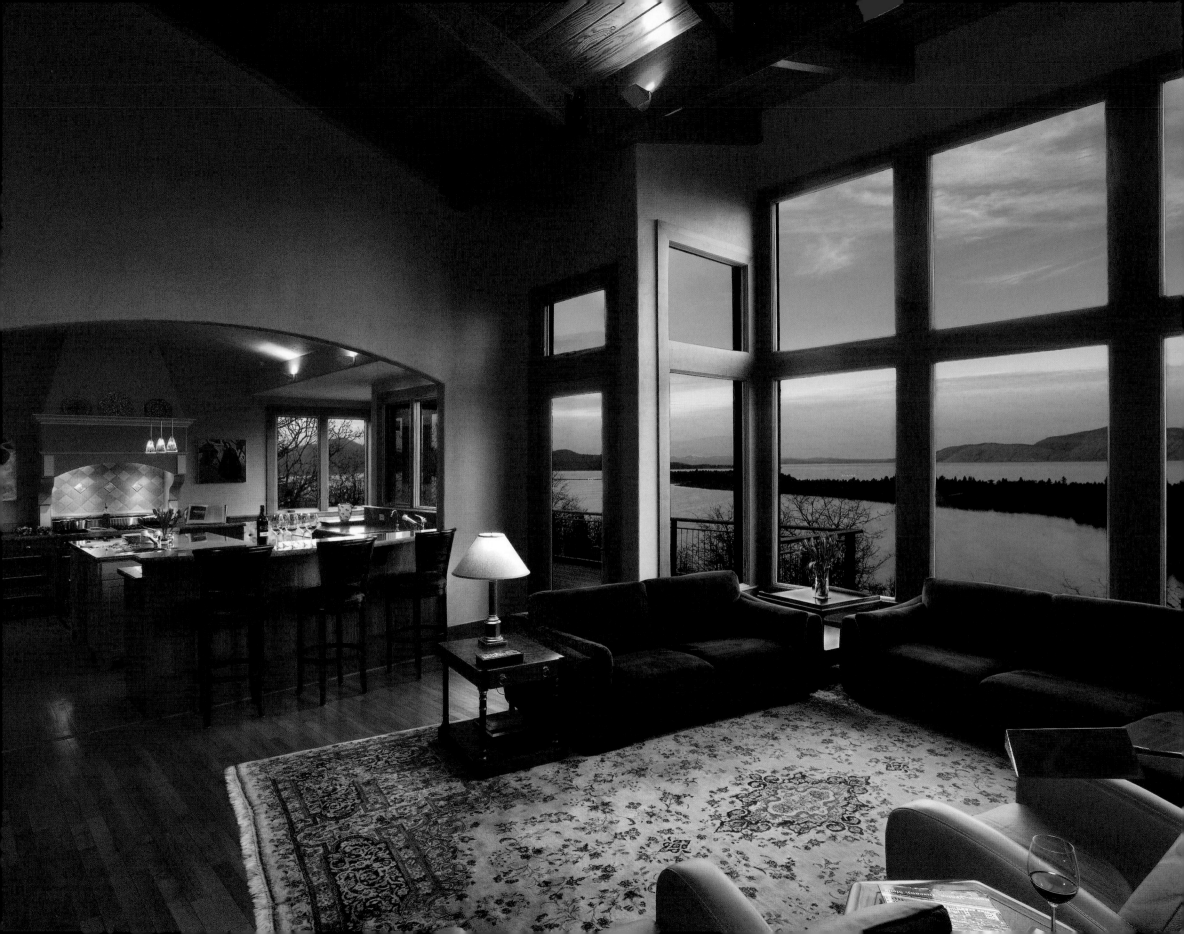

Nancy Merryman
Linda Barnes

Robertson Merryman Barnes Architects

The principals at Robertson Merryman Barnes Architects attest that two keys to good architecture are accessible architects and engaged clients. Designing a home—or any structure, for that matter—is a process, one that requires a great deal of communication and collaboration. Those guiding the process must first listen to clients and then help them to recognize and focus their desires so that their homes fulfill both functional and emotional requirements. Led by Nancy Merryman, FAIA, and Linda Barnes, FAIA, the small, all women-owned firm has fostered an atmosphere of openness and approachability, facilitating its creation of architecture that fully responds to clients' needs and aspirations.

Their respect for the role of clients leads the principals to actively include their clients in the design process, apprising them of options and ensuring that they are fully involved in decisions. Often, a client

Above Top: The second-floor addition to this residence changed a mid-century, flat-roofed "box" into a contemporary light-filled home.
Photograph by Michael Mathers

Above Bottom: This southern Oregon home was carefully sited to follow the ridge overlooking Upper Klamath Lake and to integrate with the existing oak and pine trees.
Photograph by Michael Mathers

Facing Page: The great room and kitchen are the informal heart of this southern Oregon home, which overlooks Klamath Lake and abundant wildlife.
Photograph by Michael Mathers

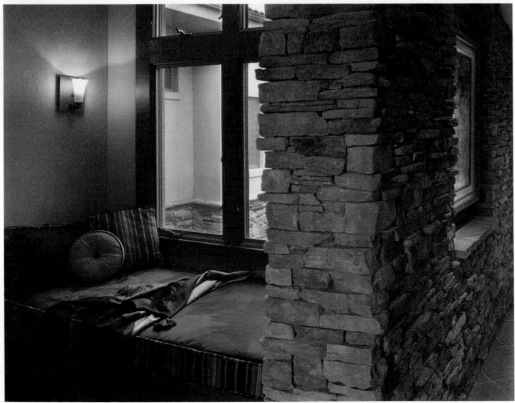

will profess an affinity for a specific style. The principals work to distinguish which qualities of the style resonate with the clients' sensibilities and then incorporate those into what they call a "humanistic modern aesthetic"—that is, fresh, clean-lined designs tempered with the essence of their clients' preferred architectural genre. The firm's homes thus resist specific categorization, embodying the features and the feelings characteristic of a genre yet infused with modern principles. Their goal is to create architecture that is clearly of our time but has depth that comes from an appreciation of the best aspects of past historical precedents.

Common to all of the firm's projects is the relationship of the architecture to its site. Before beginning a project, the principals conduct a thorough site analysis to determine how best to take advantage of the sun, wind and natural features. They believe that a thoughtfully designed site plan is the foundation for a successful project and must be completed before beginning the building design. Responding to climate and landscape conditions, the architects begin with the approach, creating a progressive experience that sets the mood for the home from the street up the driveway. Proper site planning is central to the firm's commitment to sustainability, a longtime hallmark of the principals' work.

Recently garnering LEED® accreditation, Nancy and Linda each considers Green design her distinct obligation. Indeed, for Linda, environmentally sensitive design harkens to her Arizona State days, when she discovered the benefits of solar energy. Finding that Oregon's mild climate naturally lends itself to such renewable sources of power, Linda has employed passive solar design in many of her homes and works with a number of nonprofit organizations devoted to promoting public education of solar techniques. From the firm's beginning in 1992, the principals have encouraged clients to consider renewable energy sources and to do more with less, subsequently leaving a smaller footprint. As Linda describes it, to produce sustainable architecture means to "design as if the future mattered."

Certainly the shape of the future matters to the women of Robertson Merryman Barnes. Along with supporting the environment, the firm's diverse projects—many of them civic, institutional and nonprofit—improve the families and communities they serve. The recipients of numerous awards from the likes of AIA, HUD and LEED®, among others, the principals are duly rewarded for their passion.

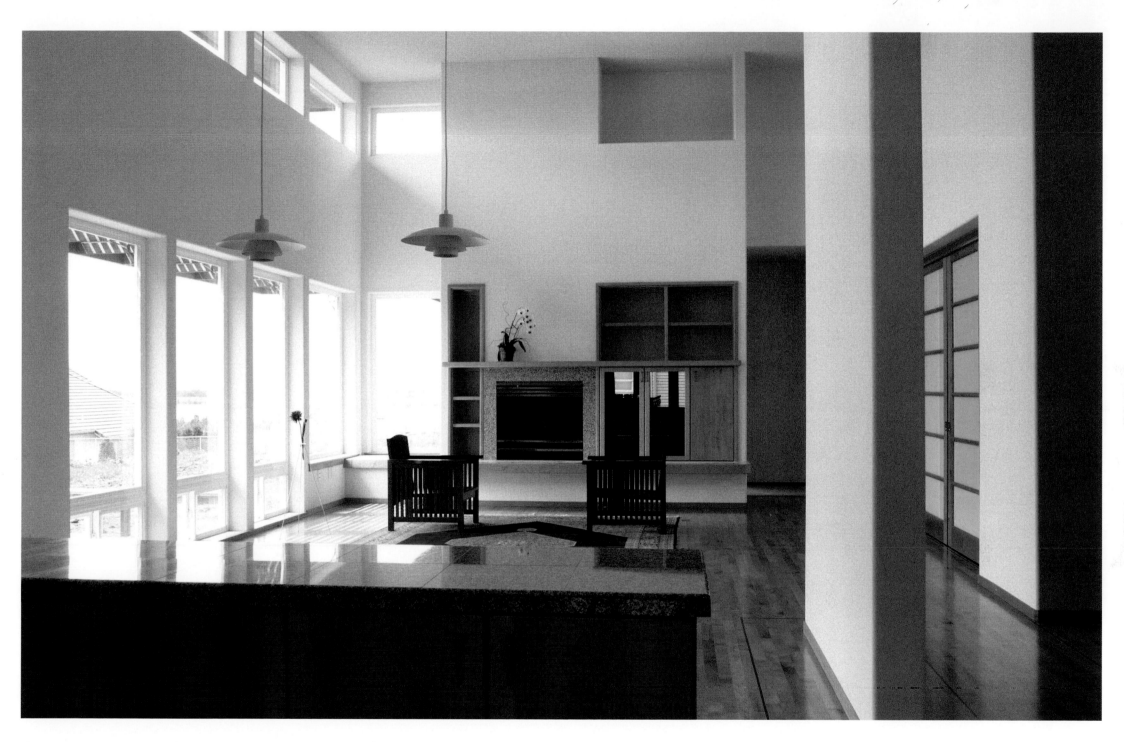

Above: Inspired by the clients' love of Asian simplicity, this great room is the true heart of the residence.
Photograph by Laurie Black

Facing Page Top: The solar hallway in this central Oregon home provides for passive solar heating, thermal storage mass and natural ventilation.
Photograph by Steve Mahon

Facing Page Bottom: This cozy window seat is one of the home's many surprise interior features and provides an additional sleeping area for guests at large family gatherings.
Photograph by Michael Mathers

DON VALLASTER
MIKE CORL

Vallaster Corl Architects, P.C.

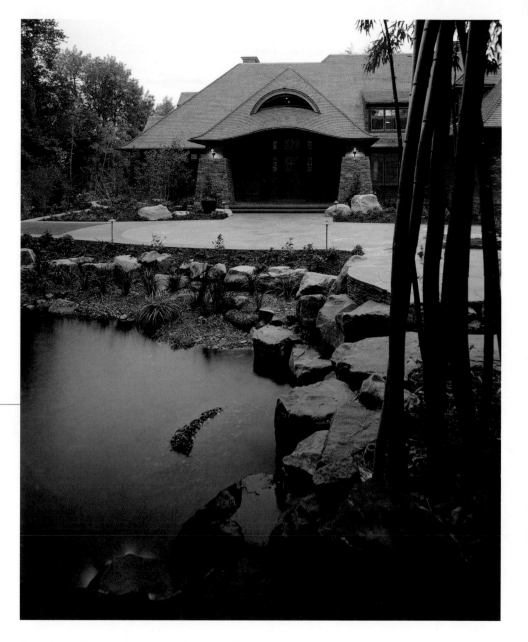

Above: A cascading natural water feature flows by the front entry.
Photograph by Sally Schoolmaster

Facing Page: Located along the mighty Columbia River amid a restful verdant setting, this residence embraces a Northwest adaptation of the English Arts-and-Crafts style to form a tranquil environment for an active family of five.
Photograph by Sally Schoolmaster

Don Vallaster, AIA, and Mike Corl, AIA, established their collaborative practice in 1985, shortly after returning to Portland from Indonesia, where they worked together for an extended time. The Indonesian experience gave both partners the opportunity to explore a rich and complex culture that has, in subtle ways, continued to inform the work of the firm—in particular, the reliance on and utilization of indigenous materials and time-honored building forms that evolved in response to regional climate differences. From that experience, the partners have looked to the building traditions and available construction materials native to the Pacific Northwest for direction in the design of single-family homes.

At the heart of Vallaster Corl Architects' work is a commitment to tailoring each project to meet the client's needs and expectations. The design process is thorough, complete and at its best melds

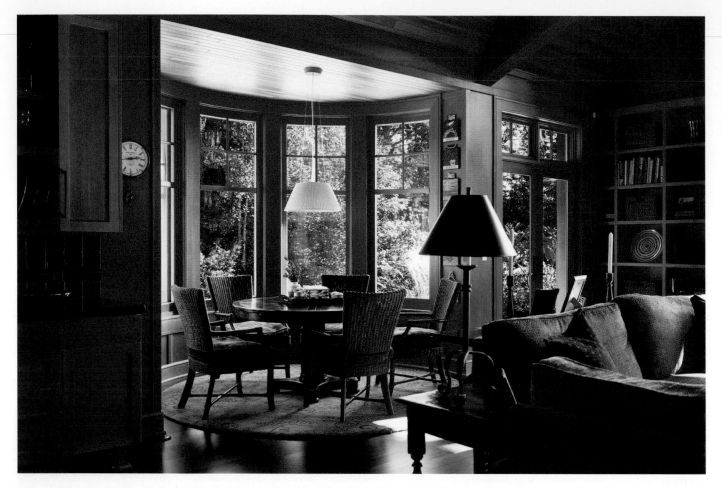

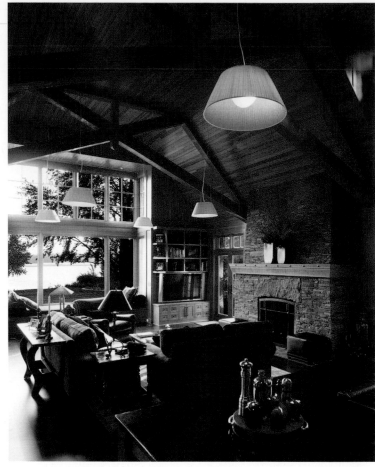

seemingly contradictory requirements into a cohesive, seamless design. And while the projects vary considerably in size and character, all reflect the firm's careful consideration of and response to both context and site.

Vallaster Corl is deeply committed to sustainable building practices. The firm's first priority is to use locally available materials. When that is not an option, energy-efficient and renewable building systems and materials are researched and included in the design. But the firm believes that it is the careful siting of buildings that offers the greatest opportunity for energy conservation. Maximizing southern exposure for solar heat gain in the winter months and controlling and filtering harsh western light in the summer reduce the need for energy-intensive heating and cooling equipment.

In addition to new construction, Vallaster Corl is dedicated to rehabilitating and finding new uses for old and sometimes historic buildings. Recent projects have included renovating a long-dormant railroad building, several old warehouses and an abandoned hotel into vibrant mixed-use buildings. Recycling old buildings is a sustainable building practice, but more importantly, it maintains the architectural memory of the community for future generations.

Both partners have been asked to present work at educational and professional conferences. Their remarkable projects have been published in *Traditional Home*, *Metropolitan Home*, *Architectural Record* and local publications. Design awards include The Governor's Livability award, AIA Design awards and a national HUD/AIA award. The firm's unflagging commitment to its clients and Green building practices ensure that Vallaster Corl will enjoy wide recognition for years to come.

Above Left: A curved bay window defines the casual dining nook.
Photograph by Stickley Photo Graphic

Above Right: The central great room frames the view of the Columbia River.
Photograph by Stickley Photo Graphic

Facing Page: The riverside outdoor terraces surround the low eaves of the cedar roof and stone chimneys to provide a comfortable, pleasing scale for outdoor living and entertaining.
Photograph by Sally Schoolmaster

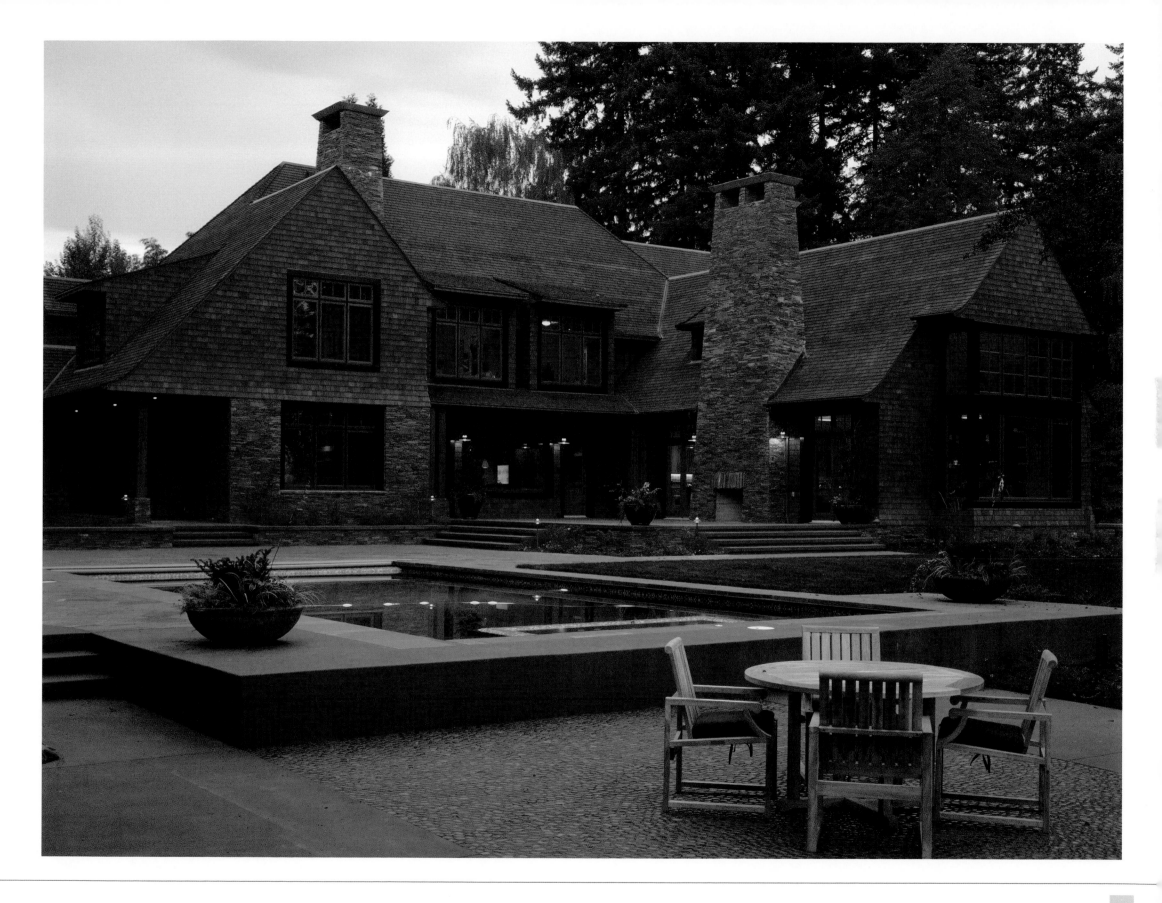

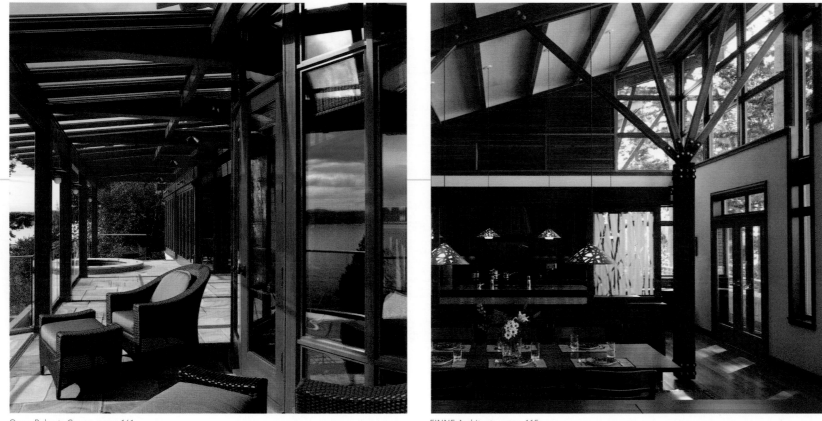

Owen Roberts Group, *page 161*

FINNE Architects, *page 115*

E. Cobb Architects Inc., *page 87*

WASHINGTON

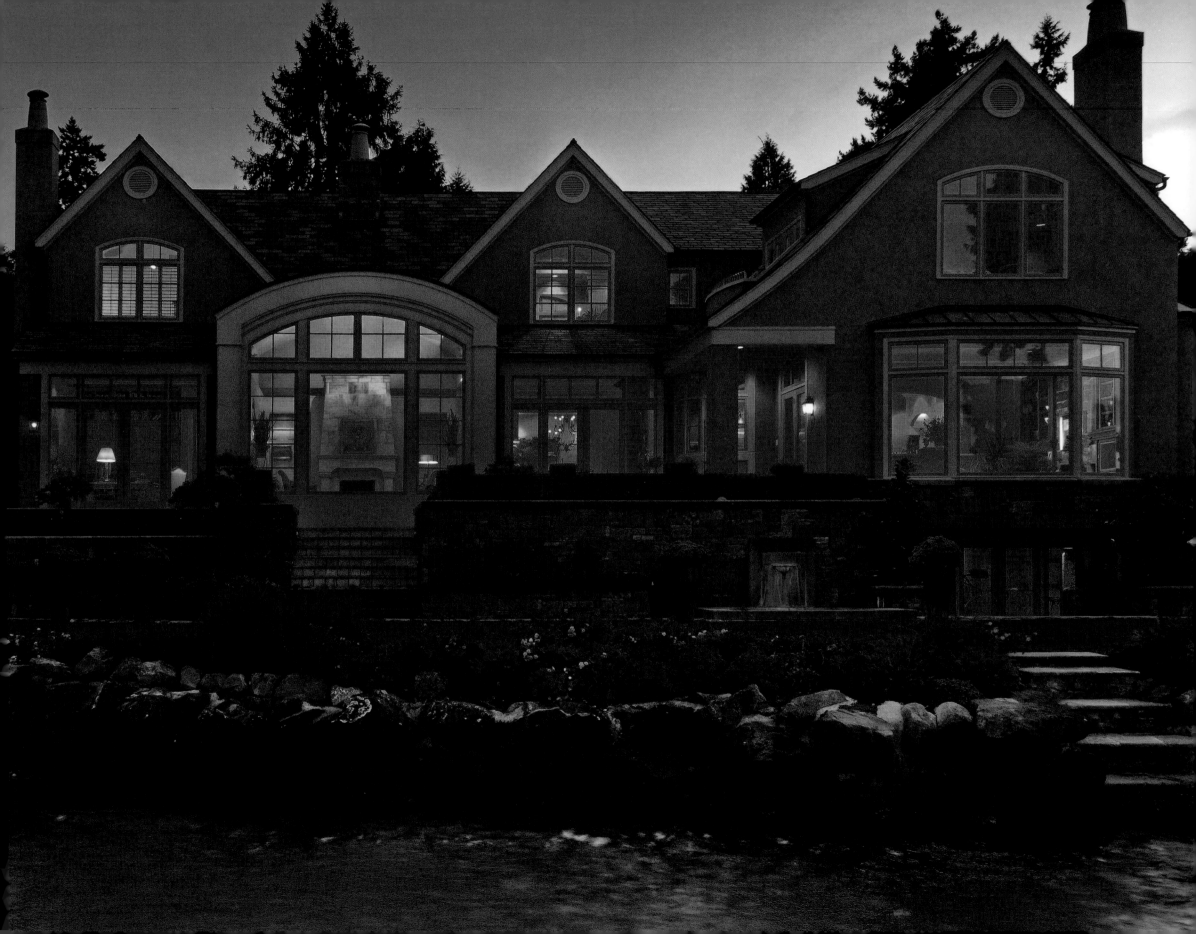

MARK ANDERSON
MARK OLASON
DENNIS MARSH
MARK ELSTER

AOME Architects AIA

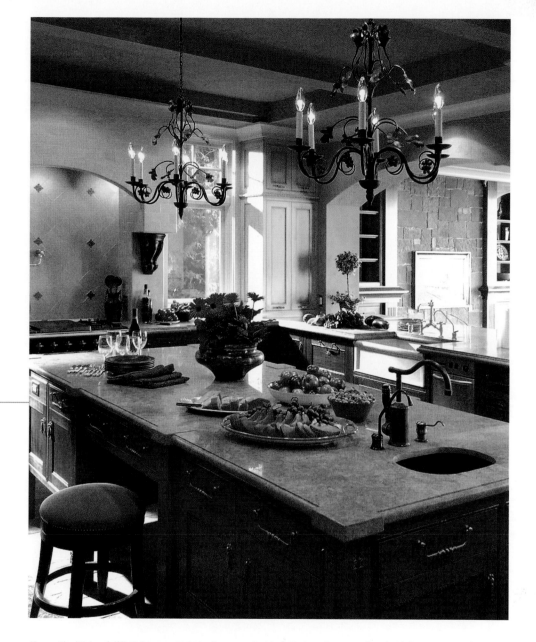

Above: The kitchen fulfilled the owner's desire for a grand and sophisticated room outfitted with furniture-quality cabinets abundant in architectural detail and time-seasoned character.
Photograph by Mike Jensen Photography

Facing Page: After 10 years of biding their time, the owners knew what they wanted in a lakeshore home—lots of glass and European-inspired sophistication. The result is a beacon of light in the evening.
Photograph by Mike Jensen Photography

A careful balance of traditional yet modern, sheltering but open, technically inventive yet artistically creative, the work of AOME Architects is a study in contrasts and dualities. Natural materials contrast with man-made. Simplicity and complexity coexist along with the open and the private. Pragmatic needs are balanced against aesthetic delight. The ancient shares space with the ultra-contemporary. AOME Architects successfully creates this harmonious disparity by combining cues from the natural environmental, physical and cultural context, architectural heritage and their clients' own dreams and aspirations with thoughtful manipulation of basic architectural elements: light and space, color, pattern, texture and proportion.

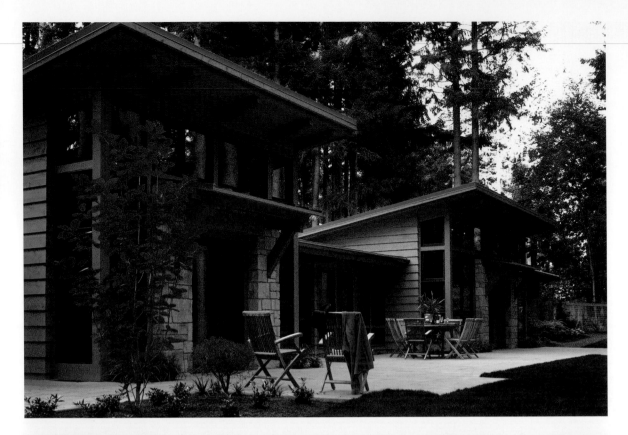

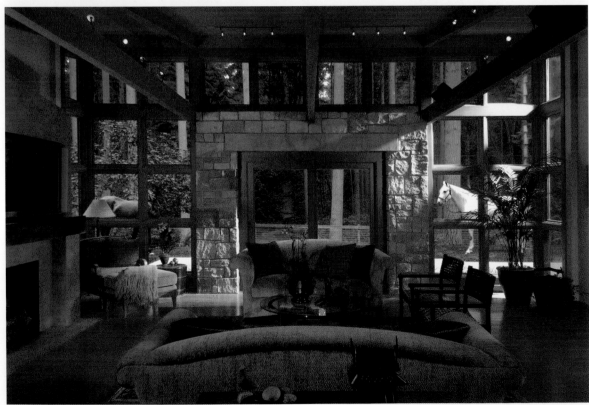

Like so many of their clients who have traveled the world and felt the aura and serenity of aged buildings and the warm, tactile nature of materials from generations past, each of the principals at AOME appreciate the lessons history has to offer. They understand that this fast-paced, ever-changing world spawns clients' profound yearning to capture some of that older, quieter world within their homes. While this desire often correlates to an interest in traditional styles of architecture, many clients search for ways to incorporate the same underlying elements of age-graced structures into modern architectural styles as well. No matter the aesthetic preference, the principals of AOME enjoy exploring the many ways in which patrons express their meaning of home. Whether neo-traditional or modern, a home must convey a sense of sanctuary, timelessness, happiness, beauty, pragmatism, and perhaps most importantly, clients' identities.

While some firms reject the stigma of "living in the past," AOME Architects welcomes the give and take between past and present and pursues the challenge of blending the two. While an adobe hacienda is an unlikely candidate for the Pacific Northwest, it is worth exploring how and why that particular vernacular struck a chord for a client and further, how a more appropriate architectural response to the region might resonate in the same manner. Similarly, the firm understands a client who is drawn to a more modern aesthetic and can articulate that style in a manner that makes the home appear 100 years old. AOME Architects relishes the challenge of timeless modernism that acknowledges its relationship to its forebears just as they find neo-traditional designs stimulating and rewarding expressions of modern lifestyles within historical forms.

Top Left: This contemporary remodel of a rambler on horse acreage boasts new lines and forms that echo the majestic forest setting that surrounds.
Photograph by Mike Jensen Photography

Bottom Left: An upturned roof opens the living room to the sky and the tree canopy, with glimpses of the horse paddocks beyond.
Photograph by Mike Jensen Photography

Facing Page Left: A sensitive remodel redeemed a classic Craftsman home previously targeted to be torn down. By cleaning up several previous haphazard remodeling projects and adding a wraparound veranda with a new trussed-gable entry porch, the home's character was restored and its unrealized potential was finally fulfilled.
Photograph by Northlight Photography Inc.

Facing Page Right: The arrangement of architectural details and interior appointments manages to engage guests in an intimate way that is surprising in such a large entry foyer. The soaring space is capped with a dramatic skylight and flanked by a split stair, adorned with custom metal railings and richly paneled wainscoting.
Photograph by Mike Jensen Photography

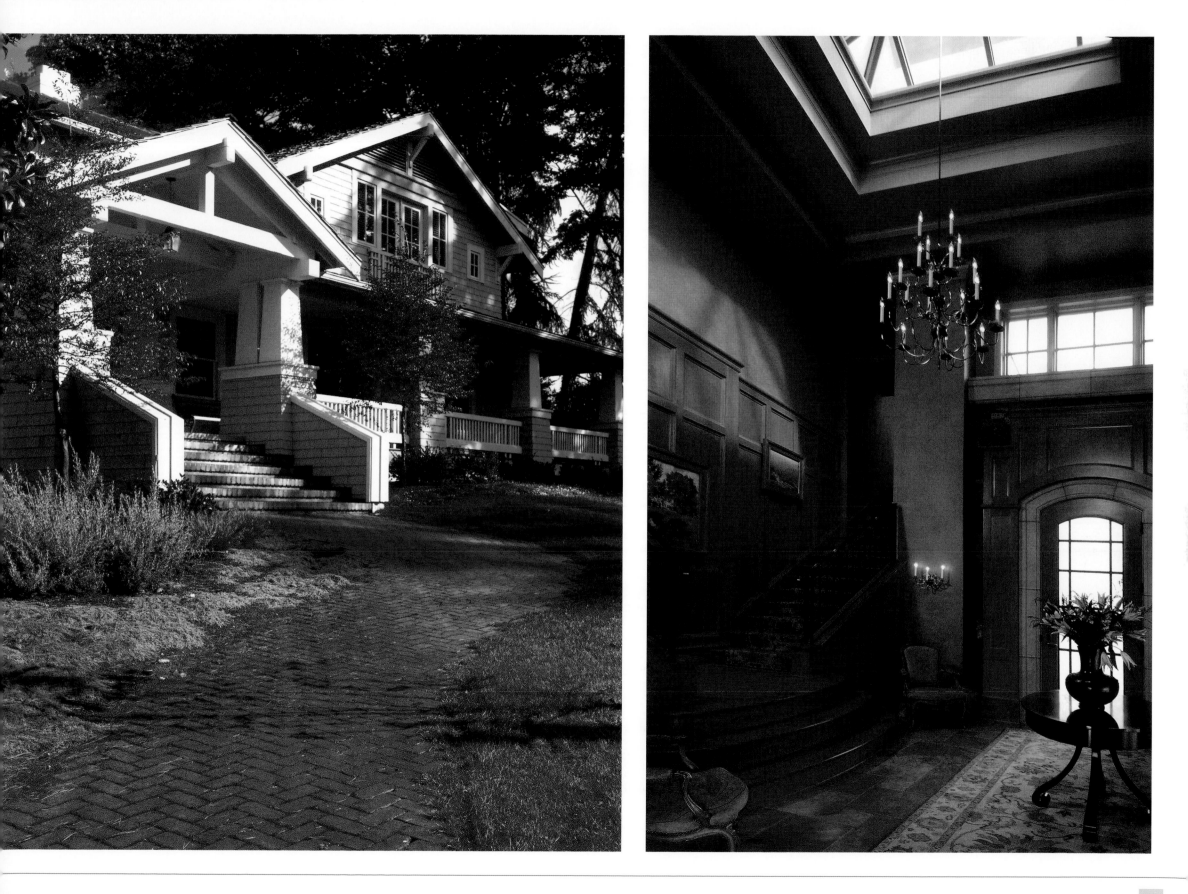

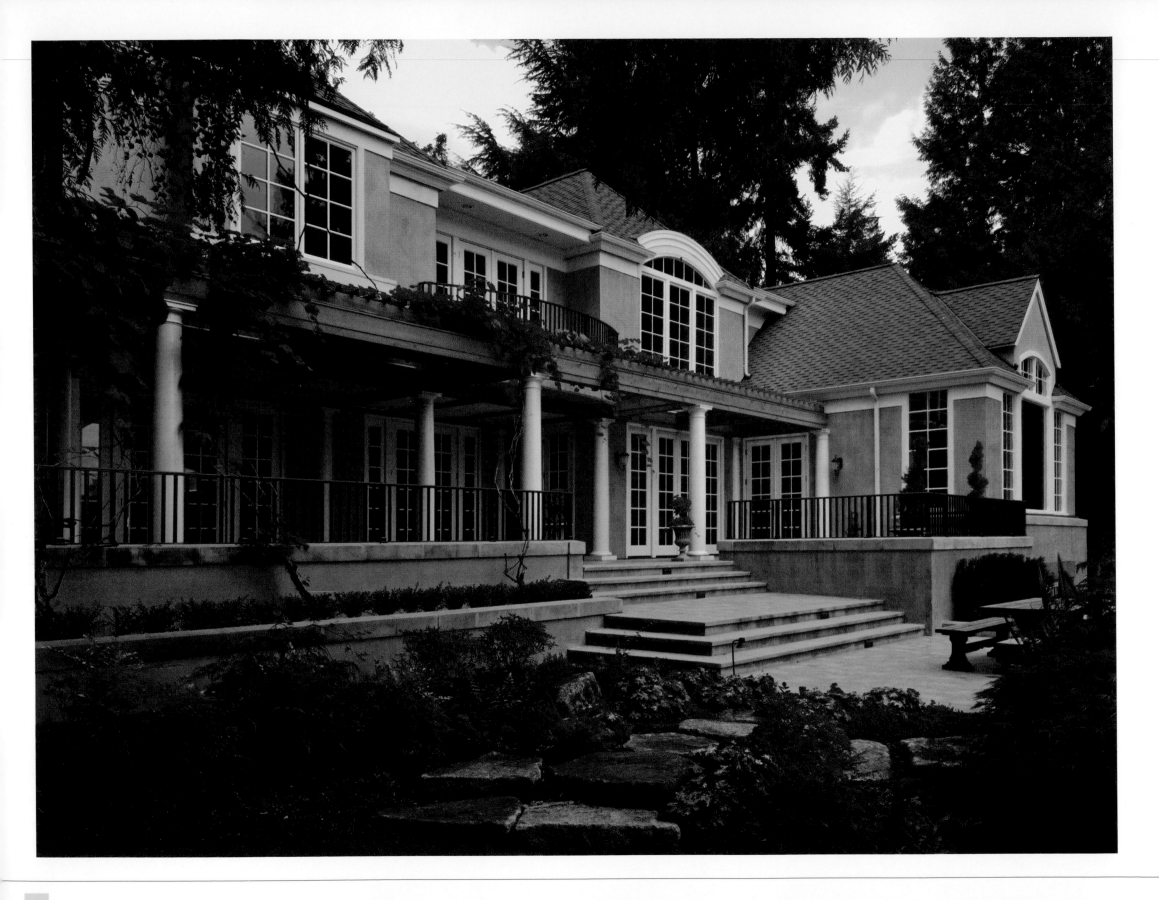

Mark Anderson, Mark Olason, Dennis Marsh and Mark Elster all trained in architecture at the University of Washington and are all AIA members. They met in the 1980s while working in the office of a prominent Northwest architect and soon discovered they had a mutual affinity for residential architecture. They so enjoyed collaborating that they started their own firm in 1986, adopting its current form in 1991 when Mark Elster was licensed and became the fourth partner. Beginning with multimillion-dollar projects in Hawaii and the Northwest, the firm rapidly developed a reputation for creating high-end residential architecture in a wide variety of styles with unusual attention to detail and extraordinary service. It also became known for the team's ability to foster highly effective and collaborative relationships with contractors, consultants, artisans and their clients.

None of the lofty goals AOME aspires to can be achieved alone. A cast of numerous dedicated individuals and companies contribute expertise, creativity, artistry, craft and hard work to each of their successful projects. The collaboration begins within—the principals, architects and designers work side by side throughout the design process. The same collaborative environment is extended to the contractors and craftsmen, the consultants, and ultimately, the client—the firm's most important partner. The client's desires and energy are the seeds that begin the process. While the architect contributes new concepts and solutions, much of the time he simply guides and interprets. Discussions center on the nature of the project in the context of the neighborhood and community. Project systems are considered from

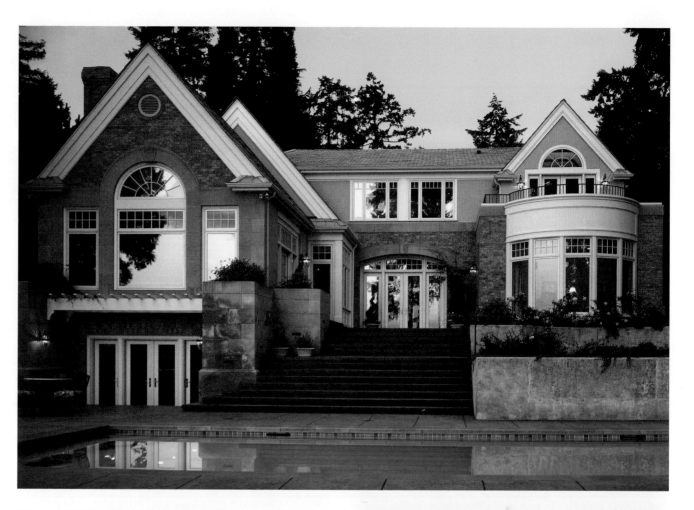

Top Right: Limestone and brick veneer combine with wood and limestone trim elements and a slate roof to lend this lakefront residence a traditional flair that suits the estate setting.
Photograph by Northlight Photography Inc.

Bottom Left: Simple forms, bold color and symmetry make this striking entry quite inviting.
Photograph by Mike Jensen Photography

Bottom Right: A quiet, secluded courtyard off the piano alcove produces a music all its own.
Photograph by Michael Shopenn Photography

Facing Page: In the Pacific Northwest, a mild climate and lots of gray days interspersed with idyllic sunny days demands an abundance of glass and accommodations for outdoor living. The carefully arranged terraces of this home extend the living areas out toward the shore of the lakefront setting.
Photograph by Mike Jensen Photography

an environmental and sustainability standpoint. Spaces are conceived and created with purpose and intent, and material and finish choices, either ancient or new, are blended to reinforce the nature of the space. Details are considered that reflect the underlying premises of the design so that, upon completion, a unity is produced in the whole of the project, imbuing it with a sense of "rightness" that permeates throughout.

Just as each of AOME's clients is unique, so too is each project. There is no underlying belief that clientele should conform to the latest design trends or predilections of the architect. Indeed, the home will be the clients' to enjoy, to occupy, and to experience on a daily basis and must thus truly reflect their personalities, lifestyles and beliefs. Yet ultimately, AOME's projects are constructed to be enjoyed, admired and respected and to remain long after the client, and architect, are gone.

Above: East Coast architectural forms were carefully adapted to the setting of this Pacific Northwest farm estate.
Photograph by Northlight Photography Inc.

Left: Casually sophisticated interior spaces are suffused with light and warmth year round.
Photograph by Phillip Clayton Thomas

Facing Page: A sweeping veranda takes in the full breadth of the stunning territorial view beyond the pool.
Photograph by Northlight Photography Inc.

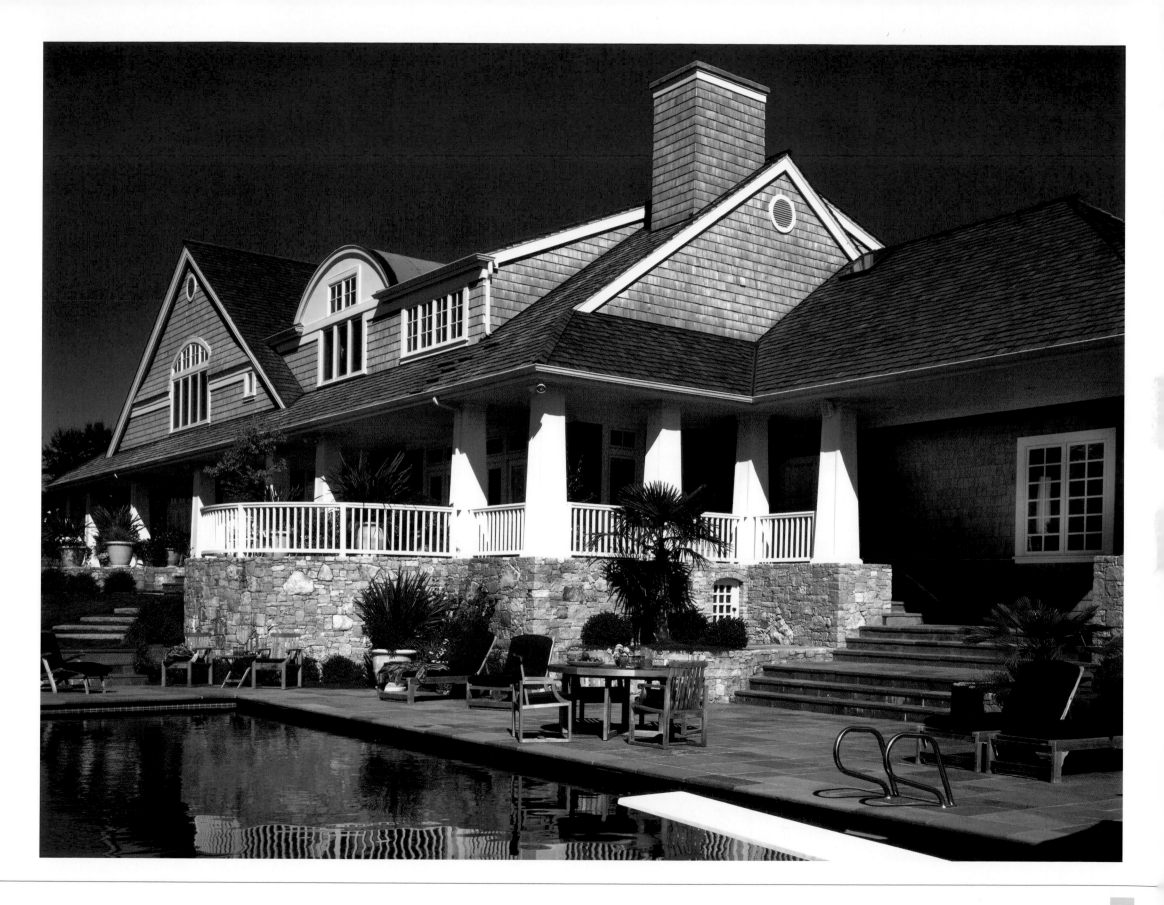

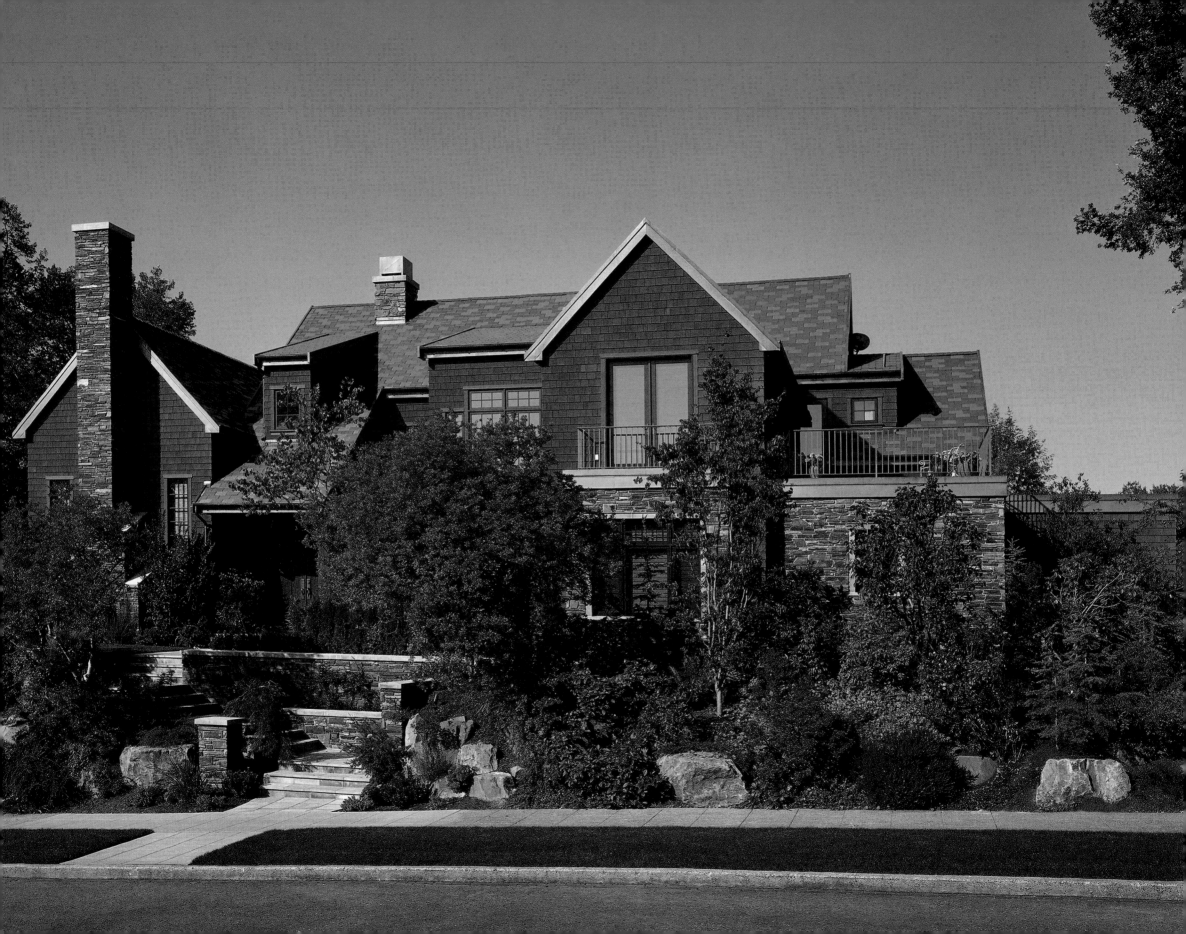

Don Bender
Stephen Bender

Bender Chaffey Corporation

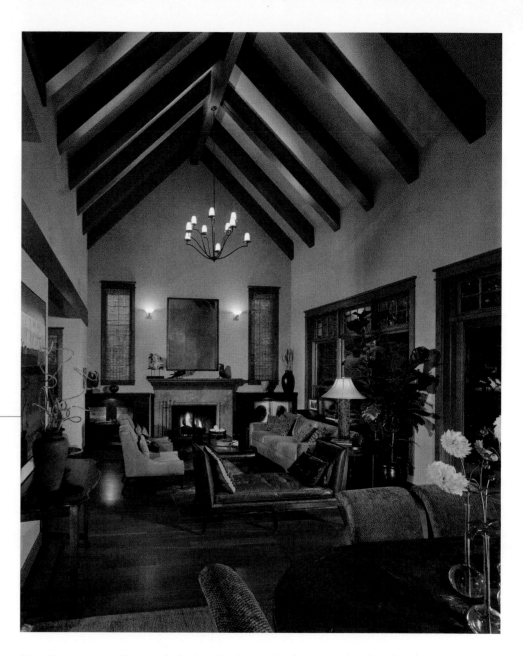

Page through the real estate section of Sunday's *Times*, and you just might notice Bender Chaffey Corporation listed as the builder of a custom home for resale—not a common practice, but Realtors understand that the name carries with it a reputation for excellence, both in construction and in service. With 25 years of experience constructing custom residences throughout the Pacific Northwest, Bender Chaffey has garnered ample attention and accolades from a multitude of industry authorities and satisfied clients, alike. Architects are drawn to the firm for its organization and efficient project-management systems; builders associations recognize the team's immense talent for detail and craft; homeowners appreciate Bender Chaffey's commitment to successfully express their home's aesthetic vision as quickly, economically and flawlessly as possible and, most importantly, to provide them a truly enjoyable home-building experience.

Above: Dramatic wrapped beams and refined woodwork demand the finest materials and time-honored carpentry methods and provide warmth to this room's formality.
Photograph by Chris J. Roberts Photography Inc.

Facing Page: The award-winning use of exterior materials helps to create a home that settles comfortably into the surroundings of its historic Seattle neighborhood.
Photograph by Chris J. Roberts Photography Inc.

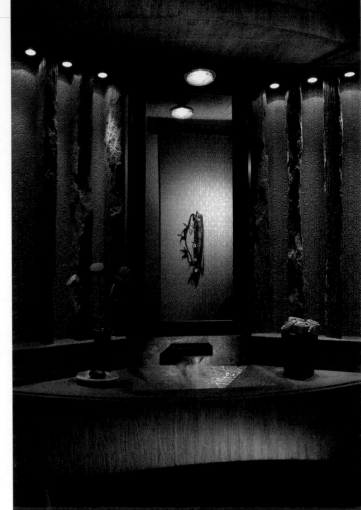

Cofounded in 1982 by Don Bender and Herb Chaffey, the firm has since built more than 250 homes and now houses a team of 15 caring, experienced professionals. At the firm's foundation, the partners resolved to keep it small enough to ensure close collaboration with clients while maintaining sufficient manpower to effectively produce the highest quality structures possible. Herb is no longer a partner—Don's son Steve has taken his place—but the firm's objective remains the same: to create beautiful homes and forge lasting relationships with clients. With more than 300 years of combined home-building experience and a broad network of top-notch architects and subcontractors, the team easily and consistently achieves this goal.

The firm's wealth of knowledge and experience affords it the ability to construct anything an architect and client can envision. From elegant European mansions and Southern Colonial manors to clean-lined contemporary residences, Bender Chaffey has constructed homes in virtually every imaginable architectural vernacular. While historically much of its work has been comprised of new construction projects, the firm has broadened its repertoire to include an ever-increasing number of home additions and renovations. Whether

Above Left: The total renovation of the clients' original home included extensive unique artistic features and details such as leather ceilings and wire-wheeled walnut casework.
Photograph by Kaminsky Productions

Above Right: Walking into this powder room activates a granite waterfall that flows to the slate sink. The basalt columns, walnut counter and floating mirror reflect organic sophistication.
Photograph by Kaminsky Productions

Facing Page: Construction of this multiple-structure Northwest contemporary residence included channeling a meandering stream to its waterfront. Warm fir interiors provide casual elegance for an active family.
Photograph by Pro Image Photography, Ed Sozinho

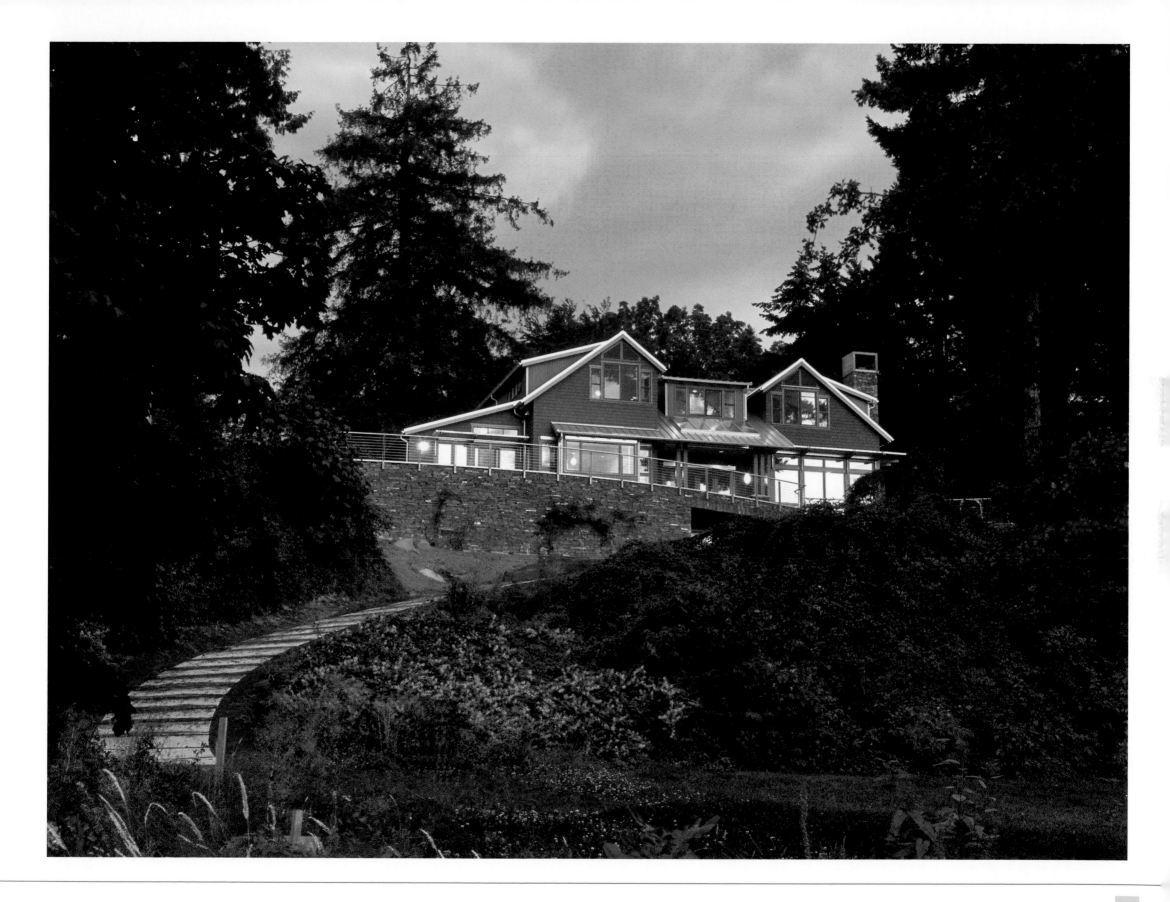

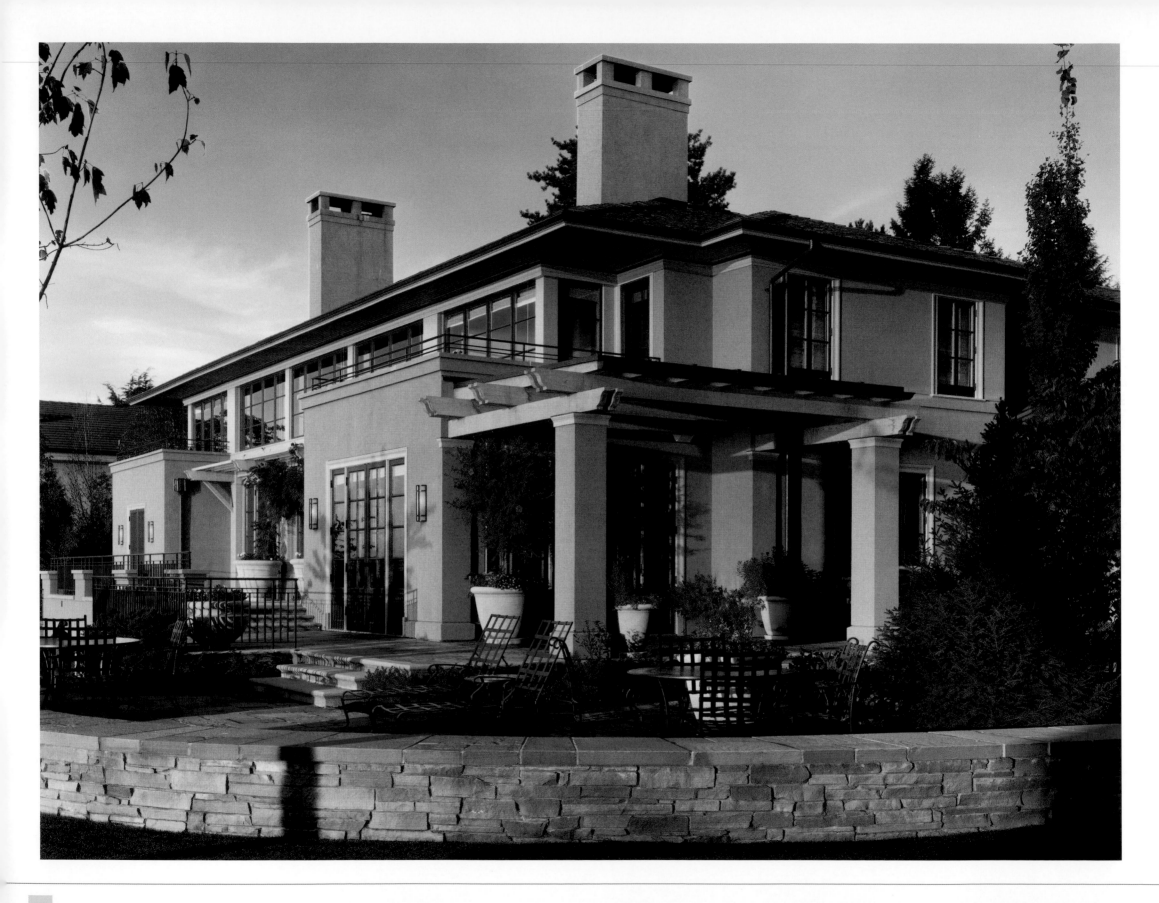

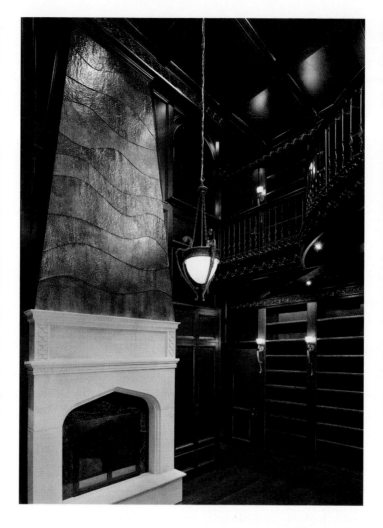

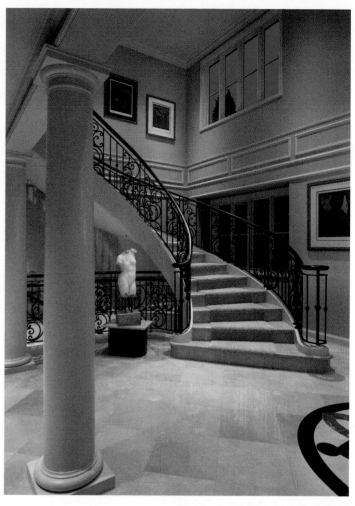

constructing a 17,000-square-foot palatial estate replete with 80,000 square feet of barns or a third floor beneath an existing two-story structure, the team surmounts each difficult challenge with grace and aplomb.

In addition to their extraordinary range of style and size, Bender Chaffey homes are well-known for their unique features. Wine cellars, home theaters, floating staircases, elevators, even equine hyperbaric chambers—the team has the skill and the resources to meet the most unusual of requests. Helping further the prevalent trend of Green living, the firm is committed to producing environmentally and socially responsible homes. Don and his

staff maintain a sense of duty to continually exceed set industry standards of Green practices, diligently striving to improve homes' air quality, employ sustainable products and reduce job-site waste. Moreover, Bender Chaffey is an active member of Built Green, the Seattle Master Builders Association's nonprofit organization devoted to promoting Green principles.

Don Bender strongly believes that the prolonged success of the firm necessitates constant evolution, and the firm relentlessly endeavors to expand the scope of its work and refine its skills. The team's ability to preserve the integrity of an architect's vision while bringing it into physical form ensures that Bender Chaffey

will continue to foster strong professional associations for years to come. Highly esteemed in the building community, the firm has won upwards of 11 MAME Awards, either for "Best Custom Home," "Best Master Suite" or "Best Kitchen," as well as several awards from the National Association of Masonry.

Above Left: The entrance to this magnificent stone estate reveals a cathedral-like interior with ironwork bridges between the public areas and private quarters.
Photograph by Chris J. Roberts Photography, Inc.

Above Middle: A custom copper-clad and stone fireplace is one of many unique features in this paneled library of impressive finishes and detailing.
Photograph by Chris J. Roberts Photography, Inc.

Above Right: This grand foyer features classic grace through extensive details and refined materials requiring meticulous workmanship and awareness of the architectural concept.
Photograph by Chris J. Roberts Photography, Inc.

Facing Page: A lakeside Northwest villa is distinguished by courtyards, generous windows and a subtle palette. The arbored stone terraces provide sheltered retreats.
Photograph by David Story Photographer

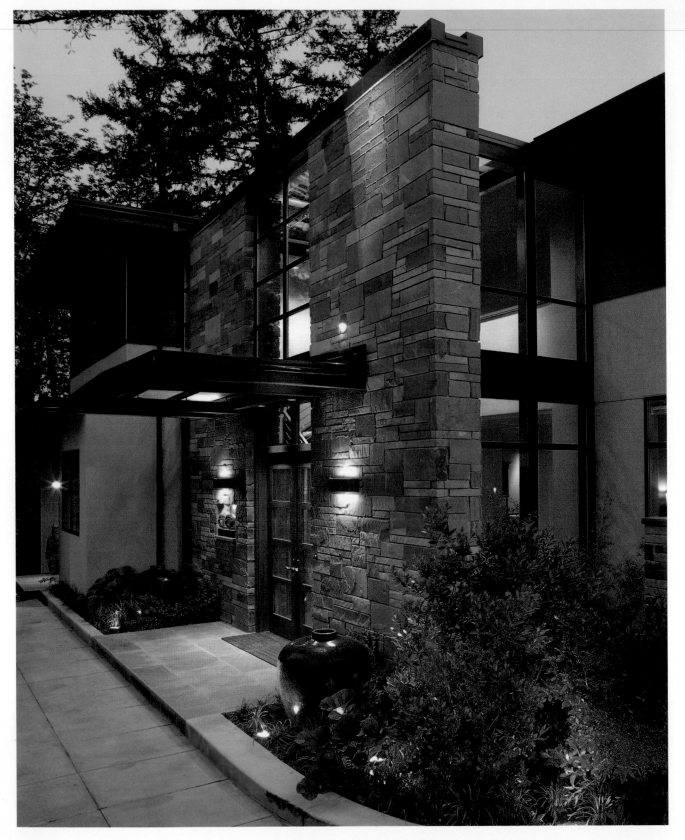

Yet one need merely look to the clients to affirm Bender Chaffey's exquisite work. Don recalls a Christmas card he received from a client who wrote, "You must be proud of the beauty you create in this life. Every day, I get to see the beauty you've created for me." For Don and his team, praise such as this epitomizes honor.

Left: An Asian influence on Northwest contemporary architecture and careful correlation of indigenous materials and landscaping blend this home into its urban wooded hillside.
Photograph by Pro Image Photography

Facing Page Left: A soaring atrium and a sculptural staircase provide a strong connection of this home's interior to the sky and tranquility gardens beyond.
Photograph by Pro Image Photography

Facing Page Right: This light-filled kitchen offers Brazilian cherry floors and detailed glazed cabinets for a comfortable family cooking and gathering area. Interior design services by Bender Chaffey.
Photograph by Michael Seidl Photography

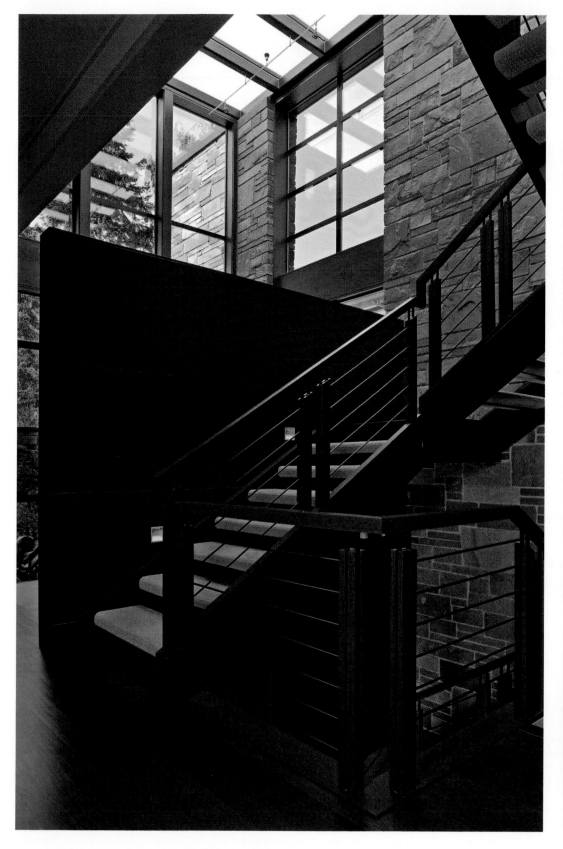

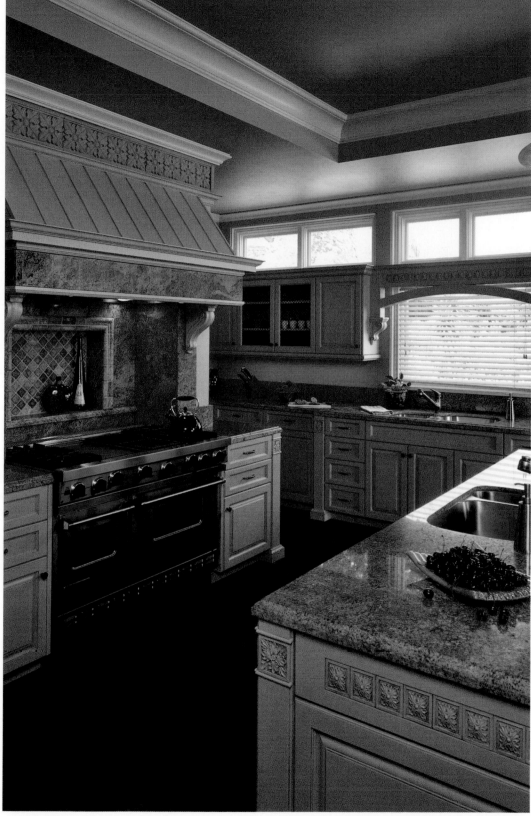

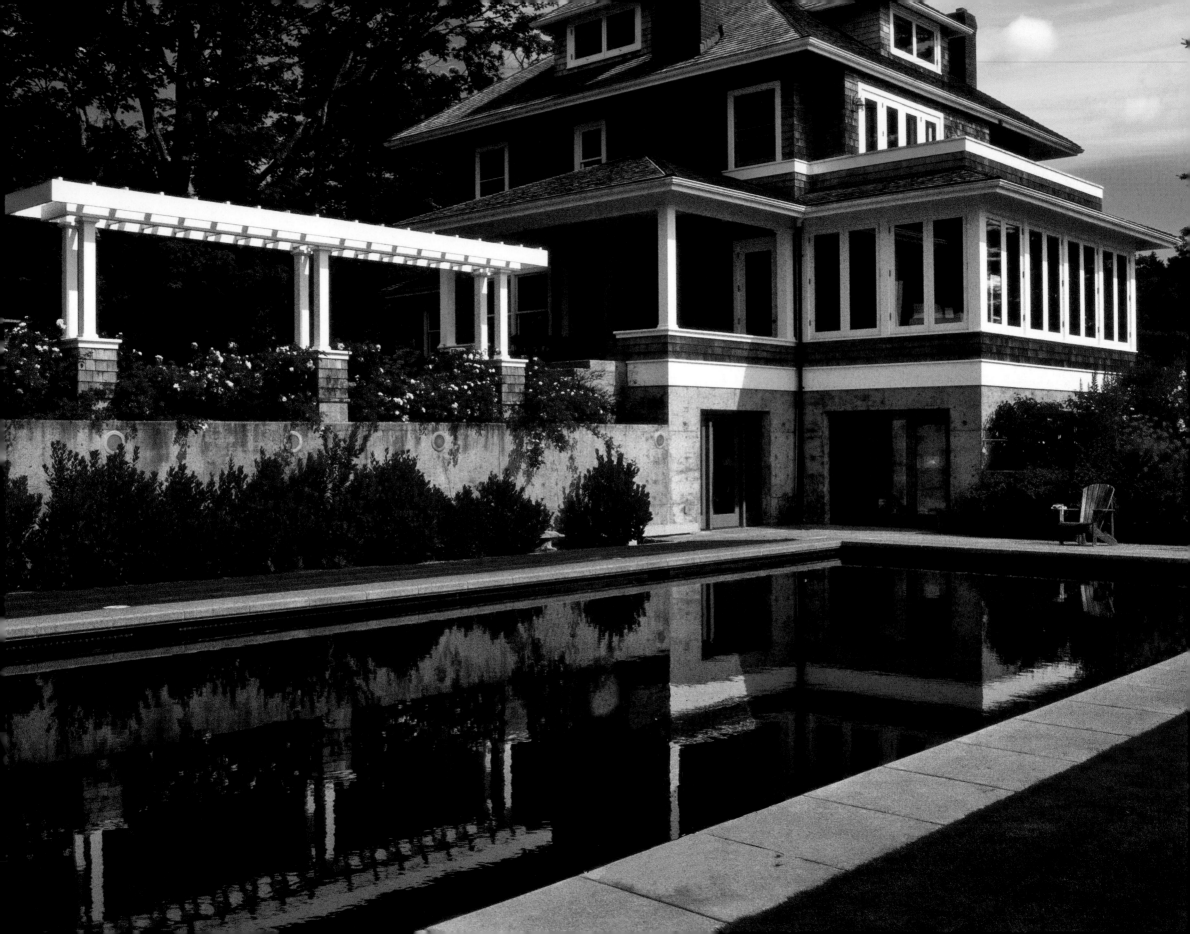

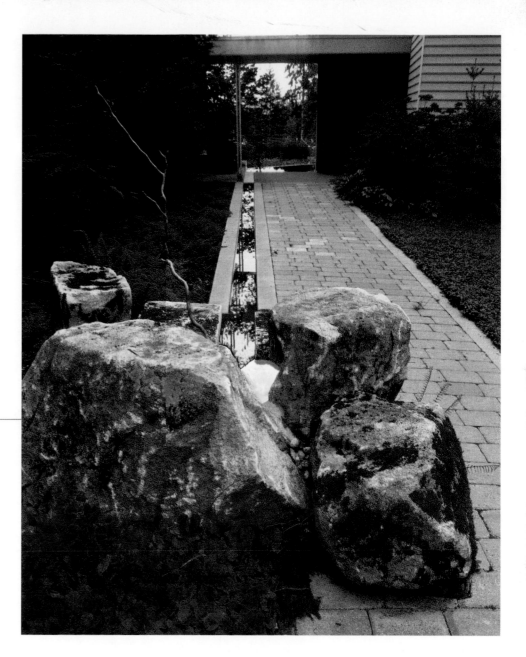

Tom Berger
Jason Henry

The Berger Partnership, PS

Above: Water from a water feature of mossy boulders tumbles into an entry walk runnel and terminates in a zero-edge pool.
Photograph by Norah Scully

Facing Page: A lawn-edged, dark pool flanked by a bright white rose arbor echoes the architecture of this Cape Cod-style island home.
Photograph by Norah Scully

More than merely a structure, a home is an experience, the sum of each element that comprises one's sensory perception. A person knows he is home by the familiar sights, smells and feelings evoked before even stepping foot in his house. The patterns of light diffused through the trees, the trickling of a waterfall cascading into the pond, the light scent of roses wafting from the cutting garden—all combine with the house itself to create a personal sanctuary, at once a part of and a retreat from the surrounding world. Tom Berger, FASLA, understands the profound emotional impact of landscape and has built a successful firm on this fundamental principle.

Tom's inspiration to pursue his profession was his family's nursery, in which he worked as a child. Harboring an inherent proclivity for fine art and architecture through adolescence, he was naturally drawn to landscape architecture's fusion of science and design and geared his studies accordingly.

Founding The Berger Partnership in 1971, Tom has assembled a group of incredibly gifted specialists dedicated to botanical artistry. Alongside design principal Jason Henry, ASLA, LEED® AP, and four other partners, Tom creates natural havens for commercial commissions, parks and custom residences.

Central to the firm's design philosophy is symbiosis. The team works to design environments completely derived from the sites, the architectural programs and the ambience clients wish their landscapes to evoke. Rather than imposing a preconceived style, the designers strive to locate forms and plant materials that become an extension of the structure's aesthetic. The diverse network of architects with whom the firm collaborates ensures that no two Berger Partnership landscapes look alike. Yet common to all is a marked attention to the quality of light, color and texture—those characteristics that meld to create a structure's mood as people experience it.

Indeed, the sense of arrival is fundamental to symbiosis, and it is a hallmark of the firm's residential designs. Tom and Jason are proficient at setting just the right scene for a home, creating entries that connect guests and residents, alike, to the landscape and create both the physical and emotional atmosphere while guiding them toward the house itself. For one project, they incorporated an existing creek into the arrival, designing the driveway to bridge the water so that one interacts with it upon every departure or approach. Entry gates welcome or protect; paths jauntily meander or directly guide; driveways are flanked by manicured foliage or indigenous growth; context dictates all.

It comes as no surprise that sustainability permeates the firm's designs. Eight of its designers are LEED® Accredited Professionals, and every member of the Berger Partnership team is dedicated to environmental stewardship. Yet the nature of the firm's work allows the designers to go beyond sustainable design to habitat restoration and resource renewal. As often as possible, the firm

Left: Basalt columns and Kaffir lilies add a casual counterpoint to the more formal and linear concrete pavers.
Photograph by Norah Scully

Facing Page: A circular perch provides a sweeping view of downtown Seattle at sunset.
Photograph by Michael Walmsley

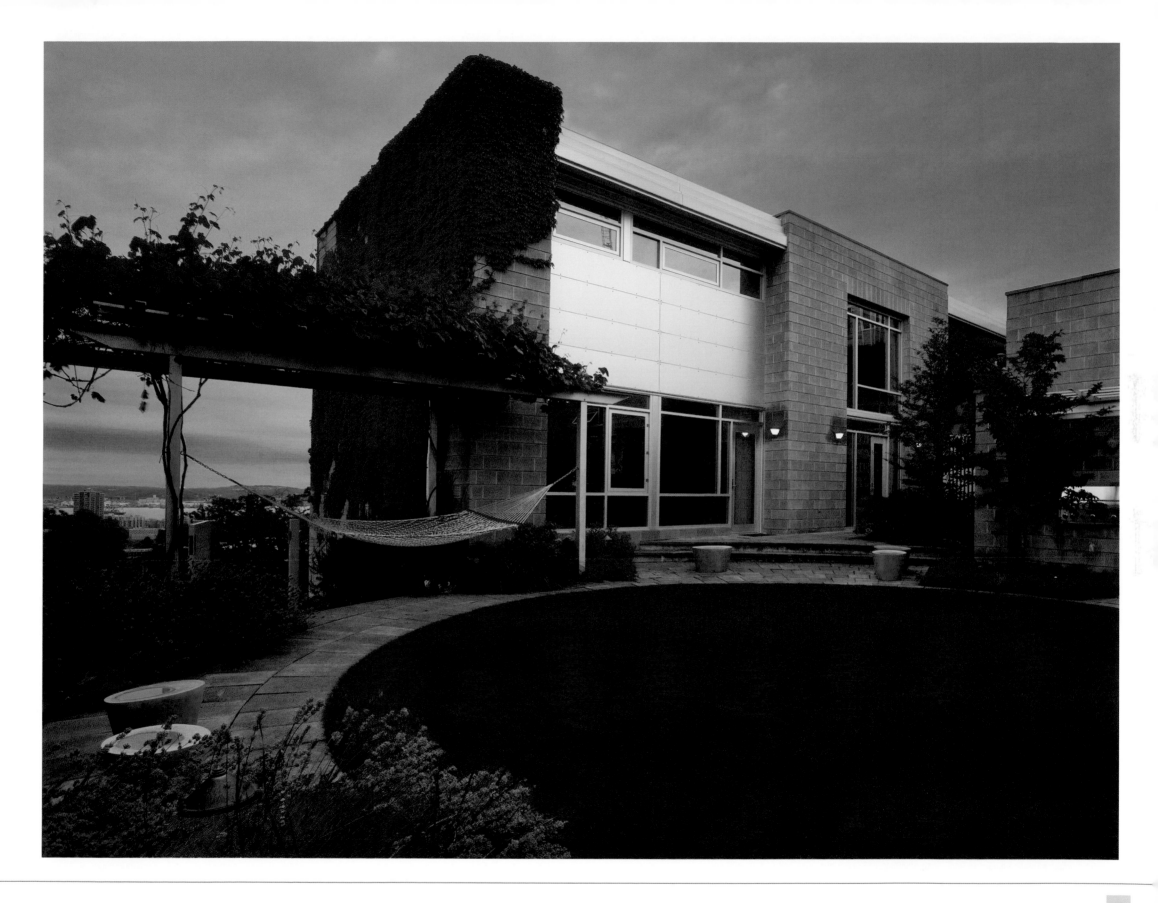

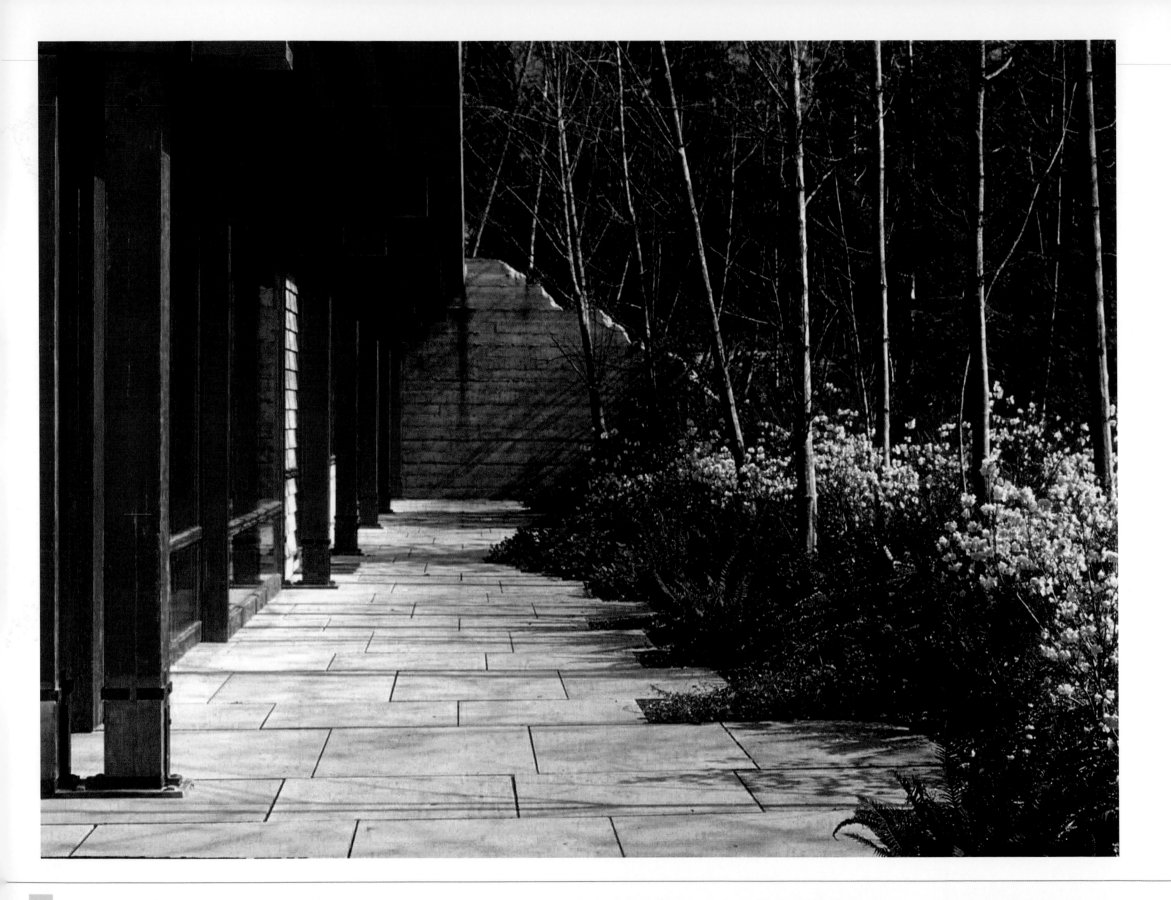

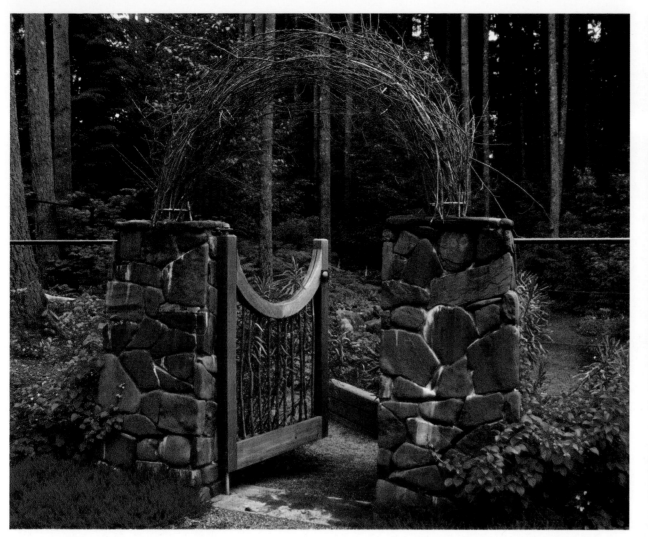

works to preserve and reuse biomass, retaining the native vegetation and soil and grinding any unwanted materials for mulch to be used on site. In so doing, the firm reduces waste and also minimizes disruption of the existing ecosystem. In one commercial project, the team restored a failing creek, devising a system whereby its water supply was constantly replenished by that from the site. Projects such as this have garnered numerous awards, including the AIA Committee on the Environment "Top Ten Green Projects" national award and several from the Audubon Society, ASLA and the Arbor Day Foundation.

These awards punctuate a long list of others, and Tom is further honored to have been named a Fellow of the American Society of Landscape Architects. The firm's excellent relationship with architects and its sympathy for architecture facilitated its distinction as an honorary member of the AIA. The pride from this recognition is matched only by the immense gratification of referrals, the primary source of nearly every new residential client. Architects,

contractors, former clients and the designs themselves promote the firm's harmonious landscapes. The team's passion for plant material and artistry and its shared commitment to the firm's philosophy ensures that The Berger Partnership will long continue to create environments that encourage clients to bring their lives outside.

Above Left: A stone gate and willow arbor protect the vegetable garden from hungry woodland critters.
Photograph by Norah Scully

Above Right: Native flagstone straddled by dense, late-season perennials creates a cool oasis in arid eastern Washington.
Photograph by Richard Nicol and Norah Scully

Facing Page: A deconstructed concrete wall transitions the built architecture into the organic edge of an emergent alder forest.
Photograph by Tom Berger

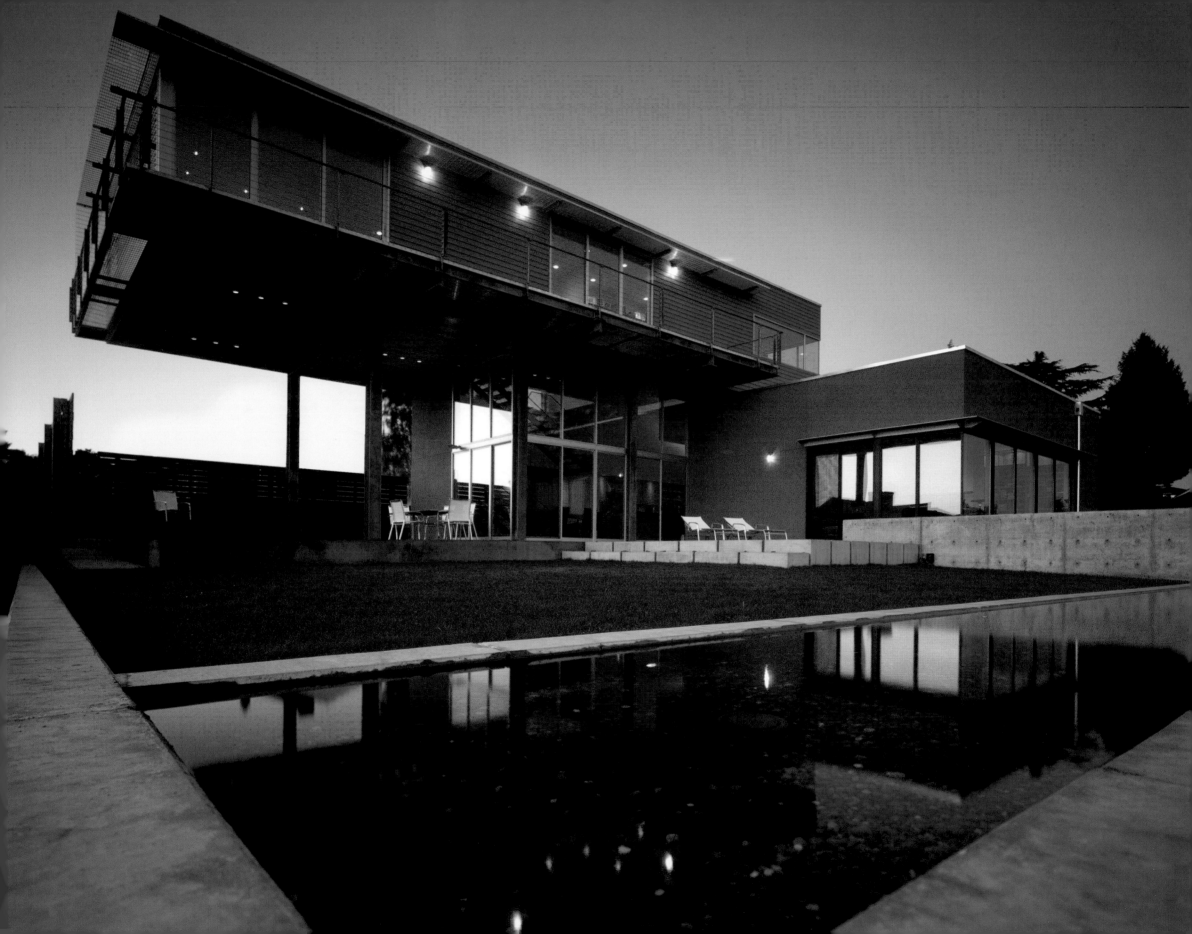

ERIC COBB

E. Cobb Architects Inc.

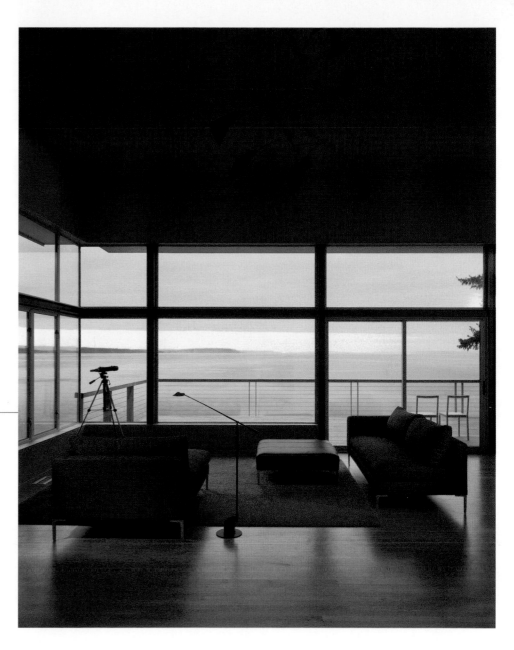

Above: Abundant glass in the great room affords a spectacular panoramic view of the water.
Photograph by Chris Eden

Facing Page: The southwest corner of the private yard affords an exquisite view of the home's floating second story.
Photograph by Paul Warchol

Innovation. Detail. A commitment to responding to a project's specific conditions with innovative solutions and extraordinary artistry. These qualities describe the highly acclaimed work of E. Cobb Architects, a Seattle-based firm dedicated to creating Modern residences, home additions and structures for clients attuned to contemporary architectural design.

Founded in 1994 by renowned architect Eric Cobb, the firm comprises a team of nine talented architects and designers. Working primarily in the Greater Seattle area—Eric prefers to take on projects close to home so that he can frequently visit sites and ensure successful execution of the artistic vision—the team closely collaborates with clients and carefully selected consultants, actively engaging them in each phase of the design from the outset. Indeed, the firm carefully considers the ideas, interests and character of each patron, and the resulting design successfully expresses these attributes.

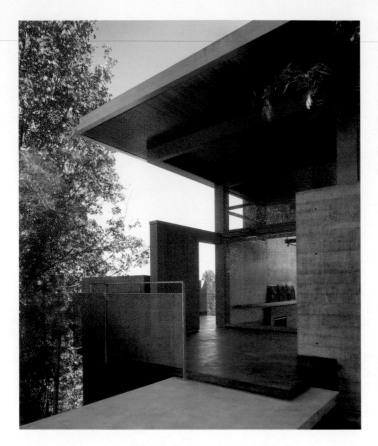

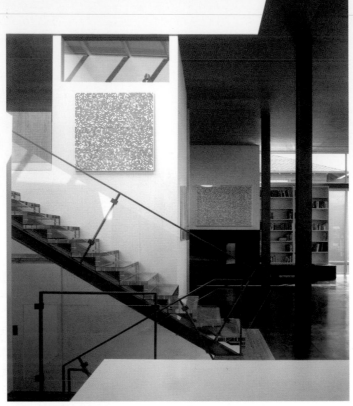

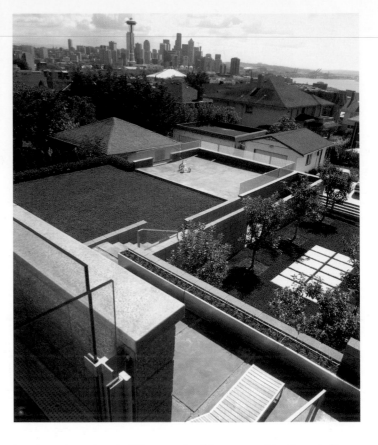

Along with the client's desires and personality, the unique characteristics of the site strongly influence the firm's design. Viewing all challenges as exciting opportunities to effect creative, original solutions and contribute to a structure's aesthetic, E. Cobb enthusiastically embraces complex projects. Unusual circumstances such as difficult terrain and extremely narrow urban lots—conditions common to the region—continually shape and refine the firm's approach. The team's tenacity in investigation has led to exceptional solutions, producing structures as rich and intricate as the factors that helped sculpt them.

While each E. Cobb home is by nature unique, all exhibit principles and traits inherent in Modern design. The firm's material selection—often steel, glass and concrete—and articulation of space—fluidity abounds with vast, open areas that serve several functions—are frequent elements of its abstract vocabulary. So, too, is the connection of interior and exterior space through transparency, geometry and materials that extend through walls of enclosure. Exposed structural elements and cantilevered planes prevail, as do simple geometric forms. Whether new construction or renovation, each home created conveys a sense of engagement and respect to its site and residents, alike.

E. Cobb is widely recognized and celebrated for its ingenuity and talent. Featured in numerous publications—*Dwell Magazine*, *The New York Times*, *Metropolitan Home*, *The Seattle Times*, *Sunset* and James Trulove's *The New American House II*, *III* and *IV* and *The New Glass House*, to name just a few—and on HGTV and the Travel Channel, the firm's work has also won *Seattle Homes & Lifestyles*' "Design Achievement Award" and a number of local and regional AIA awards. Moreover, *Northwest Home + Garden* named Eric Cobb the "Modern Master" in its list of "Top 50 Architects." Eric has also lectured and exhibited work at Columbia University, Parsons School of Design and Washington State University. While Eric's credentials are extensive, they cannot quite compare to the dramatic sense of light, space and vitality that greets an E. Cobb home owner each day.

Above Left: Repeating rectilinear forms guide guests to the entry of this contemporary residence. Landscape design by Bruce Hinckley.
Photograph by Paul Warchol

Above Middle: The acrylic stair lends an expansive feel to this richly detailed great room.
Photograph by Paul Warchol

Above Right: From the second-floor great room deck, residents can view and access the private yard below. Landscape design by Bruce Hinckley.
Photograph by Paul Warchol

Facing Page: Large windows and a floating staircase imbue the kitchen and dining room with a transparent, airy ambience.
Photograph by Paul Warchol

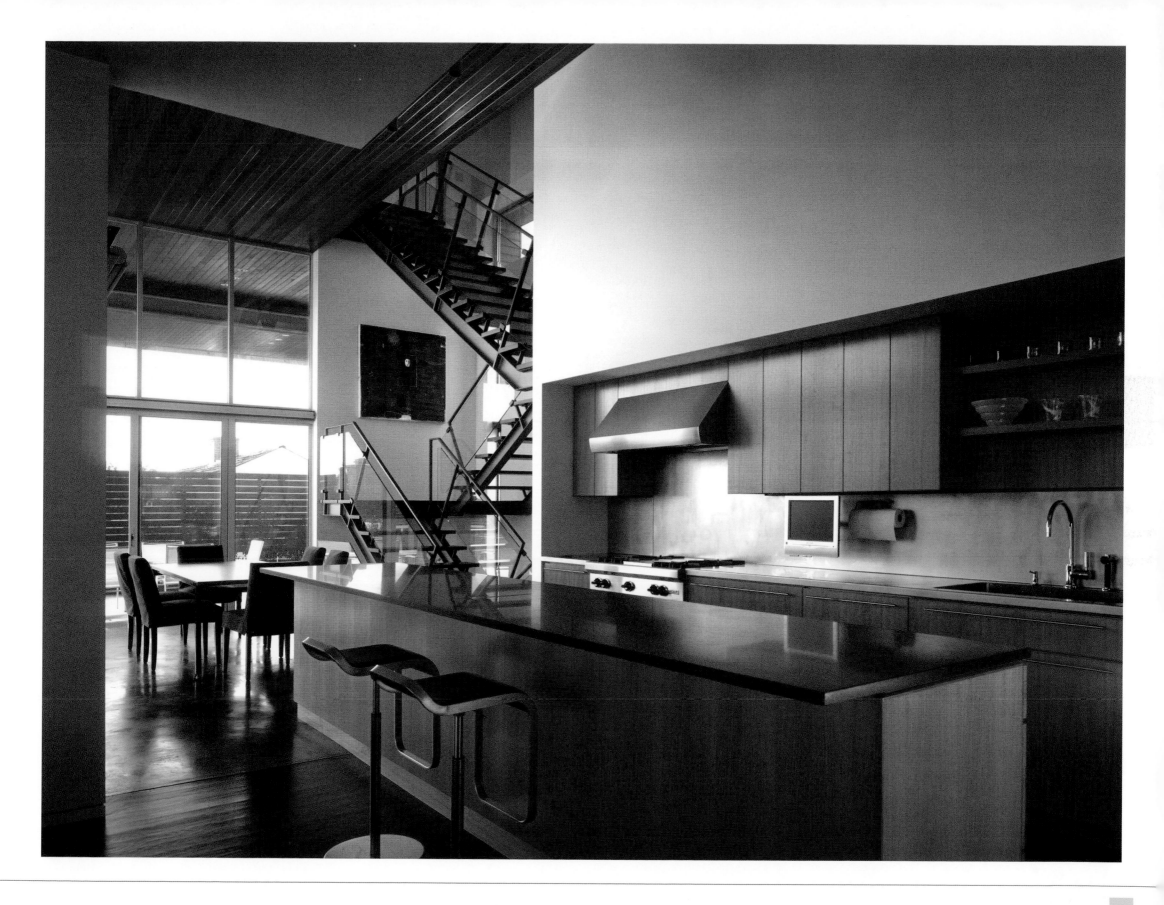

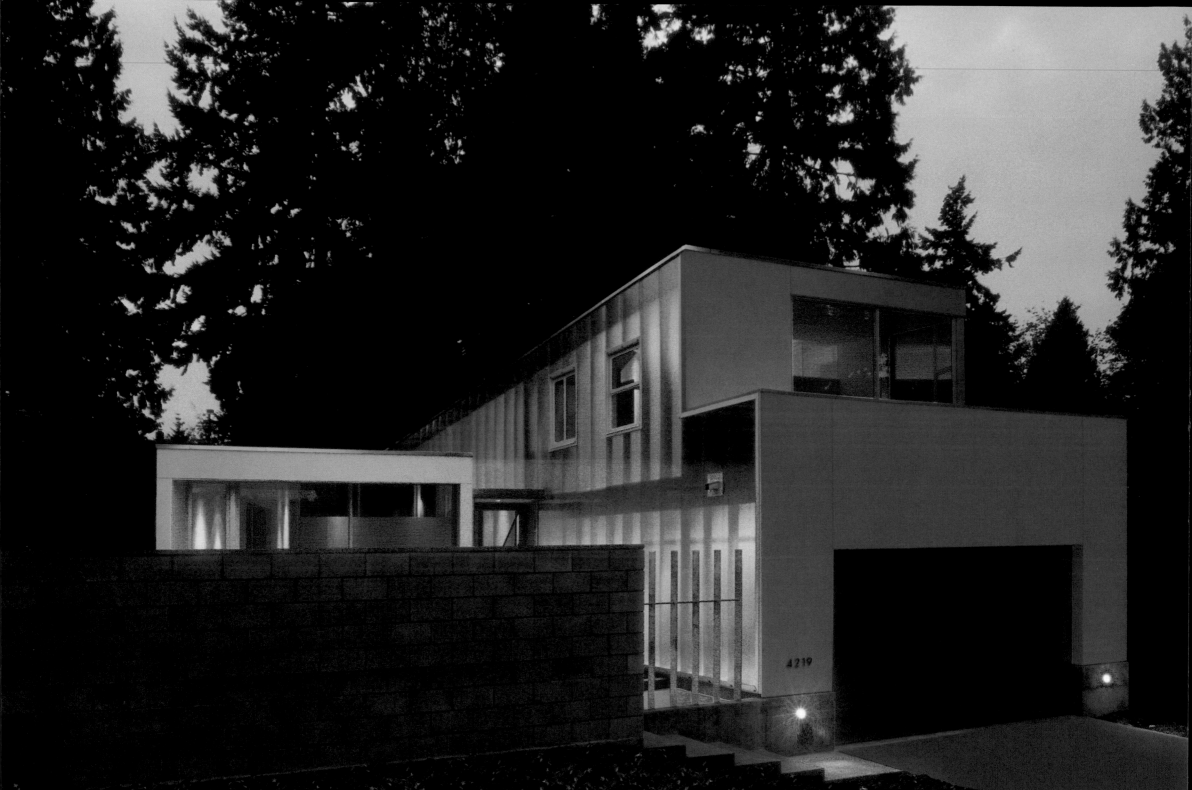

DAVID COLEMAN

David Coleman / Architecture

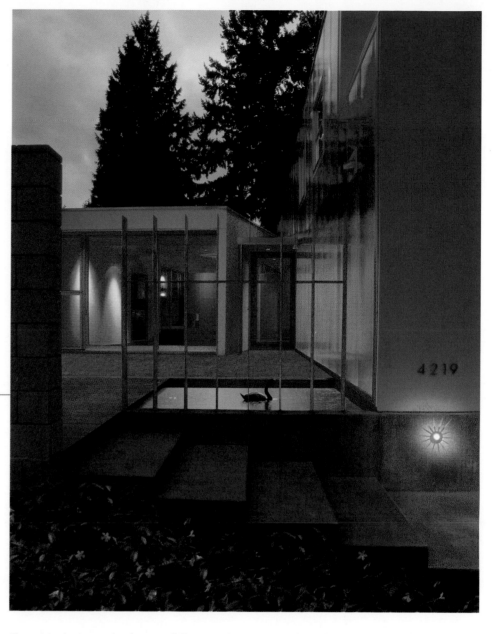

Above: A bottle-green, polycarbonate wall illuminates the entry courtyard at night, and a rectilinear reflecting pool defines the edge of the stair, marking a dynamic procession from street to vestibule.
Photograph by David Coleman

Facing Page: The Zig Zag house, as seen from the street, glows behind the masonry garden wall. Private, terraced courtyards wrap three sides of the building.
Photograph by David Coleman

As a child growing up in New York, David Coleman, AIA, spent much of his free time building tree houses and go-carts. His summers were spent in the lush Green Mountains of Vermont, where he learned to appreciate the qualities of the rural landscape and developed a profound appreciation of nature. Initially pursuing environmental design and fine art at Pratt Institute in New York, David went on to study architecture at the Rhode Island School of Design before completing his education at the Royal Danish Academy of Fine Arts, School of Architecture. Struck by the quality of northern light and its seasonal effect on the verdant, mountainous landscape distinctive of both the northern United States and Scandinavia, David sought a similar environment for his own practice. Initially finding accord in Vermont, he later settled in Seattle, which offered the vitality of an urban center along with the easy access to nature that he sought for both his life and his work.

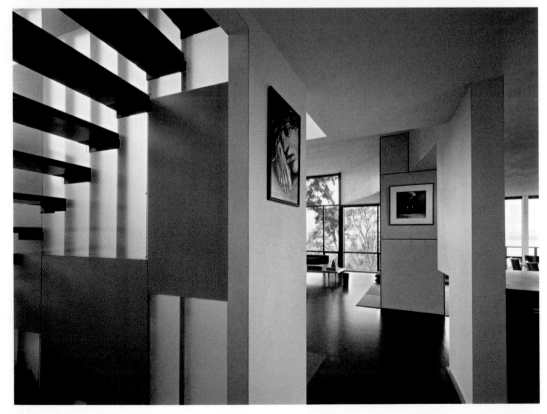

David's reverence for the natural environment continues to inform his work. Whether designing an urban residence or a rural retreat, David and his team strive to redefine the relationship between building and landscape, effecting seamless transitions from interior to exterior space. Maintaining that the relationship of the two starts at the street, he works to create a clear procession through the landscape to the building's entrance, establishing awareness of the building's physical context in the process. Further enriching the sense of place, David thoughtfully molds each building's design to capture and enhance the qualities in the landscape, consciously locating windows, for example, to channel sunlight and frame views. The natural light thus serves the spatial dynamic, playing off the walls, enlivening and altering the mood of a room based on the sun's trajectory.

To create the compelling interiors characteristic of his projects, David works with complex geometries, forming a dichotomy of understated and bold qualities by varying shapes and volumes, materials and details. Doing so evokes a sense of transformation as one moves from nurturing to dramatic spaces. Further enhancing a structure's visual interest, David explores formal collisions in his work. His unique methods for resolving the intersections between different forms and planes—curvilinear and rectilinear walls, say—distinguish his homes, fostering rich, metamorphic environments that simultaneously stimulate and sooth.

David's desire to be actively engaged in every project, from concept to completion, led to his decision to keep his studio small. The firm's intimate nature ensures that clients are fully involved in the development of a project's vision, which David considers the most important stage of the process. Learning as much as possible from the outset about each client provides the team the necessary framework to capture the desired mood and guide every phase of the firm's holistic approach.

Creating homes that support clients' lifestyles is only part of the firm's mission. Dedicated to both environmental and material sustainability, David strives to minimize a structure's ecological footprint while employing enduring natural materials. Recognized by a wide variety of publications, the firm has also garnered AIA and Design Achievement awards for its timeless modernism. But David Coleman / Architecture's most prominent exposure could be its office. Located in a storefront in one of Seattle's historic districts, the firm figures prominently within the community fabric it helps to compose.

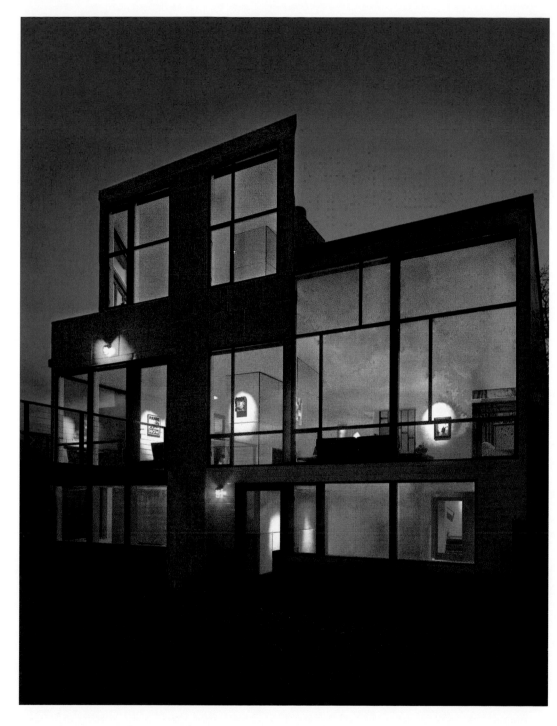

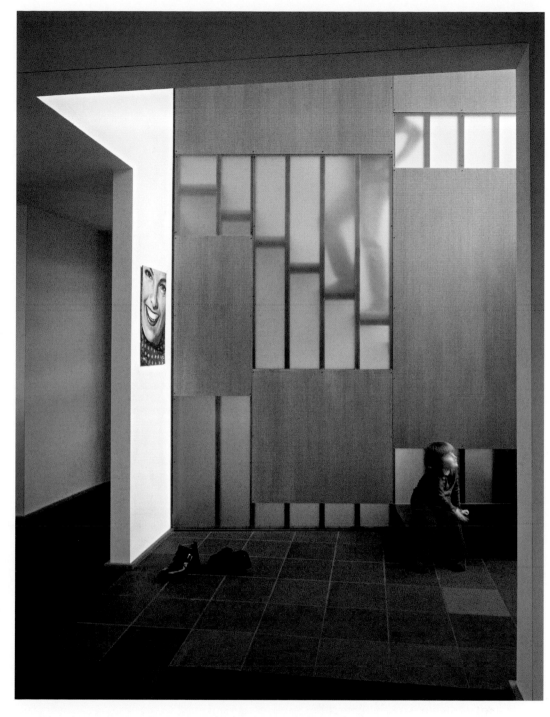

Facing Page Top: Inside, rooms in the Zig Zag house are animated by the collision of geometric forms that comprise the three wings of the house. A polycarbonate wall filters daylight from the south and casts a bottle-green glow.
Photograph by David Coleman

Facing Page Bottom: The interior of this west Seattle residence is characterized by freestanding panels of natural plaster and wood. Spaces are enlivened by the intersection of varied geometric forms and surfaces.
Photograph by Benjamin Benschneider

Above Left: Copper cladding and cedar siding alternate with glass to form the dynamic, west-facing façade of this west Seattle residence, opening the interior to dramatic views of Puget Sound and the Olympic Mountains.
Photograph by Benjamin Benschneider

Above Right: A geometrically patterned wall—composed of alternating panels of Douglas fir and translucent lexan—marks the edge of the central stair and provides a focal point to the entry.
Photograph by Benjamin Benschneider

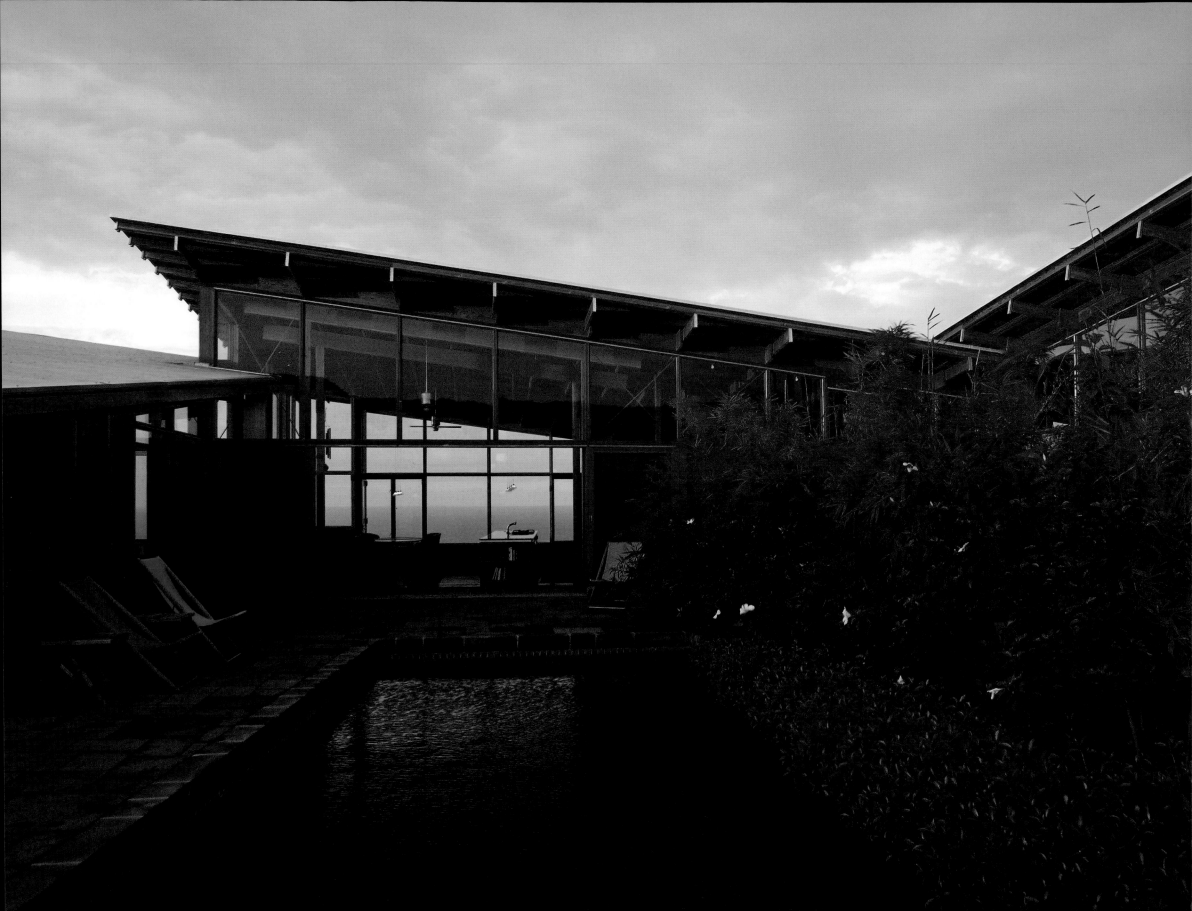

JAMES CUTLER
BRUCE ANDERSON

Cutler Anderson Architects

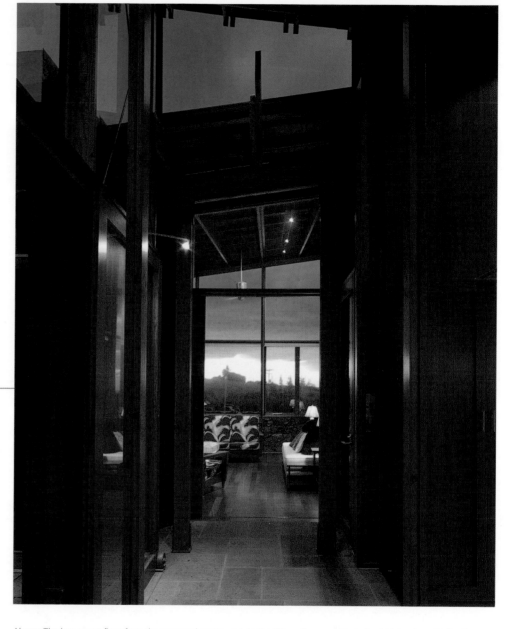

Above: The lava-stone floor from the courtyard continues into the Ohana house as the hall, which leads to the family room on one end and past the dining room and kitchen to the bedrooms on the other.
Photograph by © Art Grice

Facing Page: The protected courtyard of the Ohana house at Niulii on the Big Island of Hawaii shelters the pool and provides a comfortable outside garden space.
Photograph by © Art Grice

When the principals of Cutler Anderson Architects commence a project, the voices ensue. Indeed, the partners maintain that the multitude of elements and conditions specific to each commission emits a cacophonous din, one that the architects are charged to conduct and tune. Their more than 300 unique commercial and residential projects spanning the globe attest to the fact that James Cutler, FAIA, and Bruce Anderson, AIA, are experts at crafting harmony.

Founded in 1977 as James Cutler Architects, the firm became Cutler Anderson when Bruce, who had joined the firm in 1982, became partner in 2001. The partners share a unique perspective on their work: Believing that every aspect of a project—from the land to the materials to the people the structure will house—has a will and a spirit that desires and deserves to be expressed, Jim and Bruce create architecture that thoughtfully and poetically reveals the nature of each element.

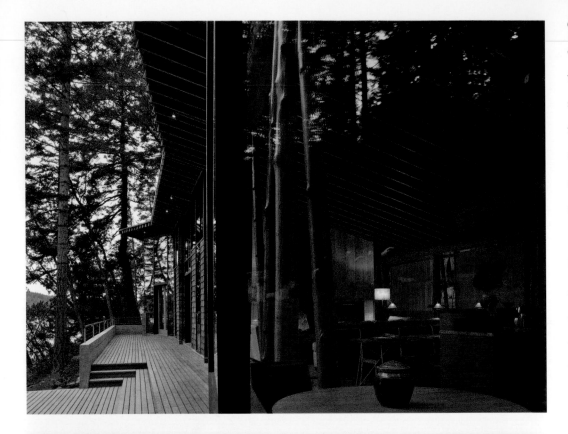

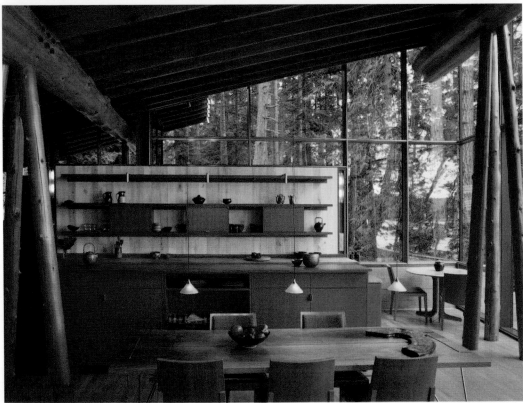

Central to the partners' approach to architecture is a deep respect for these circumstances. They carefully study the environment in which the structure will reside, taking note of every natural feature—indigenous flora and fauna, undulations of the land, possible effects of the weather and so on—so as to create a design the landscape will gracefully accept. Bearing these issues in mind, the firm further considers the qualities inherent in the institution they are working to accommodate, deciding how the structure should function to best support the lives of those therein. These considerations help determine the materials, and the partners strive to maintain the integrity of the distinct characteristics unique to each.

Illustrating their success is a home the partners designed on the north shore of Hawaii's main island. Along with its spectacular ocean view, the site was known for its frequent exposure to heavy rain and extremely high winds. To protect the residents from the weather while preserving the exquisite view, Cutler Anderson designed a U-shaped house entirely of glass, enveloping a wind-sheltered court. To keep the home's light frame firmly planted, the partners designed steel straps that extend from roof to base to pin it to the ground. While essentially functional, the straps are a defining aesthetic element. The wind thus helped shape and continues to speak through the physical characteristics of the design—the ideal manifestation of the firm's objective.

Committed to expanding their knowledge, the partners travel widely and work in such locations as Alaska, New York, Rhode Island and even Moscow. The firm's media exposure is as widespread as its work; projects grace the pages of *Architectural Record*, *Newsweek*, *The New York Times*, *Smithsonian* magazine and countless other publications. In addition to the firm's six AIA National Honor Awards and more than 40 other national and regional honors, five of Cutler Anderson's homes have been named "Record Houses" by *Architectural Record*. While their efforts to give voice to every characteristic of a project require painstaking research and labor, the partners are duly rewarded with buildings that look and feel as though they truly belong.

Top & Bottom Left: The expansive use of glass blurs the line between inside and outside in the kitchen/dining room area and across the entire front of this residence in Orcas Island, Washington. Western red cedar-log tripods harvested specifically for this project form the column system supporting the log beams.
Photograph by © Art Grice

Facing Page: A glass passageway provides a view of the vineyard from the pool court at the Meteor Vineyards residence in Napa, California. A bridge through the vine rows connects the main residence to a guesthouse.
Photograph by © Art Grice

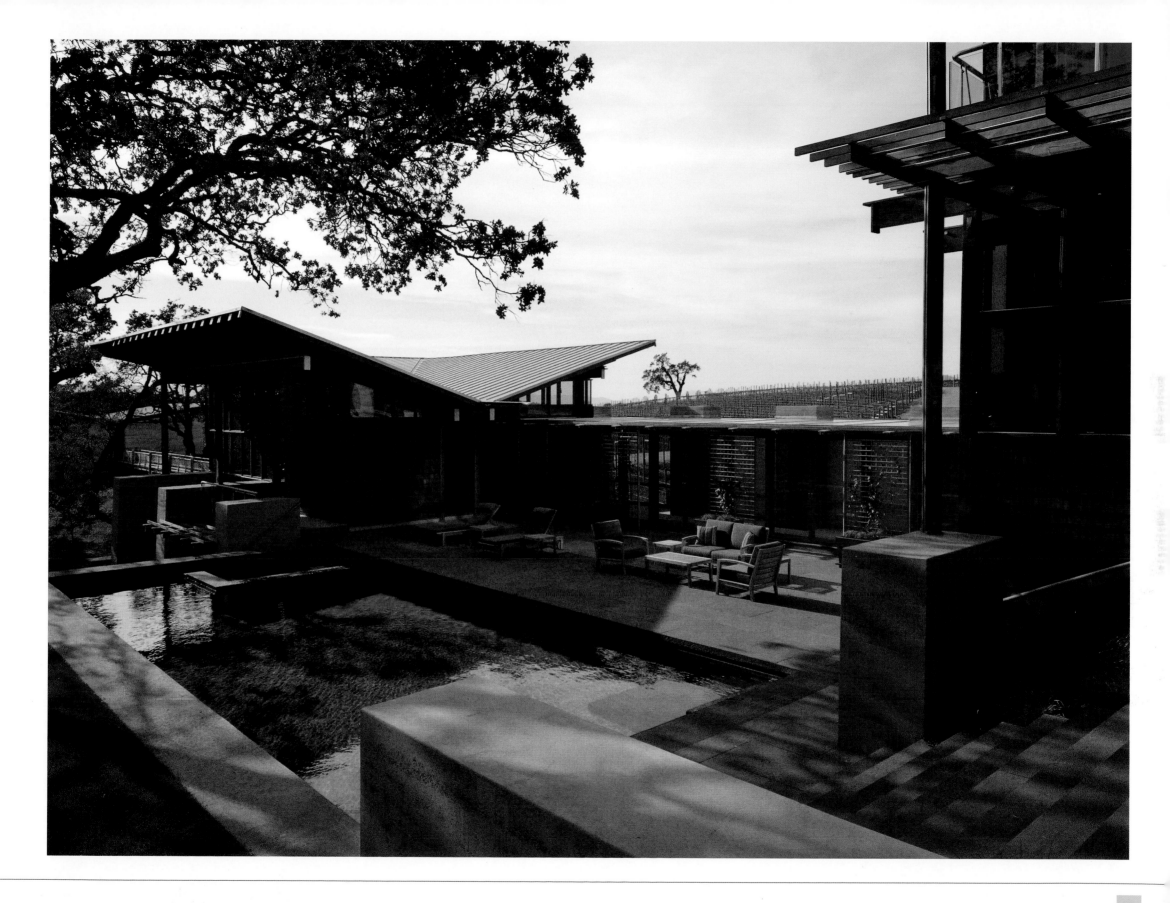

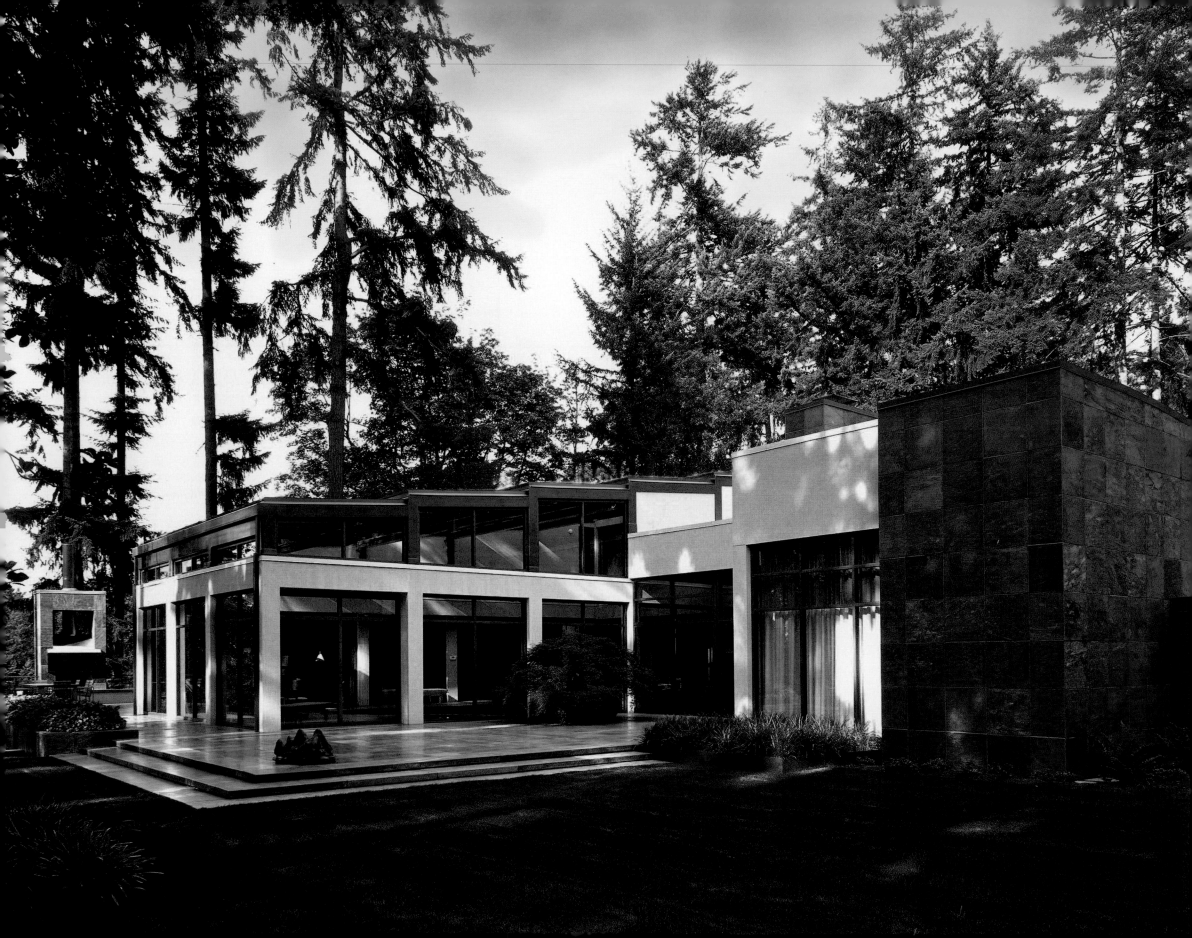

VASSOS M. DEMETRIOU

Demetriou Architects

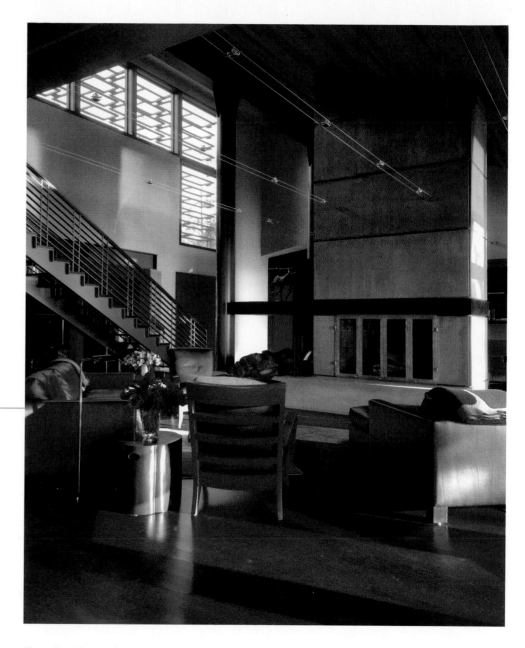

Above: Natural materials and a repeating rectilinear theme lend a sense of simplicity and peace to this San Juan residence's great room.
Photograph by Michael Jensen, Michael Jensen Photography

Facing Page: Abundant glass on this Bellevue residence's pool enclosure brings in the light, allowing for year-round swimming. During warmer months, doors retract so that residents may enjoy alfresco living on the adjacent patio.
Photograph by Gregg Krogstad, Krogstad Photography

An architect once said, "God is in the details." For many, this rings true. For Vassos Demetriou, God is in the concept; the details will follow. Every home Demetriou Architects creates begins with a completely unique, thoroughly investigated concept, derived from the integration of environmental issues, clients' desires and Vassos' artistic vision.

Raised on the island of Cyprus during the English occupation, when attending university meant geographical relocation—and money, which was limited—Vassos discovered architecture quite by chance. A recent graduate of the London University School of Architecture had established a practice there and offered Vassos a job. Fascinated with the work as well as the magazines and books in his mentor's library, Vassos resolved to earn his architecture degree. Accepting a partial scholarship from

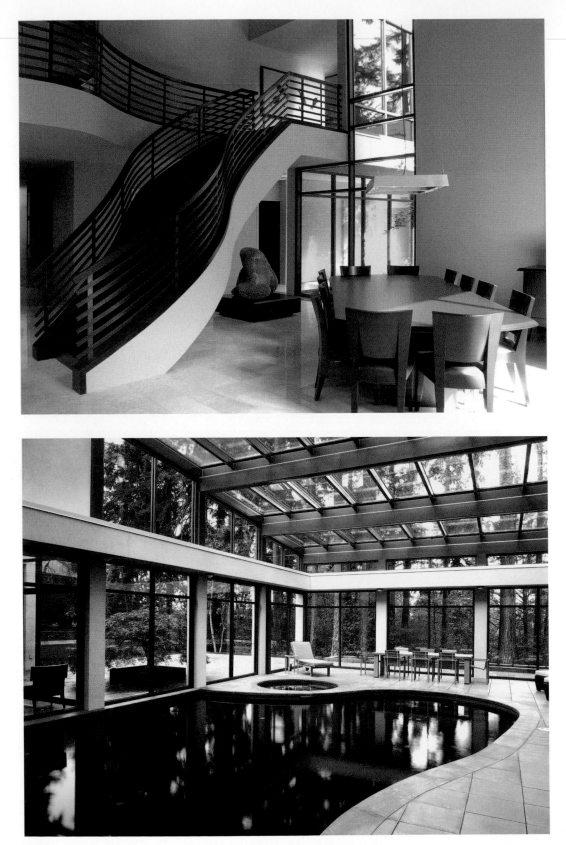

the University of Oregon, Vassos worked his way through the five-year architecture program, earning his degree and bolstering his education with graduate coursework in art and cinematography, two other passions.

After practicing in his native Cyprus and in London, Vassos returned to the Pacific Northwest to form his own practice in the late 1970s. His work experiences in Europe and throughout the United States have exposed him to a variety of architectural vocabularies, all of which inform his residential architecture today. But Vassos is careful to assert that he does not seek to reproduce a particular aesthetic in his homes. A modernist at heart, he is guided by the freedom and purity characteristic of the movement, and he brings these principles to every project.

As a result, Vassos begins each home design free of preconception. Assuming responsibility for nearly all of the conceptual design at the firm—90 percent, in fact—he listens closely to clients, encouraging them to voice even those ideas that seem beyond the realm of possibility. From their stylistic preferences and innermost desires, he extracts the essence: those aspects of a particular style that captivate their senses; the features they dream of but deem unattainable. Marrying the spirit of the clients' desires with the project's regional and functional requirements, Vassos infuses the concept with the intangible qualities that evoke emotion and separate a mere structure from an artistically expressed home.

Vassos' homes thus take many forms. Some embody the qualities of traditional styles, while others are distinctly modern; many possess unique elements, such as underground basketball courts. In all, Vassos employs a holistic approach, performing exterior and interior architecture, interior design and furniture design as needed to ensure complete integration of the design. Recognized in many publications, most recently *Metropolitan Home* and *Seattle Homes & Lifestyles*, and with AIA and national and local Master Builders Association awards, Vassos is incontestably gifted. Truly, his mentorship many years ago has proven fortuitous to all.

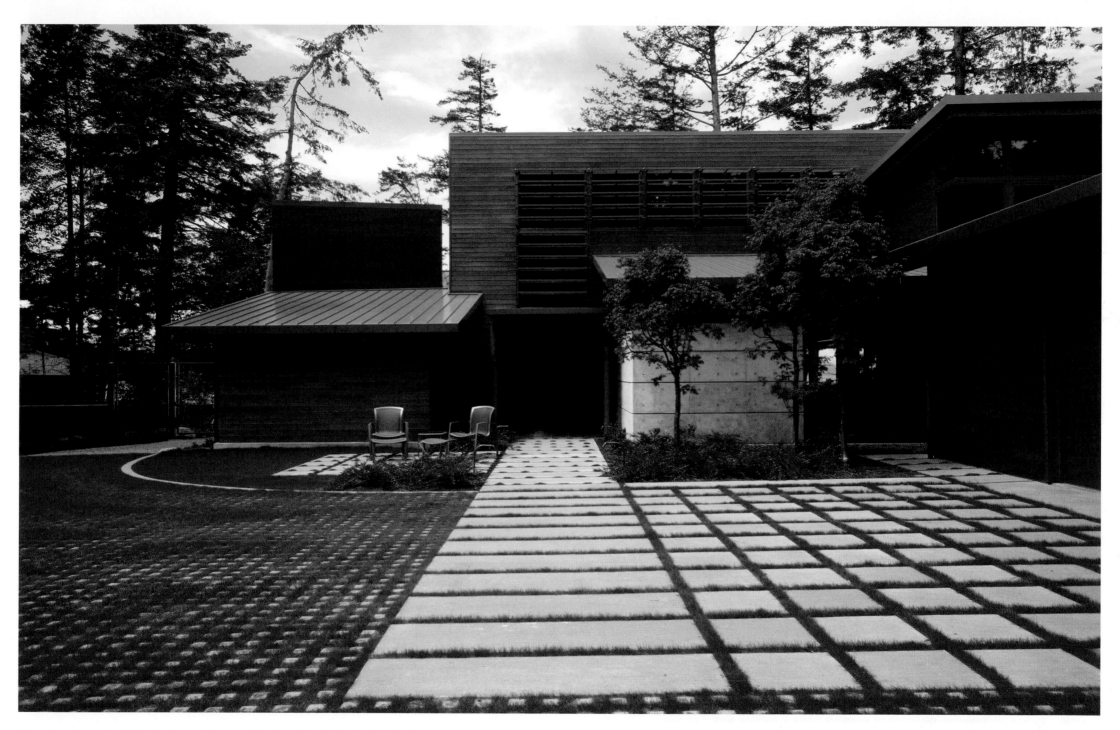

Above: The entry courtyard of the San Juan residence aesthetically and literally blends with the landscape.
Photograph by Adam Behringer

Facing Page Top: In this Bellevue residence, the stair serves as both a functional and a sculptural element, beautifully juxtaposing the adjacent wall's linear theme.
Photograph by Gregg Krogstad, Krogstad Photography

Facing Page Bottom: Swimmers feel at one with nature in the Bellevue residence's indoor pool.
Photograph by Gregg Krogstad, Krogstad Photography

TYLER ENGLE

Tyler Engle Architects PS

Responsive. Grounded. Essential. Tyler Engle, AIA, keeps these three words—among many others—at the forefront of his mind when he designs each of his projects. It is one reason why every residence he completes contains its own unique aesthetic and purpose, while being rooted in its place and tailored for its inhabitants.

After earning a Bachelor of Architecture with honors from Washington State University and a Master of Science in Advanced Architectural Design from Columbia University, Tyler honed his talents with large-scale projects, including the design of the Alhambra Visitor's Center and Master Plan in Spain and numerous institutional commissions in New York City. He then returned to his home state to join the renowned George Suyama Architects. It was there that Tyler developed a balance of his Western education of opposites with the Eastern philosophy of inclusion: When it comes to architecture, contrasts and opposites—formal versus casual, closed versus open—need not exist.

Above: The pendants, designed by Tyler Engle with local craftsman David Gulassa, provide a tensile counterpoint to the mass of the family room's stone fireplace in this new, classically inspired house.
Photograph by Nic Lehoux Photography

Facing Page: In this substantial remodel, an introverted garden that serves the dining room is set behind a louvered fence, while new windows and roof openings provide daylight without sacrificing privacy. Tyler designed the entry door using rift white oak, bronze and pickled brass.
Photograph by Doug Scott Photography

For Tyler, design solutions are not "either/or," but "both/and." That philosophy forms the foundation of Tyler Engle Architects PS, established in 2000, and has manifested itself in each project ever since.

A native of the Pacific Northwest, Tyler embodies a regionally sensitive attitude, and it shows in his designs, as does his acute attention to detail. His work is aptly described as "site-specific modernism," thanks to his resolve to ensure that each project is indelibly rooted in its place—whether it abuts a golf course, is situated on a bucolic lake-view property or encompasses a narrow urban lot, each of his projects seamlessly responds to its surroundings.

No matter the challenge, Tyler works to connect structure and site, dissolving the boundaries between the two. This modern principle is both an aesthetic choice and a regional demand, as the Northwest's spectacular landscape and views beg to be accentuated and celebrated.

For one home on a golf course, walls of windows embrace the verdant view from inside. When the weather beckons, outdoor living spaces provide for summer entertaining, and a colonnade extending from the entry's interior serves as the homeowners' personal path to the fairway. In another home, Tyler created a double-walled elliptical stair on which clients can weave in and out of the home's interior as they descend. Still other homes have exterior rooms or trellis-covered corridors which are features that mitigate the contrast of inside and out, physically connecting residents to the outdoors, as well as each house to its particular site.

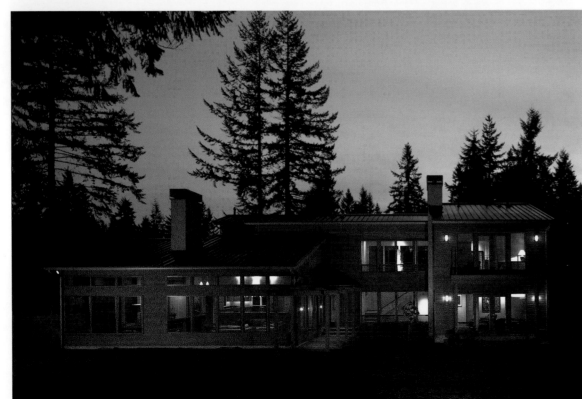

Top Left: To capitalize on the intimacy of this wooded site, the dining room and dining terrace behind the concrete wall are tucked under the tree canopy. A bridge beyond provides direct access from the kitchen.
Photograph by Doug Scott Photography

Bottom Left: From the golf course one can see, from left to right, the dining and living spaces, entry trellis, triple-height stair and bedrooms. Windows were standardized, and the massing was kept simple for economy.
Photograph by Doug Scott Photography

Facing Page: This central hall organizes the house into zones of private and public spaces. Rooms are clearly defined yet interconnected: kitchen to living room to study loft above.
Photograph by Doug Scott Photography

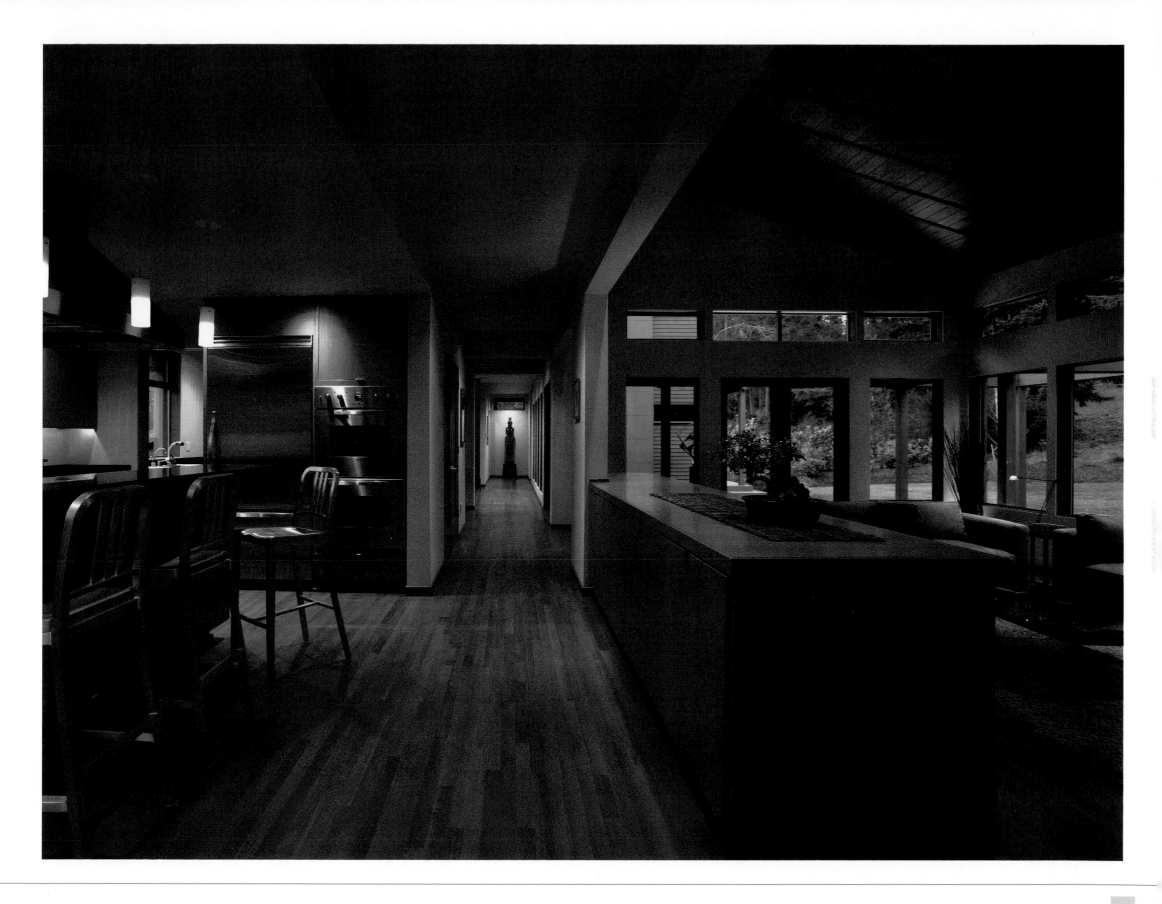

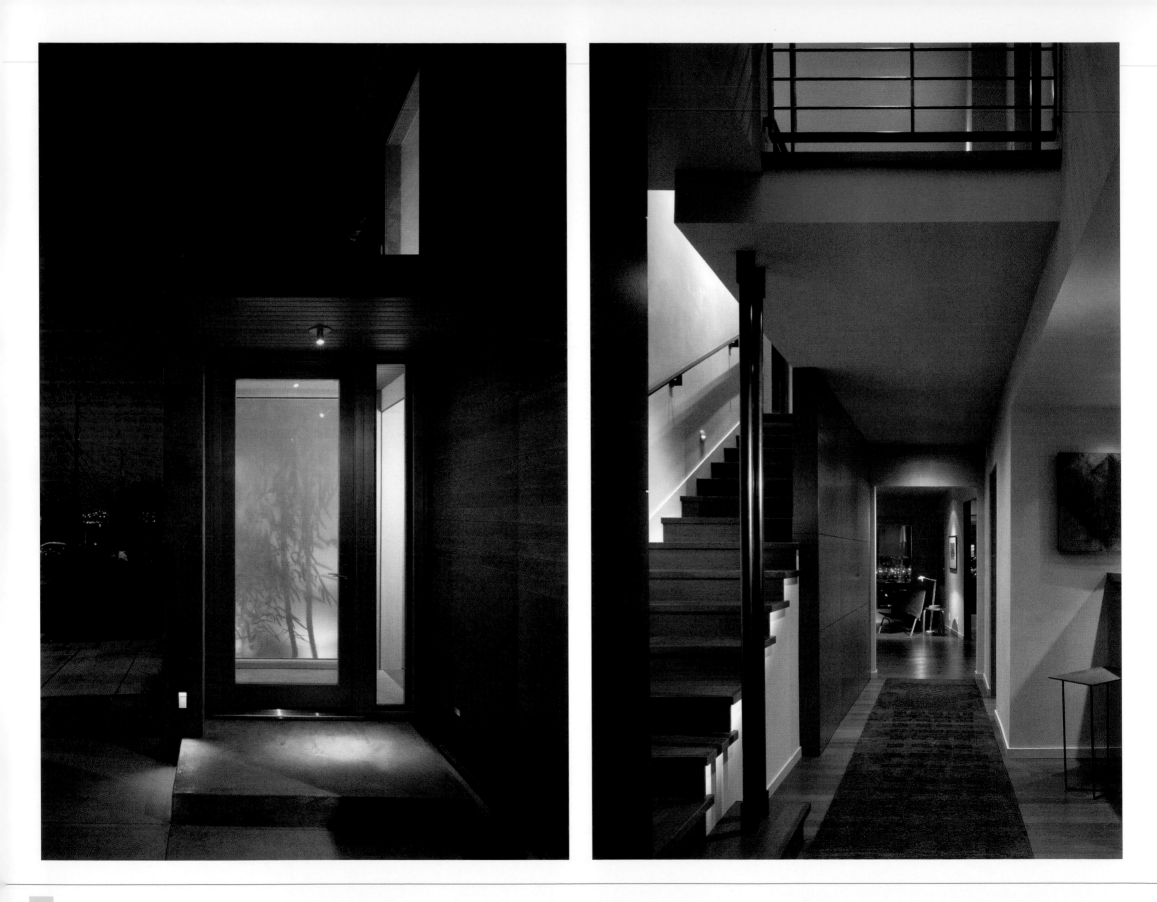

In urban projects, Tyler is charged with creating comfortable homes in limited spaces. Taking cues from Japanese shrines, he cultivates a feeling of openness in the smallest spaces, varying spatial volumes that contract and expand to dramatic effect.

Best illustrating this technique is a home Tyler designed on a narrow lot in west Seattle. Only 25 feet wide, the home feels much larger because of its carefully planned exterior and interior spaces. Located only seven feet from the street, the entry foyer is an outdoor courtyard, providing a seamless transition from outside to in. The front door opens to a glass-walled vestibule with eight-foot ceilings. From there, the home expands first vertically then horizontally, stretching out to a large window that features an exquisite view of the city beyond. Tyler's successfully executed spaciousness fully compensates for the home's restricted width; closed and open spaces seamlessly coexist.

It comes as no surprise that Tyler Engle Architects has been named one of *Seattle Homes & Lifestyles* magazine's "Seattle 100: The People, Places and Things that Define Seattle Design" and one of *Northwest Home and Garden* magazine's "Top 50 Architects." Certainly, the firm's attention to detail from concept to completion and the rigor with which the team works to provide clients timeless solutions within their budgetary frameworks merit such praise. Clearly, Tyler's work stands as vivid testimony that practicality and artistry can brilliantly blend.

Above Left: The entry was extended to provide a more gracious arrival. A radial foyer surrounded by lacquered panels gives order to the original structure and its new circulation.
Photograph by Doug Scott Photography

Above Middle: Skylights and clerestory windows bathe the interior stair with natural light. Lacquered panels and guardrails of art glass framed in bronze separate the stair from the entry.
Photograph by Doug Scott Photography

Above Right: A new bronze-clad two-sided fireplace separates the casual and formal living areas, yielding well-scaled rooms that flexibly accommodate both intimate family gatherings and large parties.
Photograph by Doug Scott Photography

Facing Page Left: In a tight urban setting, this house uses an exterior courtyard as its entry foyer, separating the pedestrian from the street. One is greeted by the shadow of backlit bamboo on frosted glass.
Photograph by Nic Lehoux Photography

Facing Page Right: Once inside, the house expands vertically then horizontally, providing the illusion of width. In the distance, a skewed wall guides the eye to a panoramic view of downtown Seattle.
Photograph by Nic Lehoux Photography

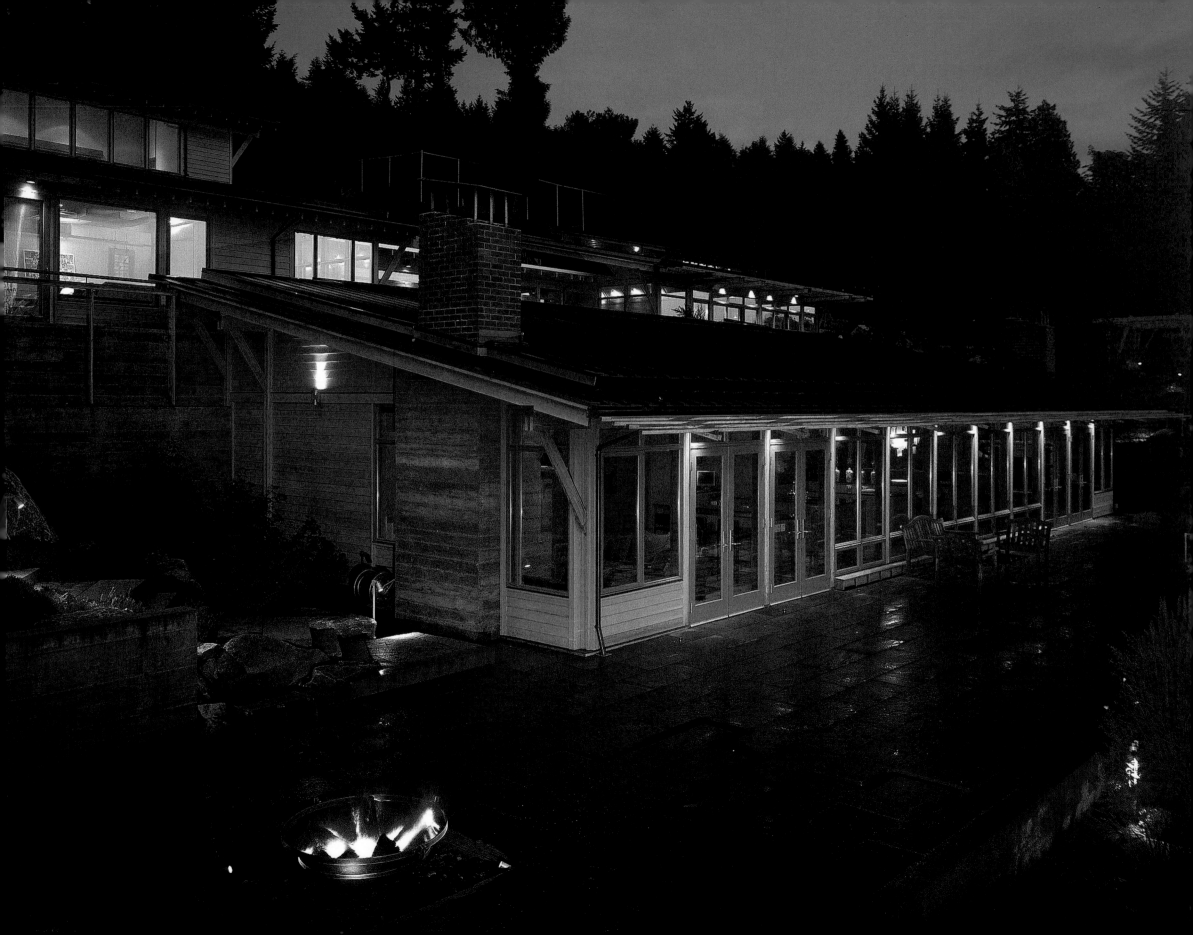

TAD FAIRBANK

Fairbank Construction Company

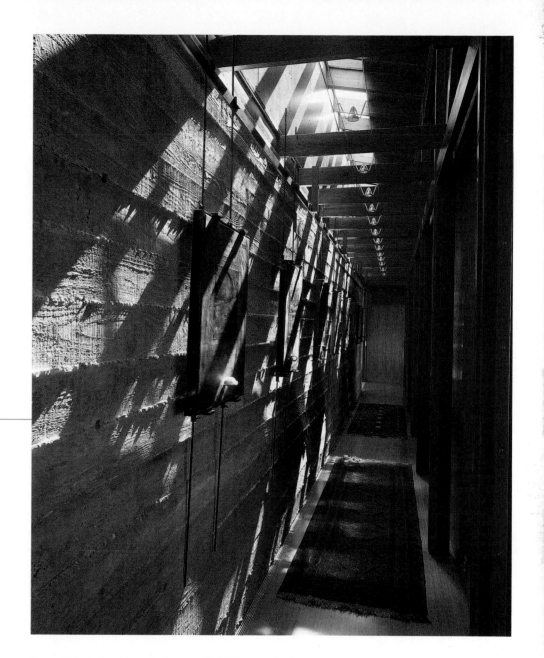

Above: A blend of rusticity and refinement, this 5,600-square-foot home incorporates raw materials with a level of detailed finish that provides casual elegance.
Photograph by Krogstad Photography

Facing Page: Over 1,500 yards of concrete went into this hillside home on a bluff overlooking Puget Sound and the Olympics.
Architecture by Cutler Anderson Architects.
Photograph by Krogstad Photography

Raised outside of Chicago in homes designed by Frank Lloyd Wright and other preeminent architects, Tad Fairbank naturally developed a fascination with architecture. His intrigue grew as he did, leaning more toward the craft than the design of structures. Eventually, Tad followed his instinct and sought out a mentor—a custom builder alongside whom he could learn to perform the labor and gain exposure to all aspects of the business. This experience would give him the tools to eventually build a solid and successful career in the custom home construction industry.

While Tad was still an apprentice, friends asked him to construct their parents' vacation home, a commission he enthusiastically accepted. So impressed were Tad's first clients that they soon asked him to do another, and Tad recognized that he could not perform two full-time jobs at once. Encouraged

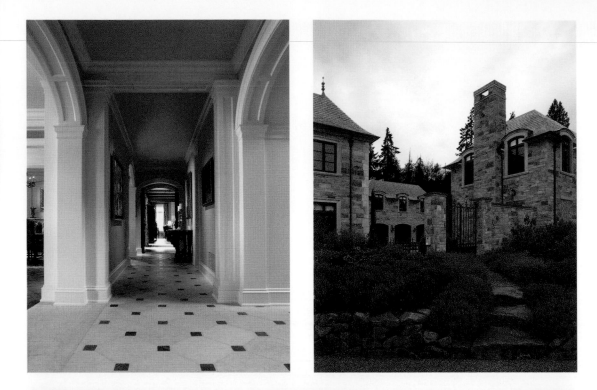

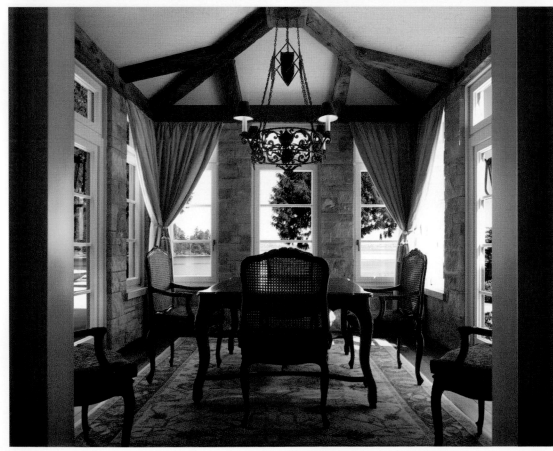

by his boss, Tad accepted the second solo project, laying the foundation for his construction firm. Officially established in 1978, Fairbank Construction Company now houses more than 70 talented professionals and constructs commercial projects and custom residences in five counties across the Puget Sound.

Evidence of the firm's mission "to provide the highest quality construction services and products in the industry," each member of the Fairbank Construction team adheres to the utmost standards in every stage of the construction process. One of the firm's five managing principals works closely with clients from the outset of a project, and the team devotes the same amount of energy and care to the structural elements of a home—those essential components that are not readily visible—to the architectural details that finish a home and add the aesthetic flavor.

Working with a variety of architects affords the team the opportunity to express a variety of architectural styles in the homes they create. From very contemporary homes composed of steel and glass to more traditional Shingle-style cottages with layers of trim—even an all-concrete house with a sod roof—no architectural style is out of the realm of constructability. In addition to genre, the size and complexity of Fairbank Construction's homes vary widely. Consistent throughout its projects is the extremely high level of execution apparent in every element. The team meticulously labors to ensure that everything from the siding to the floor planks exhibits a sure fit and sound finish. It is this utmost standard to which every member of the Fairbank team adheres that sets the firm apart and earns it its reputation for redefining excellence and luxury at every level.

Top Left: Limestone floors, pilastered arches and classical detailing create elegant architectural forms in the main gallery of this French provincial home.
Photograph by Holley Stickley Photography

Top Right: Designed by Stuart Silk Architects, this limestone home fulfills the owners' dream to recreate the classic courtyard structures of France's Normandy and Brittany regions.
Photograph by Holley Stickley Photography

Bottom Left: Reclaimed hand-hewn beams and stone walls enrich the château's light-filled breakfast room.
Photograph by Holley Stickley Photography

Facing Page: Carefully detailed limestone arched dormers and cornices create a timeless presence for this home, located on Bainbridge Island with views of Seattle and the Cascade Mountains.
Photograph by Holley Stickley Photography

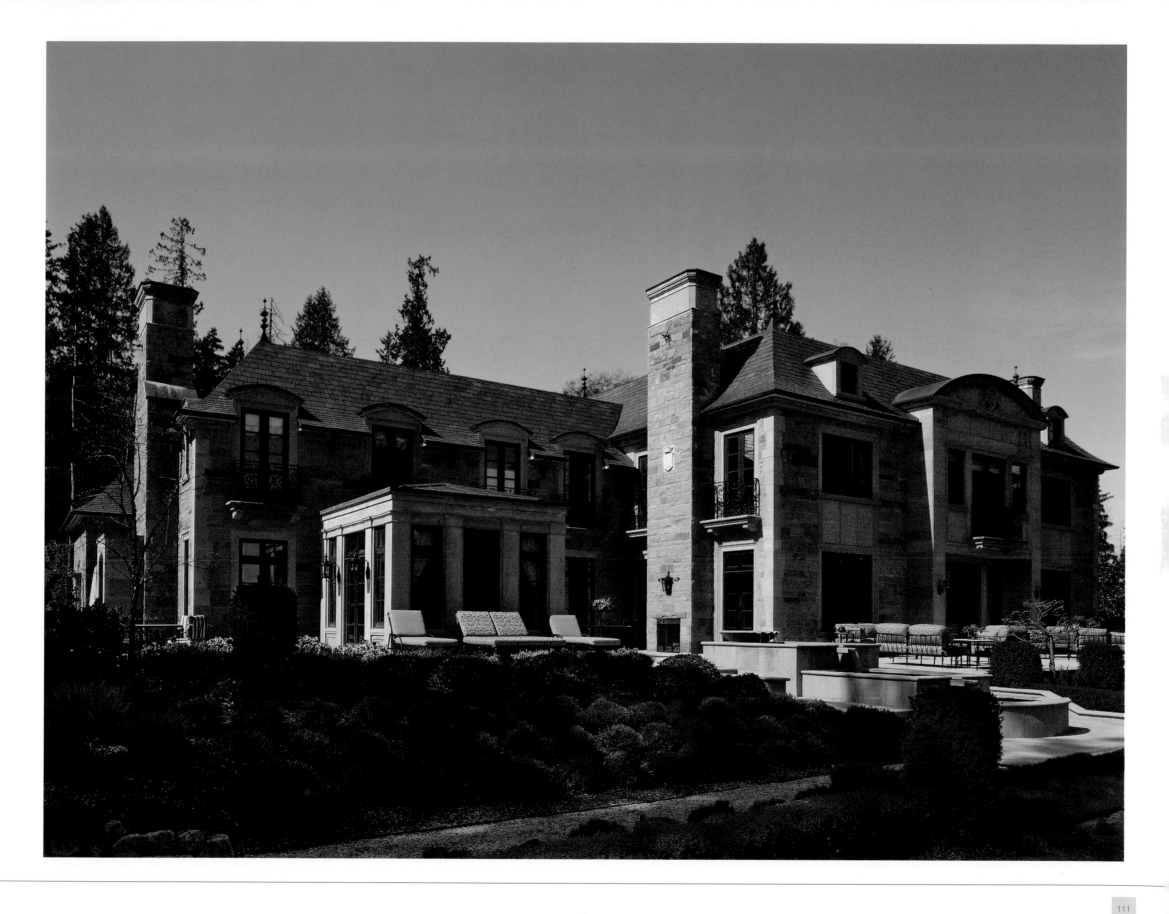

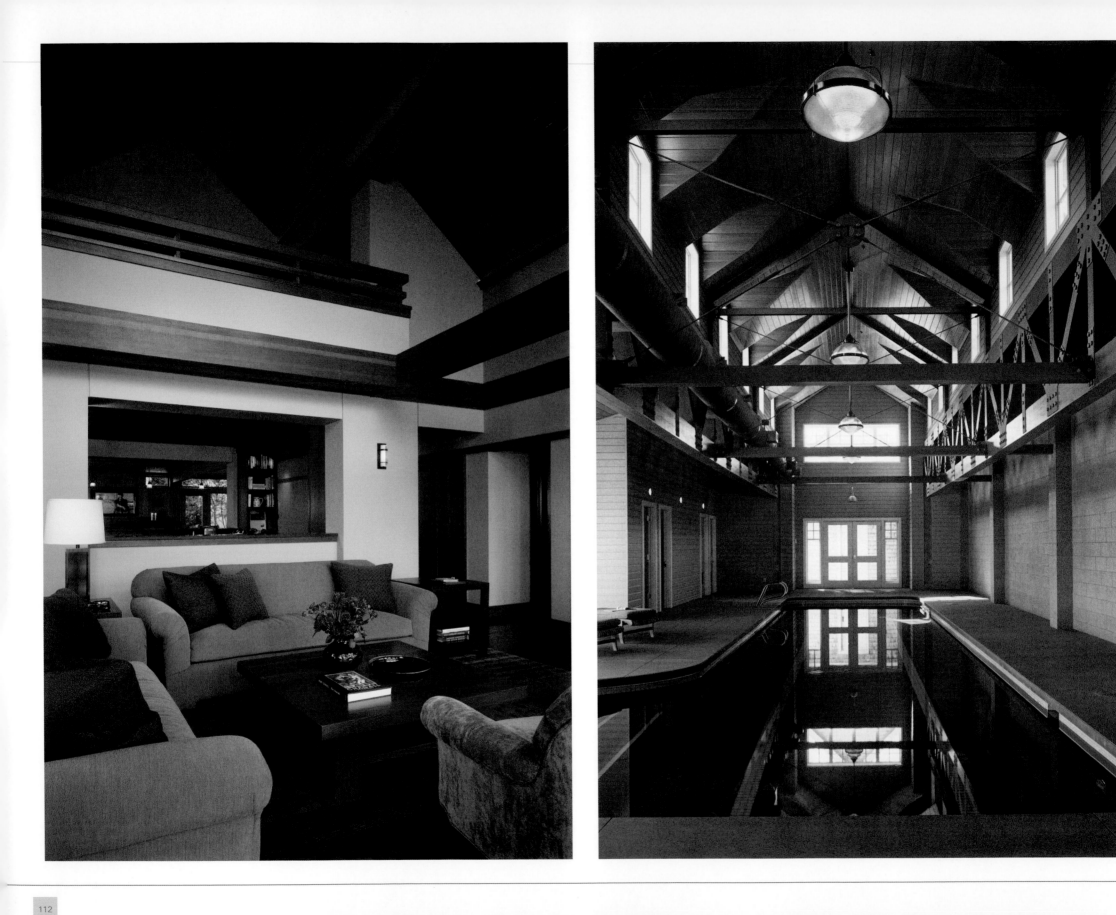

While new custom homes comprise the greatest percentage of the firm's work, the team also undertakes a select number of home renovation projects, many of which are quite extensive. As with every project, supreme attention is paid to precise composition with the added challenge of remaining sensitive to the existing structure. One project that exemplifies the firm's remodeling expertise involved doubling the size of a house originally constructed of timbers salvaged from a warehouse. To match the exterior materials of the new portion to that of the existing structure, the team aged each piece, scrubbing with bleach and sand-blasting all of the new timbers and rusting the brackets in salt water to ensure that the addition seamlessly fused with the home. The team also frequently creates custom cutter heads to accurately replicate antique millwork. Techniques such as these illustrate the firm's characteristic industry and aplomb.

At the heart of every project is Fairbank Construction's genuine commitment to clients. The team provides unparalleled service to and cultivates close relationships with patrons both during and after the construction process, as clients become close friends. The care each team member takes on every project—the firm works around clients' schedules so as not to interrupt their daily lives—and the genuine effort taken to exceed expectations leads clients to refer the firm to family and friends, alike. The recipient of numerous AIA and other regional awards, Fairbank Construction has been featured in the likes of *Seattle Homes & Lifestyles*, *Sunset*, and *Metropolitan Home* and has made numerous appearances in local newspapers. Their constant pursuit of perfection ensures that Tad and his team will enjoy abundant future success.

Above: Attached to the pool is a guesthouse and a garage, which accompany the main house across the street.
Photograph by William Wright Photography

Facing Page Left: With its elaborate use of vertical grain fir, this Stephen Bobbitt-designed home provides the warmth and elegance that the owners desired for their country estate.
Photograph by William Wright Photography

Facing Page Right: Sixteen dormers and 75-foot, site-built glu-lam trusses with stainless steel fastenings provide the roof structure for this indoor pool.
Photograph by William Wright Photography

Nils Finne

FINNE Architects

Above: Material contrasts are evident in the kitchen: steel columns with Douglas fir inserts, floating cherry shelves, glass, stone mosaic tile and Burlington stone counters.
Photograph by Benjamin Benschneider

Facing Page: The Redmond residence, located 25 miles east of Seattle, features a stunning glass, steel and wood living pavilion surrounded by a secluded, wooded property.
Photograph by Benjamin Benschneider

Raised in Norway and the United States, Nils Finne, AIA, brings a distinctly Scandinavian flair to the architectural community. A lover of craft and natural materials, Nils finds the Pacific Northwest a nurturing environment in which to build his now 27-year career. Earning his Master of Architecture degree from the Harvard Graduate School of Design in 1980, Nils founded FINNE Architects in 1990 and has since designed new homes and renovation projects in Washington, California, Michigan, Virginia, Rhode Island and Norway.

Dedicated to establishing a close personal relationship with each of his clients, Nils has chosen to keep his firm small—FINNE Architects houses between three and five people and takes on seven to 10 projects at a time, finishing about three each year. By limiting the number of projects, Nils is able to maintain the acute attention to detail and thorough realization of each home's overall aesthetic that

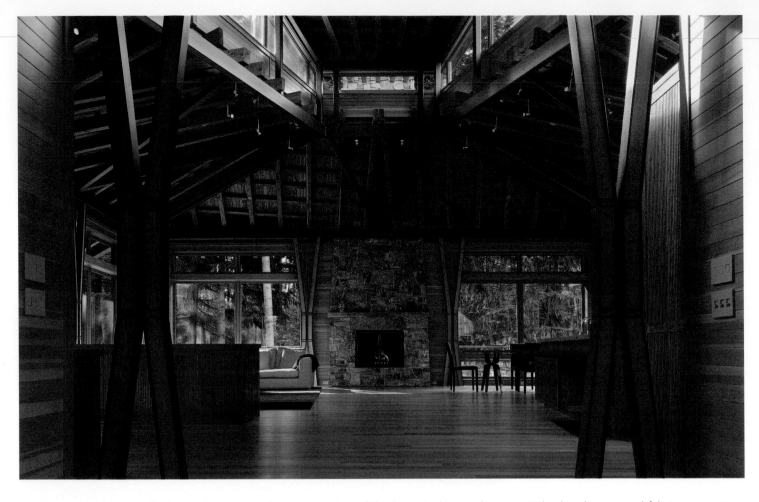

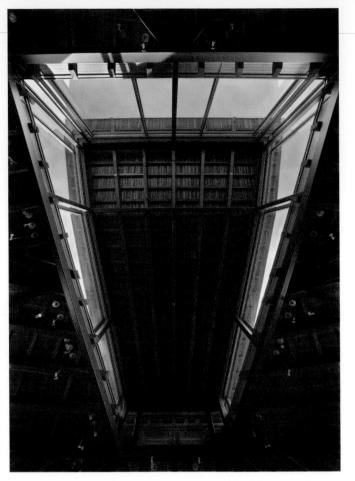

so distinguish his work. To further foster complete integration of the home's design elements, Nils also designs and fabricates custom furniture, light fixtures and hardware elements, a service that sets his firm apart.

To create custom pieces, Nils displays characteristic Scandinavian ingenuity by employing advanced technology. Using computer numeric controlled (CNC) routing equipment software that drives a machine to produce a pattern from a drawing, Nils can create intricately detailed textures and reliefs in a matter of minutes. The CNC software allows Nils to send information directly from CAD programs to robotic manufacturing equipment, ensuring the utmost precision in fabrication. In so doing, Nils eliminates the need for any interpretation of artistic renderings—he manufactures exactly what he designs, and his clients therefore receive the highest quality, finest pieces possible.

Nils states that his work embodies a type of "Crafted Modernism," one that incorporates Modern principles but maintains a humanistic quality due to his heavy emphasis on fine detail, craft, and his frequent use of natural materials, such as wood, brick and stone. Recently, he has completed custom-designed Alaskan yellow cedar cabinets with a beautifully variegated pattern created by a CNC router.

Another recent project is a dining table made from thin strips of mahogany bent to form two interlocking curved shapes.

Above Left: The living pavilion is wrapped by glass walls and capped by a soaring set of clerestory windows in the center of the space. The fireplace is Montana Ledge stone with a custom forged screen.
Photograph by Benjamin Benschneider

Above Right: Architect Nils Finne calls the roof structure a "wood quilt," with a dramatic series of tall clerestory windows providing natural light and ventilation.
Photograph by Benjamin Benschneider

Facing Page Top: The kitchen is an integral part of the living pavilion, with beautiful natural materials such as Burlington stone counters, custom cherry cabinets and a stone mosaic backsplash.
Photograph by Benjamin Benschneider

Facing Page Bottom Left: A stair detail reveals meticulous craftsmanship in custom, laser-cut steel railings, steel-and-oak stair treads and an unusual asymmetrical teak handrail.
Photograph by Benjamin Benschneider

Facing Page Bottom Middle: A sinuous custom dining table with a bentwood mahogany top and an interlocking, blued-steel base.
Photograph by Benjamin Benschneider

Facing Page Bottom Right: A detail of the custom glass-and-mahogany front door at the Redmond residence. The textured pattern in the mahogany was created with computer-guided cutting technology.
Photograph by Benjamin Benschneider

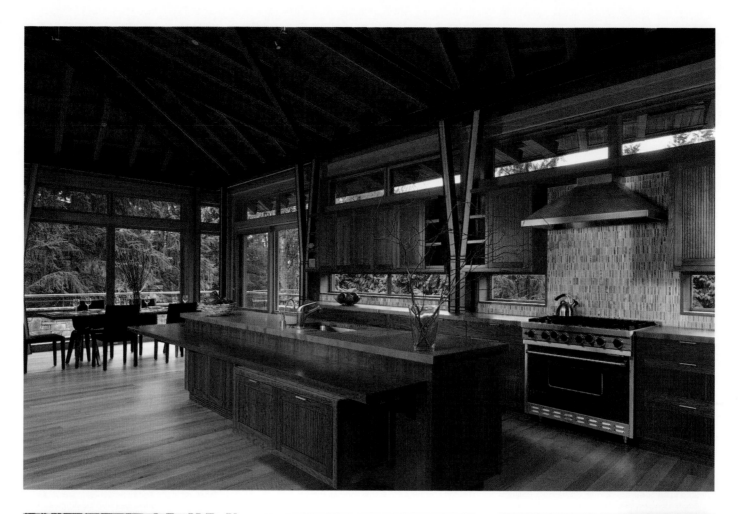

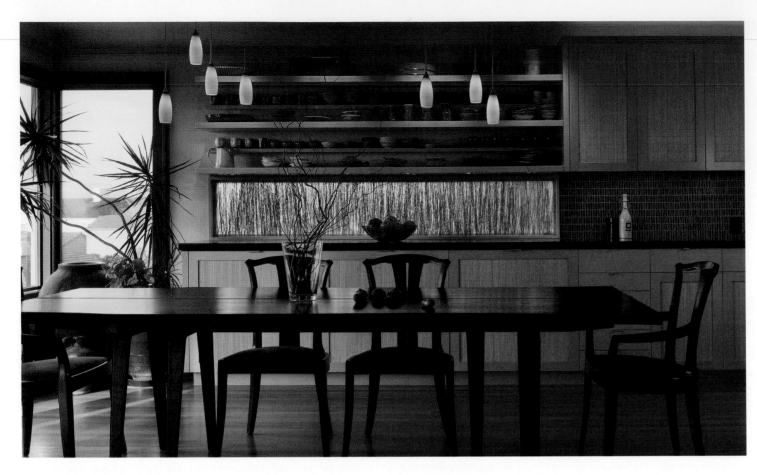

In looking at Nils' work, it is evident that he has a passion for wood, as he uses beautifully detailed woods such as Douglas fir, mahogany, cherry or yellow cedar to create a wonderful richness in both custom houses and furniture. Often, Nils will create a vivid juxtaposition between wood elements and contrasting materials such as blued steel, bronze, stone or even thin resin panels containing actual sea grasses.

Nils' involvement with furniture manufacturing and design leads him to think about architectural elements in a similar way. Some magazine writers have commented that a house designed by Nils feels like one large piece of furniture. A recently completed house outside of Seattle features a stunning wood roof structure that Nils calls "a wood quilt." He often blurs the distinction between furniture and building by either imagining building elements such as stairs as pieces of furniture, or creating pieces of furniture as natural extensions of the house design.

While the majority of Nils' residential work is new construction, he enjoys the opportunity to renovate and add on to older homes. He believes that interiors with a Modern feel, but also a high level of craft, blend nicely with traditional vocabularies—the human touch and the love that has gone into crafting the various elements harkens to days past. His exceptional design work has earned him recognition

in various local and national publications, including *Western Interiors*, *Residential Architect*, *Pacific Northwest* and *NW Home+Garden* magazines. FINNE Architects has also won design awards from the AIA's Seattle Chapter. Yet the true rewards belong to Nils' clients, who enjoy the fruits of his labors for years to come.

Above Left: A renovated dining/kitchen space in Seattle has an Asian elegance, utilizing a custom elm/steel dining table, "sea-grass" resin window panels and custom bamboo/yellow cedar cabinets.
Photograph by Benjamin Benschneider

Above Right: A detail of the custom dining table reveals a striking combination of blued steel, laser-cut bronze and stained elm.
Photograph by Benjamin Benschneider

Facing Page: The master bathroom in the Redmond residence creates warmth and tranquility with limestone, glass mosaic tile, custom cherry cabinets and a custom steel vanity-lighting wall with integral mirrors.
Photograph by Benjamin Benschneider

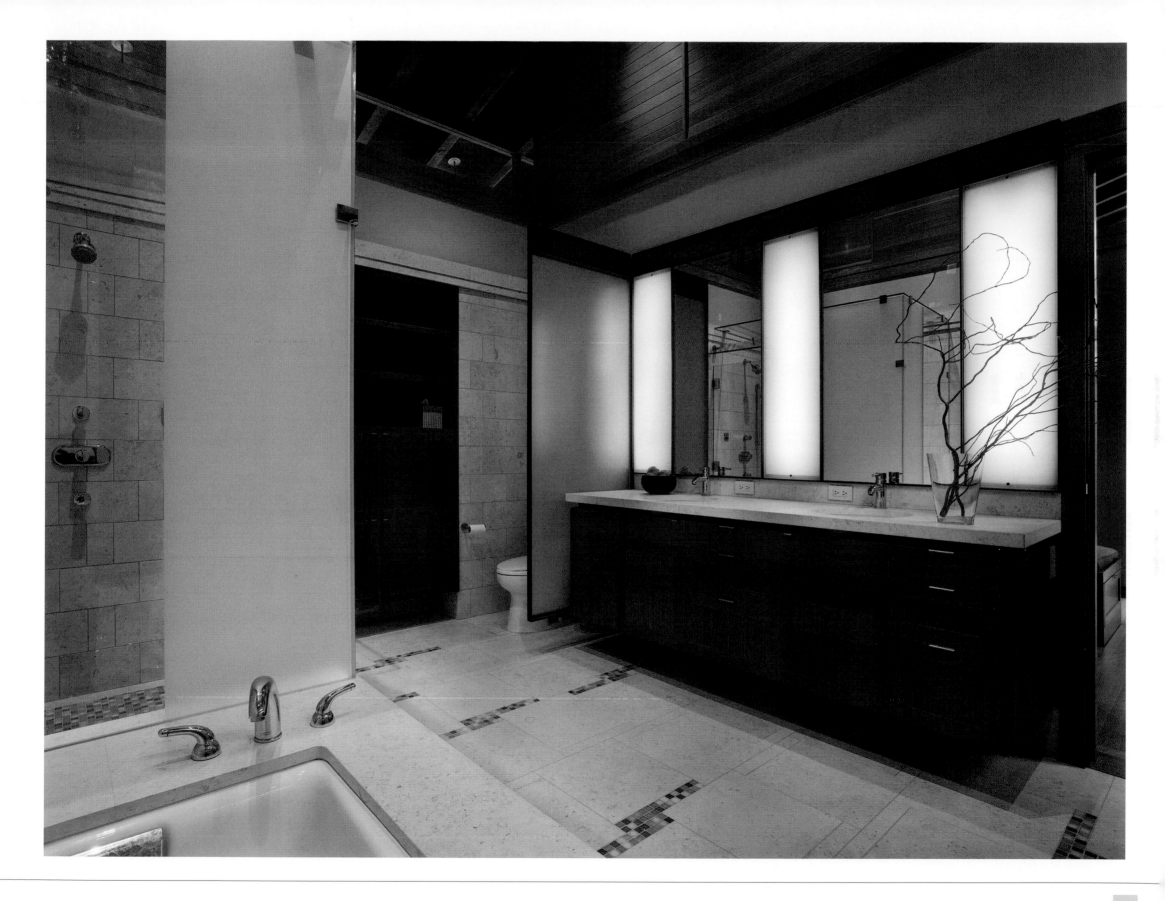

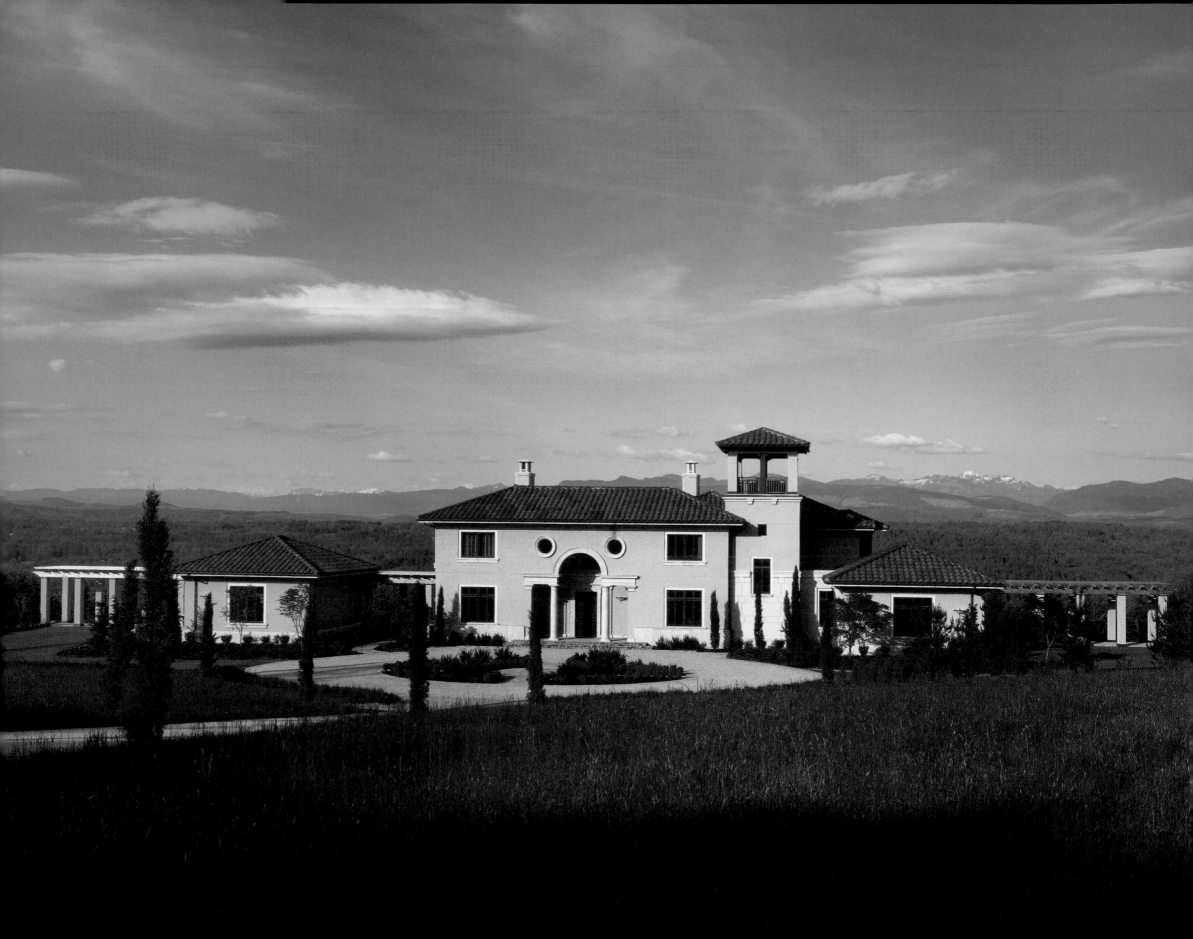

CURTIS GELOTTE
SCOTT HOMMAS

Curtis Gelotte Architects

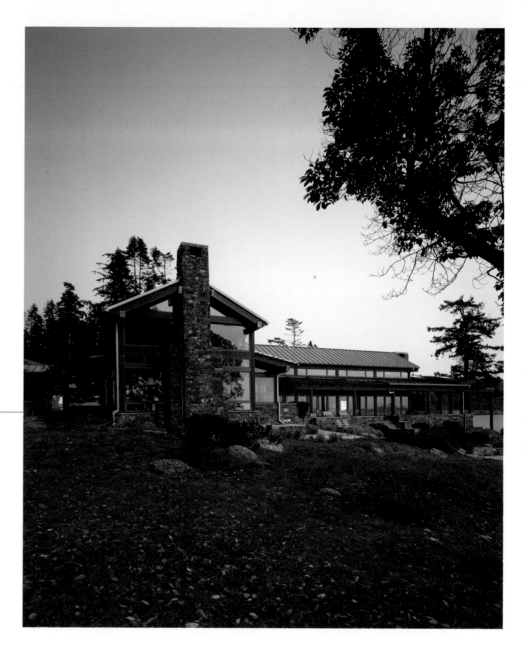

Above: Nestled into a rocky coastline, this home interprets an open and airy plan in wood, stone and glass.
Photograph by Michael Seidl

Facing Page: This classical Tuscan home responds to its delightful setting, while careful and sensitive detailing conveys an aura of permanence.
Photograph by Chris J. Roberts Photography

It is not common to find an architect who will design a doghouse, but Curtis Gelotte is one of the few. Indeed, such is his range of talents that Curtis will design anything constructible, from art glass to furniture to tree forts, at the behest of his firm's clients. With nearly a lifetime of architectural experience—Curtis began working for an architect in his hometown of Juneau, Alaska, at age 15—and a unique ability to visualize in three dimensions, Curtis offers patrons architecture of unparalleled artistry and innovation.

Establishing Curtis Gelotte Architects in 1983, Curtis now works alongside principal Scott Hommas and a team of 12 talented architecture professionals. The firm is dedicated to guiding patrons through every stage of the design, from determining site feasibility to drafting construction documents. A great deal

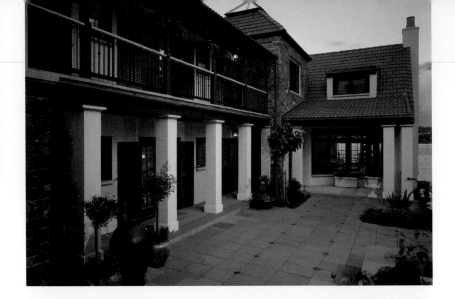

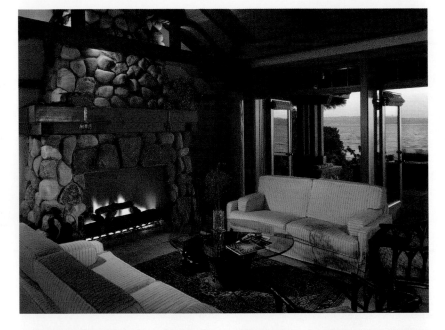

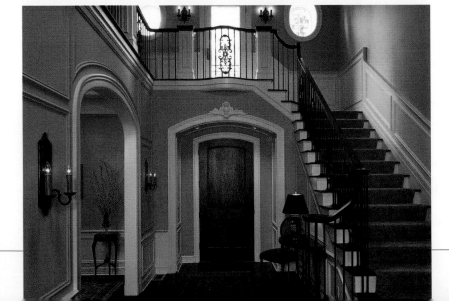

of time is spent in determining logistics—architectural vernacular, conceptual heating and lighting plans, construction materials, and so on—to ensure the utmost integrity in and flawless execution of the design.

Due to its architects' varied backgrounds and their insistence on client input, the firm creates homes that express a broad array of styles. Homes range from classical to contemporary, and Curtis and his team enjoy the opportunity to diversify. Every home is inspired by the site and oriented to best take advantage of views and daylight—a precious commodity in the Seattle area. In each project, the team works to inject the clients' personalities, incorporating valued collections and combating pet peeves regarding their current homes, such as improperly placed light switches. The firm's meticulous attention to these details ensures that the mood clients aspire to achieve in each room is fully and beautifully realized through the interior details.

Along with providing clients with exquisite and precise architecture, Curtis Gelotte Architects assists clients in prioritizing their homes' features and materials to help them build projects within their means. Curtis contends that sophisticated detail and well-planned and proportioned layouts can make even the simplest designs timeless works of art, and therefore he demonstrates to clients that complexity does not translate to quality. The firm's efforts to guide clients to make smart, informed decisions extends to its renovation work as well, and Curtis and his team extensively analyze the existing structure to determine whether to remodel or raze.

While it has won numerous awards, the firm's most memorable are the two "Best in the West" Gold Nugget Awards. Curtis submitted an Arts-and-Crafts-style bungalow and an extremely contemporary residence for consideration, and both won in their respective categories—a testament to the firm's aesthetic scope. In addition to these honors, another of the firm's projects was selected for feature in respected architect and author Russell Versaci's book *Creating a New Old House*. But the firm's true affirmation comes when clients step into their new house and say, "This feels like home, only better!"

Top Left: A south-facing courtyard and thoughtfully detailed veranda reminded this family of their roots in the British colony of India.
Photograph by Michael Seidl Photography

Middle Left: A reinterpretation of the best of the bungalow: rubble stone, timbers secured with hand-forged iron straps, plenty of light and a breeze off the lake.
Photograph by Chris J. Roberts Photography

Bottom Left: Informed by the rich heritage of classical designs, this elegant and artful foyer creates a striking entry to a wonderful home.
Photograph by Michael Seidl Photography

Facing Page: Articulated volumes reinforce individual functions within this open plan that focuses on the spectacular sunsets.
Photograph by Chris J. Roberts Photography

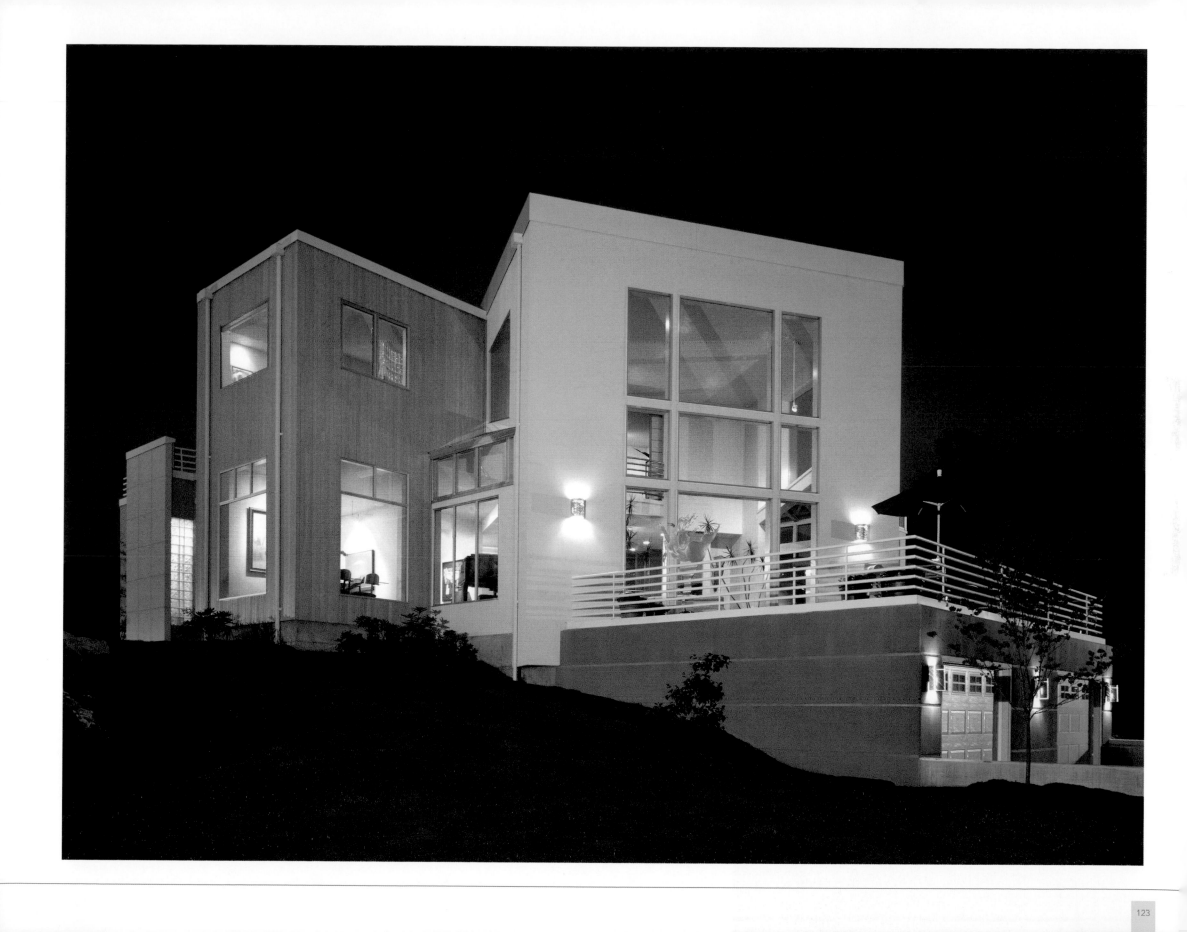

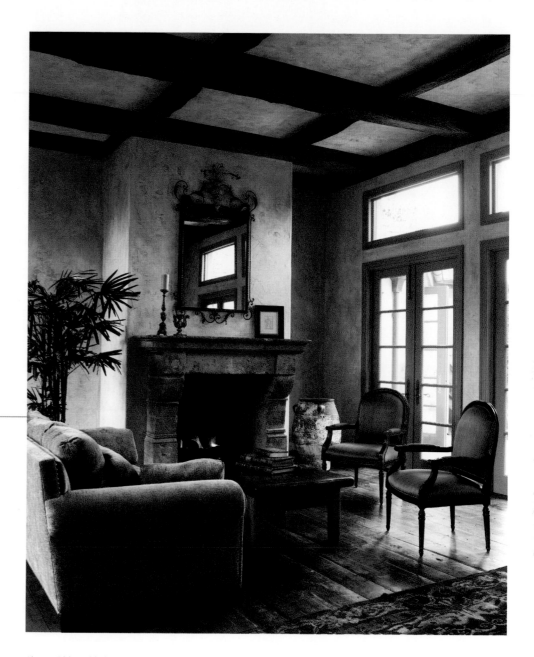

Bob Gradwohl

Gradwohl Construction, Inc.

Above: Old World elegance abounds with aged plaster walls and reclaimed antique features: stone fireplace, French white oak flooring and ceiling beams.
Photograph by Dan Langley

Facing Page: Soft lighting illuminates the front entry courtyard, accented by a stone fountain, lush vegetation and multiple French doors and windows.
Photograph by Tom Clements

Bob Gradwohl is not your average builder. A fine art and art history major in college, Bob brings to his work a keen eye for aesthetics and an intrinsic passion for creating beauty. Immersion in the construction industry from a young age—both his father and grandfather were builders, and Bob worked summers for them in his youth—honed his carpentry skills and provided the ideal outlet for his artistic leaning, effecting his entrée into the field of commercial construction. While certainly a thorough education, Bob's commercial endeavors did not satisfy his artistic cravings. He broke from the commercial sector to launch his career in residential, one that would afford him the opportunity to exercise his creativity and share his love of craft with clients as invested in the projects as he.

One need only visit a Gradwohl home to know that Bob has a gift for creating exquisite residences. Whether the home is 2,000 or 30,000 square feet, Bob and his team of 20 construction professionals provide clients with the personal attention of a boutique firm and the professionalism and skill of a large

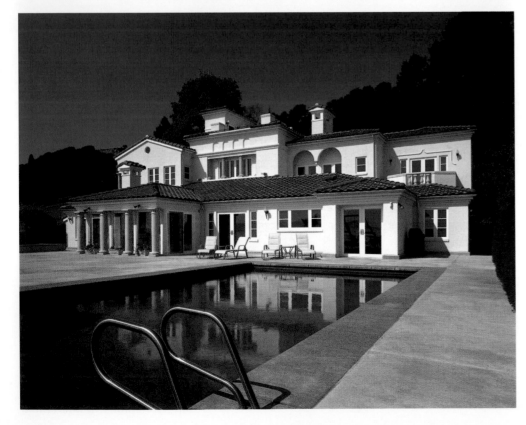

company. Since its inception in 1987, Gradwohl Construction has built a reputation among architects and homeowners alike for crafting precisely detailed, technologically innovative homes in a variety of architectural styles, from Old World to Contemporary. This versatility allows the team to achieve any look clients may desire.

One of Gradwohl's hallmarks is its immense in-house resource library. The firm's devotion to creating unique, interesting homes has led to intense research to find the best and most unusual materials and architectural elements from around the world. Drawing from its compendium of sources, the firm has incorporated such elements as hand-carved limestone fireplaces, Mexican mesquite floors, antique English chimney pots—even 300-year-old beams from France. Demonstrating characteristic ingenuity, Gradwohl's talented craftsmen have fashioned fireplace surrounds from iron-cast window frames and roofed new homes with slate tiles from razed buildings. These authentic elements season the story the home will tell, paying homage to architecture's past while creating its future.

Reusing materials not only improves the home's visual interest but minimizes its environmental impact as well. Indeed, the firm's longtime practice of blending old and new naturally evolved into a commitment to Green building techniques. Gradwohl equips its homes with radiant heating, multiple-zoned HVAC and water recycling systems to reduce the amount of energy they require. For one of its projects, the team installed a green roof replete with a waterproof roof deck, soil, irrigation and drought-tolerant plants that naturally insulate the home and enhance the surroundings. Still another involved the team's constructing the largest private solar installation in the Northwest on a 26-acre compound. Clearly, Gradwohl Construction is enhancing the beauty of Washington's natural and built environments. Featured in a variety of publications, including *Architectural Digest* and *Better Homes and Gardens*, the firm's talent is garnering well-deserved attention for its efforts. Yet Bob's true reward is the knowledge that his creations will be cared for and appreciated for years to come.

Top Left: Copper-clad mahogany windows, a reclaimed slate roof, a tumbled-stone veneer, copper gutters, pre-cast stone lintels and sills, mesquite doors and stucco walls create a multi-textured exterior.
Photograph by Randy Corcorran

Bottom Left: Whitewashed stucco walls, a clay-tile barrel roof and a pool deck lend a Mediterranean feel to this home on the Puget Sound.
Photograph by Randy Corcorran

Facing Page: This home's extensive stone cladding, cedar-shingle siding, wood windows, copper gutters and Brazilian slate roof give it a warm, embracing feel.
Photograph by Randy Corcorran

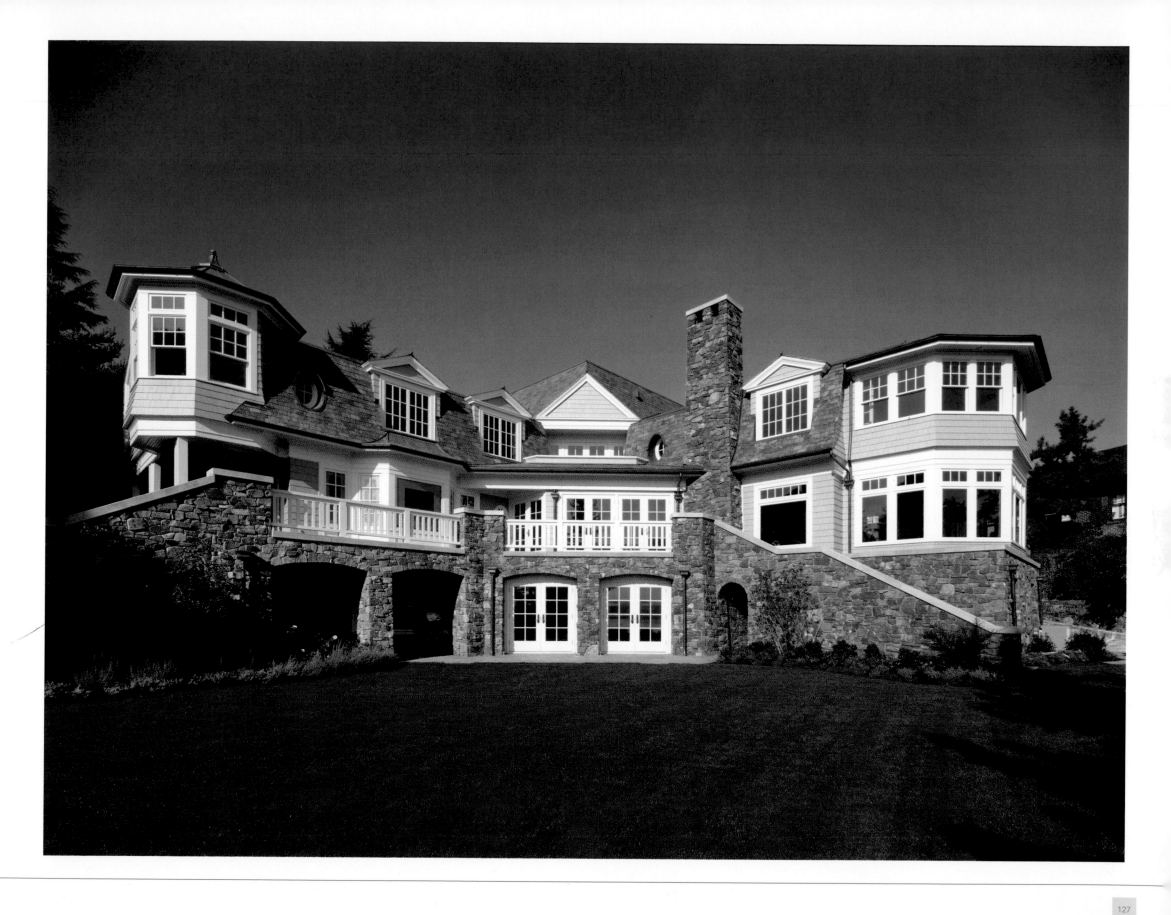

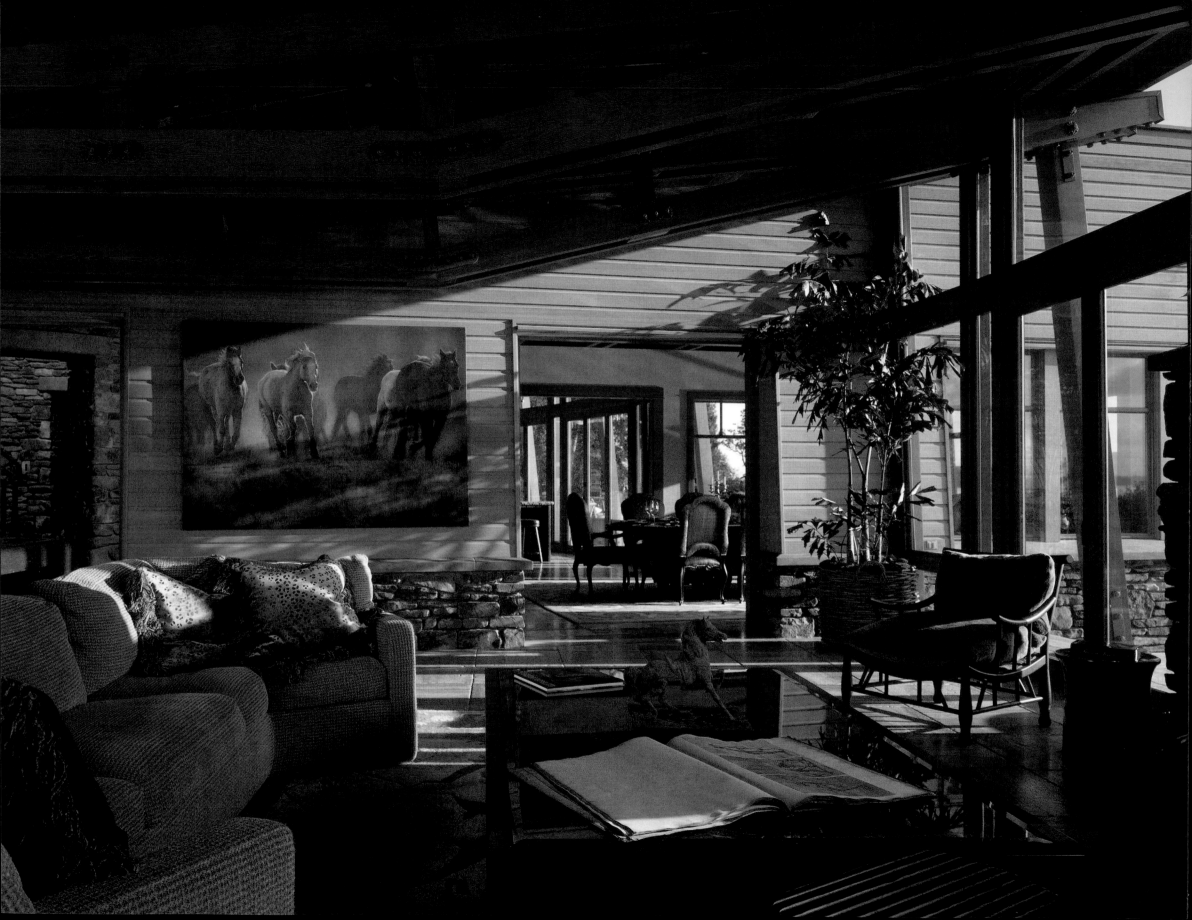

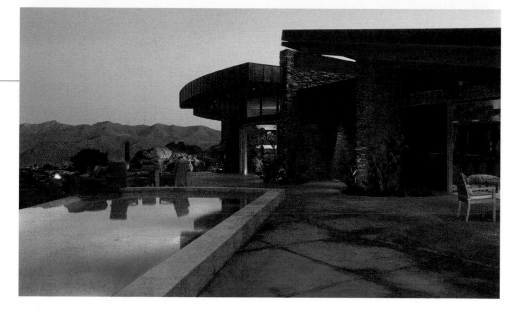

BRYAN KRANNITZ
BARRY GEHL

Krannitz Gehl Architects

Bryan Krannitz and Barry Gehl opened their Seattle firm eight years ago in a 1930s'-era Army warehouse–turned–boat repair shop–turned–architecture studio. With unfinished plank floors, a corrugated metal ceiling and exposed beams, the space retains the rugged feel of its early days. Outside, a crane hovers over Lake Union.

It may seem hard to imagine a Krannitz Gehl dream home conjured in this industrial setting, but once you know the architects, it is not really surprising. Just as the commercial waterfront inspired their office design, it is the same with their home designs. "We home in on what's special in the site," Bryan says. Of course, for these architects that usually means drawing inspiration from a Puget Sound beach, or a mountain lake in Montana, or a rocky bluff in the California desert—one-of-a-kind environments that demand one-of-a-kind structures.

Above Top: The use of native materials makes this Palm Desert home seem to rise out of its site.
Photograph by Big Horn Golf Club

Above Bottom: Enjoying outdoor living in any weather is enhanced in this Palm Desert home by large roof overhangs and expansive openings.
Photograph by Big Horn Golf Club

Facing Page: A large beach house feels intimate when divided into a series of enclosed volumes connected by glass pavilions. Exterior materials continue through the interiors to reinforce this concept.
Photograph by Ben Benschneider

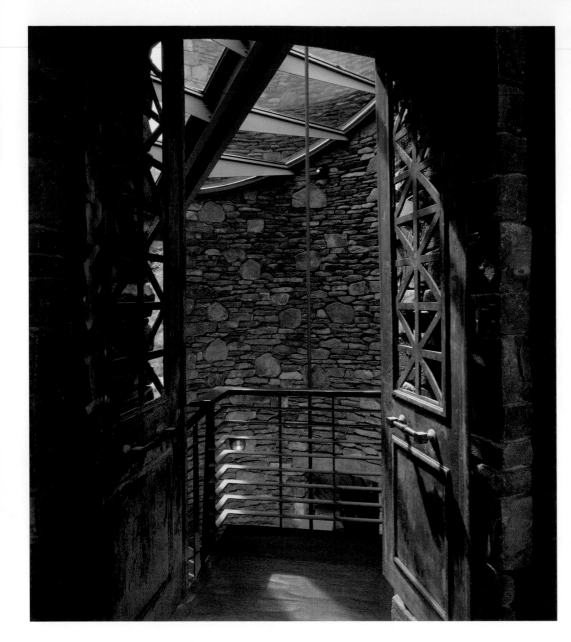

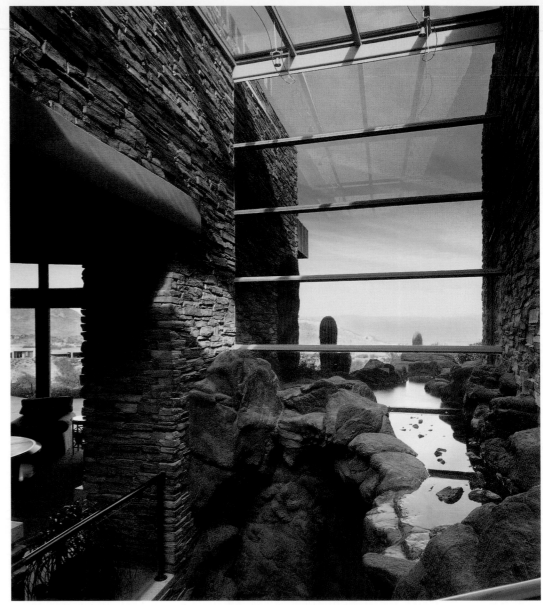

In keeping with their office, Bryan and Barry actually dress more like boat builders than big-city architects. But appearances are deceiving. Over two decades, they have honed a sophisticated sensibility that is grounded in an open exchange with clients, the love of discovery and the pursuit of diversity in everything from architectural styles to building materials.

"We don't have a set style," Barry says. "Instead, we have a design philosophy that responds in an aesthetic manner to the site and the dreams of the individual client." Identifying a client's needs and desires is not always easy. It helps that Bryan and Barry are easy to talk to and that their goal is to encourage open dialogue and collaboration. "We want to get into our clients' heads," Bryan says. "That's how we come up with uniquely creative solutions."

Above Left: The dramatic space for a stair landing illustrates the depth and range of the firm's artistic and technical savvy.
Photograph by Ben Benschneider

Above Right: The entry of this home blurs the boundaries between interior and exterior by enclosing the space between the two massive stone walls with continuous glass. The stream appears to flow into the interior from outside.
Photograph by Big Horn Golf Club

Facing Page: This mountain lake home for an avid outdoorsman and his family appears perfectly attuned to the unique conditions of its rocky site.
Photograph by Heidi Long

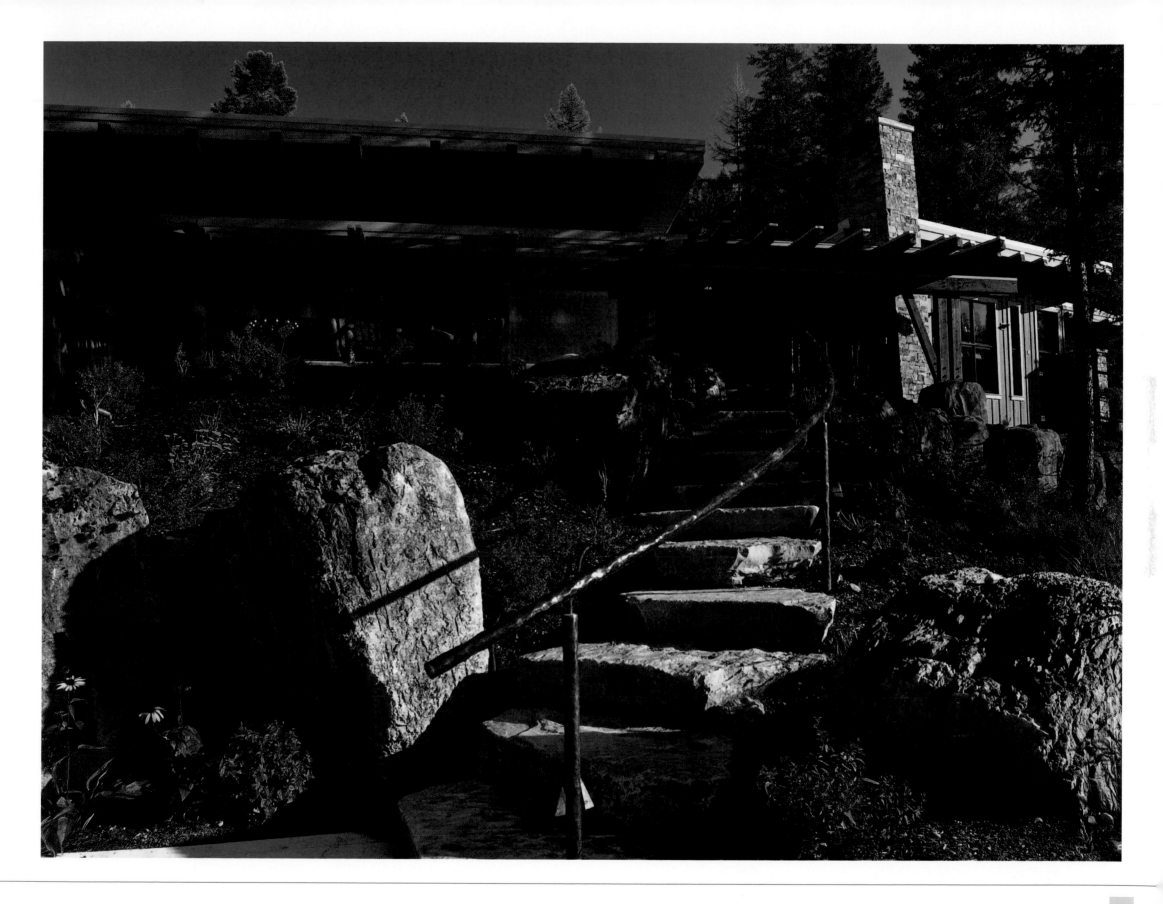

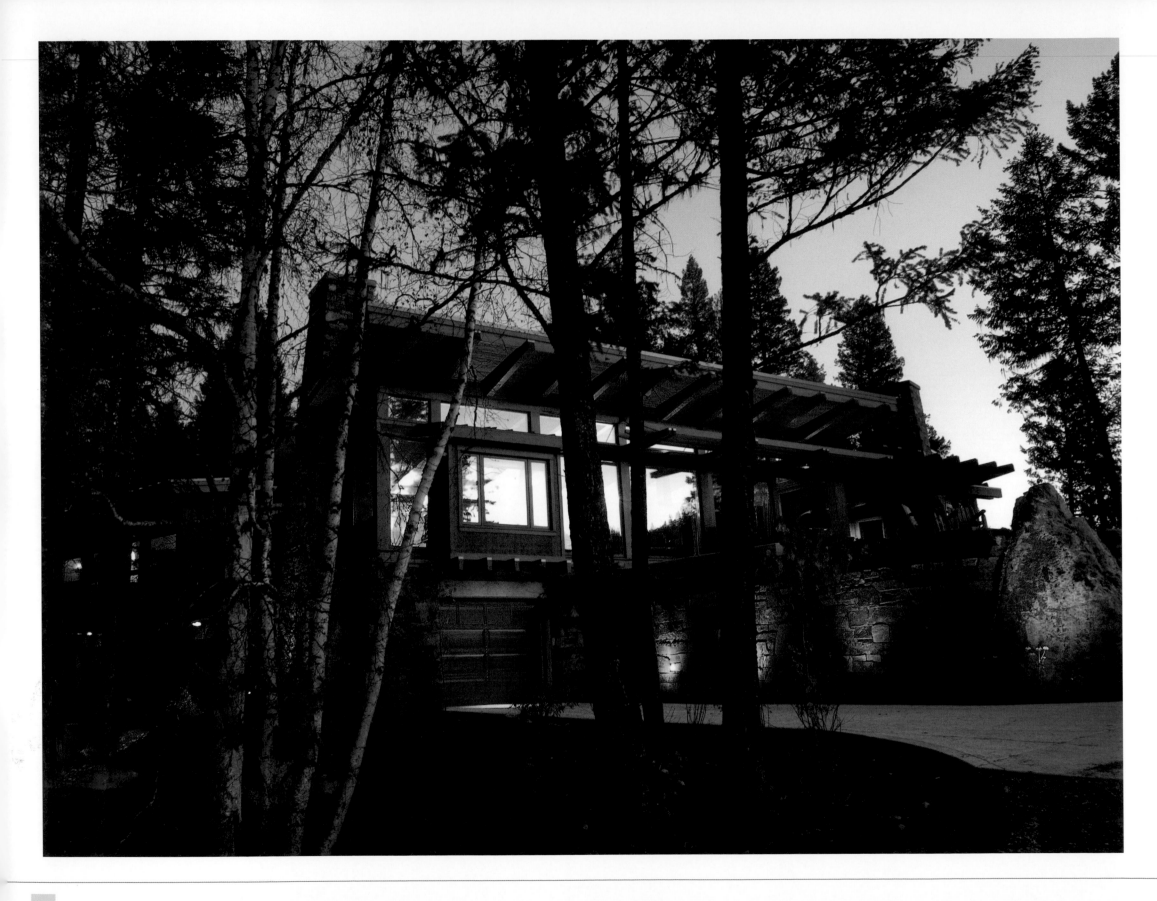

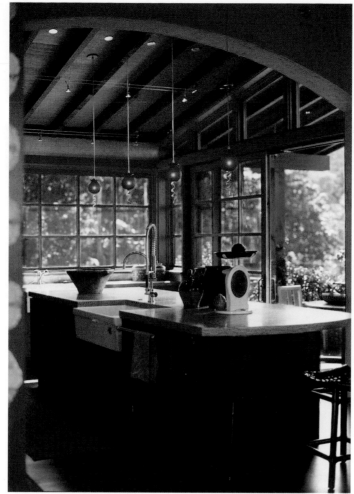

One studio at Krannitz Gehl is crowded with tools for brainstorming. Boards covered with images and keywords, floorplans and three-dimensional models depicting several possible designs help to draw seasoned and novice clients into the design process.

The results are never the same. For an avid outdoorsman, a collection of cabins on the outfall of a Montana lake evokes the spirit of a fishing camp. A tall bluff-top home, which looks like a centuries-old Tuscan villa, satisfies an eclectic client who desires something timeless. In a Palm Desert spec house, Krannitz Gehl created an entrance of two rough stone walls inspired by a

desert gulch. A stream flows from the outside and cascades into an interior pond. The developer decided to keep it for himself.

Cooling, calming water is a signature element in Krannitz Gehl homes. Chalk it up to Barry; the native Chicagoan is a dedicated sailor. He actually moved to their waterfront office in a net-tending skiff. In addition to being beautiful, moving water fosters an important connection between the indoors and the outdoors.

In their designs, Bryan and Barry strive to dissolve, as much as possible, the boundary between the built environment and the

natural world. They aim to capture the yin-yang pleasure of open space and enclosure, vista and refuge, movement and stillness that resonates deep inside every one of us. They use walkways, bridges, natural materials, glass walls and design elements to bring the outside in both formally and in spirit.

Above Left: The home was carefully sited to take advantage of panoramic views while preserving portions of an existing swimming pool.
Photograph by Bill Holt Photography

Above Middle: The kitchen serves as a gathering place where abundant natural light and fresh air nourish the soul.
Photograph by Bill Holt Photography

Above Right: Building artifacts collected by the owner from distant countries and from a variety of cultures were carefully integrated with new construction to create the Promontory residence.
Photograph by Bryan Krannitz

Facing Page: The lakeside elevation of this Whitefish, Montana, home features large expanses of glass and lift/glide doors, connecting it to south-facing terraces.
Photograph by Heidi Long

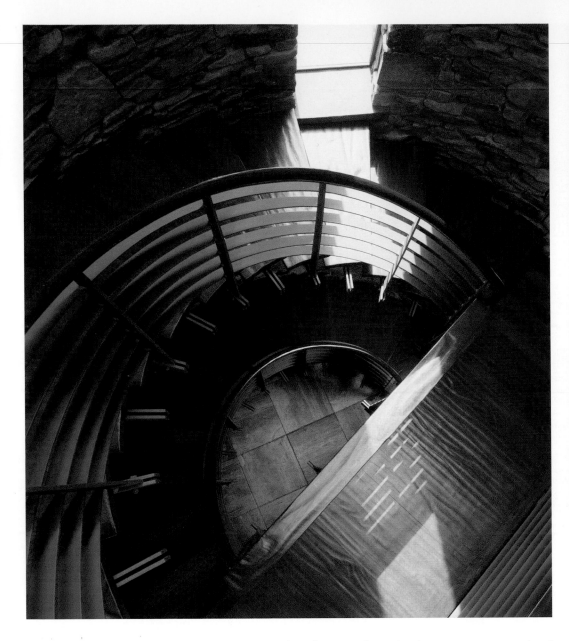

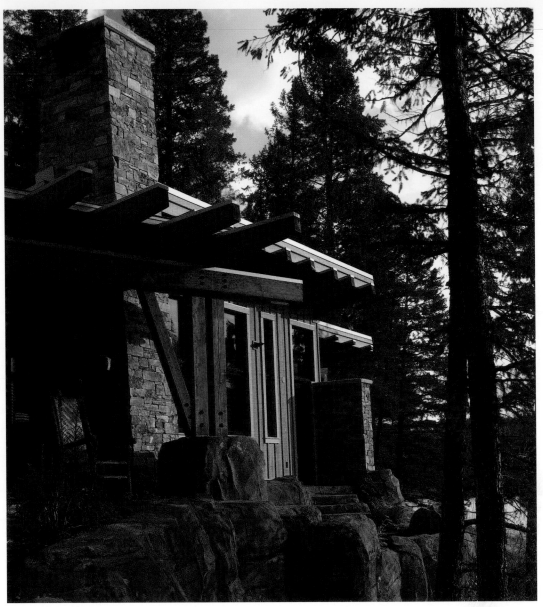

Elements such as stone walls, exposed wood and rammed earth also create an emotional connection with the land. "There is something warmer and more spiritual about a place when you can start to relate it to natural materials," says Bryan, who grew up building models and forts on the shores of Lake Michigan.

While every Krannitz Gehl home is unmistakably individual, they all share a core realness. Through simple, clear forms that celebrate the surrounding landscape and respond to the individual's aspirations, Barry and Bryan create living spaces that satisfy, thrill and inspire.

Above Left: Natural materials combined with space and light transform an everyday necessity into a dramatic event.
Photograph by Ben Benschneider

Above Right: Creating a place of refuge on the edge of a larger view is a core belief of Krannitz Gehl.
Photograph by Heidi Long

Facing Page: A strong sense of structural expression and the use of natural materials influenced the design of this home on Washington's Puget Sound.
Photograph by Ben Benschneider

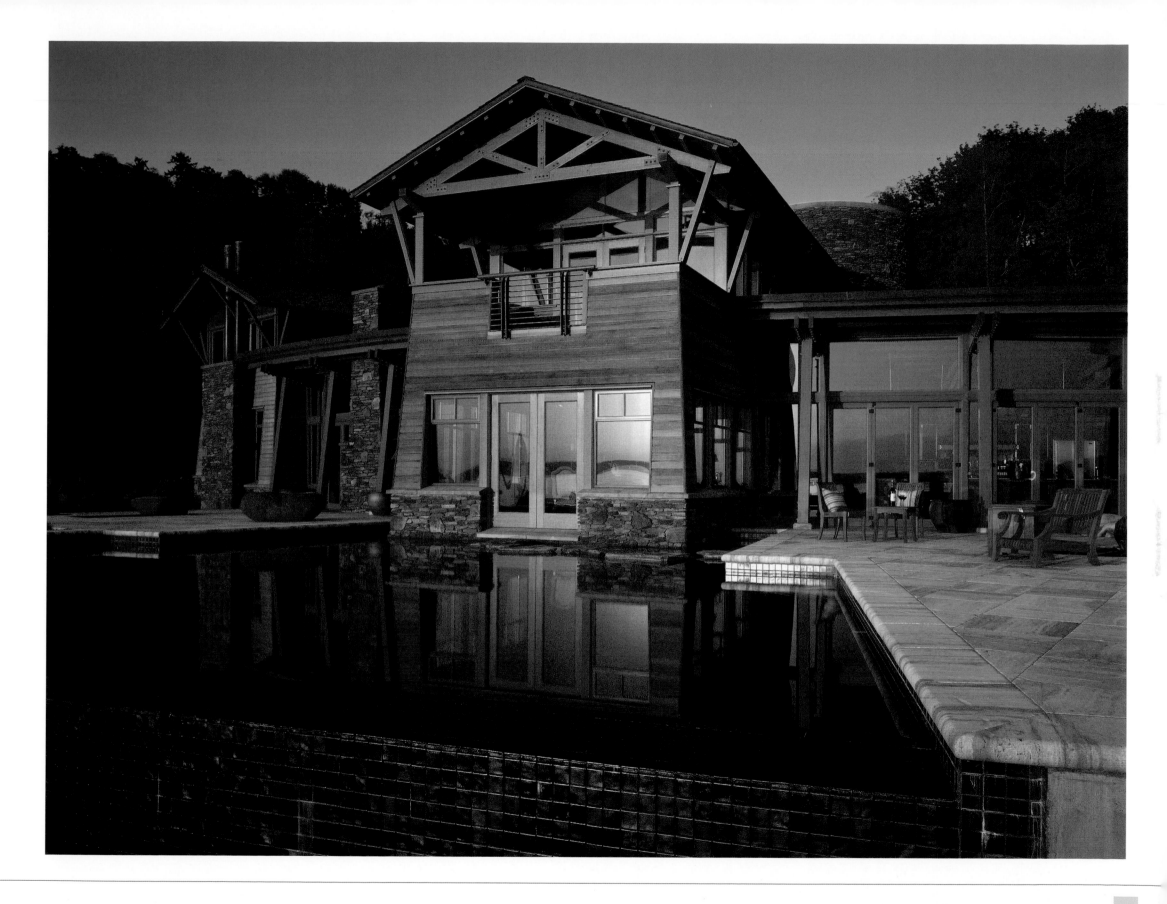

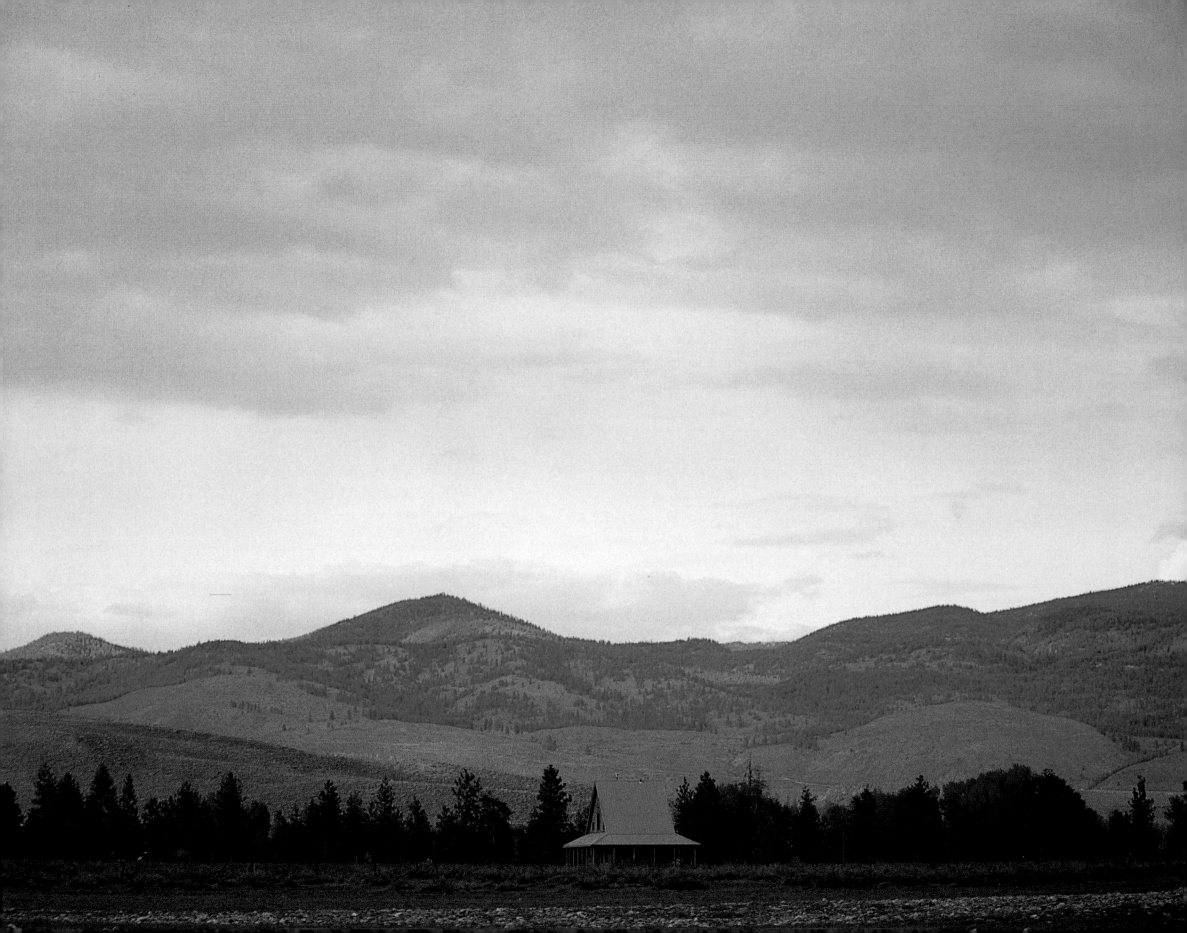

THOMAS LAWRENCE

Lawrence Architecture

Tom Lawrence, AIA, is a firm believer in the power of a good concept. To create an excellent work of architecture, one must have a thoroughly investigated, clearly elucidated plan, one derived from a thoughtful and meticulous process. Tom credits his complete commitment to this process—and the resultant success of his projects—to his two primary influences, Jim Cutler and Ed Weinstein, under whom he studied and for whom he worked before founding his own firm, Lawrence Architecture, in 1995.

Having earned his Bachelor of Environmental Design in Architecture degree from North Carolina State University, Tom sought a Master of Architecture at the University of Washington, where he would meet his mentors, both instructors at the university. Under their tutelage and subsequent employ, he developed and refined a rigorous, methodical design process, one that governs every residential

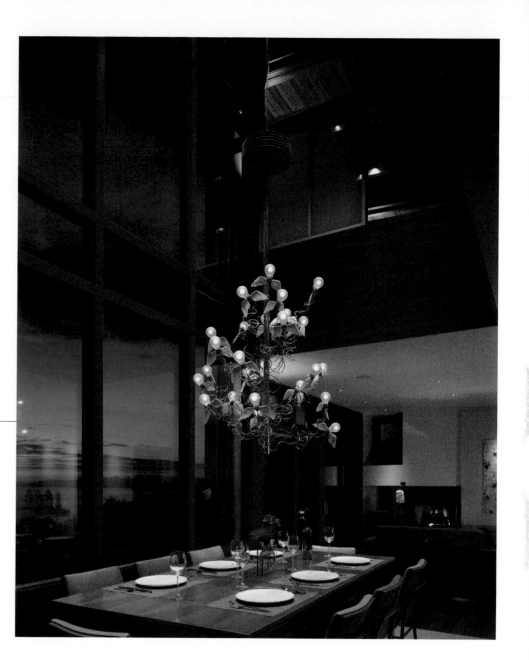

Above: Wood details punctuate the wall of windows in this Seattle residence, giving diners an exquisite view of the Puget Sound.
Photograph by Benjamin Benschneider

Facing Page: Set amongst the trees in Washington's Methow Valley, this thoughtfully oriented cabin is second only to the view.
Photograph by Thomas Lawrence

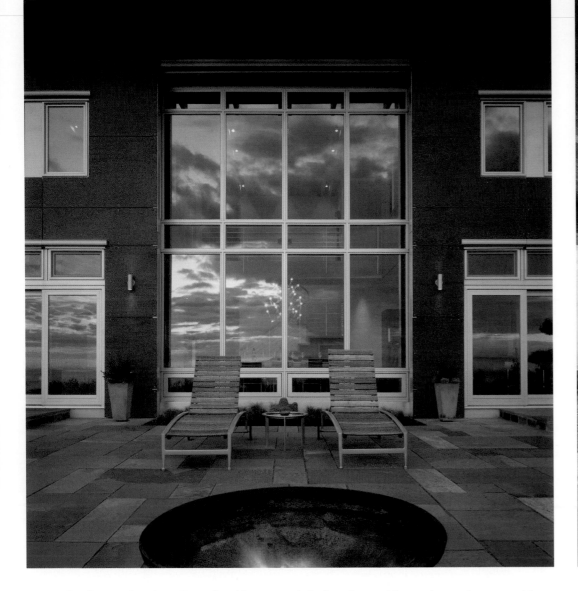

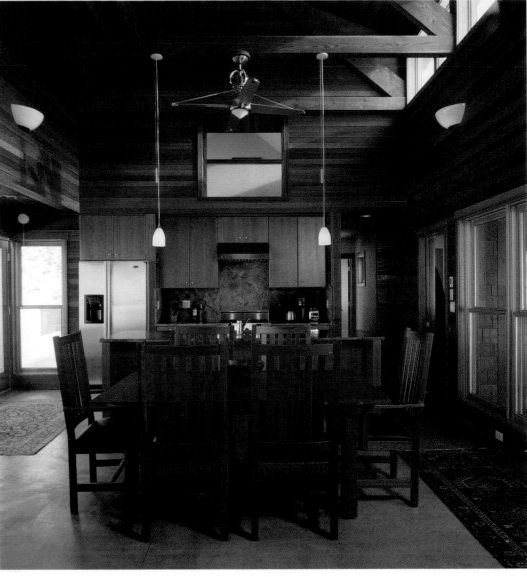

project his firm undertakes. Central to his approach is the client, without whom a home could not take shape. Understanding the clients' goals for a project—what motivates, excites and inspires them—facilitates the design solutions and allows a successful home to take shape.

Tom considers the clients' intangible needs for their homes as thoroughly as he does their functional requirements, as these difficult-to-define qualities make a home unique. Tom works to establish precisely what those intangible qualities mean to the client and how best to express the client's vision. Each homeowner has a different story to tell with his home, and Tom listens closely to ensure that the image clients want portrayed to the public is beautifully achieved. Equally

painstaking is the attention he pays to the requirements of each site. Before beginning a design, he visits the site, noting the surrounding context to glean inspiration from the natural, built and cultural environments. The synthesis of client and context creates a home that is both practically and aesthetically apt.

Throughout the process, Tom collaborates with landscape architects, structural engineers, and interior designers—many of whom he has worked with for over 15 years—to ensure the integrity of the design vision. He is also blessed to consult his wife, herself an architect specializing in preservation work, for technical advice. Keeping the firm small—Tom works alongside between

one and three associates at any given time—allows him to devote the time and attention necessary to create exceptional homes.

Lawrence Architecture sets itself apart from other firms in that its homes are usually modest in size. Primary residences most often fall between 2,500 and 3,500 square feet, and vacation homes—which Tom regularly designs—are smaller still. Additionally, a large portion of Tom's work is renovation and additions, particularly in the Seattle area. Small projects, especially those that fall within an existing architectural framework, present an especial challenge, one that Tom not only easily surmounts but truly enjoys. He has received several design awards, and his homes have been featured in a number of publications. But Tom bestows his highest gratitude to his mentors, without whom he posits he would not be doing the work he so enjoys today.

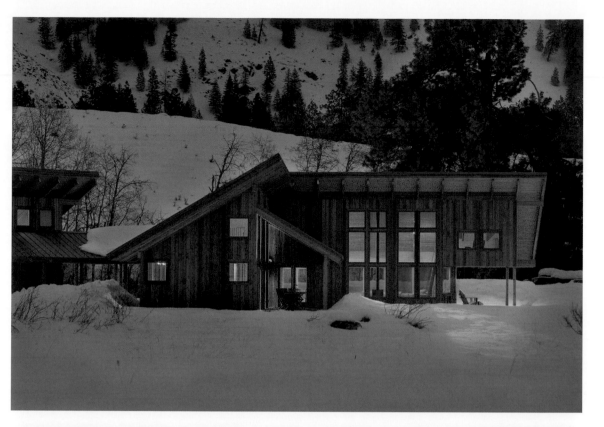

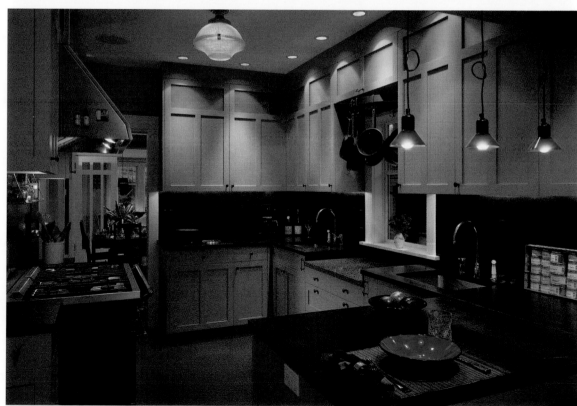

Top Right: Transparency defines this Granite Mountain, Washington, cabin, which appears to grow out of the surrounding snow.
Photograph by Benjamin Benschneider

Bottom Right: The kitchen of this 1920s' Seattle home was updated to accommodate a contemporary lifestyle.
Photograph by Benjamin Benschneider

Facing Page Left: Just outside the dining room, the waterfront terrace provides a soothing retreat for residents to enjoy the Sound.
Photograph by Benjamin Benschneider

Facing Page Right: Natural materials and large windows connect the Bear Creek retreat with its rustic Washington locale.
Photograph by Benjamin Benschneider

TOM LENCHEK

Balance Associates, Architects

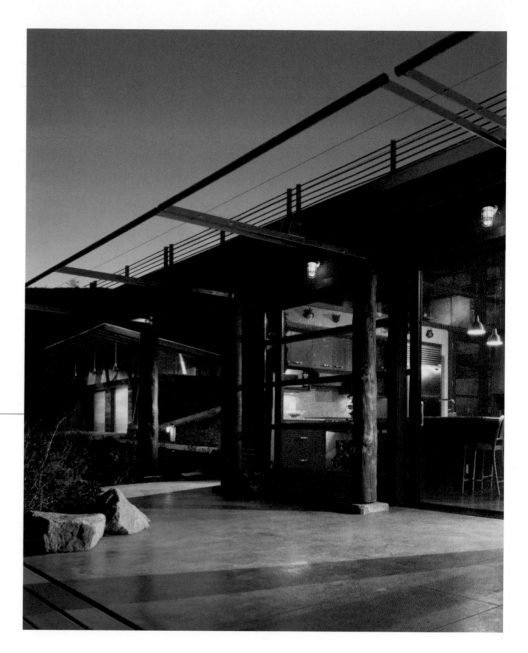

Above: This modern mountain retreat in the eastern Cascade Mountains provides exquisite views.
Photograph by Steve Keating

Facing Page: The living room of the Garden House in suburban Seattle seems one with the woods beyond, with abundant windows and wood elements.
Photograph by Steve Keating

A climate and topography as varied as the West's afford Balance Associates, Architects the opportunity to express a range of architectural forms. Early in his education, principal Tom Lenchek, AIA, grew fascinated with the vital role physical conditions play in determining a structure's shape. His design philosophy grew from this reverence for the environment, providing a foundation for the firm he established in Seattle in 1980.

Now positioned in both Seattle and eastern Washington, Balance Associates creates custom primary and secondary residences and seamless home renovations in urban, mountain and desert regions throughout the West. The firm specializes in residential work because of the close personal connections it affords with clients. Tom maintains that residential patrons have a more passionate investment in their

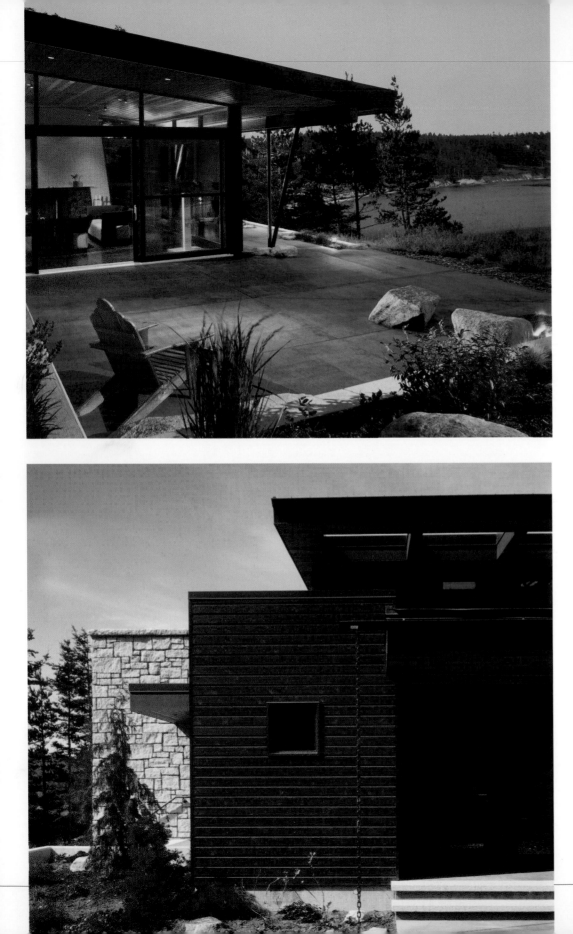

projects than do many commercial clients, as the former plan to live in their homes for many years. Stimulated by this passion, he and his team help clients create structures that beautifully express their characters and lifestyles.

The firm adopts an approach to its work that Tom describes as "natural modernism." Focusing on form and light, the Balance Associates team designs homes that are highly detailed without ornamentation. While the distinction seems subtle, it is actually fundamentally important to the firm's aesthetic philosophy: The details derive from the way the team expresses each element of composition. By exposing and celebrating the natural states of those pieces that make a home function, the firm ensures a structure that is complex yet straightforward, visually interesting yet minimalist in form.

Central to Balance Associates' process is the significance of incorporating each building with its site. Espousing Frank Lloyd Wright's notion that a structure should be "of the hill, not on the hill," the team designs homes that derive from and frame their landscapes, honoring their surroundings with their orientation and connection to the outdoors. The firm's commitment to contextualizing each home is rooted in tradition, as prior to the invention of electricity and central air, homes had to be properly sited and designed to allow sufficient lighting and climate control throughout the year.

Reverting back to this early yet supremely logical method promotes environmental sustainability as well, as smart design translates to efficient homes. Early in his career, Tom worked as a consultant to utility companies and state governments and was a contributing editor of *Solar Magazine*, helping

Top Left: The patio connects the living room to the exterior of this waterfront home in the San Juan Islands.
Photograph by Steve Keating

Bottom Left: The entry's combination of natural materials sets the tone for the home.
Photograph by Steve Keating

Facing Page Left: A suspended ramp unites the upper floor of a Seattle house to a light-filled living, dining and kitchen area.
Photograph by Steve Keating

Facing Page Right: This glowing stair tower connects a play barn to an upper recreation area by way of an outdoor bridge.
Photograph by Steve Keating

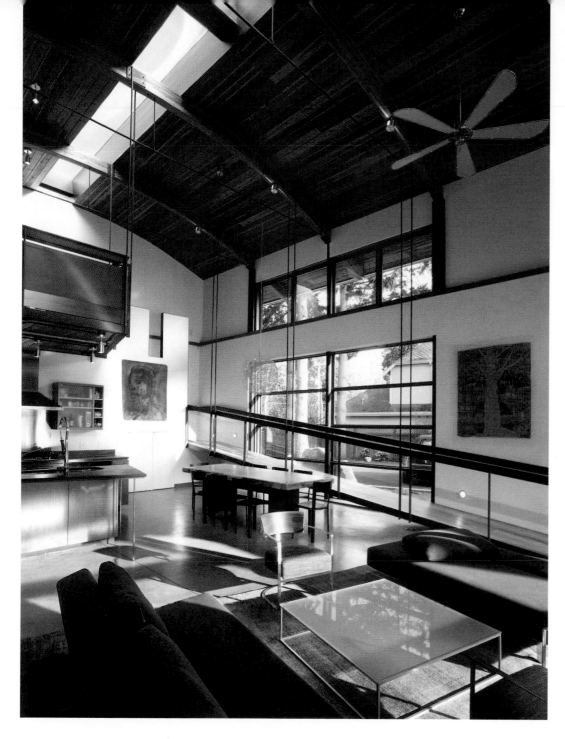

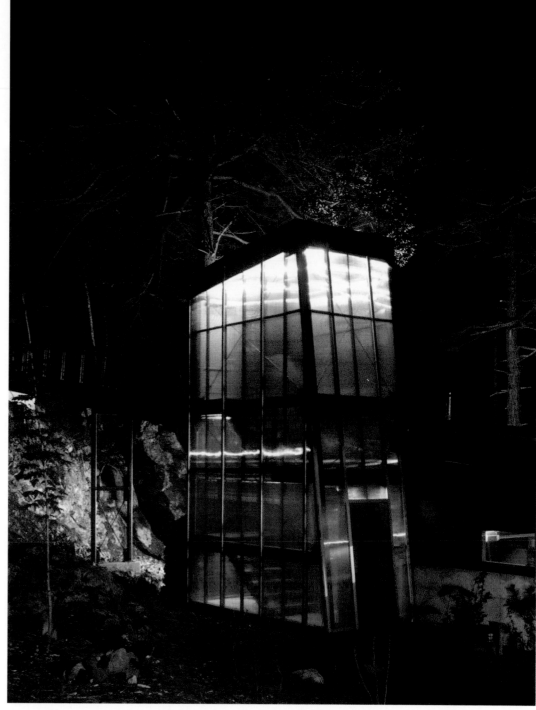

foster awareness of available measures for efficient building design and energy conservation. He lends this expertise to residential clients, encouraging them to choose recycled and reclaimed materials and build smaller homes, reducing their ecological impact. Additionally, the firm is dedicated to creating healthy homes, choosing low-VOC materials and improving indoor air quality to promote clients' physical health as well as their quality of life.

As the firm's name suggests, the key to a successful home is balance. Climate, context and client's goals—criteria Tom dubs "the three Cs"—must harmoniously blend to yield designs that meld utility and beauty. In creating a symbiotic relationship between the built and natural environments, Balance Associates creates homes that enhance their majestic settings.

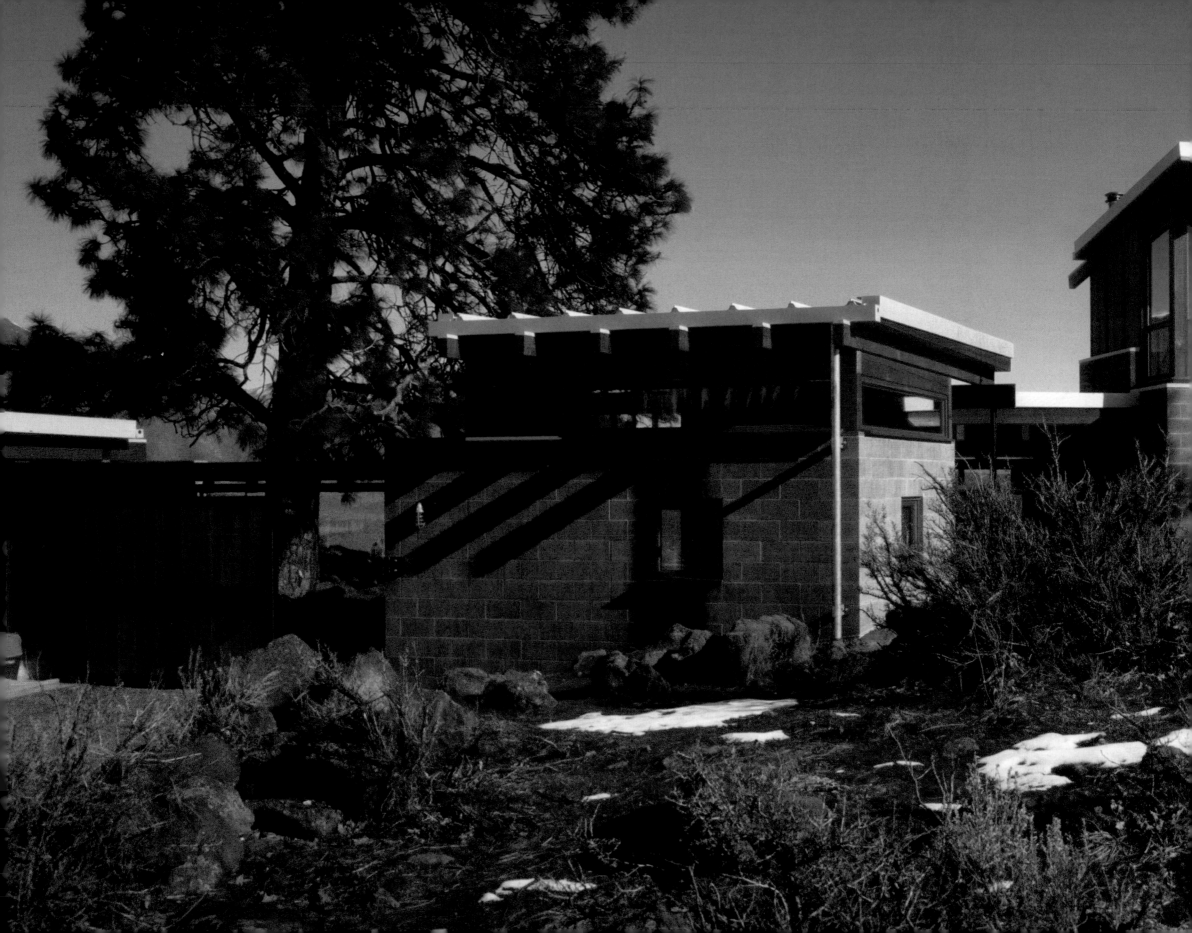

DAVID MILLER
ROBERT HULL
NORMAN STRONG
CRAIG CURTIS

Miller | Hull Partnership

Time in the Peace Corps catalyzed the formation of the Miller | Hull Partnership. Planning and constructing schools in Afghanistan for four years and community buildings in Brazil for two years respectively, Robert Hull, FAIA, and David Miller, FAIA, learned a great deal about the true nature of intelligent and socially responsible design. Often working in regions that lacked power, the architects devised natural methods of heating and lighting, positioning outdoor classrooms against heat-retentive mud walls for winter warmth, creating large wind scoops on the school roofs to capture the cool air from the north in the hot summers and using affordable mud brick strengthened with cement. This foray into solar design proved invaluable when the two founded their firm during the energy crisis in the late 1970s.

Left: Nestled into the rock and sagebrush of the high desert in eastern Washington, the design takes advantage of rugged masonry and reclaimed timber from an old apple warehouse.
Photograph by David Livingston

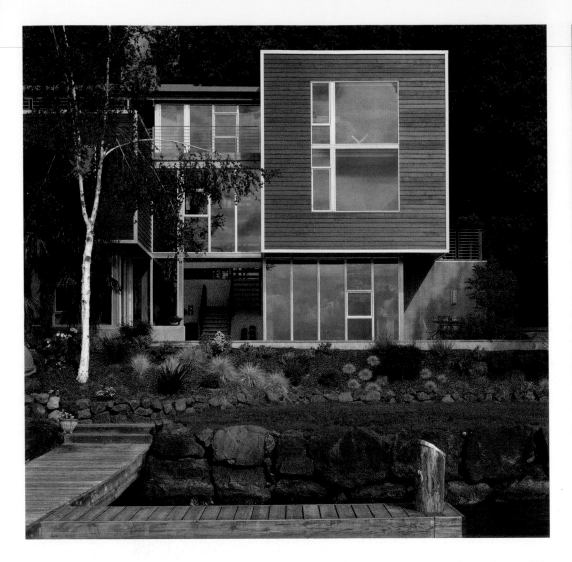

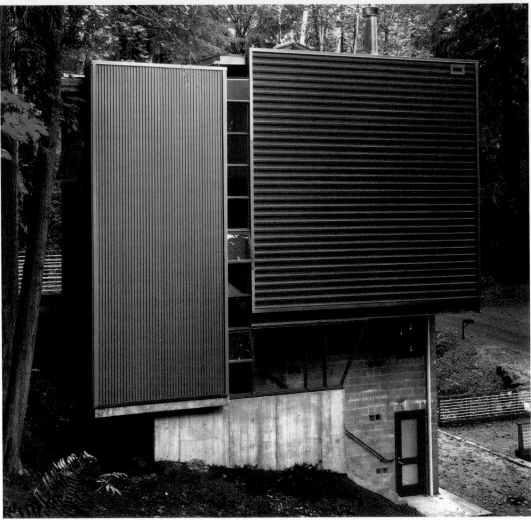

Since its formation, the firm has grown to house partners Norm Strong, FAIA, Craig Curtis, AIA, and a team of more than 50 architecture professionals devoted to environmental and social stewardship. The team has completed projects across the country, serving a variety of functions while expressing a distinctly modern aesthetic. While public projects comprise the majority of the firm's commissions—70 percent involve public funding—the partners consider their residential work fundamentally important. In its residential projects, the team experiences the most conceptual breakthroughs. As they are smaller and privately owned, homes present opportunities for greater creative latitude, and innovative design elements readily take shape.

Moreover, residential architecture informs the firm's other projects. Indeed, the architects frequently find themselves designing a home and a public project simultaneously, and Bob maintains that

there is little difference in the design of the two. In each, the architecture serves to provide comfort and protection, relate to its context and respond to environmental and climate concerns. Often, the same design solution proves mutually effective. When the firm designed a private cabin and a corporate cafeteria at the same time, it found that creating a solid core for the private spaces— in the cabin, the bunks and baths, in the cafeteria, the kitchen—and a transparent shell for the public living and dining areas worked as well in the former as the latter. While the projects were of different scales and served separate functions, the design successfully served the needs of both.

Above Left: Large wood-clad boxes house private functions. A glass-enclosed stair with entry from above leads to the ground-floor living functions and lake-level activities.
Photograph by David Livingston

Above Right: Concrete forms deeply inserted into a steep, forested hillside contrast the lighted metal features above that open into the site.
Photograph by David Livingston

Facing Page: A mix of materials such as steel and concrete set off the warmth of furniture to create an active ambience.
Photograph by David Livingston

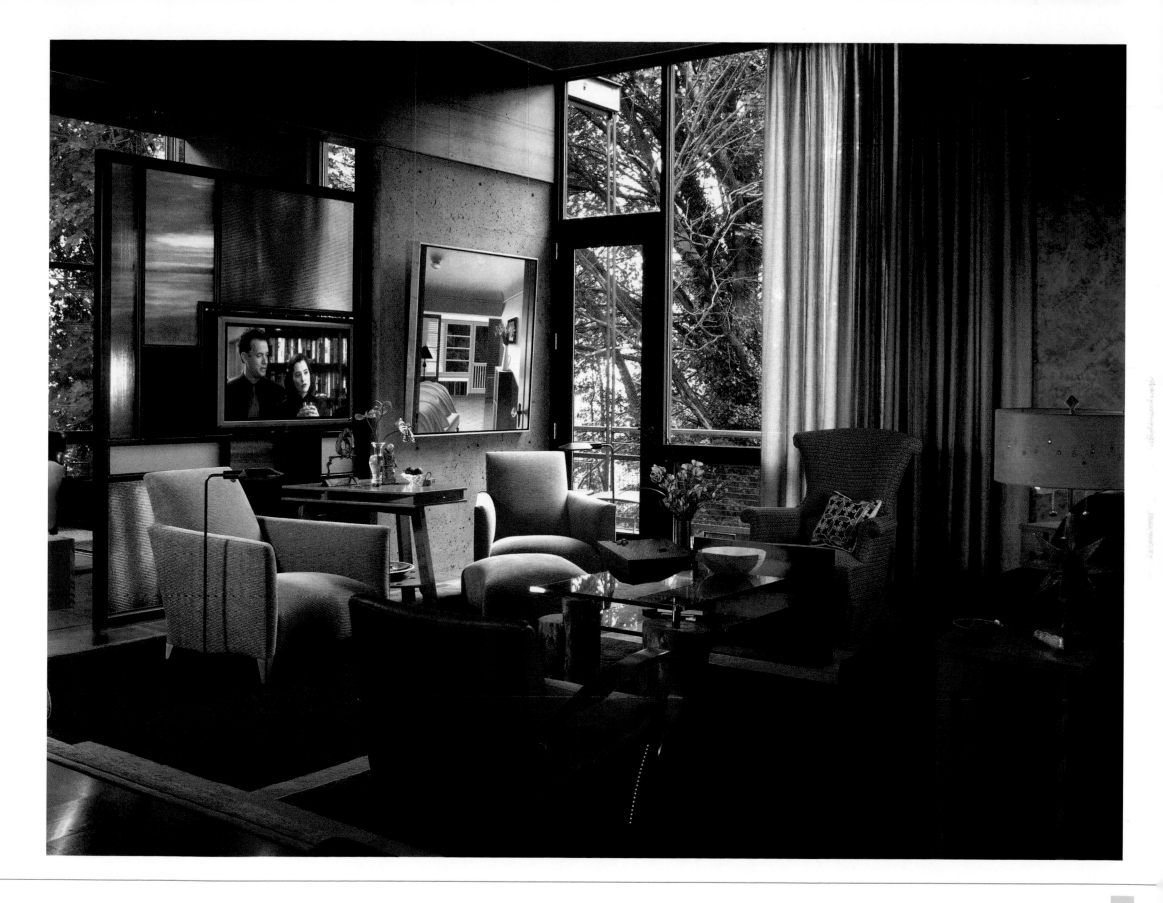

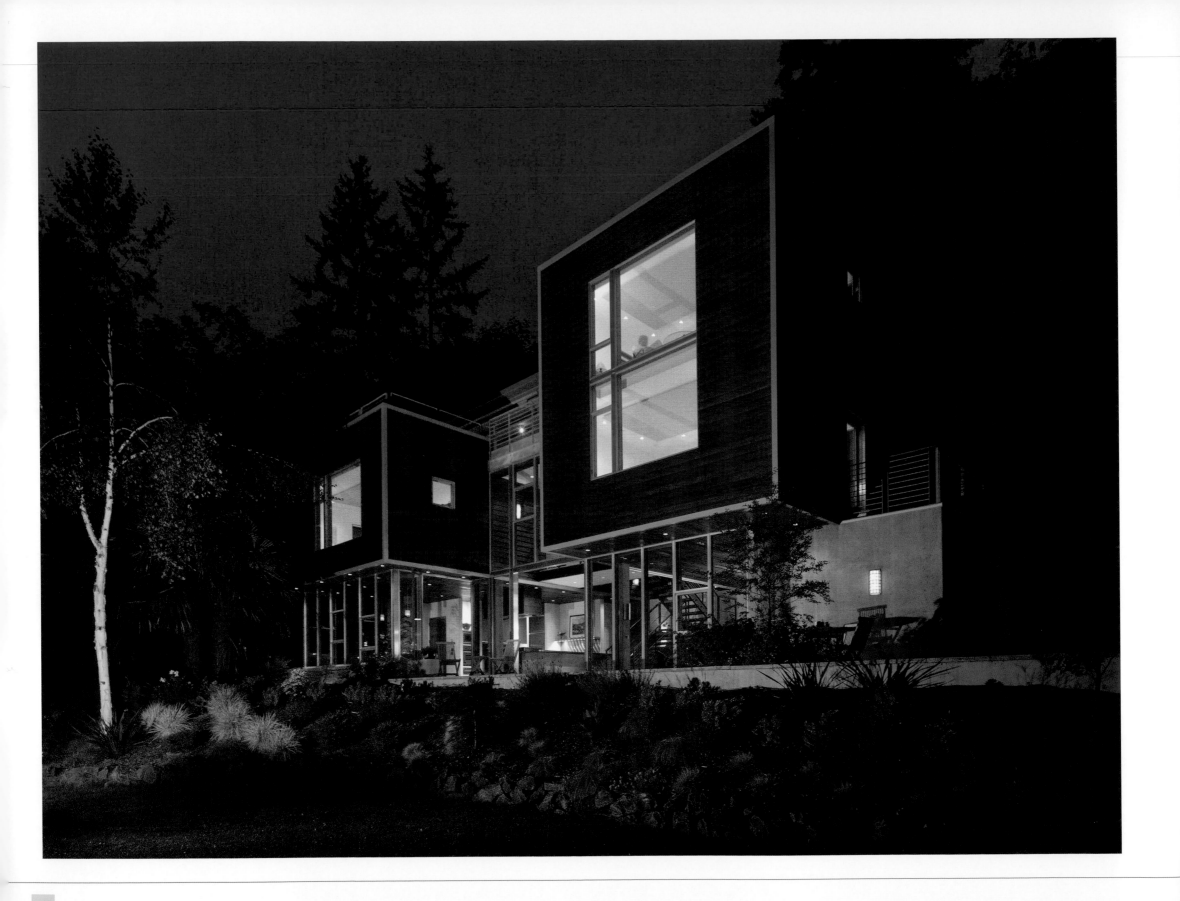

In all projects, the firm works to foster a sense of place. Whether in a city or on an island, the structure is indelibly shaped by its site. The partners fully explore each project's location, allowing it to reveal its particularities. The Pacific Northwest offers abundant natural features—beautiful views of mountains and lakes, lush hillsides and old-growth trees, to name just a few—and the team takes advantage of as many of these elements as possible, creating architecture that enhances rather than compromises the existing beauty. The team has snuggled homes around trees, built them into the sides of rock outcroppings and designed them around foliage crucial to the stability of surrounding hills—all to the benefit of the design and the landscape, alike.

The team's efforts to preserve and utilize the sites' offerings go hand-in-hand with its philosophy to build small and smart. The architects encourage residential clients to live in smaller homes and avoid the prevalent tendency to create a room for every function. An 850-square-foot home can live much larger than its actual size if designed efficiently, and the Miller | Hull team's work testifies to this fact. The architects utilize the landscape, thoughtfully positioning openings to capitalize on connectivity to the outdoors and often creating rooms just outside a structure's skin. Visually and physically extending interiors beyond the walls evokes a sense of magnitude while imposing a minimal footprint.

The firm's efforts have garnered widespread media attention, and numerous publications display and discuss its work. Upwards of 170 design awards, including four National AIA Committee on the Environment's "Top Ten Green Project" awards, bespeak the team's talents. But far more than praise, passion drives the architects forward—a passion to consistently better their community, their region and modern architecture, itself, through good design.

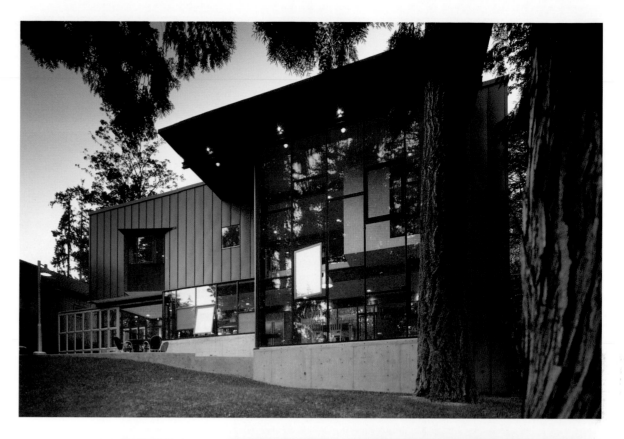

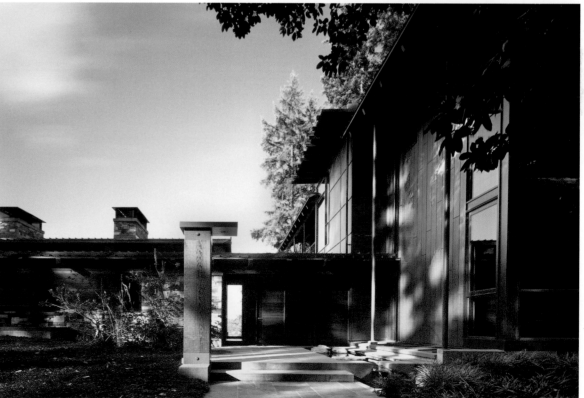

Top Right: Large overhangs and the sun protection provided by large fir trees allow expansive views and transparency.
Photograph by David Livingston

Bottom Right: Reclaimed timbers and clear cedar from an existing tree on site provide warmth for this Northwest home.
Photograph by David Livingston

Facing Page: The ground floor social functions open out onto the site to create active outdoor living areas.
Photograph by David Livingston

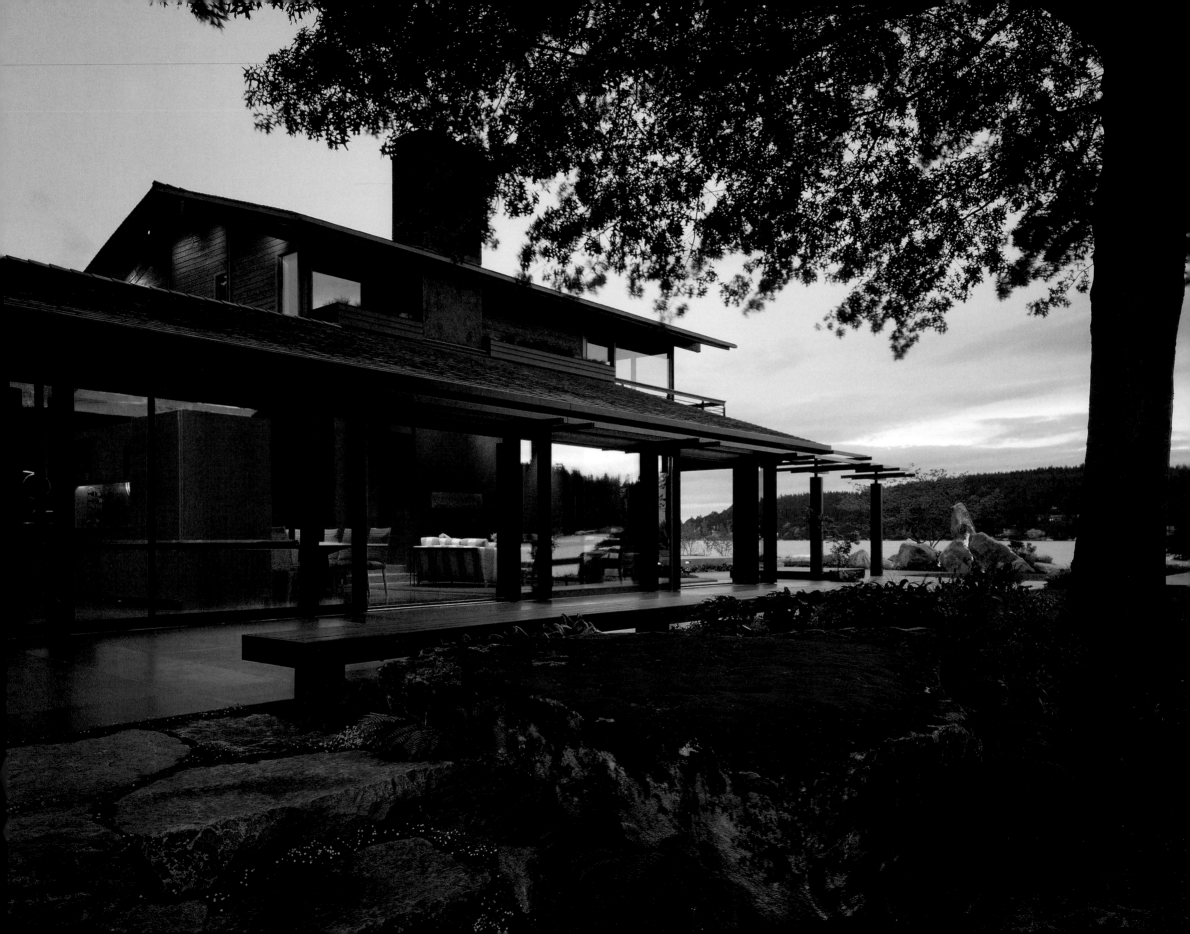

Jim Olson
Rick Sundberg
Tom Kundig
Scott Allen

Olson Sundberg Kundig Allen Architects

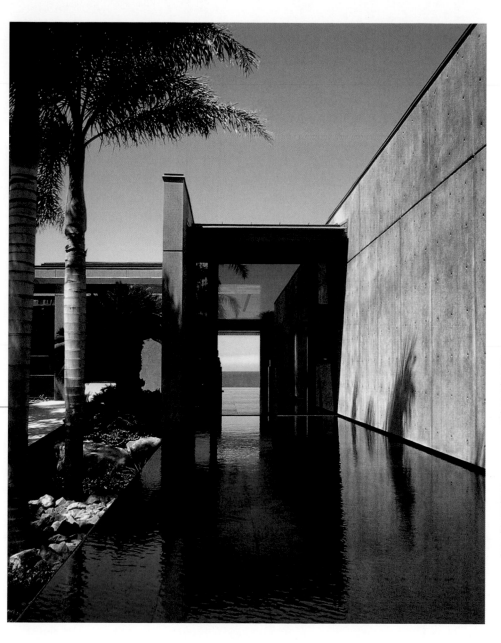

Above: Axial views orient the viewer to the house and the house to its setting.
Photograph by Jim Olson

Facing Page: Large expanses of glass and sliding doors open the inside to the outside.
Photograph by Farshid Assassi

Just as the firm's architecture harmoniously melds with its environment, Olson Sundberg Kundig Allen Architects is a name that resonates with shelter professionals and aficionados of architecture throughout the country. Founded in 1966 by Jim Olson, FAIA, the firm has grown to house some of the most gifted and well-known architects the world over. The firm's partners—Jim, Rick Sundberg, FAIA, Tom Kundig, FAIA, and Scott Allen, AIA—lead a team committed to architectural exploration and innovation, arriving at structures that are at once attentive to context, craft and contemporary principles.

Common to all of Olson Sundberg Kundig Allen Architects' projects is a sensitivity to regional conditions. Each partner is a Washington native and is deeply invested in preserving the area's rich environment. Climate, topography and foliage inform each design so that homes become one with their

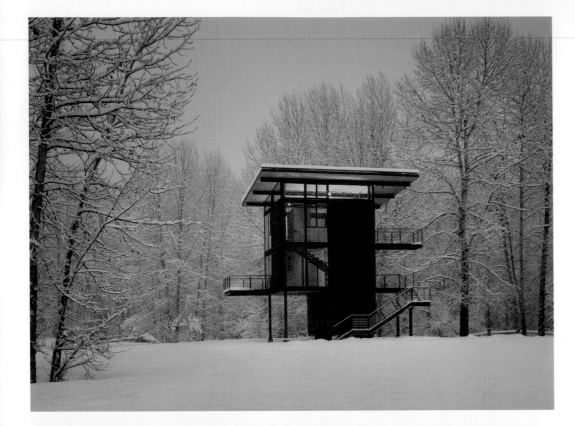

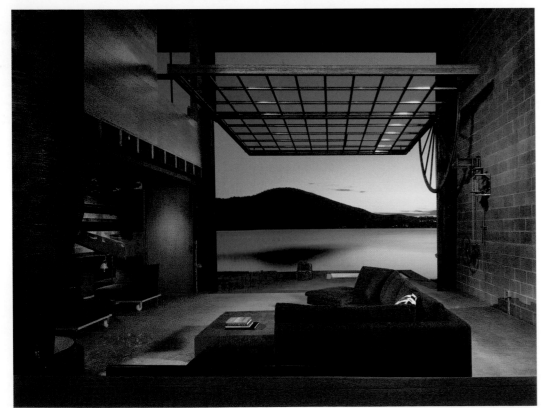

surroundings, as though at once shaped by man and nature. Collectively adhering to the principle that materials should appear in their original states, the firm celebrates the essence and warmth of the natural materials abundant in their designs. Wood, concrete and stone create comfortable, welcoming dwellings, as do the firm's efforts to capture and capitalize on sunlight, a precious commodity with the Northwest's long winters and wet weather.

While the firm's projects share these attributes and the architects are rigorous in their efforts to revise and refine one another's designs—at weekly "crits," the team examines current projects and openly shares ideas and suggestions—each partner works independently, blending his unique expertise with the firm's philosophy to create aesthetically original, regionally responsive forms. Indeed, the partners' disparate interests have come to define the firm. Jim holds that a home is itself a working background for natural and manmade art: Windows frame the exquisite views, just as walls provide space for artwork. Homes thus need be subtly expressed to enhance rather than compete with the beauty around and within them.

Rick Sundberg's blend of art and architecture derives from his emphasis on craft. Hailing from a family of Swedish contractors, Rick developed a profound appreciation for things handmade. His deeply embedded passion helps define the firm's identity—Olson Sundberg Kundig Allen Architects has long worked with talented craftsmen and designs custom pieces as often as possible. Tom Kundig takes custom design a step further. Known for architectural features that move, Tom is adept at poetically blending function and tectonics to create visually and tactilely engaging homes. Skylights open via water pressure, window walls open to the landscape via pulleys—mechanical devices become essential aesthetic elements.

At the core of the firm's exploration is the client. Scott Allen is quick to point out that once the architects have distilled the particularities of the sites, they must work to express their ideas in the voices of their clients. This process is complicated, and Scott maintains that one must allow each design to emerge slowly, fostering its gestation until the time comes to bring it into being. Widely recognized by industry leaders and publications alike, Olson Sundberg Kundig Allen Architects has undoubtedly mastered this process.

Top Left: The cabin opens to views on all sides. Exterior materials are allowed to weather, merging the cabin with its environment.
Photograph by Tim Bies

Bottom Left: The large, operable 20-foot by 30-foot window wall dissolves the line between inside and outside.
Photograph by Benjamin Benschneider

Facing Page Left: Natural materials are left as unfinished as possible to reinforce connections to nature.
Photograph by Benjamin Benschneider

Facing Page Right: A bridge element allows the landscape to flow through the architecture.
Photograph by Paul Warchol

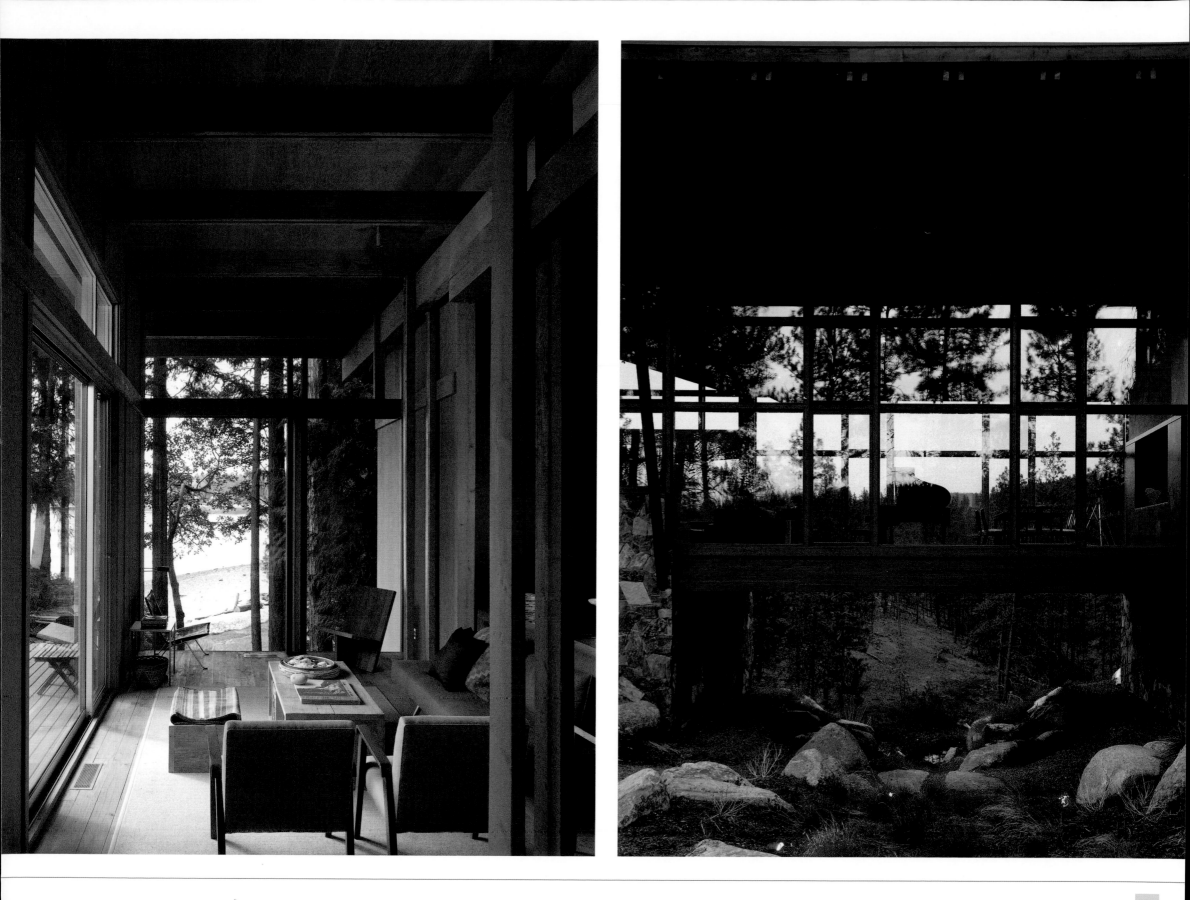

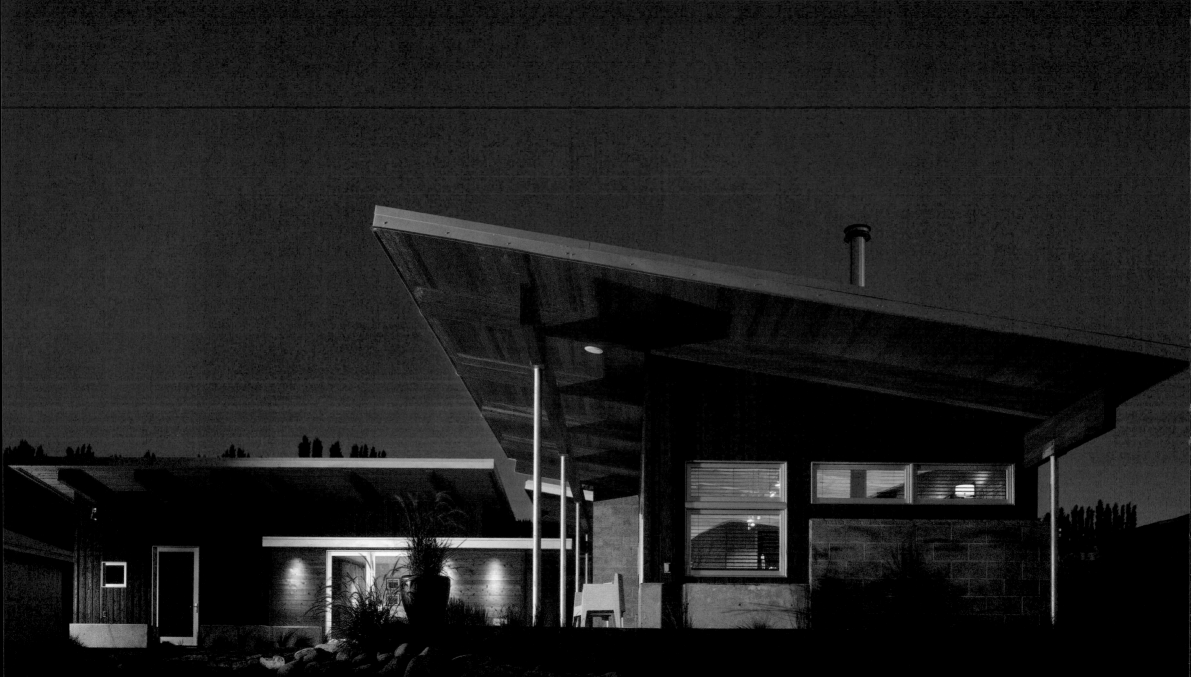

SHANNON RANKIN
KYLE C. GAFFNEY
BRIAN COLLINS-FRIEDRICHS
DOUG McKENZIE

SkB Architects, Inc.

Above: The concrete block tower signifies the main entry and houses a modest-sized master bedroom above, affording views of the Columbia River.
Photograph by Ben Benschneider

Facing Page: Large roof overhangs create the sense of outdoor covered rooms and shield the cabin from the hot summer sun in eastern Washington.
Photograph by Ben Benschneider

For the principals of Seattle-based SkB Architects, Inc., building design is an integrated process: Exterior architecture and interior design, often considered separate entities, form a unified whole and should thus be designed by the same design professional. The firm's three founders, Shannon Rankin, Kyle Gaffney and Brian Collins-Friedrichs, have long adhered to this philosophy—indeed, their shared conviction was the catalyst for their breaking from the firm at which the three met to form their own in 1999. Now 21 strong, SkB has grown to include a fourth principal, Doug McKenzie, and has built a practice on the foundation that acute attention to detail and a complete approach consistently yield excellent design.

The notion of unity extends to the firm's mode of operation as well, and the principals insist that a project is not the responsibility of an individual but of a team. Adamant that collaboration and critique are key to a project's evolution and refinement, the SkB team works as what the principals like to call a "design brain trust," reviewing and revising one another's ideas. While Modernists at heart, the architects base their palette on the demands of the sites and the goals of their clients. Due to the region's often cooler, gray weather, Seattle residents lean toward warm, natural materials with an emphasis on natural daylight. SkB takes these materials and principles and manifests them into Modern designs. The firm's clients thus become an integral part of the design team, helping shape the structures they will eventually inhabit.

Furthering the firm's pursuit of excellence, SkB does not limit its talents to a single type of work, positing that continually creating structures that served one purpose could lead the team to predetermine solutions and, in essence, design by rote. Instead, the firm works within many different market sectors, designing single- and multi-family homes, corporate offices and spas, to name but a few. This knowledge of different genres and market-sector trends informs each design, thereby keeping ideas current and forward-thinking. Commercial structures become more approachable and comfortable. Homes are infused with the technological innovation of a corporation and the luxury of a resort. Designs and clients benefit alike.

Left: Bamboo, river rock, a concrete pier and a fir screen combine to form a sculptural entry sequence.
Photograph by Ben Benschneider/Seattle Times

Facing Page: An expansive window wall allows views of downtown Seattle and affords lots of natural daylight to the public spaces.
Photograph by Ben Benschneider/Seattle Times

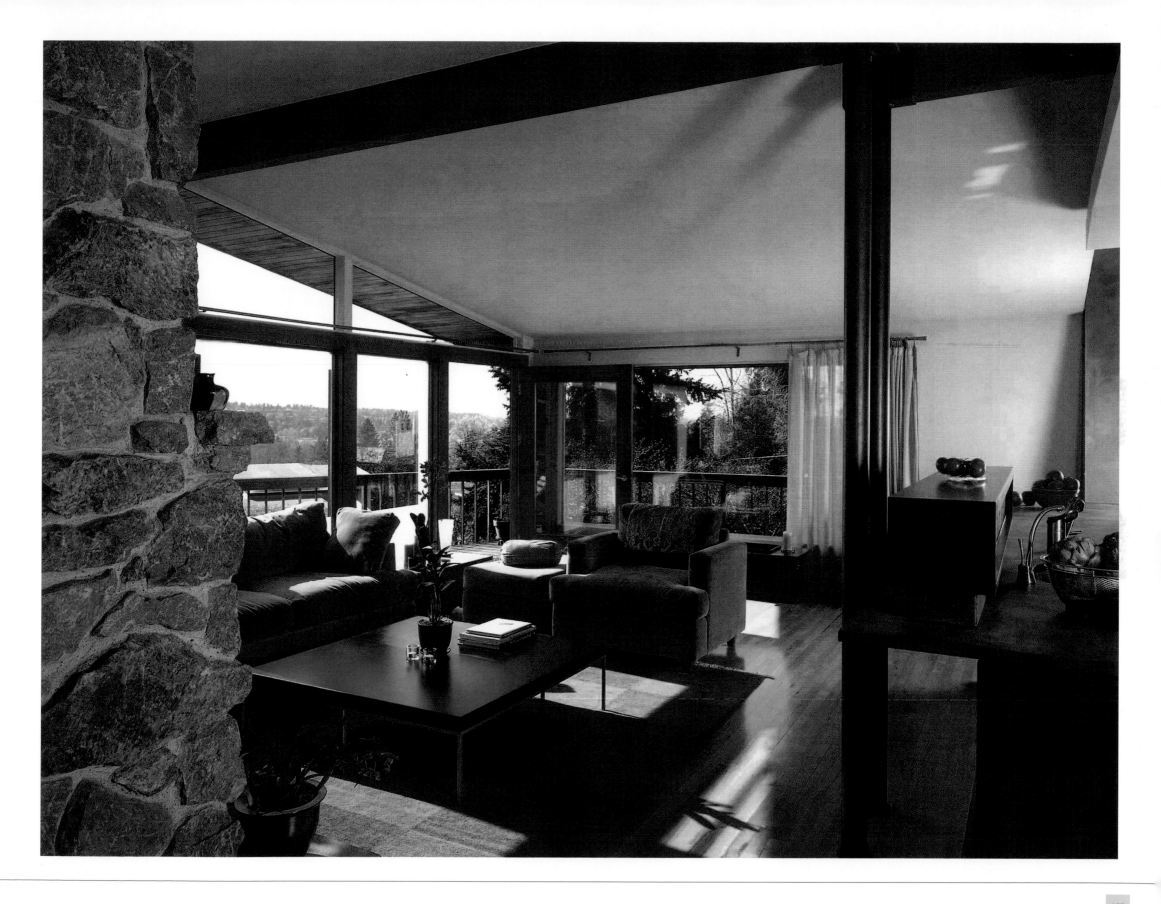

Maintaining that material quality is central to the human experience, the firm explores their composition and function in its structures to imbue a humanistic feel. Every project is not only investigated in terms of spatial relationships but refined through the subtle integration of specific materials, colors, textures and lighting. The principals will even go so far as to push manufacturers to develop and customize their products to better blend with SkB's overall design vision. The intent is to create an atmosphere that dovetails with the clients' goals and encourages personal interaction.

The true hallmark of SkB's work is the team's total design approach. Indeed, the architects' extensive knowledge of and passion for interiors as well as exteriors sets the firm apart, and they design many projects both outside and in. This enthusiasm has led the team to add product design to its repertoire in addition to helping clients with the selection of interior fixtures, furniture and accessories. The firm's unique approach has been well received, with its work gracing the pages of national and regional publications such as *Metropolitan Home*, *Interior Design*, *Sunset*, *Residential Architect*, *Custom Home* and the *Seattle Times*. For SkB Architects, design is design: No matter a project's size or type, the team creates places of resonance.

Top Right: A textural stacked-stone curved wall affords privacy from the street and creates an art gallery inside.
Photograph by John McKinney

Bottom Right: Walnut floors and stacked stone against crisp white exterior walls create a modern but tactile entry foyer with a spectacular view of Elliot Bay.
Photograph by John McKinney

Facing Page: The cantilevered dining/work table, composed of blackened steel and wenge wood, is a social gathering spot for the modest combination kitchen/dining/living room. The tile backsplash becomes "art" for the room.
Photograph by Ben Benschneider

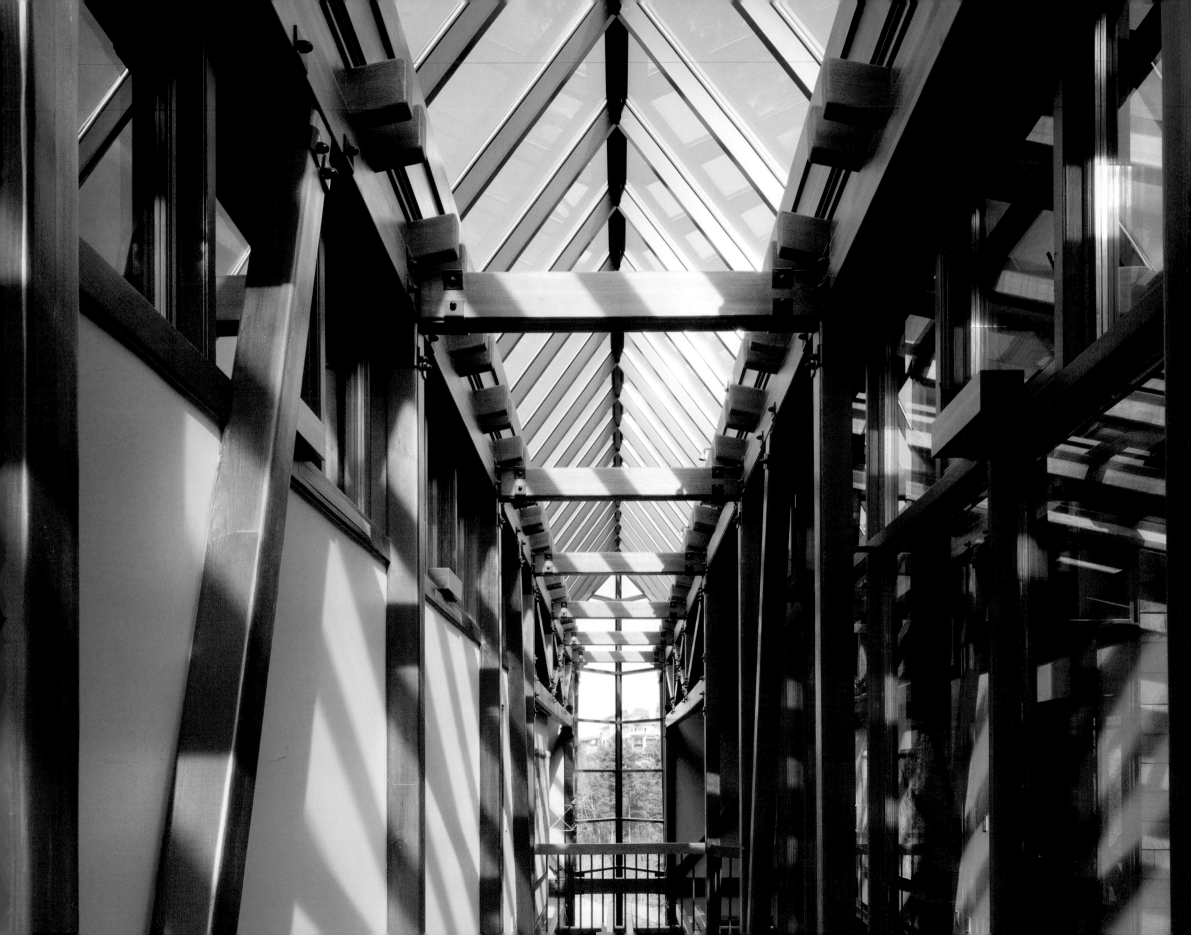

OWEN ROBERTS

Owen Roberts Group

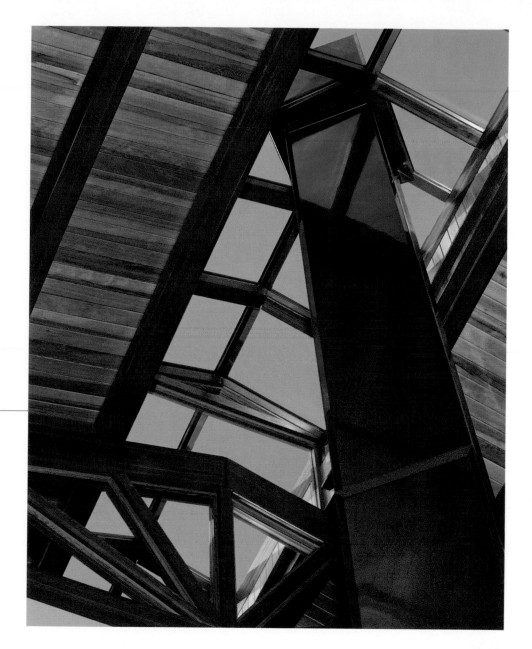

Above: A custom copper-clad chimney rises up through a two-story space and out of a ridged skylight.
Photograph by Sam Van Fleet

Facing Page: The skylight at the roof peak of this contemporary timber-frame home turns and drops down at both ends, terminating at the lower level.
Photograph by Mike Seidl

Recently, the principal and the general manager of Owen Roberts Group were both asked to write down what they believe sets them apart from other builders. Without consulting each other, they answered with the same word: honesty. Honesty is the first of four guiding principles to which Owen Roberts Group invariably adheres. Keen attention to detail, clear communication among team members and a dedication to accuracy comprise the other three. These principles ensure that the firm always provides the highest possible quality and value to every client.

Third-generation builder Owen Roberts founded the company in 1988. Begun as a one-man shop, Owen Roberts Group now employs a talented staff of between 20 and 30, many of whom have been with the firm for 10 years or more. The company fosters long-term relationships with like-minded designers and

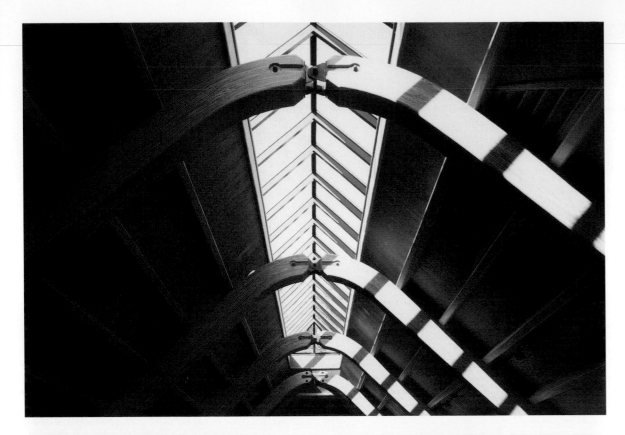

subcontractors, and the integrity of each individual involved in an Owen Roberts Group project is fundamental to the firm's success. Owen remains personally involved and lends his years of experience as a carpenter, supervisor and subcontractor to all phases of construction. In addition to the intimacy and personal attention of a small business, each Owen Roberts Group client enjoys the organization and resources more typical of a large commercial company. Sophisticated project management systems and well-developed industry connections mean that homeowners can rest easy in the confidence that Owen and his teams have ample skill and business acumen to bring any project to fruition.

Owen Roberts Group completes seven or eight unique projects in the Greater Seattle area each year. Because it works with a variety of architects, the company is equally skilled in a wide array of architectural genres—from Traditional to Contemporary, Shingle style to Tuscan. This expertise ensures that unusual techniques and special requests will be easily and gracefully achieved.

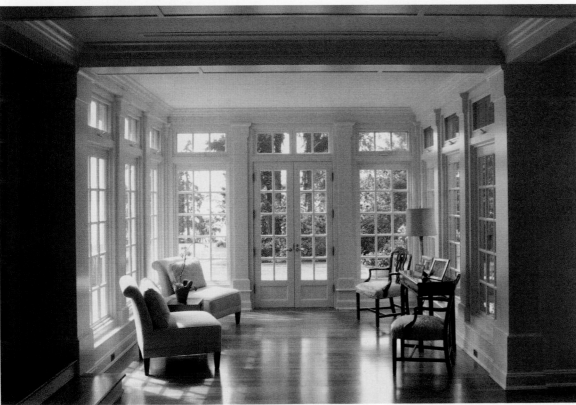

Top Left: The gracefully arched, heavy timber roof structure defines this Arne Bystrom-designed home.
Photograph by Laurie Black

Bottom Left: The detailing of this Tom Bosworth-designed addition draws its inspiration from the original home, designed by Arthur L. Loveless and built in 1928.
Photograph by Mike Jensen

Facing Page: With its stained and polished concrete floors, antique buffet and hand-hewn timber ceiling, this Bob Hoshide-designed home is casually elegant.
Photograph by Sam Van Fleet

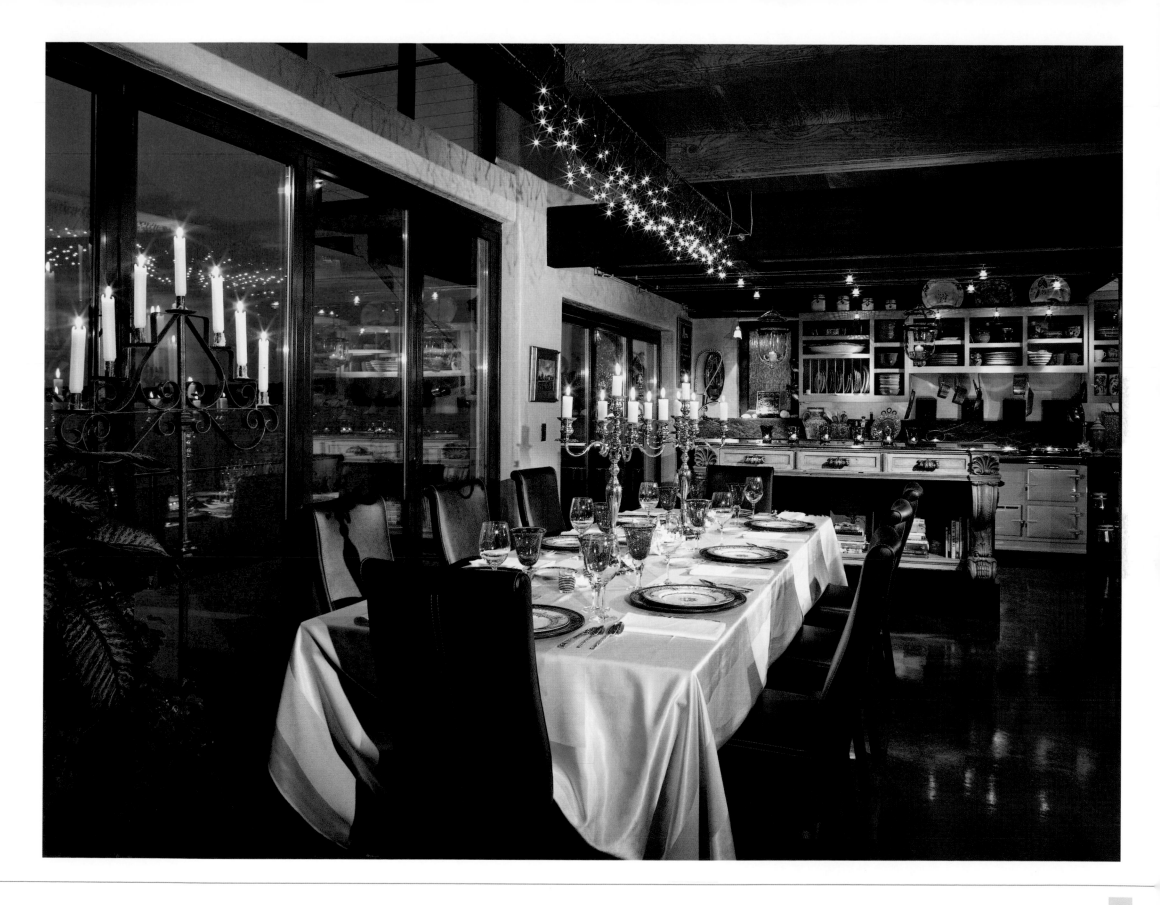

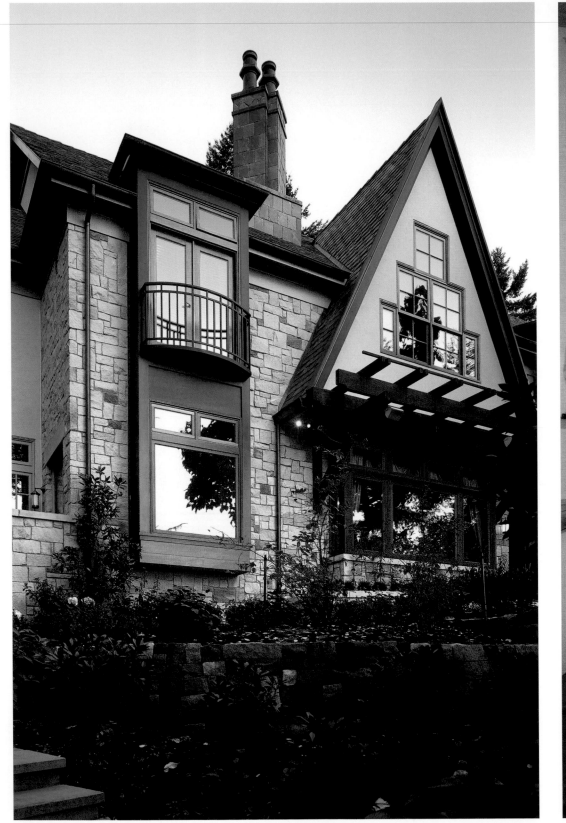

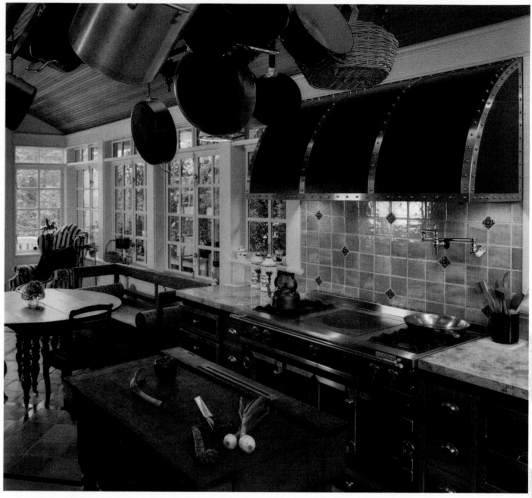

Furthermore, Owen Roberts Group is continually seeking to improve its skills and methods, and as a result the firm is at the forefront of environmentally sustainable building. Because of his concern for both the community and the customer's bottom line, Owen Roberts was building Green long before it was known as such. Owen, now a member of the King County Built Green program, explains that many of the products and procedures hailed for sustainability and low environmental impact also greatly benefit clients' budgets. For many years the firm has recycled rather than dumped home-demolition waste materials, reducing contributions to the landfills and also cutting the cost of disposal by as much as half—a savings that is passed on to the client. Owen is teamed with a geothermal heating subcontractor to provide alternative methods of heating and cooling homes. An excellent means of conserving energy, geothermal heat is also more economical for homeowners because it greatly reduces utility bills. The low operating expenses completely pay back the extra initial cost in less than a decade.

Owen Roberts Group develops and executes detailed project budgets and schedules using a combination of reliable management systems and years of personal experience. The firm's skill, precision and enthusiasm for creative solutions to the challenges of construction guarantee that

Above Left: This heavy beam passes cleanly through an exterior window. Expert craftsmanship is required to make such an unusual detail both functional and beautiful.
Photograph by Sam Van Fleet

Above Right: A barrel-vaulted ceiling and French doors add a feeling of light and space to this James Castanes-designed kitchen.
Photograph by Michael Moore

Facing Page Left: Dynamic juxtaposition of shapes and materials gives this Sortun/Vos-designed home an Old World feel.
Photograph by Mike Seidl

Facing Page Right: Stairways should be integrated into a house so as to be comfortable to the hand, eye and foot. That accomplished, they become an inspiration, as this staircase vividly exemplifies.
Photograph by Sam Van Fleet

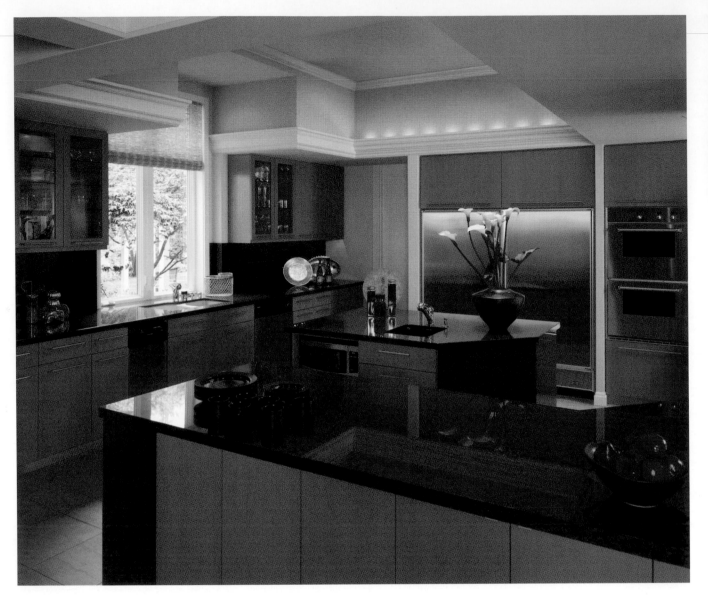

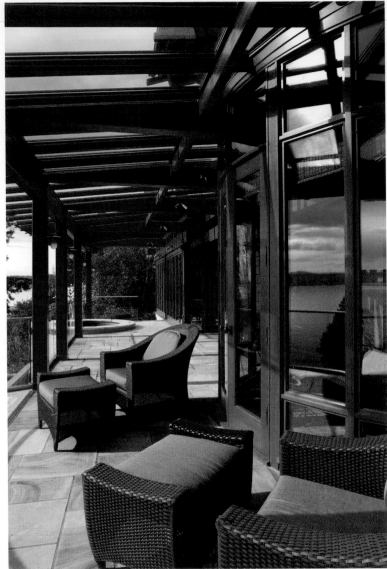

clients will gain the homes of their dreams. Superior craftsmanship ensures that those homes will last the lifetime of their owners—and beyond. The client is invited to participate in the building process at every phase. Owen maintains an open-book policy, presenting homeowners with receipts and frankly relaying expenses. The team educates homeowners about the building process and helps them to make informed decisions. The result is a superior product and a superior building experience for the homeowner.

Owen Roberts Group has been widely recognized for all-around quality by the likes of *Pacific Northwest Magazine*, *Puget Sound Business Journal*, *Custom Home* and *Custom Builder*, the last of which awarded the firm the distinction of "Builder of the Month—Splendid Vision." Although he is honored by these accolades, Owen most appreciates compliments from his

clients, who tell him time and again, "You told me that building my home was going to be fun, and I didn't believe you. You were right."

Above Left: The clean lines and sleek finishes of this contemporary Jack Odell-designed kitchen highlight the modern design without compromising comfort or practicality.
Photograph by Mike Seidl

Above Right: A covered outdoor living area extends the style of the interior into the surrounding environment and makes the most of a waterfront location.
Photograph by Sam Van Fleet

Facing Page: The stonework and timber of this lakeside home blend naturally into the Northwest landscape.
Photograph by Sam Van Fleet

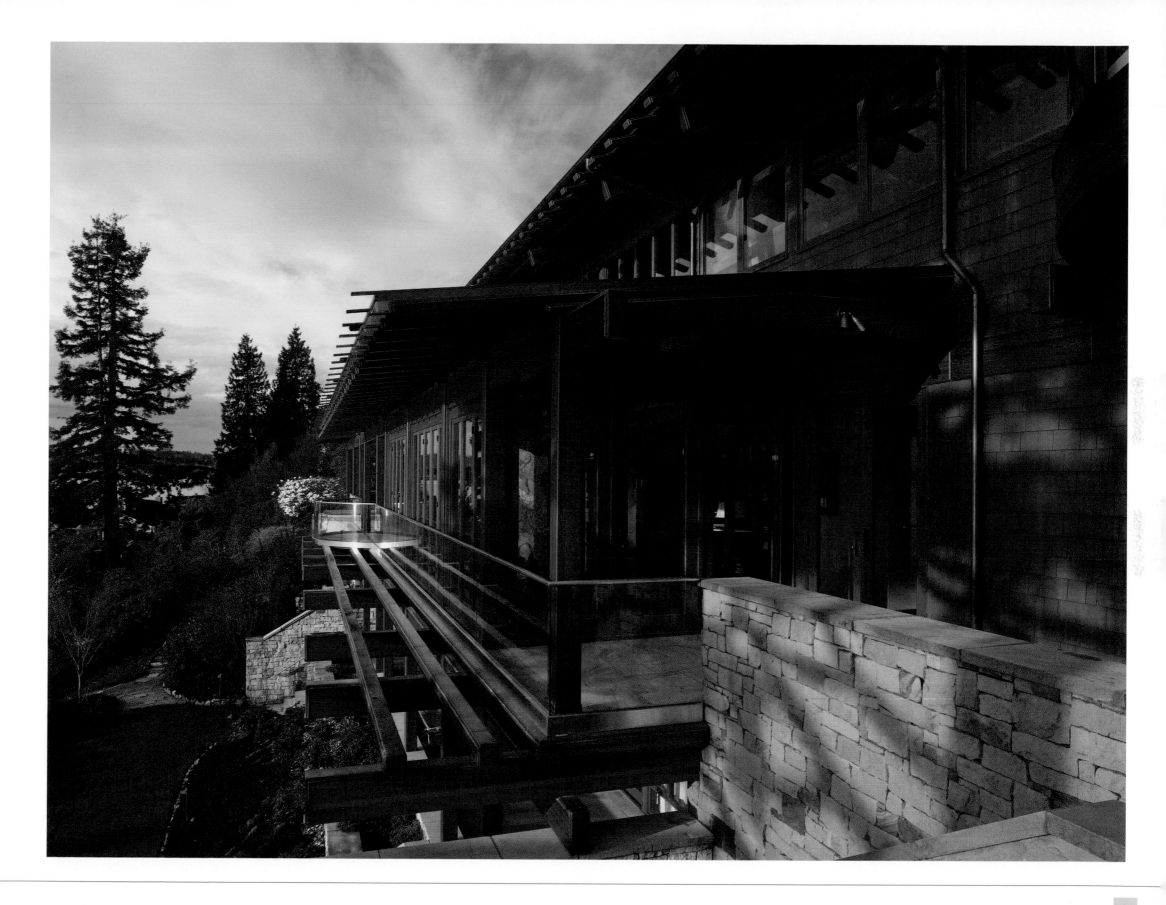

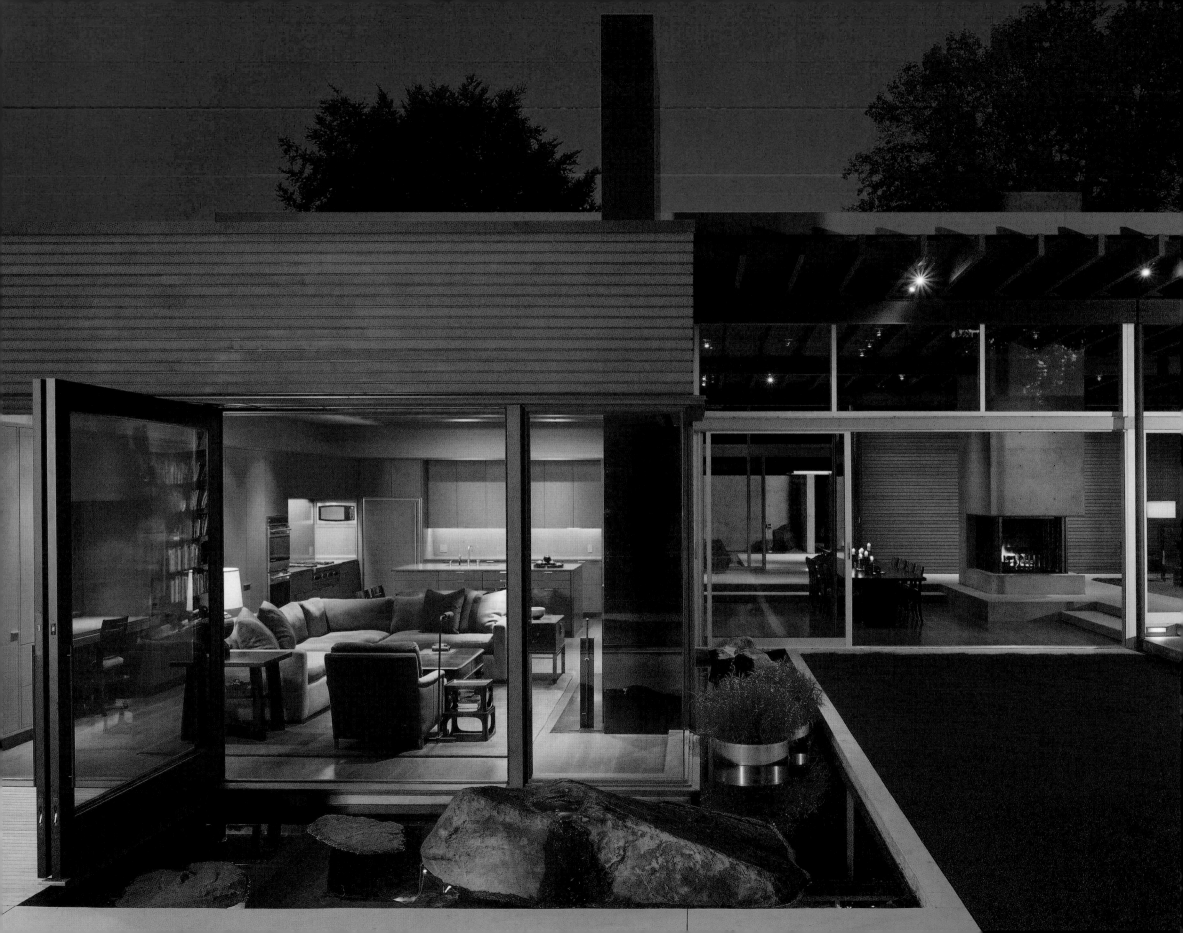

GEORGE SCHUCHART
JIM DOW
JOHN HOEDEMAKER
JOSEPH YOUNGBLOOD

Schuchart/Dow, Inc.

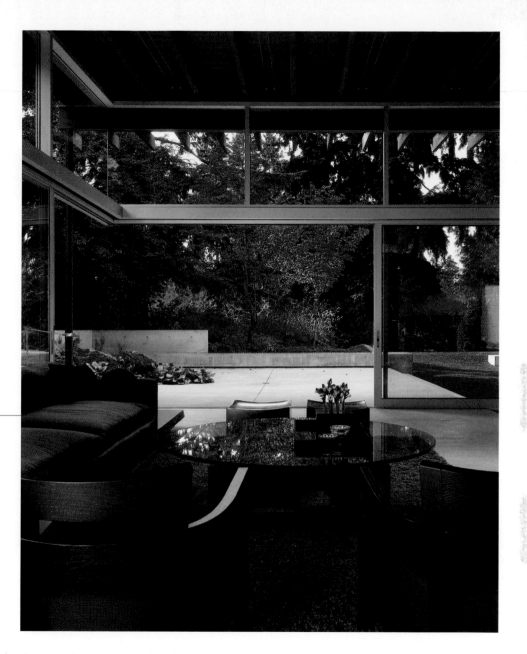

Above: To enhance views across the rolling green of the golf course beyond, the house was sunk into the terrain.
Photograph by Ben Benschneider

Facing Page: Designed to create a seamless transition from the interior to the outside, the central great room is surrounded by three "boxes": master, kitchen/family and guest rooms.
Photograph by Ben Benschneider

The principals at Schuchart/Dow love architecture. General manager John Hoedemaker hails from a long line of architects and pursued it himself in school. Partners George Schuchart and Jim Dow, along with John and operations manager Joseph Youngblood, commit themselves and charge their team of professionals to craft only the best and most interesting architectural forms. Yet Schuchart/Dow is not an architecture firm, but a team of 60 craftspeople and construction professionals dedicated to producing completely custom homes steeped in inspiration and artistry.

Founded in 2004, Schuchart/Dow is backed by the principals' 60 years of collective experience—George has a solid foundation of 30 years in commercial construction, and Jim, who began building at age 13, has equal years under his belt running a residential construction company. The two eventually

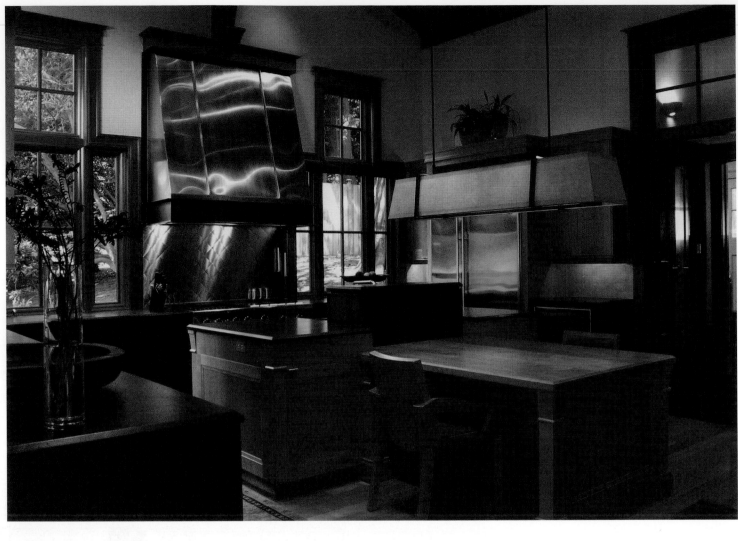

combined their talents to specifically focus on high-end homes. Their shared passion for structural beauty informs how they build their crew of superintendents, carpenters and laborers. They hire only the most talented and experienced individuals—a number of whom have earned architecture degrees—helping to ensure the precise execution and highest standard of excellence in every residential project they undertake. While the firm maintains a network of trusted subcontractors with whom they regularly team, the principals prefer to keep all aspects of construction in house as often as possible and work diligently to build just the right team for each architect and client.

Because the focus is on fine architecture and sophisticated craftsmanship, the work typically demands the skillful management of a rigorous process. Such highly complex designs necessitate very close collaboration between the contractors and architects, and here, the firm is in its element. The principals do not simply build from plans but help conceive of a home's plan, sharing their ideas with architects to arrive at a structure that embodies the combined vision of architect, contractor and client, alike. Architects appreciate the firm's active involvement, and the principals delight in their creative role.

Certainly collaboration is essential to the building phase as well, and the firm turns time and again to its pool of gifted craftspeople to fashion intricately detailed architectural elements. The principals have cultivated strong relationships

Above Left: The kitchen is the heart and soul of this home, a generous-sized and welcoming gathering place for family and friends.
Photograph by Michael Walmsley

Above Right: Located in Seattle's historic Lawtonwood neighborhood, this home sits on two lush, landscaped acres, featuring a natural stream and the city's first residential in-ground pool.
Photograph by David Kreutz

Facing Page: Environmental stewardship was a guiding principle of this project. Nearly the entire house was created using reclaimed wood—doors, windows, beams, cabinetry, trimwork and more.
Photograph by Michael Walmsley

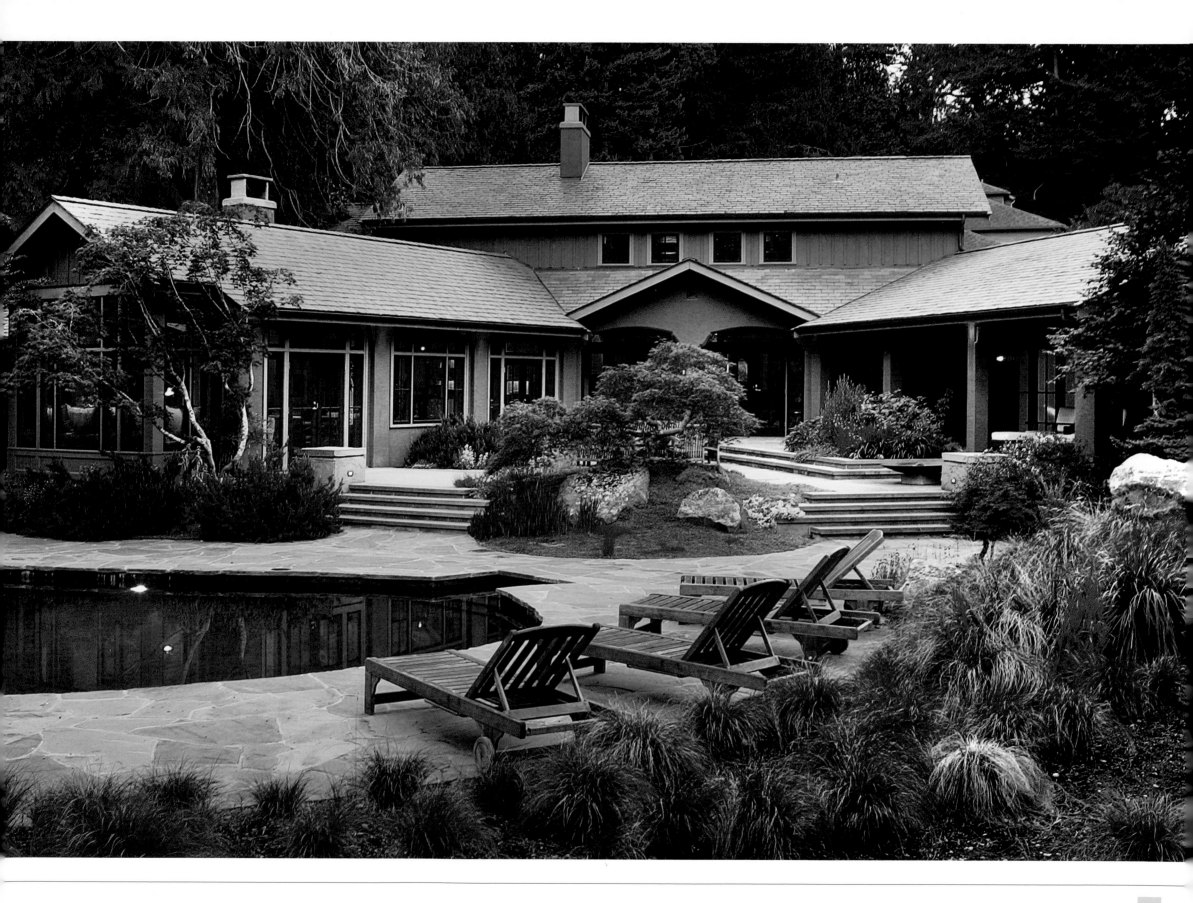

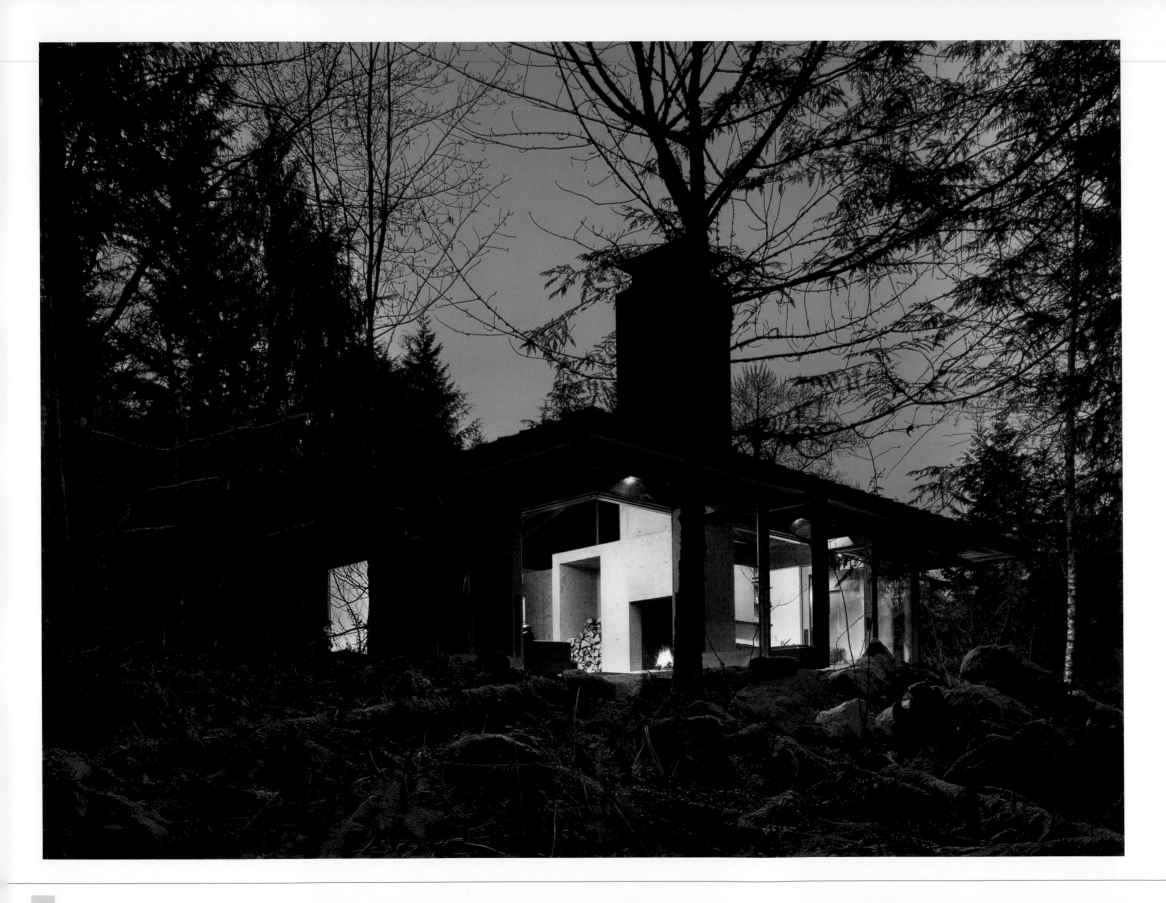

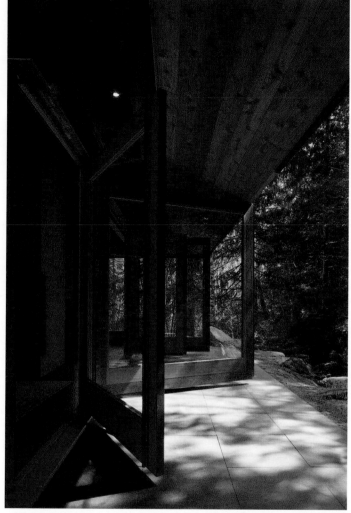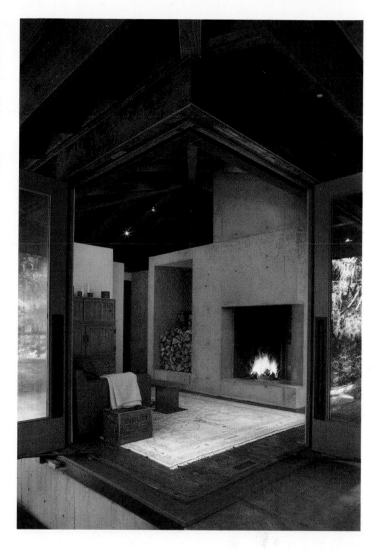

with the region's finest artisans and frequently call upon them to fabricate sophisticated and elegant pieces in wood, steel, marble and other high-quality materials. These artisans form an invaluable resource, helping Schuchart/Dow fulfill its obligation to build the most aesthetically rich homes possible.

It thus comes as no surprise that Schuchart/Dow has garnered a number of AIA awards for its projects, including personal residences for both Jim and George. Additionally, the firm's work has been featured in many publications. But George and Jim are quick to state that their motivation is not derived from

public recognition. It is a genuine love for their work that inspires the partners and their team, a love made manifest not only in their exceptional homes but in the level of excellence their associates embody.

Not long ago, Jim was on an airplane next to a very prominent architect with whom he frequently partners, heading home from an out-of-town project site. Jim asked the architect to describe the characteristics he seeks in a contractor. His answer was simple yet powerful: He works only with contractors who "get it." This assertion proved immensely gratifying to Jim, as it affirmed

his company's philosophy. While at the end of the day its homes must be functionally accurate, the team achieves this goal with flair and finesse. Its portfolio of work undeniably conveys that Schuchart/Dow "gets" architecture.

Above Left: Evoking the natural surroundings, the stairs are composed of reclaimed timber, concrete and steel.
Photograph by Tim Bies

Above Middle: Every door is also a window to the outside, dramatically enhancing the connection to nature.
Photograph by Tim Bies

Above Right: The poured concrete fireplace features a large firewood niche, evoking the rugged outdoors.
Photograph by Tim Bies

Facing Page: This cabin retreat was designed in harmony with nature, with a small ecological footprint and minimal impact on the surrounding environment.
Photograph by Tim Bies

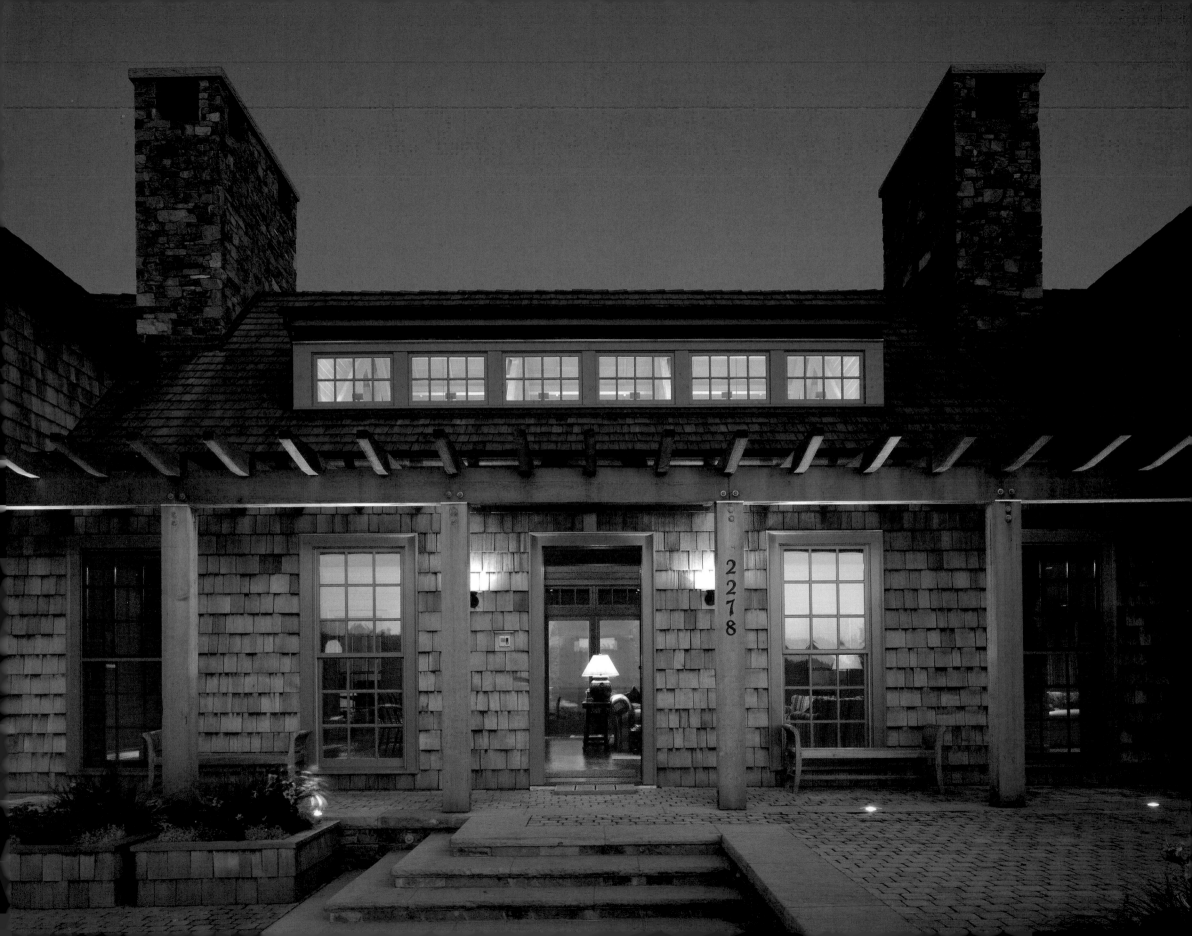

STUART SILK

Stuart Silk Architects

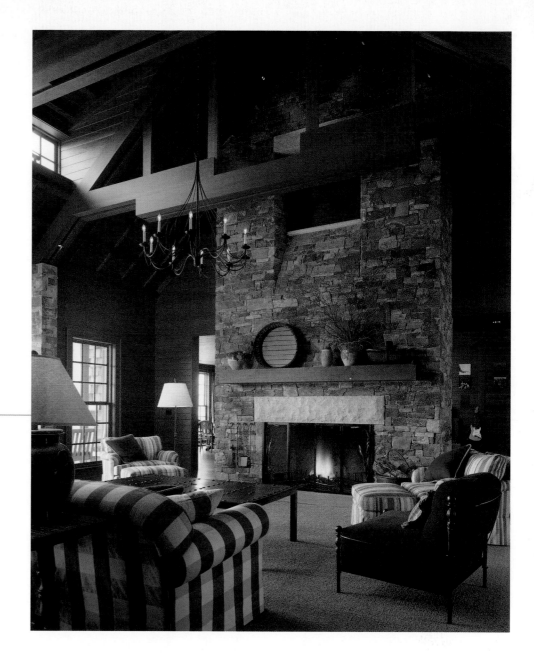

Above: Identical two-story natural stone fireplaces embrace the great room, as clerestory windows draw in daylight. The dramatic ceiling is detailed with clear fir trusses and a crossed pattern of purlins. Located on 10 acres with a beach, the residence has sweeping views of Puget Sound and the mountains.
Photograph by Ben Benschneider

Facing Page: Carefully proportioned, double-hung eight-foot windows flank the entry to this Whidbey Island beach house, allowing views through the home to the water. Regionally quarried stone complements other natural materials, such as weathered shingles and cedar beams and columns.
Photograph by Ben Benschneider

Extensive travel throughout the United States and abroad in his youth proved a seminal experience for Stuart Silk, AIA. An art history enthusiast, his mother exposed Stuart to indigenous art and architecture, shaping his sensibility and inadvertently revealing his vocation. Galvanizing his artistic penchant at the Yale School of Architecture, Stuart founded Stuart Silk Architects in 1981 and has since devoted his professional life to creating for clients and their communities the structural beauty that so profoundly affected his own life.

The firm, now 17-strong and more than 25 years old, has designed new residences, historical renovations and extensive remodels in a wide range of aesthetics. Stuart credits his expansive architectural vocabulary both to his early travels and to his education, which provided a broad view of the architectural world and imbued him with an insatiable intellectual curiosity. As fascinated

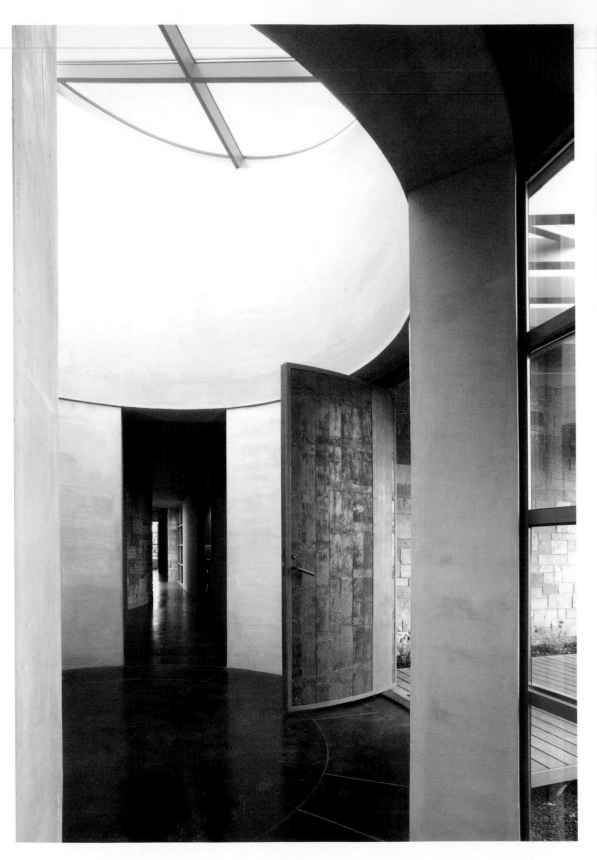

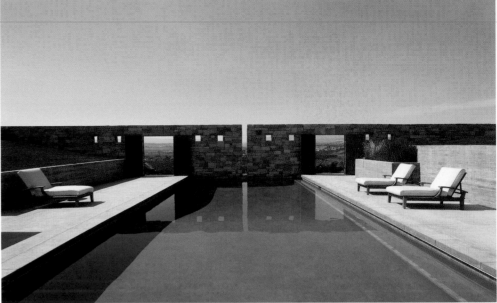

with European architecture as with American, both historical and contemporary, Stuart is continually building his repertoire through travel and observation and applying his knowledge of diverse influences from different regions to create globally inspired yet regionally appropriate forms. The firm's portfolio reflects the fluidity with which it can move from traditional to modern.

Fundamental to the firm's philosophy is collaboration. The project team works very closely with clients to understand their modes of perception and aesthetic preferences in order to successfully translate them into memorable built forms. This process of discovery ensures that Stuart and the team refrain from imposing their ideas on clients but instead produce fresh and innovative interpretations of their visions into the physical realm. The team is guided by the character and unique texture of each site as well as the surrounding context.

Left: The uncluttered entry to this home—a dramatic 18-foot, glass-covered concrete drum—is located at the axis of two stone, gabled buildings and fills the home with natural light.
Photograph by Steve Keating

Above: Stone walls shield the pool and cabana from prevailing summer winds, while wood shutters open to views of the rural landscape and mountains.
Photograph by Stuart Silk

Facing Page: At the rear of the home, a trellised courtyard off the living and family rooms overlooks concrete terraces leading down to the sheltered pool area. The home's simple, contemporary forms were inspired by the agrarian land near Selah, Washington.
Photograph by Stuart Silk

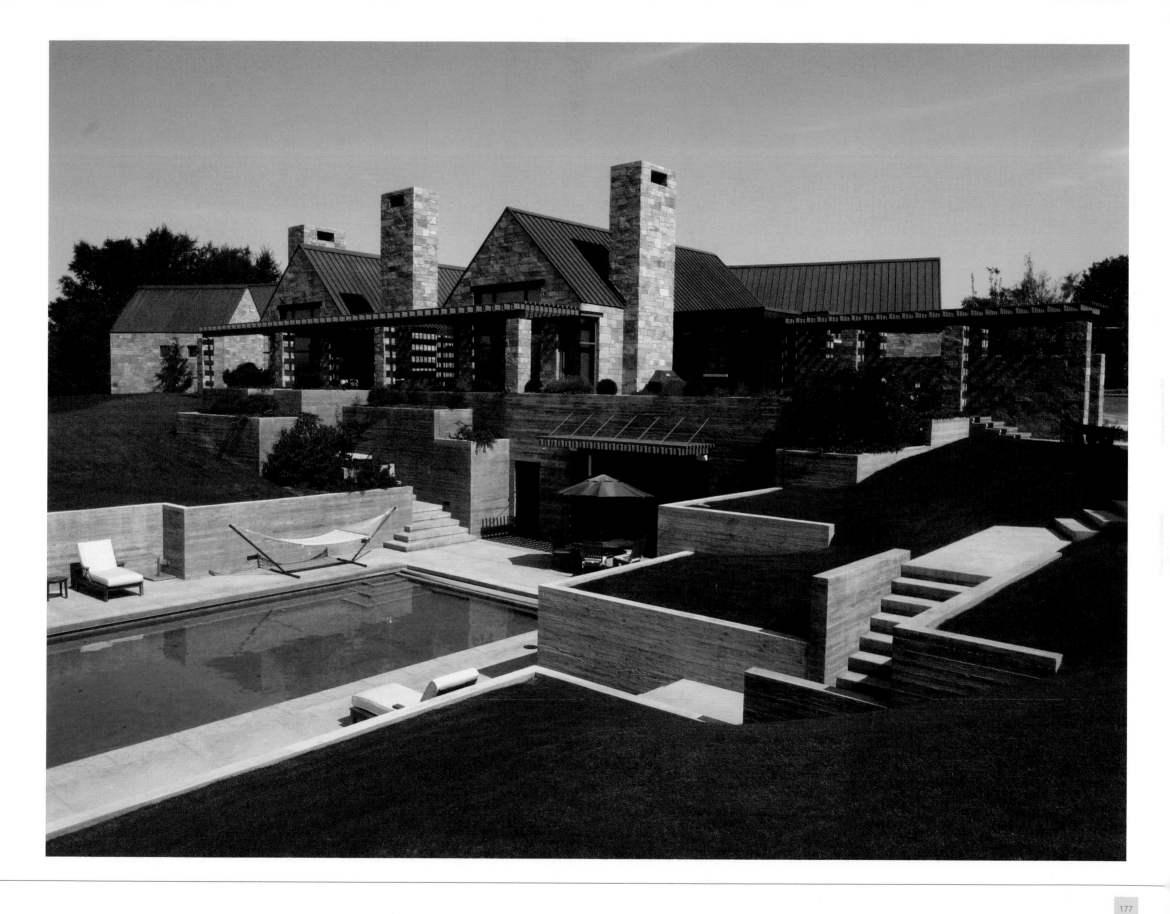

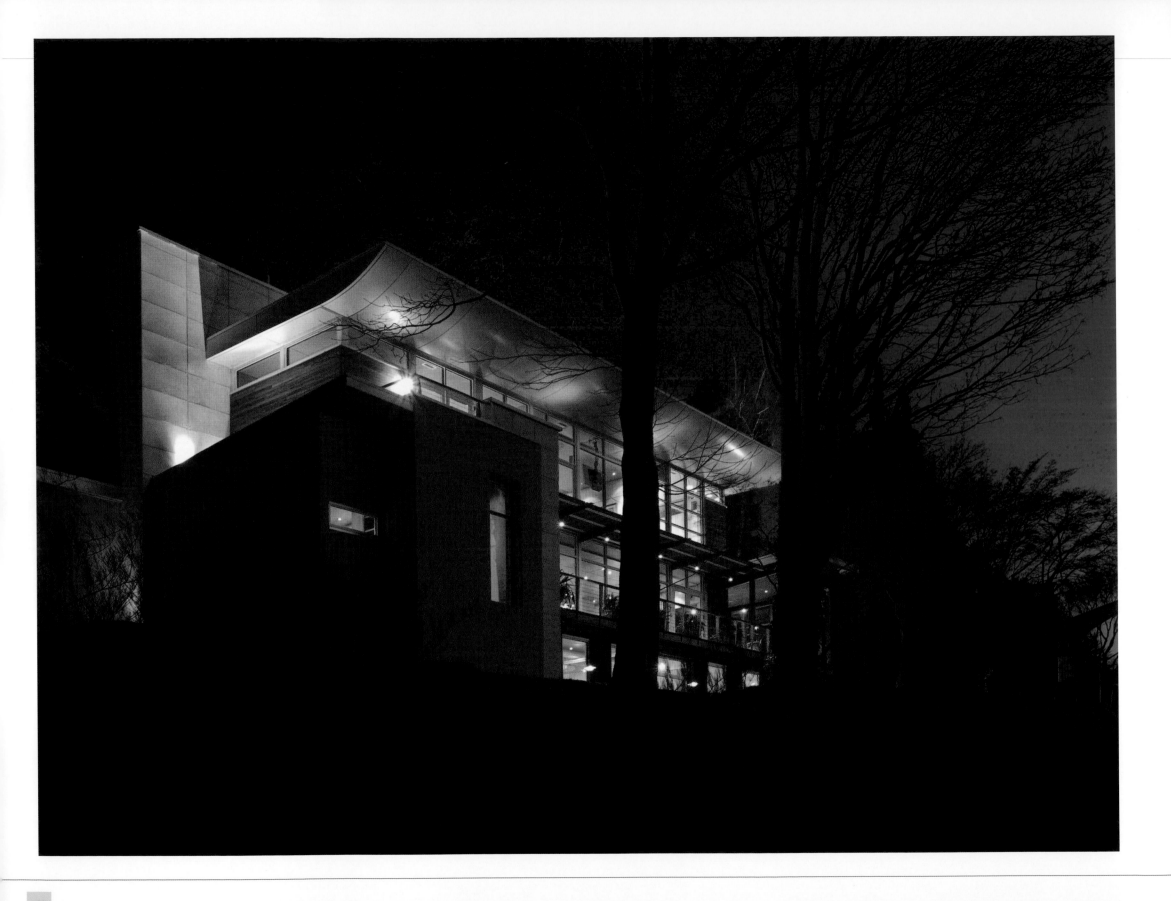

The firm's emphasis on the importance of site characteristics underlies its Green design efforts. Taught the importance of energy conservation early on, Stuart carries that responsibility to each project, carefully studying each site and informing clients of environmentally conscious design and building techniques, encouraging their use. The architects purposefully orient their homes to promote passive solar energy and preserve native vegetation. They choose durable materials, employ energy-efficient appliances and use such heating and cooling methods as solar panels and geothermal loop systems.

So committed is the firm to Green principles that it created the "Stuart Silk Green Guide," a tool used to measure projects according to proper siting, water and energy conservation, ample ventilation and the extent to which homeowners are educated about environmentally friendly living. A member of King County's Built Green program—one of the firm's architects sits on its executive committee—the firm works to integrate as many Green components as possible in every project.

In addition to receiving numerous awards, Stuart Silk Architects has been recognized for its diverse and innovative designs in such notable publications as *Architectural Digest*, *Traditional Home*, *Metropolitan Home*, *House & Garden* and *Seattle Homes & Lifestyles*. Moreover, the firm recently was chosen along with seven other U.S. architects to design nine villas, each of which had to be unique, for an upscale, gated community in Shanghai. Stuart and his team were honored to have been so distinguished and consider the opportunity among their most remarkable to date.

Yet what Stuart most loves about his work is that each project is a new and extraordinary experience. Driven by the need to feel invigorated and challenged every day, Stuart constantly pushes his team and himself to improve upon and expand their capabilities and arrive at increasingly more creative and exciting projects. While persistently laboring to develop his designs, Stuart staunchly adheres to an unchanging goal: to create for each client a memorable home.

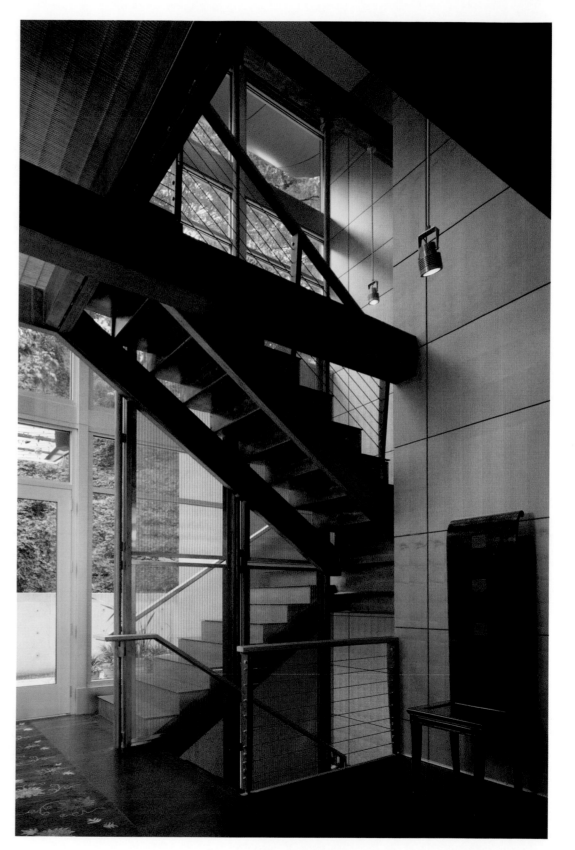

Right: Stuart Silk Architects celebrated the clean, structural aspects of the stairway by exposing the steel framing. Carefully selected wood panels provide a warm backdrop. "The tower created a new identity for the home," says Silk, "and projects light throughout the loftlike interiors."
Photograph by Ben Benschneider

Facing Page: In this Seattle residence overlooking bustling Lake Union, the airfoil curves of an aluminum-clad roof inspire a feeling of soaring over the trees.
Photograph by Steve Keating

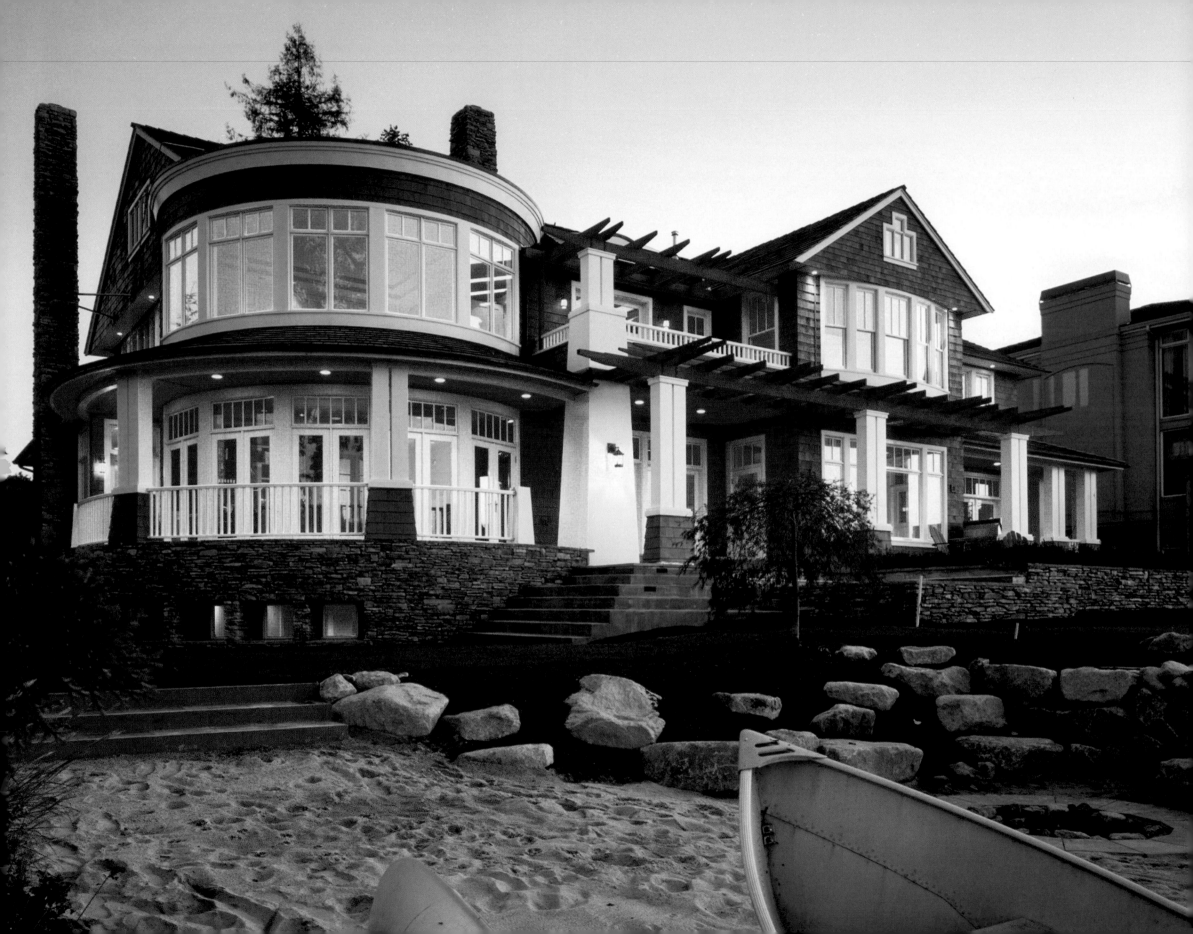

DAVE THIELSEN

Thielsen Architects, Inc. PS

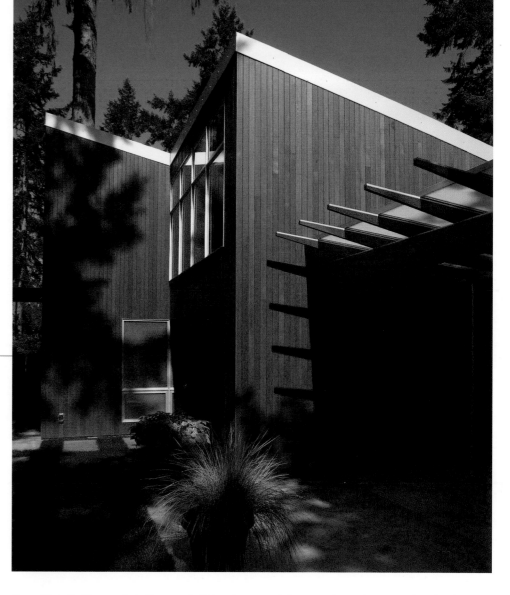

Above: Clean shed forms and a trellis covered with translucent panels frame a patio, creating a tranquil outdoor living space for this home.
Photograph by © Art Grice

Facing Page: Anchored by the rotunda, the interior living spaces of this traditional home open to the exterior porches and terraces, which cascade down to the beach.
Photograph by © Steve Keating

F inding a way to unite his two passions—art and construction—into a successful career led Dave Thielsen, founder and principal of Thielsen Architects, Inc., to pursue a future in architecture. To Dave it just made sense; "Our homes should be sculptures in which we live."

Quite significantly, Dave's foundation began in construction, where as a teenager he worked in several trades around building sites and later as a carpenter. This hands-on practical experience helped shape him as an architect and overwhelmingly benefits his clients by giving him insight into construction practices few architects possess.

Upon graduation from The University of Idaho, Dave gained critical experience with several Seattle firms in the multidisciplinary fields of municipal and commercial architecture as well as construction

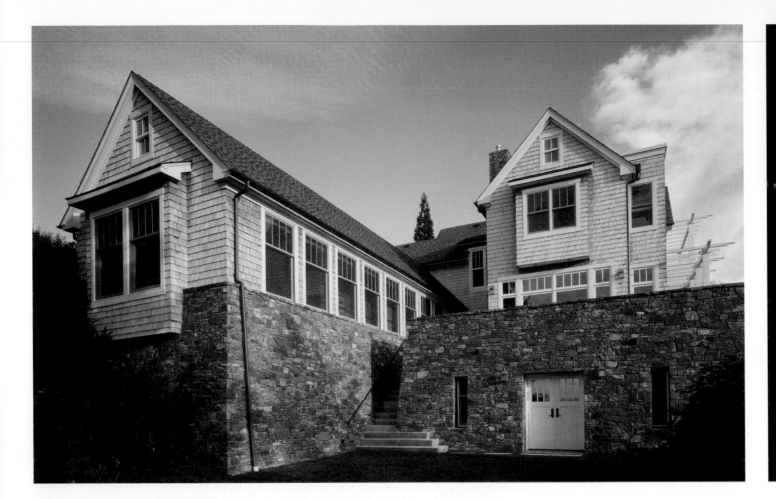

management. Dave soon set his sights on what inspired him most: custom residential architecture. In 1991, he established his own firm.

Avoiding the pitfall into which some firms fall, home designs are not repetitive at Thielsen Architects, but each are unique and specific to the client and setting. Dave believes design must respond to its environment, location and client. It is true design acumen that uncovers this perfect balance. Instead of "branding" his firm with a particular architectural style, Dave enjoys working in a number of styles while ensuring that each design's floorplan focus on circulation and overall functionality of the home. In order for this to happen, a thoughtful, clear

relationship between spaces must exist, regardless of the desired style.

Through well-planned architecture, Dave strategically places each window to make certain natural light keeps the light switches off well into evening. This is especially important and appreciated in Seattle where sunlight is cherished and people are becoming increasingly interested in Green architecture. Dave has included sustainable design in his work for many years, even jokingly calling it "Guerilla Green," which he defines as making conscious, sustainable design decisions on all projects, even when not specifically requested to by the client. One client was amazed to learn that her home was using 30 percent less energy

than like-sized houses. She initially had no idea that reducing impact on the environment was something Dave incorporated into his designs in simple, effective ways; she only knew that he had designed the home of her dreams. This is just one of the reasons people seek Thielsen Architects.

Above Left: The carefully articulated forms of this Shingle-style lake home are set firmly on a base of battered stone, anchoring the house to the hillside.
Photograph by © Steve Keating

Above Right: The see-through concrete fireplace and slender stainless-steel flue of this urban beach house allow views of the fire and water to be enjoyed simultaneously.
Photograph by © Gregg Krogstad

Facing Page: The horizontal forms and an open, lineal floorplan are arranged to capture views of the Cascade foothills and the snow-capped summits beyond.
Photograph by © Art Grice

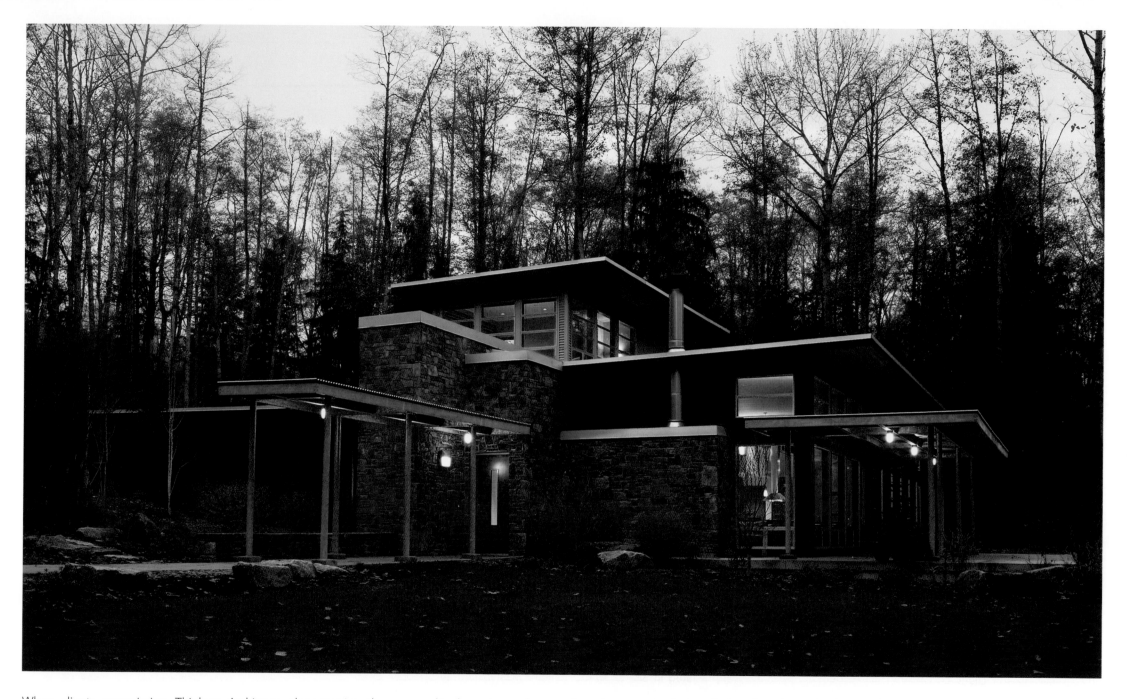

When clients commission Thielsen Architects, they receive the personalized services of an award-winning designer and his team of talented architects. Dave is involved in designing and developing each project. By keeping his firm a small, "well-oiled machine," Dave makes certain that clients receive the time and attention they deserve and require to reach their goals. The design phase is given priority to ensure his client's expectations are met and even exceeded. Through a series of in-depth meetings, Dave walks the site, listens to his clients' dreams and draws out the key elements needed to design their distinctive home. The final design always reflects the client's desires and expectations expressed in the design meetings and fits the family perfectly.

"Our work is all about our clients, their wants and needs. Whatever their goals are, we help our clients achieve them. If we do that, and the client has had fun and enjoyed the process, then we have done our job."

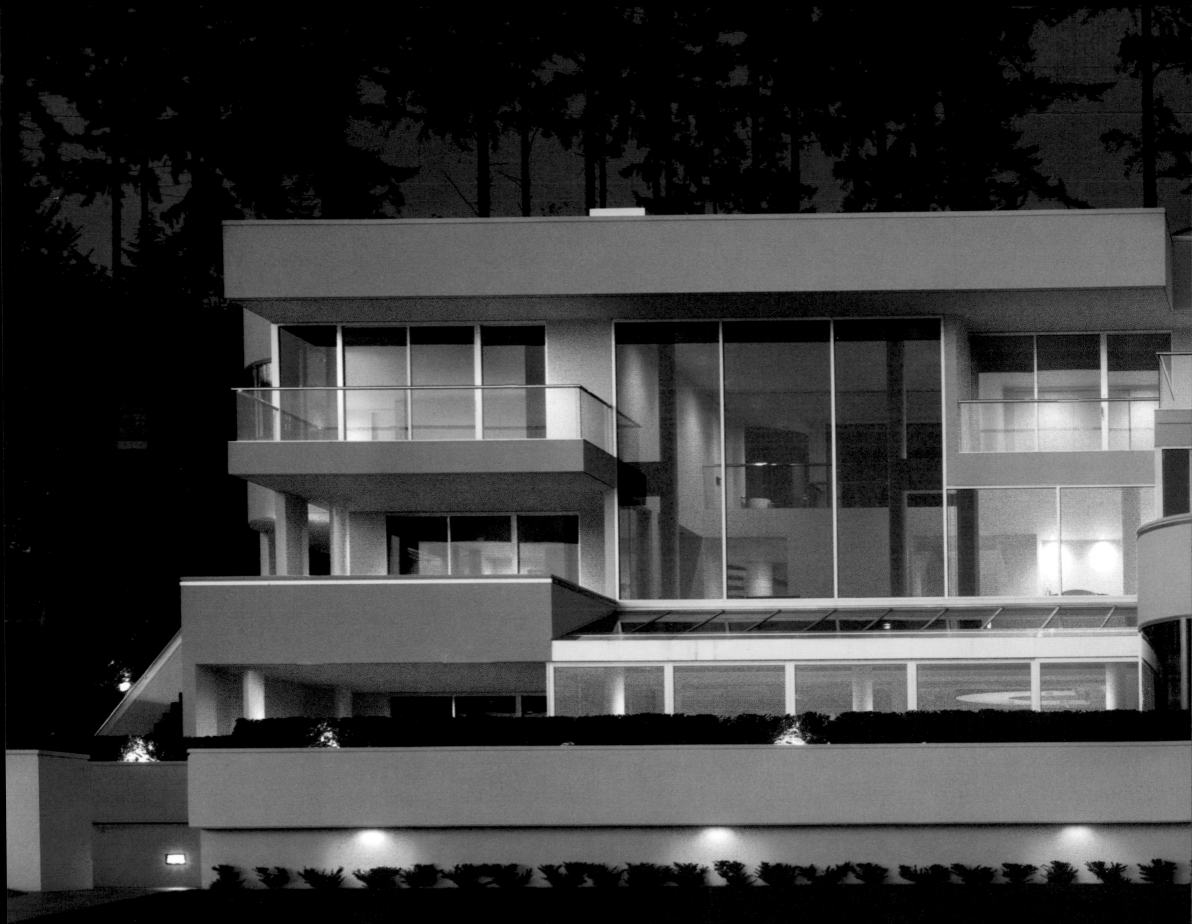

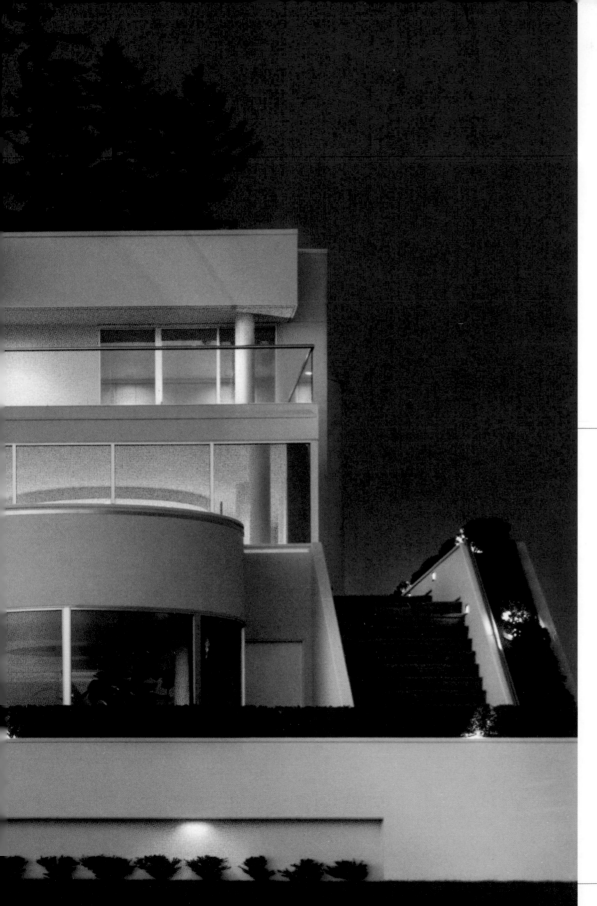

GAREN WILLKENS

Willkens Construction

According to Garen Willkens, there are two types of contractors: the "new school," run by businessmen who generate electronic reports and coordinate and employ a large number of subcontractors and tradespeople, whose scope is very narrow in relation to the overall project, to manage and execute the actual construction, and the "old school," run by those with firsthand construction experience, who are actively engaged not only intellectually but also physically in the production of each project. The latter describes Garen's own firm, Willkens Construction, which he incorporated in 1975. Involved in the construction industry from his youth, Garen worked as a carpenter for the better part of his early 20s. As such, he gained an education of and a great deal of valuable experience with a variety of building techniques and materials as well as an insider's view of the business in its entirety.

Left: Glass abounds on this Bellevue, Washington, contemporary residence, letting in the light and providing ample views of the lake beyond.
Photograph courtesy of Willkens Construction

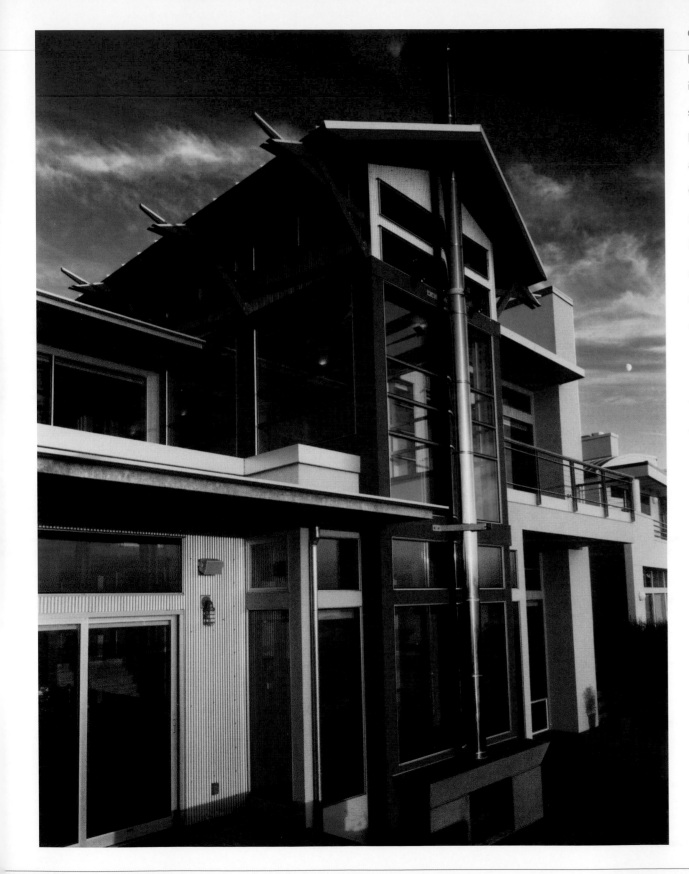

Garen's intimate familiarity with the literal nuts and bolts of building facilitates his firm's hands-on approach to custom-home creation. His team, which includes long-time superintendent Poul Erickson and a select number of highly skilled carpenters, does as much of the carpentry as possible and utilizes loyal subcontractors in an effort to maintain the high-level of accuracy and artistry upon which Garen insists. Yet with more than 35 years in the business, Garen knows where to turn for outside expertise—the firm has forged solid relationships with a broad network of talented tradespeople, many of whom he has collaborated with for upwards of 20 years. Willkens Construction has thus garnered the strong support of numerous architects who readily and confidently enlist the firm to bring their visions into being, knowing that even the smallest detail will receive the team's utmost attention.

Each exquisite home Willkens Construction creates is an original. From Traditional to Modern in style, as large as 20,000 and as small as 2,500 square feet, the homes express an array of motifs and schematics. While Garen's focus is new construction, he undertakes a handful of remodeling projects, primarily for clients for whom the firm has previously built. While there is no single defining characteristic of a Willkens Construction home, a recurring theme seems to be especially challenging sites. Garen recalls one such problematic location, an island property that featured a dramatic 75-foot drop. In order to raze the existing homes and construct the new structure, the team found it necessary to access the site by boat and haul away the waste materials on barges—a solution demonstrative of the firm's determination and enterprising spirit.

Left: The numerous windows and clerestories express a rectilinear theme in this Kirkland, Washington, home, capturing exquisite lake views and establishing an interior-exterior connection.
Photograph courtesy of Willkens Construction

Facing Page: Harmonious materials, flawless detail and an open floorplan evoke a sense of warmth and connectivity in the kitchen and living room of this Kirkland, Washington, home.
Photograph courtesy of Willkens Construction

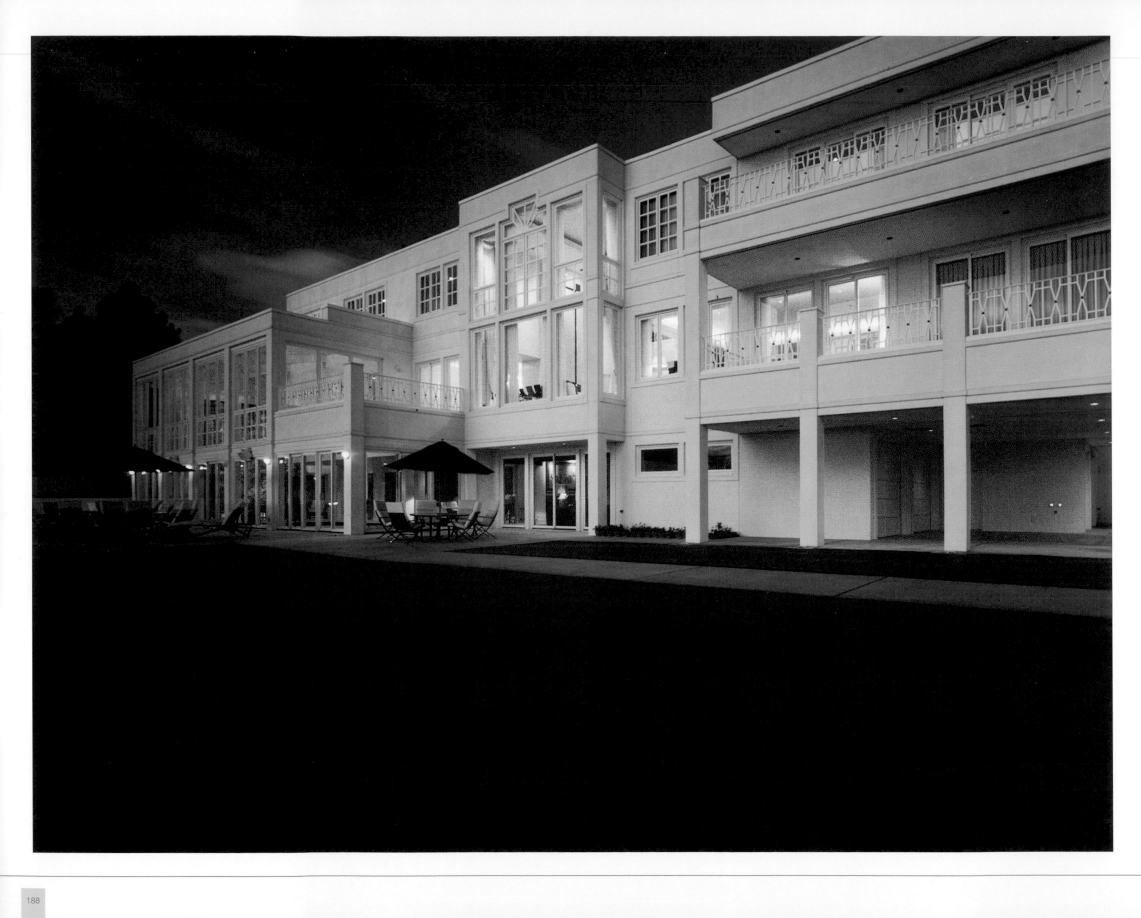

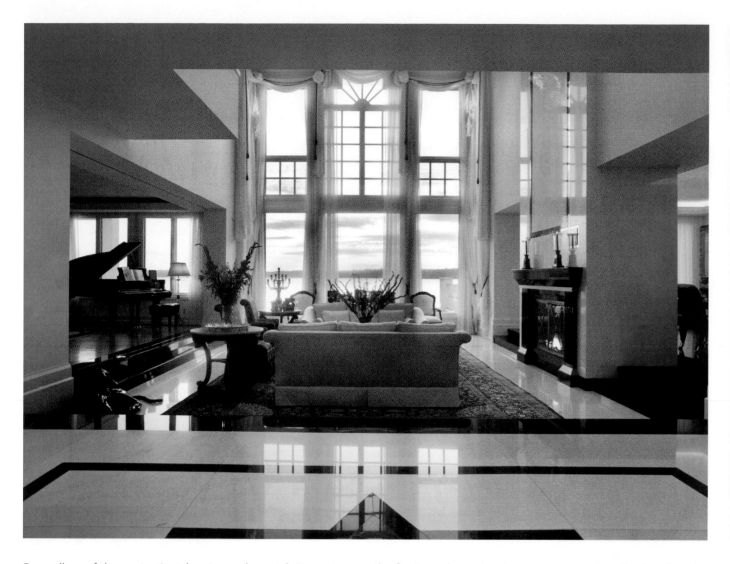

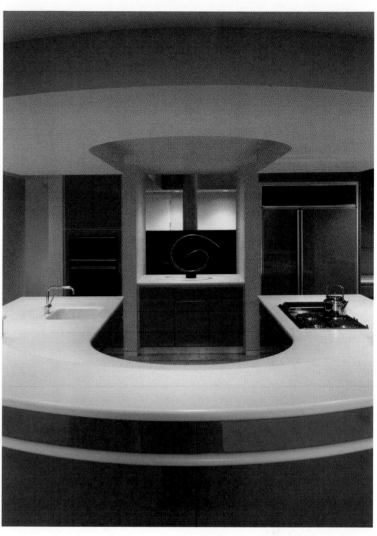

Regardless of the project's style, size and special circumstances, the firm's goal remains the same: to produce flowing, friendly, functional homes, resolving any utilitarian issues without compromising the design while creating an enjoyable building experience for the homeowner throughout the construction process. Garen and his team thoroughly review each home's plans from the outset and meticulously monitor the construction to ensure that the artistic concept is fully realized. If, for example, the architect does not account for the complex ductwork in a home when establishing ceiling height, his design will ultimately fail; Willkens recognizes the significance of the design vision and helps architects identify potential problems such as this early enough in the process to prevent them. Intricate millwork, elaborate cabinetry, accurate alignment—no component or concern escapes the team's scrutiny.

By cautiously guarding all of the elements that affect the home's plan, Willkens Construction ensures the creation of crisp and precise architectural features. While the beauty of its homes has garnered the recognition of such publications as *The Seattle Times Pictorial*, the firm most treasures its clients' praise and delight. The team's ability to beautifully and seamlessly fuse the practical and the aesthetic results in spectacular custom creations that are as gratifying to inhabit as to view.

Above Left: Floor-to-ceiling windows framing views of the lake and thick marble walls create a dramatic effect in this Medina, Washington, estate's living room.
Photograph courtesy of Willkens Construction

Above Right: Visual interest and utility marry in the U-shaped kitchen peninsula of a Bellevue, Washington, residence.
Photograph courtesy of Willkens Construction

Facing Page: With multiple balconies and lake views in every room, this three-story Medina, Washington, estate seems a veritable resort.
Photograph courtesy of Willkens Construction

PUBLISHING TEAM

Brian G. Carabet, Publisher
John A. Shand, Publisher
Steve Darocy, Executive Publisher
Kathie Cook, Associate Publisher
Beth Benton, Director of Development & Design
Julia Hoover, Director of Book Marketing & Distribution
Elizabeth Gionta, Editorial Development

Michele Cunningham-Scott, Art Director
Mary Elizabeth Acree, Graphic Designer
Emily Kattan, Graphic Designer
Ben Quintanilla, Graphic Designer

Rosalie Z. Wilson, Managing Editor
Katrina Autem, Editor
Lauren Castelli, Editor
Anita Kasmar, Editor
Ryan Parr, Editor

Kristy Randall, Managing Production Coordinator
Laura Greenwood, Production Coordinator
Jennifer Lenhart, Production Coordinator
Jessica Garrison, Traffic Coordinator

Carol Kendall, Administrative Manager
Beverly Smith, Project Management
Carissa Jackson, Project Manager
Amanda Mathers, Project Manager

PANACHE PARTNERS, LLC
CORPORATE OFFICE
13747 Montfort Drive, Suite 100
Dallas, TX 75240
972.661.9884
www.panache.com

SEATTLE OFFICE
425.647.4470

PUBLISHER'S NOTE

When I moved to Seattle from my hometown of Dallas, Texas, six years ago, I fell in love. The sheer majesty of the ever-present Cascades and the superior quality of life of everyone I encountered seemed other-worldly, impossible even. Having traveled throughout the Pacific Northwest and lived it myself, I passionately and confidently assure you that it is very real.

So when the opportunity to work with architects and builders who love this incredible corner of the country as much as I came along, I found it impossible to resist. Though I knew nothing about structural design or construction at the outset, the talented people I came to know opened my mind to what can only be called their art form. Along the way, my appreciation and respect for the region grew as I learned how our architecture enhances it, and I made many lasting friendships. Meeting and viewing the work of these artists, visionaries and environmental stewards was not only a pleasure, but an honor.

My sincere thanks goes out to all of the architects and builders with whom I collaborated for sharing your inspirations and passions with me and, most importantly, our readers. I must also thank the photographers who bring to life these magnificent works of art and my production and editorial team for bringing the book to fruition. Last but not least, thank you to Bill and Jonathan, who continue to inspire me and support what I love to do.

Kathie Cook
Associate Publisher

THE PANACHE COLLECTION

Dream Homes Series

Dream Homes of Texas
Dream Homes South Florida
Dream Homes Colorado
Dream Homes Metro New York
Dream Homes Greater Philadelphia
Dream Homes New Jersey
Dream Homes Florida
Dream Homes Southwest
Dream Homes Northern California
Dream Homes the Carolinas
Dream Homes Georgia
Dream Homes Chicago
Dream Homes San Diego & Orange County
Dream Homes Washington, D.C.
Dream Homes Deserts
Dream Homes Pacific Northwest
Dream Homes Minnesota
Dream Homes Ohio & Pennsylvania
Dream Homes California Central Coast
Dream Homes Connecticut
Dream Homes Los Angeles
Dream Homes Michigan
Dream Homes Tennessee
Dream Homes Greater Boston

Additional Titles

Spectacular Hotels
Spectacular Golf of Texas
Spectacular Golf of Colorado
Spectacular Restaurants of Texas
Elite Portfolios
Spectacular Wineries of Napa Valley

City by Design Series

City by Design Dallas
City by Design Atlanta
City by Design San Francisco Bay Area
City by Design Pittsburgh
City by Design Chicago
City by Design Charlotte
City by Design Phoenix, Tucson & Albuquerque
City by Design Denver
City by Design Orlando

Perspectives on Design Series

Perspectives on Design Florida

Spectacular Homes Series

Spectacular Homes of Texas
Spectacular Homes of Georgia
Spectacular Homes of South Florida
Spectacular Homes of Tennessee
Spectacular Homes of the Pacific Northwest
Spectacular Homes of Greater Philadelphia
Spectacular Homes of the Southwest
Spectacular Homes of Colorado
Spectacular Homes of the Carolinas
Spectacular Homes of Florida
Spectacular Homes of California
Spectacular Homes of Michigan
Spectacular Homes of the Heartland
Spectacular Homes of Chicago
Spectacular Homes of Washington, D.C.
Spectacular Homes of Ohio & Pennsylvania
Spectacular Homes of Minnesota
Spectacular Homes of New England
Spectacular Homes of New York

Visit www.panache.com or call
972.661.9884

PANACHE PARTNERS, LLC

Creators of Spectacular Publications for
Discerning Readers

FEATURED ARCHITECTS & BUILDERS

AOME Architects AIA
Mark Anderson, AIA
Mark Olason, AIA
Dennis Marsh, AIA
Mark Elster, AIA
80 Vine Street, Suite 202
Seattle, WA 98121
206.622.3304
www.aomearchitects.com

Balance Associates, Architects
Tom Lenchek, AIA
80 Vine Street, Suite 201
Seattle, WA 98121
206.322.7737
Fax: 206.322.0465
www.balanceassociates.com

Eastern Washington Office
104 Riverside Avenue
Winthrop, WA 98862
506.996.8148

Bender Chaffey Corporation
Don Bender
Stephen Bender
205 Lake Street South, Suite 203
Kirkland, WA 98033
425.827.5511
Fax: 425.827.4291
www.benderchaffey.com

The Berger Partnership, PS
Tom Berger, FASLA
Jason Henry, ASLA, LEED® AP
1721 8th Avenue North
Seattle, WA 98109
206.325.6877
Fax: 206.323.6867
www.bergerpartnership.com

Blazer Development, Inc.
Ray Derby
Rick Lesniak
15573 Southwest Bangy Road, Suite 200
Lake Oswego, OR 97035
503.598.3992
www.blazerdevelopment.com

Chesshir Architecture
Stan Chesshir, AIA
415 Northwest 11th Avenue
Portland, OR 97209
503.228.3273
Fax: 503.228.1692
www.chesshirarchitecture.com

COLAB Architecture + Urban Design, LLC
Mark Engberg, AIA
421 Southwest 6th Avenue, Suite 1250
Portland, OR 97204
503.827.5339
Fax: 503.827.8164
www.colabarchitecture.com

Curtis Gelotte Architects
Curtis Gelotte
Scott Hommas
150 Lake Street South, Suite 208
Kirkland, WA 98033
425.828.3081
Fax: 425.822.2152
www.gelotte.com

Cutler Anderson Architects
James Cutler, FAIA
Bruce Anderson, AIA
135 Parfitt Way Southwest
Bainbridge Island, WA 98110
206.842.4710
Fax: 206.842.4420
www.cutler-anderson.com
www.reveal-designs.com

David Coleman / Architecture
David Coleman, AIA, NCARB
5206 Ballard Avenue Northwest
Seattle, WA 98107
206.443.5626
Fax: 206.443.5560
www.davidcoleman.com

Demetriou Architects
Vassos M. Demetriou
5555 Lakeview Drive, Suite 200
Kirkland, WA 98033
425.827.1700
Fax: 425.889.0308
http://demetriouarchitects.com

Dowd Architecture Inc.
Mike Dowd, AIA, NCARB
0753 Southwest Miles Street
Portland, OR 97219
503.282.7704
www.dowdarchitecture.com

E. Cobb Architects Inc.
Eric Cobb
911 Western Avenue, Suite 318
Seattle, WA 98104
206.287.0136
Fax: 206.233.9742
www.cobbarch.com

Fairbank Construction Company
Tad Fairbank
220 Madison Avenue
Bainbridge Island, WA 98110
206.842.9217
Fax: 206.842.9284
www.fairbankconstruction.com

FINNE Architects
Nils Finne, AIA
217 Pine Street, 12th Floor Penthouse
Seattle, WA 98101
206.467.2880
www.finne.com

Giulietti/Schouten, AIA Architects PC
Dave Giulietti, AIA
Tim Schouten, AIA
2800 Northwest Thurman Street
Portland, OR 97210
503.223.0325
Fax: 503.241.9323
www.giuliettiassoc.com

Gradwohl Construction, Inc.
Bob Gradwohl
33 Woodhaven Place
Woodway, WA 98020
206.546.9762
Fax: 206.542.4555
www.gradwohl.com

Green Gables Design and Restoration, Inc.
PO Box 4264
Portland, OR 97208
503.223.5109
Fax: 503.241.2413
www.ggables.com

Haggart Luxury Homes
Jason Haggart
Jeff Haggart
10151 Southeast Sunnyside Road
Suite 495
Clackamas, OR 97015
503.654.2030
Fax: 503.654.2028
www.haggarthomes.com

Jeffrey L. Miller Architect, P.C.
Jeffrey L. Miller, AIA
834 SW St. Clair Avenue, Suite 202
Portland, OR 97205
503.222.2234
Fax: 503.222.6134
www.jlmarchitect.com

Krannitz Gehl Architects
Bryan Krannitz, AIA
Barry Gehl, AIA
765 Northeast Northlake Way
Seattle, WA 98105
206.547.8233
Fax: 206.547.8219
www.krannitzgehl.com

Lawrence Architecture
Thomas Lawrence, AIA
320 Terry Avenue North
Seattle, WA 98109
206.332.1832
www.lawrencearchitecture.com

Miller | Hull Partnership
David Miller, FAIA
Robert Hull, FAIA
Norman Strong, FAIA
Craig Curtis, AIA
71 Columbia, Sixth Floor
Seattle, WA 98104
206.682.6837
Fax: 206.682.5692
www.millerhull.com

Olson Sundberg Kundig Allen Architects
Jim Olson, FAIA
Rick Sundberg, FAIA, LEED® AP
Tom Kundig, FAIA
Scott Allen, AIA
159 South Jackson Street, Suite 600
Seattle, WA 98104
206.624.5670
Fax: 206.624.3730
www.oskaarchitects.com

Owen Roberts Group
Owen Roberts
10634 East Riverside Drive, Suite 300
Bothell, WA 98011
425.483.0234
Fax: 425.481.0299
www.owenrobertsgroup.com

Richard Brown Architects AIA
Richard Brown, AIA
239 Northwest 13th Avenue, Suite 305
Portland, OR 97209
503.223.4957
Fax: 503.223.7633
www.rbarch.com

Robertson Merryman Barnes Architects
Nancy Merryman, FAIA, LEED® AP
Linda Barnes, FAIA, LEED® AP
1231 Northwest Hoyt, Suite 403
Portland, OR 97209
503.222.3753
Fax: 503.295.6718
www.rmbarch.com

Schuchart/Dow, Inc.
George Schuchart
Jim Dow
John Hoedemaker
Joseph Youngblood
4001 Aurora Avenue North
Seattle, WA 98103
206.633.3003
Fax: 206.633.0990
www.schuchartdow.com

SkB Architects, Inc.
Shannon Rankin
Kyle C. Gaffney
Brian Collins-Friedrichs
Doug McKenzie
2333 Third Avenue
Seattle, WA 98121
206.903.0575
Fax: 206.903.1586
www.skbarchitects.com

Stuart Silk Architects
Stuart Silk, AIA
2400 North 45th Street, Suite 200
Seattle, WA 98103
206.728.9500
Fax: 206.448.1337
www.stuartsilk.com

Thielsen Architects, Inc. PS
Dave Thielsen, AIA
720 Market Street, Suite C
Kirkland, WA 98033
425.828.0333
www.thielsenarchitects.com

Tyler Engle Architects PS
Tyler Engle, AIA
2126 Westlake Avenue
Seattle, WA 98121
206.621.7150
Fax: 206.621.7754
www.tylerengle.com

Vallaster & Corl Architects, P.C.
Don Vallaster, AIA, NCCARB
Mike Corl, AIA
711 Southwest Alder Street
Penthouse Suite
Portland, OR 97205
503.228.0311
Fax: 503.228.0314
www.vcarch.com

Willkens Construction
Garen Willkens
17226 Southeast 60th Street
Bellevue, WA 98006
425.641.9460
Fax: 425.641.9460